CAPITAL PUNISHMENT

and Roman Catholic Moral Tradition

CAPITAL PUNISHMENT

and Roman Catholic Moral Tradition

■

■

■

E. CHRISTIAN BRUGGER

■

University of Notre Dame Press
Notre Dame, Indiana

■

Library of Congress Cataloging-in-Publication Data
Brugger, E. Christian, (Eugene Christian), 1964–
 Capital punishment and Roman Catholic moral tradition / E. Christian
Brugger
 p. cm.
 Includes bibliographical references and index.
 ISBN 0-268-02359-x (alk. paper)
 1. Capital punishment—Religious aspects—Catholic Church. 2. Capital
punishment—Moral and ethical aspects. 3. Catholic Church—Doctrines.
I. Title.
HV8694 .B78 2003
241'.697—dc21 2003012363

∞ *This book is printed on acid-free paper.*

To

My wife Melissa.

My father and my mother.

Contents

PART III ■ RETHINKING THE CHURCH'S TRADITIONAL NOTION OF JUSTIFIABLE HOMICIDE

Abbreviations

AAS	*Acta Apostolicae Sedis*
ANF	*Ante-Nicene Fathers*, ed. Alexander Roberts and James Donaldson, vols. 1–8.
CCC	*Catechismus Catholicae Ecclesiae* (*Catechism of the Catholic Church*), *Editio typica*, 1997.
CF	*The Christian Faith in the Doctrinal Documents of the Catholic Church*, 6th ed., ed. Josef Neuner and Jacques Dupuis. New York: Alba House, 1996.
CIC-1	*Corpus Iuris Canonici*, vol. 1.
CIC-2	*Corpus Iuris Canonici*, vol. 2.
DEC-I/II	*Decrees of the Ecumenical Councils*, ed. Norman P. Tanner, S.J., and G. Alberigo. 2 vols. London: Sheed and Ward, 1990.
Denz.	Henry Denzinger, *Enchiridion Symbolorum*, 30th ed. English translation, *Sources of Catholic Dogma*, trans. Roy J. Deferrari. London: B. Herder Book Co., 1957.
EV	*Evangelium Vitae* (*On the Value and Inviolability of Human Life*). Encyclical Letter of John Paul II (25 March 1995), Vatican translation.
FOC	*The Fathers of the Church*
In Lib. Sent.	Thomas Aquinas, *Scriptum super Libros Sententiarum Petri Lombardi*, Books I–IV.

LG	*Lumen Gentium* (*Dogmatic Constitution on the Church*), Second Vatican Council (21 November 1964).
NPNF-I	*Nicene and Post-Nicene Fathers*, 1st series, ed. Philip Schaff, vols. 1–14.
NPNF-II	*Nicene and Post-Nicene Fathers*, 2d series, ed. Philip Schaff and Henry Wace, vols. 1–14.
PG	*Patrologiae Cursus Completus*, Series Graeca, ed. J. P. Migne.
PL	*Patrologiae Cursus Completus*, Series Latina, ed. J. P. Migne.
SCG	Thomas Aquinas, *Summa Contra Gentiles*
ST	Thomas Aquinas, *Summa Theologiae*
VS	*Veritatis Splendor* (*Regarding Certain Fundamental Questions of the Church's Moral Teaching*). Encyclical Letter of John Paul II (6 August 1993), Vatican translation.

CAPITAL PUNISHMENT

and Roman Catholic Moral Tradition

Introduction

But the ungovernables, the ferocious, the conscienceless, the idiots, the self-centered myops and morons, what of them? Do not punish them. Kill, kill, kill, kill, kill them.

—George Bernard Shaw[1]

Not only must human life not be taken, but it must be protected with loving concern. The meaning of life is found in giving and receiving love. . . . Society as a whole must respect, defend and promote the dignity of every human person, at every moment and in every condition of that person's life.

—John Paul II, *Evangelium Vitae*, no. 81

For over three decades an international effort has been afoot to restrict the death penalty throughout the world, with a view to abolishing it. Statistics testify to the success of this effort. As of January 2003, more than half the countries of the world had abolished the death penalty in law or practice,[2] while in 1965 "abolitionist" countries numbered only about thirty.[3] Among the largest and most outspoken participants in this effort has been the Roman Catholic Church.[4]

A leader in this effort has been Pope John Paul II, who, with the publication of his 1995 encyclical *Evangelium Vitae*, initiated a reevaluation of the morality of capital punishment in the Catholic Church. By his repeated pleas on

behalf of the condemned and his general admonitions to Christians and non-Christians alike, the pope has made every effort to minimize the infliction of the death penalty in the modern world, as an expression of commitment to the dignity of the human person.[5]

The Catholic Church has not always opposed the death penalty with such force. From its earliest days, up to and including the first half of the twentieth century, it has maintained a relatively confident, consistent, and coordinated defense of the right of the state to kill criminals. Visible signs of change in this regard can be seen as early as the 1950s, when mainstream Catholic writers and individual members of the hierarchy began to take public stands in opposition to the death penalty. The momentum increased—albeit gradually—in the 1960s. And in the 1970s the floodgates burst. Since then, literally hundreds of public statements opposing the death penalty—more perhaps than in the previous centuries combined—have been published by members of the Catholic hierarchy on a local, national, and international level.[6]

Given the Church's traditional teaching on the subject, the writings of the last decades of the twentieth century, particularly of the 1990s, are bound to prompt a number of questions. Is the Catholic Church for or against the death penalty? Under what circumstances, if any, may the death penalty be legitimately inflicted? What is responsible for the recent turn toward abolishing the death penalty by Catholics? What are the philosophical and theological constituents of the Church's present position? What is the relationship of that position to the traditional teaching on the subject? What are its implications for other forms of Catholic moral teaching, particularly in the tradition of justifiable violence? Is it reasonable to refer to it as a "doctrinal development" over and above the traditional position? If so, by what mode or modes has the development taken place (or is it taking place)? Can we anticipate that the present teaching will progress further? If so, what systematic form might that teaching take? These are the questions I intend to explore in the chapters that follow.

Chapter 1 addresses a question on many people's minds, namely, what is the nature of the present Catholic teaching on the death penalty? The chapter undertakes a relatively detailed examination and interpretation of the statement on the morality of the death penalty found in the *editio typica* (authoritative version) of the *Catechism of the Catholic Church* (1997).[7] I conclude that the text, while not explicitly stating that the death penalty is always wrong, lays down premises which, when carried to their logical ends, yield just such a conclusion. Rather than addressing the morality of the death penalty in terms of punishment, the *Catechism* addresses it as a form of self-defense. In addition,

the act of killing entailed in capital punishment, as well as all acts of "legiti-mate" killing, are subsumed under a model of double effect. A careful reading shows that implicit in the *Catechism* is an understanding of capital punishment that limits its lawful infliction to conditions traditionally circumscribing legiti-mate killing in private self-defense. In legitimate self-defense, according to Catholic theological tradition, any killing that results (and any harm, for that matter) must not be willed for its own sake or as a means to some further end, but rather must be accepted as a side effect, perhaps foreseen, of an act of force intended to render an aggressor incapable of causing harm. If we apply this logic to capital punishment, we must conclude that it is not legitimate, even though it aims at the good end of a restored order of justice, because its means is the intentional killing of a human person.

The *Catechism of the Catholic Church* was prepared under the pontificate of John Paul II, and its sections pertaining to the morality of the death penalty were directly influenced by papal ideas and teachings. If what I have said is sound, one would expect the moral reasoning found in other authoritative docu-ments prepared under the same pontificate to support the same conclusion. Against the broader backdrop of the authoritative teaching of John Paul II, therefore, I examine the moral reasoning set forth in the encyclicals *Evangelium Vitae* (1995) and *Veritatis Splendor* (1993), two important pontifical documents relating to Catholic moral teaching, and attempt to show how the pastoral and methodological reasoning of both, when applied to the problem of capital pun-ishment, favors the same conclusion.

Chapter 2 is intended for readers who are interested in a deeper consideration of the philosophy of punishment traditionally accepted and defended by the Catholic Church and outlined in the *Catechism*. I give special attention to the three traditional "purposes" or "goods" of punishment held together and prioritized in the account in the *Catechism*, namely, retribution, criminal rehabilitation, and de-fense of the community. The purpose is both to clarify important concepts at stake in the capital punishment debate (such as retribution, redress, the common good, and the order of justice) and to show that the Church's account of punish-ment is superior to a number of other influential accounts that give quasi-exclusive status to one or another of these justificatory strands (e.g., strict retributivism and utilitarian penal theories). Those whose interests lie strictly with the response of the Catholic Church to the problem of capital punishment may wish to pass over this chapter.

Having concluded in chapter 1 that the *Catechism* lays a theoretical foun-dation for a development of doctrine that would reject the death penalty in

principle, I explore in the following chapters the question of whether a development of this nature would be legitimate, given the traditional teaching on the topic. That is, I explore whether the Catholic Church, constrained by the requirements of sound biblical interpretation and dogmatic tradition, could legitimately teach in a definitive way that capital punishment, as entailing an intent to kill, is wrong per se.

Before this question can be answered, it is necessary to place such a position in juxtaposition to the traditional teaching and to assess the areas of continuity and difference. Chapters 3 through 7 are dedicated in large part to providing a satisfactory account of the "traditional teaching" on the morality of capital punishment, by reviewing and analyzing the most influential biblical passages and Catholic statements on the morality of capital punishment. In chapter 3, I consider statements in the Old and New Testaments; in chapter 4, the writings of Patristic authors; in chapter 5, the teaching of the medieval Church; and in chapter 6, statements of Catholic thinkers from (approximately) the Council of Trent to Vatican II. The second part of chapter 6 traces the steps in Catholic thinking from the late eighteenth century to the present as the Church gradually moved from support for, to opposition against, the death penalty.

In chapter 7, after discussing several propositions that summarize what might be called the cumulative consensus of patristic, medieval, and modern ecclesiastical writers on the morality of capital punishment, I consider the concept of "development of doctrine" in Catholic tradition. I ask, in light of the historical analysis, whether the traditional teaching on the lawfulness of capital punishment has been proposed in such a way as to *exclude* a development of doctrine which would teach that the death penalty is wrong in principle. Toward this end, I consider whether, according to the conditions specified by Vatican II (*Lumen Gentium*, no. 25), one or more of the propositions that constitute the "traditional teaching" have been taught infallibly. I propose two models intended to explain how we may understand the notion that Catholic doctrine on the morality of capital punishment is developing (or has developed); both emphasize the continuity maintained throughout the process of change.

Chapter 8 looks to the future, namely, to what a developed teaching might look like that rejects capital punishment in principle. I begin with a practical critique of the ethical reasoning of Thomas Aquinas, who provides the most systematic, cogent, and influential account in Catholic moral tradition (and, arguably, in all of Western ethical tradition) of the foundations for justifiable homicide. I argue that Aquinas' attempts to give a rational account of justifiable

intentional killing fail. I then endeavor to provide a systematic and philosophically consistent account of what I will call the *new position*. Starting from premises regarding substantive human good, practical principles, and moral norms derived from chapter 2 of *Veritatis Splendor* and, where the encyclical is silent, from Aquinas' moral theory and the development of that theory by John Finnis and Germain Grisez, I ask, what does basic morality require of the deliberations, judgments, and actions of those responsible for the state's coercive activity? I then address the question of the concrete implications of this analysis for the state's prerogative to punish in general, to restore justice, to protect the community from internal threats (i.e., to undertake law enforcement activity), and to protect the community from external threats (i.e., to engage in war).

Because this book is primarily concerned with an intra-ecclesiastical conversation, many important questions of the wider debate on capital punishment are left untreated. The sea of literature on empirical questions such as justice in sentencing, the rights of prisoners, the condemnation of the innocent, the question of deterrence, methods of rehabilitation, penal reform, and so on is referenced only in the notes, if at all. Regarding the arguments put forward and positions defended with respect to such questions, this book takes no stand. Similarly, the many important theological contributions to the debate on capital punishment coming from Christian traditions outside the Roman Catholic Church are left untreated. It might be said, however, that the majority positions defended by the mainline Christian churches over the past five hundred years show little notable disparity.

▪

The labor and charity of a number of important benefactors helped bring this work to completion. In the first place I thank John M. Finnis and Oliver O'Donovan, who supervised my research. I thank as well Nigel Bigger and Robert Ombres, O.P., who provided extensive comments and criticisms, and Giovanni Sala, S.J., of Die Hochschule für Philosophie in Munich, who read early portions in draft. I am grateful to James J. Megivern for supplying me with a number of hard-to-find texts and providing me with timely counsel in the early stages of my work. James Megivern's important and extensive work, *The Death Penalty: An Historical and Theological Survey* (Paulist Press, 1997), served as an invaluable reference source for my research. Special acknowledgment is due Juliane Kerkhecker, who enjoyed the unenviable task of assisting me with literally hundreds of foreign language references. I thank as well Germain

Grisez, Earl Richard, Michael Pakaluk, Chris Baglow, Robert Kennedy, Robert Royal, Rev. Lawrence Dewan, Rev. Peter Ryan, Rev. Brian Harrison, Kevin Miller, Richard Stith, Patrick Lee, William Marshner, Christopher Wolfe, Michael Gorman, John F. Boyle, John Grabowski, David Solomon, and Cardinal Avery Dulles. Each of these either commented on chapters of my manuscript in draft, offered valuable criticisms in conversation, or provided speaking invitations where I was able to set forth my basic thesis and receive helpful input.

As for the individuals and institutions who supported my research, I thank the Intercollegiate Studies Institute for awarding me a Western Civilization Fellowship in 1999–2000; the Earhart Foundation and my Earhart Fellowship sponsor, Robert P. George; the Oxford Theology Faculty's Denyer & Johnson Fund for two successive scholarships; and Oxford's Squire Marriott Fund for two generous research grants. I thank as well my dean at Loyola University, Frank Scully, for funding several important travel opportunities. Special thanks are due Libby and Roger Blackwood of Berkshire, England, for extensive financial assistance in the early stages of this work.

My deepest debt is owed to those to whom this work is dedicated.

PART I

■

SORTING OUT THE ISSUES

■

■

■

■

The Present Teaching of the Magisterium

■

The *Catechism of the Catholic Church*

Some background on the stages of development of the teaching on capital punishment in the *Catechism* will help us understand the shape and content of the definitive text.[1] In 1989 a Vatican commission, established for the purpose of preparing the Church's universal catechism, distributed a text called "Revised Project" to all the bishops of the Catholic Church for consultation and criticism. The section on capital punishment—at that time numbered 3541—ran as follows:

> It would be fitting to set aside the death penalty exacted by society on those found guilty of crimes of extreme gravity. Although the punishment is legitimate, the Church hopes for a habitual recourse to clemency, which is moreover in the spirit of Scripture and particularly of the Gospel. If it is necessary to protect society and prevent crime, there is also the duty to be merciful as the Heavenly Father is merciful (cf. Lk 6:36).

Although this section did not say all that Catholic teaching has traditionally included in an account of the morality of capital punishment, it said nothing new. It taught simply that while in principle the death penalty is legitimate, it is preferable to set it aside as a fitting response to the Gospel imperative to show mercy. It proposed a Christian ideal for the way society should relate to those

who commit grave crimes, but it imposed no conditions on the lawful infliction of the death penalty.

Given the vast number of criticisms the bishops of the world raised against the whole third part of the distributed draft (the part dealing with Christian morality), the Vatican commission decided to revise the entire part. When the original edition of the *Catechism of the Catholic Church* was published in 1992 in French (from which all other translations at the time were prepared), the section dealing with the death penalty, now numbered 2266–2267, bore little or no resemblance to the text of the "Revised Project."

In 1995 Pope John Paul II published his eleventh encyclical, "On the Inviolable Good of Human Life," popularly referred to as *Evangelium Vitae*.[2] Of its 105 numbered sections, only section 56 systematically treats the morality of the death penalty.[3] Yet because its opposition is formulated in unusually strong terms for a magisterial document, stronger even than in the 1992 *Catechism*, section 56 received more notice than any other in the entire document.

Meanwhile the pope set up an interdicasteral commission charged with the preparation of the *Catechism's* Latin *editio typica* (i.e., the normative and definitive text). The 1992 edition had been subject to revisions from the first. In the years after its publication, volumes of requests were submitted to the Vatican for changes and emendations with a view to the *editio typica*. This commission, therefore, had the job not only of overseeing the Latin translation, but also of collating and provisionally approving certain among these suggestions. At length, a list of *corrigenda et addenda* was approved by the Holy Father for inclusion into the *editio typica*. According to Christoph Schönborn, secretary of the commission, the revisions to sections 2266–2267 constituted "the only substantial correction [i.e., of the 1992 text], all the others touched on minor points, corrections of references, of citations, and the like."[4] What the revisions essentially involved was an incorporation of the stronger language of opposition to the death penalty found in section 56 of *Evangelium Vitae*. One additional revision included limiting the *Catechism's* comments on the death penalty to section 2267, leaving 2266 for a treatment of the limits and aims of punishment in general.

Section 2267 consists of three paragraphs:

> Assuming that the guilty party's identity and responsibility have been fully determined, the traditional teaching of the Church does not exclude recourse to the death penalty, if this is the only possible way of effectively defending human lives against the unjust aggressor.

If, however, non-lethal means are sufficient to defend and protect people's safety from the aggressor, authority will limit itself to such means, as these are more in keeping with the concrete conditions of the common good and more in conformity with the dignity of the human person.

Today, in fact, as a consequence of the possibilities which the state has for effectively preventing crime, by rendering one who has committed an offense incapable of doing harm—without definitively taking away from him the possibility of redeeming himself—the cases in which the execution of the offender is an absolute necessity "are very rare, if not practically nonexistent" [quote from *EV*, no. 56].

The "Plain-Face" Interpretation

A popular interpretation of section 2267 runs as follows: the Church has always taught that the state has the right to inflict punishments on duly convicted criminals, including, if need be, the punishment of death. The exercise of that right, however, is only justified if it manifestly contributes to the common good. Given the rise of effective non-lethal penal alternatives in today's world, recourse to the death penalty is no longer necessary for defending the common good. Therefore, its infliction in the modern world, while in principle legitimate, is effectively illegitimate.

Some have loosely referred to this as a development in the Church's teaching on the morality of capital punishment. But they mean "development" not in terms of the formulation of a truth of Christian doctrine in a way that reveals meaning deeper than that which up till now has been understood and hence expressed, but rather in terms of a new practical conclusion resulting from the application of an unchanging principle (i.e., civil authority possesses the right to kill malefactors for the sake of the common good) to changing conditions. For example, in 1995 at the time *Evangelium Vitae* was released, Cardinal Ratzinger was reported as saying that the *Catechism* was being revised to reflect the stronger opposition to capital punishment found in *Evangelium Vitae*. The encyclical's "reservations about the death penalty," he said, "are even stronger than those already present in the [1992] catechism and are a real development."[5] Wondering about these words, Father Richard John Neuhaus wrote to Cardinal Ratzinger asking for clarification. The cardinal responded:

You ask about the correct interpretation of the teaching of the encyclical on the death penalty. Clearly, the Holy Father has not altered the doctrinal principles which pertain to this issue as they are presented in the Catechism, but has simply deepened the application of such principles in the context of present-day historical circumstances. Thus, where other means for self-defense of society are possible and adequate, the death penalty may be permitted to disappear. Such a development, occurring within society and leading to the foregoing of this type of punishment, is something good and ought to be hoped for.[6]

The cardinal's sense of development aptly characterizes what I am calling the plain-face interpretation. But to refer to the *Catechism's* teaching so construed as a "real development" of doctrine is unwarranted. To be sure, this teaching is not a reassertion of certain principles previously accepted and taught by the Church, and one is free to suppose that certain propositions taught by the magisterium in the past would even be rejected by today's magisterium. (An example is the proposition that the lawful authority of the state to inflict capital punishment derives from God mediated through the authority of the Church.[7]) But the fact that these principles are not reasserted in section 2267 is insufficient ground to conclude that a development of doctrine has taken place.

The Implicit or New *Interpretation*

It is my contention that something new is being said about the morality of capital punishment in sections 2263–2267 of the *Catechism of the Catholic Church*, contrary to the plain-face interpretation. Because the text strictly ties its analysis to a model of *self-defense* against the wider conceptual backdrop of *double-effect* reasoning, it is reasonable to conclude (1) that the act referred to in the text as *poena mortis* is not, precisely speaking, an act of punishment, but an act of collective self-defense by the community against a dangerous internal aggressor, and (2) that capital punishment as well as all acts of legitimate killing should be limited by conditions traditionally used to limit lawful killing in private self-defense.

Because the *Catechism* does not explicitly state these two conclusions, and because such conclusions on the nature of the death penalty are novel relative to the tradition, a particular burden exists to show why this interpretation is more faithful to the text and the ideas of the present magisterium than the

plain-face interpretation. By way of argument, therefore, I will carefully examine the context, content, and shape of the *Catechism's* treatment; consider key terms the *Catechism* uses in relation to the way those same terms are used in Catholic moral tradition; and compare the text of the 1997 *editio typica* with its precursor, the 1992 edition released in French and translated in 1994 into English. Having set forth my interpretation and conclusions, I will bring them into critical comparison with the moral and pastoral reasoning found in the 1993 papal encyclical *Veritatis Splendor* and the 1995 encyclical *Evangelium Vitae* and show how those two important documents offer added support for the interpretation I propose.

■

Section 2267 on capital punishment is located in Part III of the *Catechism*, dedicated to the Christian moral life. (Part I treats the articles of the Creed, Part II, the liturgy and the sacraments, and Part IV, Christian prayer.) The second general section of Part III treats the precepts of the Decalogue. Under Article 5 (on the Fifth Commandment), part 1, entitled "Respect for human life," the *Catechism* takes up questions related to justifiable homicide.

Section 2267 is the last of the group of five making up a subsection under Part III entitled "Legitimate defense." (The immediately preceding subsection is entitled "The witness of sacred history," and the four subsections immediately following, "Intentional homicide," "Abortion," "Euthanasia," and "Suicide," respectively.) The first of the five, no. 2263, introduces "double-effect" reasoning to show that not all actions that result in killing are intentional killing and thus forbidden by the Fifth Commandment. Indeed, the teaching that controls the whole of this subsection is that what the commandment excludes as murder is *intentional* killing; the paragraph ends by quoting Aquinas' influential treatment in *Summa Theologiae* of the lawfulness of killing aggressors in self-defense, provided the killing is not what is intended. No. 2264 applies "double-effect" reasoning to lawful killing in self-defense; no. 2265 treats the right and duty of anyone "who is responsible for the lives of others," particularly (but not exclusively) public authority, to defend the relevant community—if need be with arms—against unjust aggressors (for example, to defend the civil community against foreign aggressors); and no. 2266 treats the right and duty of public authority to safeguard the community against internal threats to the common good by inflicting due punishments.

In outline,

Let us first consider the heading "legitimate defense" (*Defensio legitima*). This is an atypical title under which to include a treatment of capital punishment. The predecessor of the current catechism, the 1566 *Roman Catechism*, prepared pursuant to a decree of the Council of Trent, treats capital punishment under a subsection titled "exceptions" to the Fifth Commandment.[8] And most systematic treatises, at least since Trent, follow Aquinas and treat it under the heading "whether it is lawful to kill malefactors," or something similar.[9] Not only does the *Catechism* not repeat the traditional heading, it intends right from the start to distance itself from its historical predecessor, which conceived the death penalty as an exception to the fifth precept of the Decalogue. The very first sentence of the subsection reads: "The legitimate defense of persons and societies *is not* an exception to the prohibition against the intentional killing of the innocent that constitutes murder" (no. 2263, emphasis added). To understand the teaching of the *Catechism* on capital punishment, it is important to be clear on the intended meaning of the term *legitimate defense*.

The Latin term *defensio legitima* is uncommon in Catholic theology. It does not appear for example, in Aquinas' treatments of capital punishment or the virtue of justice, or, for that matter, in any of his major works on theology or morality. But he does use a related term, namely, *inculpata tutela* (blameless defense). Discussing whether it is lawful to kill a man in self-defense, Aquinas responds, "it is licit to repel force with force provided one does so with the *moderation of a blameless defense*."[10] "Nor is it necessary for salvation," he continues, "that one omit an act of moderate defense in order to avoid killing another."[11] Aquinas' phrase *moderamine*

inculpatae tutelae has been repeated constantly over the centuries in treatments on lawful killing. But it does not appear in connection with the killing of malefactors by civil authority. Rather, in the vast majority of cases it has been used, as in Aquinas, to specify a condition for lawful killing by private persons in self-defense. And in each case the act precisely specified must not include as an end or means the death of the aggressor. The intended end is personal safety and the intended means the force proportionate for repelling aggression.[12] Death may be tolerated as a side effect, perhaps even a foreseeable side effect, of an otherwise legitimate act of self-defense,[13] but death must not be chosen per se.

A similar term also appears in the 1917 Code of Canon Law. In a section dedicated generally to crimes and punishments and specifically to the attribution of guilt owing to acts of homicide, we find: "The cause of legitimate defense against an unjust aggressor, if it preserves (due) moderation, removes guilt altogether."[14] The context, together with a footnote to a reform decree of the Council of Trent, makes it clear that the code's usage of the term "legitimate defense" refers to legitimate killing in *self-defense*.[15]

A modern use of the term "legitimate defense" occurs in the Vatican II document *Gaudium et Spes*, in its treatment of warfare: "once all means of peaceful negotiations are exhausted, governments cannot be denied the right of legitimate defense"; civil authority has the duty to "protect the safety of people," to offer to all "a defense that is just," and should never use measures which "far exceed the limits of legitimate defense" (nos. 79, 80). Again, the context is self-defense—this time not individual but collective—against an (external) aggressor whose aggression promises harm.

As noted earlier, when Aquinas addresses conditions for lawful killing in self-defense, he rules out in advance killing, or indeed harming, with intent. Should the *Catechism* also be interpreted as saying that all harm done to an aggressor in *defensio legitima* must be unintended? Because the text subsumes the act of capital punishment, as well as all acts of legitimate killing, under a model of double effect, it seems to me the answer must be affirmative.

"Double effect" refers to the insight, developed by Aquinas, that a single act can have two or more effects, one intended, the other(s) unintended; and furthermore, what is primary, though not always sufficient, for purposes of morally assessing the act falls to the *intentional*, that is, the ends and means freely chosen by the acting person for carrying out a plan of action.[16] It follows that it *can be* morally legitimate to proceed with an act that one foresees (even clearly) will have bad side effects—perhaps even lethal side effects—provided one does not intend those effects.

But this is pure sophistry, one might say. If a person *causes* an effect, surely that effect was intended. Not necessarily. If a student with fragile health rides his bike to class in the rain foreseeing he might catch cold, is he intending (i.e., *willing*) himself to get sick? Or if a mother stays late at the office foreseeing her lateness will cause her daughter loneliness, would it be correct to say she is intending her daughter to be lonely? Or more seriously, if a pregnant woman with life-threatening uterine cancer decides to have a hysterectomy, foreseeing that the non-viable child in her womb will die thereby; if she intends the good end of regaining her health by virtue of the good or at least neutral means of undergoing the surgical procedure to remove her cancerous uterus, and if she at no time intends but only foresees the bad effect to her baby; is she worthy of any blame? In each case traditional moral reflection answers "no." Double effect, therefore, is a way of noting the morally significant distinction between intention and side effects.

This applies to the case at hand. An act of *self-defense* may have two effects, one intended, the other not. The intention can be to protect oneself by an act of self-defense sufficient to render an aggressor incapable of causing harm. Sometimes this results in the aggressor's death. In such a case death can be a legitimate, unintended side effect of an otherwise legitimately intended act of self-defense.

The *Catechism* does not explicitly state that the death penalty can be justified only by an appeal to the principle of double effect. Double-effect reasoning is nevertheless used in the *Catechism* to situate its discussion of capital punishment—to situate, in fact, its discussion of every form of legitimate killing. This can be seen without ambiguity in the first two sections on legitimate defense, nos. 2263–2264, both of which quote from Aquinas' classic treatment of double-effect reasoning (*ST* II-II, q. 64, a.7 c). Section 2263 reads:

> The legitimate defense of persons and societies is not an exception to the prohibition against the intentional killing of the innocent that constitutes murder. "The act of self-defense can have a double effect: the preservation of one's own life; and the killing of the aggressor. . . . The one is intended, the other not."[17]

Why is an act of "legitimate defense [which causes death] . . . not an exception to the prohibition against the intentional killing of the innocent"? The answer is clear: because it is not intentional killing. "Legitimate defense" here refers to an act of self-defense which though lethal (and even foreseen as lethal) is *not in-*

tended to be lethal, in line with Aquinas' description of an act of blameless defense. It is revealing that this paragraph refers its description not only to acts of individual self-defense, but also (going beyond Aquinas) to collective acts of self-defense (i.e., the defense of "societies").

The next paragraph, section 2264, treats in more detail the act of individual self-defense introduced in 2263:

> Love toward oneself remains a fundamental principle of morality. Therefore it is legitimate to insist on respect for one's own right to life. Someone who defends his life is not guilty of murder even if he is forced to deal his aggressor a lethal blow:
>
> > If a man in self-defense uses more than necessary violence, it will be unlawful: whereas if he repels force with moderation, his defense will be lawful. . . . Nor is it necessary for salvation that a man omit the act of moderate self-defense to avoid killing the other man, since one is bound to take more care of one's own life than of another's.

Although this paragraph does not mention the moral requirement of an upright intent, the context set by the preceding paragraph makes it clear that this is its meaning.

As would be expected, the next paragraph, section 2265, treats in more detail the act of collective self-defense introduced in 2263:

> Legitimate defense can be not only a right but a grave duty for one who is responsible for the lives of others. The defense of the common good requires that an unjust aggressor be rendered unable to cause harm. For this reason, those who legitimately hold authority also have the right to use arms to repel aggressors against the civil community entrusted to their responsibility.

Although the context has changed from addressing the needs of an individual to those of a community, and from the right of an individual to defend his own life to the rights and duties of public authority to defend the community for which it is responsible, the context is otherwise the same. We are still referring to the need (previously individual, and now corporate) to repel an aggressor— here including both internal and foreign aggressors—and the requirement that in so doing, only the degree of force necessary to render an agressor unable to

cause harm should be used. The act of legitimate defense here, as before, is an act of self-defense. While section 2265 does not explicitly state that any death following from this act of self-defense must be unintended, the reference to collective self-defense in 2263 requires that that be the meaning of 2265. The *Catechism* certainly supplies no basis for saying that the death of an aggressor following from an act of collective self-defense as described in this paragraph may be deliberately intended. And section 2265 supplies at least one basis for concluding that any such killing must *not* be deliberately intended, namely, it says that the purpose of the act is to "render aggressors unable to cause harm." This language is used traditionally to describe lawful killing by private persons in self-defense; and the tradition has always held that that killing must not be intended.[18]

While section 2265 outlines the conditions for a legitimate act of collective self-defense against a threat posed to the community from outside, sections 2266 and 2267 address, among other things, the response of public authority to internal threats to the community. Section 2266 reads:

> The efforts of the state to curb the spread of behaviour harmful to people's rights and to the basic rules of civil society correspond to the requirement of safeguarding the common good. Legitimate public authority has the right and the duty to inflict punishment proportionate to the gravity of the offense. Punishment has the primary aim of redressing the disorder introduced by the offense. When it is willingly accepted by the guilty party, it assumes the value of expiation. Punishment then, in addition to defending public order and protecting people's safety, has a medicinal purpose: as far as possible, it must contribute to the correction of the guilty party.

The first sentence lays out the general justification for the state's coercive activity, namely, the "safeguarding of the common good." We might think, given the context of self-defense maintained up till now, that the phrase "safeguarding of the common good" should likewise be interpreted along the lines of a model of self-defense.[19] But the second sentence introduces something new, namely, the concept of *punishment*. "Legitimate public authority" has the "right" and the "duty" to inflict just punishments. What qualifies for a just punishment? One which is "proportionate to the gravity of the offence." In introducing the notion of proportionate punishment, the *Catechism* departs from the context of self-defense hitherto exclusively maintained. To be sure, defense is not unrelated to punishment—the paragraph mentions "protecting people's

safety" as *a* purpose of punishment. But it is not the primary purpose of punishment. Its "primary aim" is "redressing the disorder introduced by the offense." In stating this, the *Catechism* indicates that punishment is essentially defined as an act of retribution. While it would make sense to call an act "punishment" that had no other purpose than to respond to an already committed crime by striking back, so to speak, at the one who committed it, it would not be appropriate to refer, say, to a coercive blow against an aggressor in self-defense as punishment. Self-defense is a response to a crime in progress or being contemplated, punishment is a response to crime that has already been committed. To intend retribution without intending self-defense is still to intend punishment; the opposite is not the case. So, although the *Catechism* does not exclude forward-looking aims from a wider definition of punishment (such as deterrence, public defense, criminal rehabilitation, expiation, or incapacitation), the defining aim of punishment is to restore justice, in other words, to be an act of retribution. The formulation is traditional through and through. It is quite clear that the terms and framework of section 2266 do *not* conform to the paradigm of self-defense as established in 2263–2265.

We now arrive at section 2267, the final one under "Legitimate defense" and the one that specifies the limiting conditions for state killing in capital punishment. The question facing 2267 is this: do its conditions for lawful infliction of the death penalty conform to "self-defense" as defined in sections 2263–2265, or, like the tradition, to "punishment" as described in 2266? Or to both?

I again quote section 2267 in full, numbering statements for the sake of reference:

[1] Assuming that the guilty party's identity and responsibility have been fully determined, [2] the traditional teaching of the Church does not exclude recourse to the death penalty, [3] if this is the only possible way of effectively defending human lives against the unjust aggressor.

[3¹] If, however, non-lethal means are sufficient to defend and protect people's safety from the aggressor, authority will limit itself to such means, as these are more in keeping with the concrete conditions of the common good and more in conformity with the dignity of the human person.

[3²] Today, in fact, as a consequence of the possibilities which the state has for effectively preventing crime, by rendering one who has committed an offense incapable of doing harm—without definitively taking away from

him the possibility of redeeming himself—[3³] the cases in which the execution of the offender is an absolute necessity "are very rare, if not practically non-existent."

The first statement identifies two conditions which must be met before recourse to death can be legitimate: a crime must be committed, and its perpetrator's identity and guilt established. If these were the only conditions, there would be little doubt about the answer to the question posed above. But statements 3, 3¹, 3², and 3³ identify one further condition. Together they assert that recourse to death is legitimate if and only if the need to defend people's lives and safety against the attacks of an unjust aggressor can be met by *no other means* (i.e., execution is the absolutely necessary means of effectively rendering an aggressor incapable of doing harm). Note the language in which the condition is framed: "the only possible way of effectively defending . . . against the unjust aggressor," "means . . . sufficient to defend and protect people's safety from the aggressor," "rendering one . . . incapable of doing harm," "absolute necessity"—this is the language of proximate self-defense; the picture we get is of one who is attacking; my safety, your safety, the safety of the community is in jeopardy; there is no other way to stop him.

Reading section 2267 in this way (as asserting as a strict limiting condition the forward-looking defense and protection of society) has been called by some a "reductionist" reading. The defense and protection spoken of here, they argue, should not be limited to the pursuit of forward-looking (non-retributive) goods but should also include the realization of retributive goods, such as "the manifestation of transcendent justice in society."[20]

This criticism fails for at least two reasons. First, it fails to attend to the language in which the account is framed, namely, the language of imminent danger. The section uses the term "aggressor," not "criminal," "prisoner," or "the condemned." An "aggressor" is one who attacks. To defend against an aggressor is to defend against one who is or soon will be attacking. And the defense to which the *Catechism* refers entails rendering him "incapable of doing harm." This language is a red flag to anyone familiar with the Catholic tradition of justifiable violence. When this tradition has used the phrase "rendering aggressors incapable of doing harm," it has invariably been referring to lawful force used by private persons against aggressors for purposes of self-defense; and the tradition unambiguously asserts that that killing *must be unintended* (i.e., be no more than a side effect of an otherwise legitimate act of proportionate self-

defense).[21] There is no reference here to terms like "restoring justice," "giving a criminal his just deserts," or "manifesting transcendent justice."

Second, when the term "necessary defense" (or a related term) is found in theological literature prior to Vatican II, it is invariably used to refer to the killing of aggressors by private persons in self-defense, in most cases specifying that the injury done must be unintended. Aquinas refers to acts of homicide which, he says, "are necessarily ordered toward the preservation of one's own life"; he adds that the homicide must be unintended.[22] Alphonsus de Liguori says that the natural law sanctions the use of lethal force in the defense of one's own life provided one "incurs no more harm, nor uses more force, than is necessary to prevent injury,"[23] and quotes Aquinas saying that the death suffered by the aggressor must not be intended.[24] Influential moral manuals from the first part of this century, including those of Zalba,[25] McHugh and Callan,[26] and Aertnys and Damen,[27] repeat the same two conditions: necessary defense and unintended death.[28]

Perhaps the clearest evidence in support of my interpretation is seen when we compare the death penalty accounts in the 1992 edition of the *Catechism* with the 1997 *editio typica*. In 1992 the *Catechism* taught:

[1] Preserving the common good of society requires rendering the aggressor unable to inflict harm. [2] For this reason the traditional teaching of the Church has acknowledged as well-founded the right and duty of legitimate public authority to punish malefactors by means of penalties commensurate with the gravity of the crime, *not excluding, in cases of extreme gravity, the death penalty*. [3] For analogous reasons those holding authority have the right to repel by armed force aggressors against the community in their charge.

[4] The primary effect of *punishment* is to redress the disorder caused by the offense. When his punishment is voluntarily accepted by the offender, it takes on the value of expiation. Moreover, punishment has the effect of preserving public order and the safety of persons. Finally punishment has a medicinal value; as far as possible it should contribute to the correction of the offender. (1994 English translation of 1992 French edition, no. 2266, emphasis in [2] added)

Three points should be noted. First, section 2266 in 1992 is dedicated to the subject of *punishment*, and smack in the middle of the first paragraph we find

its treatment of capital punishment. Nothing strange here. Yet in the 1997 *editio typica* we find that capital punishment has been deliberately removed from the paragraph dedicated to punishment (still no. 2266) and confined to its own paragraph, no. 2267. Second, in 1992, section 2266 (in statement 2 above) can be understood as teaching that the *gravity* of a crime can be a legitimate basis for the infliction of the death penalty, that is to say, certain very grave crimes can deserve the punishment of death. The first paragraph surrounds its treatment of capital punishment with the language of retribution, for example, "punish malefactors," "commensurate penalties," "gravity of the crime," and "extreme gravity." Clearly it meant to teach in 1992 that capital punishment can be justified as a means of retribution—nothing remarkable, since the Church had taught the same for centuries. What is remarkable is that in the 1997 *editio typica* the clause I emphasized in sentence 2 above—"not excluding, in cases of extreme gravity, the death penalty"—*is suppressed.* The revised passage simply reads:

> The efforts of the state to curb the spread of behaviour harmful to people's rights and to the basic rules of civil society correspond to the requirement of safeguarding the common good. Legitimate public authority has the right and the duty to inflict punishment proportionate to the gravity of the offense. . . .

Third, the two editions contain two different treatments of warfare. The difference is not directly relevant to capital punishment, but is significant nonetheless in relation to the Catholic tradition of justifiable violence. In 1992 the justification for warfare falls in section 2266, dedicated to punishment. Having established the grounds for retributive killing in sentence 2, the section runs: "For analogous reasons those holding authority have the right to repel by armed force aggressors against the community in their charge." The term "analogous reasons" must be referring *inter alia* to public authority's right and duty to punish malefactors "by means of penalties commensurate with the gravity of the crime, not excluding . . . the death penalty." While the 1992 text uses terms such as "repel" and "aggressors," which are characteristic of self-defense, it seems nevertheless to be making room for wars fought to effect retributive justice—to *punish* renegade nations, in so-called "wars of aggression" (which both Augustine and Aquinas thought could be rightly waged). In the 1997 text the discussion of warfare is taken out of the context of punishment and placed into section 2265, in the context of self-defense.[29]

Limiting the morally permissible exercise of capital punishment to norms typically invoked for the guidance of acts of private (self-) defense, the *editio typica*, in section 2267, concludes that "the cases in which the execution of the offender is an absolute necessity 'are very rare, if not practically non-existent.'"[30] The last statement is of course taken directly from the papal encyclical *Evangelium Vitae*.

Thus, the context for the teaching of the *Catechism* on capital punishment is the right and duty of public authority to defend the community against harm that *will* occur unless an attack now in progress, or anticipated or envisaged, is stopped. Despite the fact that the primary purpose of punishment is to redress the disorder caused by crime—and if the primary purpose of punishment in general, then the primary purpose of all particular forms of punishment—redressing disorder is *not* the primary purpose of the death penalty. Its exclusive purpose is "defending human lives against the unjust aggressor."

To test my interpretation I consider in detail two contemporary magisterial documents, *Evangelium Vitae* and *Veritatis Splendor*. I propose that the moral reasoning found in each supports what I have argued is the logical extension of the ideas of the *Catechism*.

Evangelium Vitae

Section 56 of *Evangelium Vitae* begins, "This is the context in which to place the problem of the *death penalty*." It is clear from the preceding section that "this" refers to *legitimate defense*. Section 55, treating the question of what the Fifth Commandment of the Decalogue prohibits and prescribes, states:

> There are in fact situations in which values proposed by God's Law seem to involve a genuine paradox. This happens in the case of *legitimate defense*, in which the right to protect one's own life and the duty not to harm someone else's life are difficult to reconcile in practice. Certainly, the intrinsic value of life and the duty to love oneself no less than others are the basis of *a true right to self-defense*.

Legitimate defense here, as in the *Catechism*, is understood as private *self-defense*.

Quoting from the 1992 edition of the *Catechism*, the encyclical continues, "legitimate defense can be not only a right but a grave duty for someone

responsible for another's life, the common good of the family or of the State."
Having already established self-defense as the context for a discussion of legiti-
mate defense, the encyclical assumes that the defense of others should be as-
sessed along the same lines as self-defense. This is confirmed by the next two
sentences in section 55:

> Unfortunately it happens that the need to render the aggressor incapable of
> causing harm sometimes involves taking his life. In this case, the fatal out-
> come is attributable to the aggressor whose action brought it about, even
> though he may not be morally responsible because of a lack of the use of
> reason.

The first sentence tells us that the defense envisaged is against an aggressor
whose aggression poses a present danger, and that rendering him "incapable of
causing harm" might mean killing him. The second sentence lays the responsi-
bility for the aggressor's death not at the feet of his slayer, but at the feet of the
aggressor himself. If there was any lingering doubt that the context envisaged is
private self-defense, a footnote directs us to Aquinas' discussion of whether it is
lawful to kill a man in *self-defense* and to Alphonsus de Liguori's discussion of
whether and in what way it is lawful by private authority to kill an unjust ag-
gressor.[31] "This," the encyclical states in the first sentence of section 56, "is the
context in which to place the problem of the *death penalty.*"

Section 56 begins by acknowledging an increasing demand both inside
and outside the Church for the strict limitation or even abolition of the death
penalty, and quickly proceeds to a discussion of the three purposes of pun-
ishment. The "primary purpose of the punishment which society inflicts," it
states,

> is *to redress the disorder caused by the offense*. Public authority must redress
> the violation of personal and social rights by imposing on the offender an
> adequate punishment for the crime, as a condition for the offender to re-
> gain the exercise of his or her freedom.

Like the *Catechism*, *Evangelium Vitae* teaches that the primary aim of punish-
ment is to overcome an existing disorder brought into being by a criminal's de-
liberate crime. Punishment is not in the first place concerned with something
that *will* occur, but with something that has already occurred.

Section 56 continues:

> In this way authority also fulfils the purpose of defending public order and ensuring people's safety, while at the same time offering the offender an incentive and help to change his or her behaviour and be rehabilitated.

Societal defense and criminal rehabilitation, both forward-looking, are included as purposes of punishment, though secondary to its retributive purpose (note the adverbial phrase "also fulfils").

If effecting the retributive good of restoring a fair social order is the primary purpose of punishment, serving *also* to defend society and reform prisoners, it follows that the two latter (secondary) purposes do not alone justify punishment.[32] Yet section 56 immediately goes on to say:

> It is clear that, for these purposes to be achieved [i.e., redress of disorder, defense and reform], *the nature and extent of the punishment* must be carefully evaluated and decided upon, and ought not go to the extreme of executing the offender except in cases of absolute necessity: in other words, when it would not be possible otherwise to defend society.

A sound account of retributive punishment does not infer particular forms of punishment from the requirements of retribution, and to say that retribution is the primary justification for punishment is not to say that retribution ever necessitates this or that particular punishment. However, the particular forms of punishment, whatever they may be, must by definition have retribution as their primary aim. Thus capital punishment, too, if it is to be considered punishment, must have a retributive ground. Yet the encyclical, like the current *Catechism*, states that an exclusively non-retributive principle (the "absolute necessity . . . to defend society") justifies making punishment capital. The question arises here, as before, whether capital punishment, according to the encyclical's own reasoning, is *punishment* at all.

Limiting the lawful exercise of capital punishment to cases of "absolute necessity," the encyclical concludes with the statement that eventually found its way into the *Catechism*: "Today however, as a result of steady improvements in the organization of the penal system, such cases are very rare, if not practically non-existent."

The death penalty in *Evangelium Vitae*, as in the *Catechism*, is rigorously tied to a model of private self-defense. But does the encyclical state or imply that the death of the criminal must be unintended? Not in section 56. However, through-

out the encyclical the good of human life and its derivative rights are referred to with terms such as *inviolability, inviolable,* and *inalienable:*[33] for example, "a *precise and vigorous reaffirmation of the value of human life and its inviolability*" (no. 5); "the original and inalienable right to life" (no. 20); "the sacredness of life gives rise to its *inviolability*" (no. 40); "the commandment regarding the inviolability of human life" (no. 40); "the sacredness and inviolability of human life" (no. 53); "human life, as a gift of God, is sacred and inviolable" (no. 81); and the list goes on. A particularly noteworthy instance is in section 87, which reads: "human life is sacred and inviolable at *every* stage and in *every* situation; it is an indivisible good."[34] Section 89 states that the Hippocratic Oath "requires every doctor to commit himself to absolute respect for human life and its sacredness." Still another (no. 40), in a discussion of the Chosen People's pedagogy in the meaning of the Fifth Commandment, reads:

> Of course we must recognize that in the Old Testament this sense of the value of life . . . does not yet reach the refinement found in the Sermon on the Mount. This is apparent in some aspects of the current penal legislation, which provided for severe forms of corporal punishment and even the death penalty. But the overall message, which the New Testament will bring to perfection, is a forceful appeal for respect for the *inviolability of physical life* and the integrity of the person. (Emphasis added)

Terms such as "inviolability" and "inviolable" are not used in this way in Catholic tradition before the twentieth century and do not find prominence in magisterial documents before John XXIII's encyclical *Pacem in Terris* (1963). Thus the Church never had to contend with their implications for traditionally accepted forms of intentional homicide. Though the Catholic tradition has always affirmed the absolute immunity of *innocent* human life from intentional attacks and destruction, moral culpability for gravely wrong acts has traditionally been understood to forfeit that status. The tradition is quite clear that the lives of those who deliberately commit serious crimes are *not inviolable* (if "inviolable" is understood as a state of being morally protected against acts intending to harm or destroy life). Aquinas says that a grave sinner "falls" from human dignity and may be treated as a beast,[35] Pius XII that a dangerous criminal, "by his crime, . . . has already disposed himself of his *right* to live."[36] In both cases, the life of the malefactor through the malefactor's own deliberate act(s) *becomes* violable. This is not the teaching of the *Catechism* or of *Evangelium Vitae.* In fact, John Paul II emphatically states in the latter that "*Not even a murderer*

loses his personal dignity" (no. 9). Though the conclusion is not explicitly drawn out in the encyclical, the intentional and unalterable destruction of human life which capital punishment entails is hard to reconcile with the precise language and terms the encyclical chooses to describe the dignity of human life, and the rights and duties to which that dignity gives rise. Having said this, the three prominent, exceptionless moral norms formulated in the encyclical single out and exclude, in accord with the long-standing tradition, only the intentional killing of the innocent.[37] From this we conclude that the pope does not intend in *Evangelium Vitae* to assert the intrinsic wrongfulness of the death penalty. But since the encyclical neither asserts nor implies that intentional killing in any form is or can be morally legitimate,[38] and since its language repeatedly implies the opposite (as I have illustrated), it is reasonable to conclude that its intent is to leave open the possibility that the negative scope of the norm against homicide will in the future be judged by the Church to extend to all intentional killing.

Veritatis Splendor

The moral logic of *Veritatis Splendor*[39] leads to the conclusion that the good of human bodily life, as inextricably bound to and irreducibly invested with and expressive of the full intrinsic goodness of the human person, must be absolutely respected, namely, must not be the object of a plan of action to kill (or, indeed, to harm).

Human dignity gives rise to *moral norms* that direct *human action*. This threefold description of the foundations of morality runs throughout the systematic treatment of the foundations of morality in chapter 2 of the encyclical. Human dignity is another way of speaking of the intrinsic goodness that belongs to the nature of the human person. The encyclical teaches that "the natural moral law expresses and lays down the purposes, rights and duties which are based upon the bodily and spiritual nature of the human person" (no. 50).

Appealed to as a moral principle, "dignity" is shorthand for the complex of fundamental human goods—goods understood precisely as aspects *of persons*—toward which moral action is naturally inclined and in which authentic fulfillment is realized. Reason grasps the specific value of these goods as ends to be pursued through action and what is contrary to them as evils to be avoided.[40] Since they are goods of the human person, respect for them is respect for the human person; hence the encyclical teaches that "the primordial moral

requirement of loving and respecting the person as an end and never as a mere means also implies, by its very nature, respect for certain fundamental goods" (no. 48).

Through action, human flourishing is advanced or diminished.[41] What determines an act's morality? *Veritatis Splendor* teaches, in accord with Catholic tradition, that the morality of an act is determined by the relationship of the acting person's will to authentic human good(s). The encyclical repeats this again and again: "Every choice always implies a reference by the deliberate will to the goods and evils indicated by the natural law as goods to be pursued and evils to be avoided" (no. 67). "The morality of acts is defined by the relationship of man's freedom with the authentic good" (no. 72). "Acting is morally good when the choices of freedom are in conformity with man's true good and thus express the voluntary ordering of the person toward his ultimate end: God himself"; "The rational ordering of the human act to the good in its truth and the voluntary pursuit of that good, known by reason, constitute morality"; "Activity is morally good when it attests to and expresses the voluntary ordering of the person to his ultimate end and the conformity of a concrete action with the human good as it is acknowledged in its truth by reason"; "If the object of the concrete action is not in harmony with the true good of the person, the choice of that action makes our will and ourselves morally evil" (all from no. 72); and so forth.

On what does an act's moral assessment depend? What ensures its ordering to authentic human good and ultimately to God?[42] To answer this, *Veritatis splendor* turns to what the tradition has sometimes referred to as the "sources of morality," in particular, to the *moral object*.[43] To understand the moral object, one must "place oneself in the perspective of the acting person" (no. 78). The *object* is "a freely chosen kind of behavior . . . [i.e.,] the proximate end of a deliberate decision which determines the act of willing on the part of the acting person" (no. 78). This last statement deserves some unpacking.

We might say the object of the act of willing is what I actually choose to *do* here and now. It is a freely and deliberately chosen plan of action, writ large or small. Moral objects include the whole set of means leading to one's farthest end, inasmuch as each means is an end relative to more proximate means, and inasmuch as each means is something one must set oneself to try to attain. If my remote end, for example, is to improve my health, I may choose several means by which to realize that end, for example, vitamin therapy, exercise at the spa, and transcendental meditation. But each of these is also an end having means of its own. Taking vitamins, a means to the end of better health, involves a number of intermediate ends, such as judging and deciding which vitamins to take, finding

out where they can be most easily and economically purchased, getting in the car or on a bike or on the bus and traveling somewhere to buy them, carefully reading the instructions on the bottle, and ultimately, getting the wretched things safely down my throat. Each means includes intermediate or "close-in" ends, all of which go together to bring about my ultimate remote end (good health); and each end, insofar as it is a "closer-in" or "farther-out" willed means (i.e., is the proximate end of a deliberate act of my will), is an object of choice.

In the words of the encyclical, the "primary and decisive element for moral judgement is the object of the human act, which establishes whether it is capable of being ordered to the good" (no. 79). Certain objects (i.e., certain "freely chosen kinds of behavior"), "because they radically contradict the good of the person," are "by their nature 'incapable of being ordered' to God" (no. 80). Following the tradition, the encyclical calls these "intrinsically evil" (no. 80).

Though it often mentions human good(s), the encyclical never itemizes a complete list of goods. It does state in section 50, however, that *human life* is a "fundamental good" and that the good of life "acquires a moral significance in reference to the good of the person."[44] To appreciate this statement, we need to be clear on the encyclical's definition of "human person."

The human person exists as a unified body-soul reality. Indeed, the encyclical goes so far as to say that "human nature" *is* the person himself as he exists in the unity of body and soul.[45] This truth is repeated again and again: "body and soul are inseparable" (no. 49); "the substantial integrity or personal unity of the moral agent in his body and in his soul" (no. 67); "the unity of the human person, whose rational soul is *per se et essentialiter* the form of his body" (no. 48); "The spiritual and immortal soul is the principle of unity of the human being, whereby it exists as a whole—*corpore et anima unus*[46]—as a person" (no. 48); "Only in reference to the human person in his 'unified totality,' that is, as 'a soul which expresses itself in a body and a body informed by an immortal spirit,' can the specifically human meaning of the body be grasped" (no. 50) ; and so on. It follows that human dignity (i.e., intrinsic human value) is irreducibly predicated of the person as he exists in his substantial unity and therefore that human life, whether conceived in its bodily or spiritual dimensions, is invested with *personal* value (dignity). The encyclical teaches that this "dignity proper to the person" is "the origin and the foundation of the duty of *absolute respect for human life.*"[47] We may say that the intrinsic goodness of human life entails the conclusion that human life is to be respected absolutely. Another way to say this is that human life is *inviolable.* This "absoluteness" (unconditionality) or inviolability corresponds tightly to the exceptionlessness of the relevant negative

norm, which is exceptionless (absolute) and inviolable just in so far as it per-
tains to actions intended to kill (or to harm).

Finally, moral norms direct human action in accord with authentic human
good. Moral precepts "are meant to safeguard the good of the person, the image
of God, by protecting his goods."[48] The precepts of the Decalogue, for example,
"are really only so many reflections of the one commandment about the good of
the person, at the level of the many different goods which characterize his iden-
tity as a spiritual and bodily being in relationship with God, with his neighbor
and with the material world. . . . [They] represent the basic condition for love of
neighbor" (no. 13). If an object is hostile to human good, the norm which iden-
tifies each chosen act of that type as wrong is true and applicable always and
everywhere no matter the (further) circumstances, "because the choice of this
kind of behavior is in no case compatible with the goodness of the will of the
acting person" (no. 52).

In summary, the logic of *Veritatis Splendor*'s account of the foundations of
morality is as follows: "human dignity," appealed to as a moral principle, is
shorthand for the intrinsic goodness proper to human persons as such; human
persons are a unified body-soul reality; human bodily life, because inseparably
and irreducibly part of the body-soul reality which is the human person, is in-
vested with the full value (goodness) of human personhood; and deliberate acts
that do not have "absolute respect" for human life are wrong, that is, human life
is to be absolutely respected. The encyclical's formulation of the relevant excep-
tionless moral norm is traditional: "it is always morally illicit to kill an innocent
human being."[49] It says nowhere that killing the guilty is morally licit, nor, in
light of its own moral logic, does it account for why the norm is formulated as it
is. The death penalty is not mentioned.

Theological Anticipations

Modern Catholic reasoning *clearly* anticipating the reasoning found in the *Cate-
chism* (and *Evangelium Vitae*) can already be discerned in the late nineteenth
century in the work of F. X. Linsenmann, Tübingen professor of theology, and
in the twentieth century in the work of Jacques Leclercq, Louvain professor of
moral theology. In his 1878 *Textbook of Moral Theology* Linsenmann published an
unusually harsh (for his day) critique of capital punishment. Taking for granted
the right of the state to kill felons, he observes:

In our day however neither the justification nor the necessity of the death penalty can be deduced from the nature and purposes of punishment; rather, different penal theories agree that all the essential purposes of punishment can be reached as well or better by other kinds of penalties than by death.[50]

Like retentionist Catholic scholars in the nineteenth century, Linsenmann refers to the state's authority to inflict death as a right, but, he insists, a right that is conditional. There is no strict obligation to inflict death, and the commutation of a capital sentence to a lighter sentence, or the suspension of the death penalty altogether, is greatly to be desired.[51] "In the Church's view," he says, "such a wish is well founded and accords with the maxim: the Church has no thirst for blood!"[52]

Anticipating the reasoning of the present papal teaching, Linsenmann claims that the decision to inflict death derives from looking not so much to the nature and purposes of punishment as to whether the punishment is necessary:

The death penalty can only be considered just—and therefore permissible—if it is necessary from the standpoint of self-defense; and it remains legitimate only so long and to such an extent that the need for self-defense remains. Just as war is self-defense writ large against an external threat to the community, so the infliction of *the death penalty is self-defense writ large* against an internal threat to the community, i.e., against a dangerous element in one of the many layers of the community itself. It follows, that if a condition of civil order and safety arises in which it is possible to control individual dangerous elements with lighter coercive means than death, then the death penalty would be rendered superfluous. Indeed, legally limiting the use of the death penalty is a goal well worth striving for. Its abolition by law is simply a political or cultural question; no principle of right [*Rechtsgrund*] stands against it.[53]

Linsenmann argues that if non-lethal punishments are sufficient to adequately defend the community, then the death penalty should not be used, clearly implying that it would be wrong to use it. Defense of the community in this context, according to Linsenmann, means precisely "self-defense writ large." This is confirmed when he writes, "After all that has been said, the death penalty can only be proven necessary by returning to that which provides necessary scope

and certitude to the concept 'defense of community', namely, the concept and the right of self-defense."[54]

Nearly sixty years later, Jacques Leclercq appealed in a similar manner to the concepts of "necessity" and "defense" in his critique of capital punishment:

> The death penalty, like all punishment, is *legitimate* only *if it corresponds to the legitimate defense of the community.* It is not justified by a right of the State to dispose of the life of its citizens, but only by social necessity. The life of a man is in itself inviolable, for the State as for individuals.[55]

Leclercq flatly rejects the traditional idea that the state has a right to kill criminals. For him the premise "human life is *inviolable*" yields the conclusion that the state is not empowered to kill its citizens. "*The State*," he says, "has no right to dispose of human life."[56] It is reasonable to assume he means "*intentionally* dispose of human life," since he does not reject all killing; the killing he does allow is justified by social necessity and social necessity alone. I conclude that for Leclerq, killing must be regulated by norms traditionally circumscribing legitimate killing in private self-defense. This conclusion is supported by the fact that Leclercq, like Linsenmann, holds that legitimate defense should be narrowly construed as imminent self-defense— "unless the person in question poses a serious threat to the lives of others."[57] Leclerq also states: "Supposing there is no other effective means of defending the social order, it seems in practice that the death penalty must be limited to the case where civil authority has no other sure means of incarcerating dangerous offenders."[58] By way of example, he cites periods of revolution and situations when social authority cannot establish safe prisons.[59] But safe prisons, he argues, have existed now for more than a century. Therefore, he concludes, "today, in the Western world, the death penalty has ceased to be legitimate as States have other effective means to defend the social order."[60] The *Catechism* and *Evangelium Vitae,* of course, draw the same conclusion. In the fifty or so years following the publication of Leclercq's work this idea has recurred with increasing frequency.[61]

Conclusion and a Problem

I have argued that there is significant textual warrant for concluding that the *Catechism* (as well as *Evangelium Vitae*) lays the theoretical foundation for a development of doctrine on the morality of capital punishment. From the very

first sentence of the subsection entitled "legitimate defense," the *Catechism* deliberately distances itself from the traditional teaching of the Catholic Church. Its predecessor, the 1566 *Roman Catechism*, taught that capital punishment was an exception to the fifth precept of the Decalogue. In the 1997 *Catechism*, killing, including killing in punishment, is explicitly said *not* to be an exception to the fifth precept of the Decalogue. Moreover, the choice of terms, use of language, and the references cited to address legitimate homicide have a *very* clear precedent in Catholic moral tradition—only not in relation to capital punishment! Saying that death may be inflicted only when "absolutely necessary" for "rendering aggressors incapable of doing harm"; repeatedly referring to those who are rightly killed as "aggressors"; quoting and referencing Aquinas' influential account of lawful killing by private persons in self-defense; framing the conceptual backdrop to the question in terms of double-effect reasoning— these are all classical means for considering the moral limits on the use of force by private persons in self-defense. Finally, the changes in substance and format instituted between 1992 and 1997, namely, removing the discussion of capital punishment from the paragraph dedicated to punishment and suppressing the only reference warranting the conclusion that the death penalty can be inflicted as a means of redressing wrongdoing, indicate that the new moves in the *Catechism* are not merely a matter of oversight here or overemphasis there. Rather, they indicate a deliberate decision on the part of the drafters of the *Catechism* to re-conceive the morality of capital punishment along the lines of private self-defense.

Thus, there is ample reason for concluding that a new doctrinal teaching on the morality of capital punishment is anticipated in the *Catechism*. That doctrine would assert, at a minimum, that lawful state killing is limited to defensive killing; that the gravity of a criminal's crime is never sufficient ground for killing him; that coming against him with lethal force is only justified if lethal force and lethal force alone is necessary to render him harmless; and that in such a case his death must not be intended.

Italian theologian Gino Concetti makes an observation which bears upon this conclusion. Noting that the question of the legitimacy of the death penalty has been conceived historically in terms of retribution or community safety, he points out that "nobody has ever posed the question whether such practice might be opposed to the moral order and to the dignity of the human person."[62] This, I suggest, is the anthropological ground for the development in the *Catechism*. While we might say that perpetrators of certain reprehensible crimes *deserve*—in a distributive sense—death, nevertheless the value of their human

lives forbids us from ever choosing to destroy their lives. This value is derived not from their moral status, nor from their membership in the larger civil community, nor from the measure of their usefulness to the community, but from their intrinsic and inalienable dignity as created in God's image and likeness. Simply put, I cannot will the death of a human person, any human person, innocent or guilty, with a good will.

What about the argument that the death penalty ought to be rejected because death removes any further possibility for a criminal's reform? This is an important point with respect to the pastoral response to crime and punishment (illustrated by the fact that something similar is mentioned in both section 56 of *Evangelium Vitae* and sections 2266–2267 of the *Catechism*), but it is not a new insight. The implications of imminent death for the possibility of long-term moral and spiritual regeneration have been on the minds of Christian pastors since the early Church. Augustine, Ambrose, and Chrysostom, for example, urged Christian magistrates to exercise mercy in their duties and avoid bloody punishment if at all possible; yet each were principled defenders of capital punishment. While the point may and perhaps should be included in a general Christian argument against the death penalty, it does not present itself as a development over and above the traditional response of the Catholic Church to the problem. In fact, an ecclesiastical tradition of pleading for clemency on behalf of the condemned has stood, if not comfortably, at least confidently side by side with a firm and principled acceptance of the institution of capital punishment since the time of the early Church. One way of resolving the tension raised by such apparently incongruent bedfellows has been to point out that Catholic pastors—usually priests—as a rule have ministered to condemned criminals and as a result have been privy to a long train of gallows-side conversions. These conversions can be attributed largely to the pressing influence of the future punishment on the criminal's mind and conscience (as Sister Helen Prejean's celebrated testimony graphically illustrates). However, this matter lies in the realm of empirical questions.

The account in the *Catechism* leaves us with a problem. Although section 2267 apparently rules out retributive killing (i.e., killing *as* punishment), nevertheless it allows for the use of lethal force in cases of absolute necessity. Such force, I have argued, is best conceived as a kind of collective self-defense by the community against a malefactor who, though incarcerated, still poses a grave threat to the community; and the killing that results must be unintended. But is it ever the case that the killing of a criminal in custody is, or even can be, without intent?

We intend both remote ends and close-in ends (commonly called means) insofar as we freely resolve and attempt to bring something about. Thus, to frame a plan of action which includes as an end or means the killing of a criminal, even if the killing is meant to serve the purpose of defending the social order, is still intending to kill. From the fact that it is possible to conceive of a prison guard fatally shooting a violent prisoner without intending to kill him, it does not obviously follow that it is possible to conceive of strapping a prisoner to a gurney, pressing catheters into his veins and filling them with deadly chemicals, and yet not willing his death for its own sake or as a means to something else (such as the deterrence of others). We must therefore ask *whether it is possible* for such an act of killing to be unintended. I appeal, by way of example, to two scenarios.

Case 1: A fascist leader, having received help from the inside, escapes from a maximum security prison and is a few steps away from the helicopter that hovers near the ground, waiting to whisk him off to safety. The leader symbolizes in the minds of thousands of nationalists a promised "new world order," and hence he holds their wills in himself. His escape, even if he is wounded, threatens to lead to wide-scale civil revolt. He is reaching for his comrade's hand; a shot in the leg or arm will not prevent him from making contact; he must be stopped. I deliberate (at a moment's glance) on adequate means; I judge that shooting him in the back of the neck will stop him; I command my sharpshooter to shoot him, and the shot kills the prisoner. Is it possible in this case that the death of the prisoner is unintended?

Analysis: Felling the escapee is judged necessary to prevent his outstretched hand from making contact with his comrade's hand. Acts judged adequate to fell him include shooting him in the head, neck, or back. The first would most certainly kill him. The third has a noticeable risk of failure since the target includes effective areas (e.g., spinal cord) and ineffective areas (e.g., shoulder blades). Hence, the second seems most promising. The end of the act is to stop him, the means, a shot that will fell him. Death need not be chosen here as my end or means. I foresee that the shot may be lethal, but such a risk, given the alternative, is fair to take. It therefore *is* possible in this case for the death of the prisoner to be unintended.

Case 2: The same fascist leader has been tried, convicted, and sent to prison. Because of what he represents, his incarceration has hardly diminished his effective influence at all. Reliable sources report that a revolution is imminent. The grave danger he threatens must be stopped. I deliberate on adequate means and conclude that the only plausible way to prevent the revolution is to

hang him and announce to his followers that he is dead. I do so and the revolution is averted. Is it possible in this case that the prisoner's death is unintended?

Analysis: The end of my act is to prevent the revolution that the prisoner intends and that his continued presence threatens to bring about. I deliberate and judge that the only adequate way to prevent the threatened harm is the fascist leader's death. I adopt a plan of action that includes his death and order the prison guard to hang him. To say the prisoner's death is unintentional in this case is false.

I have stated above that if capital punishment were conceived as no more than an act of self-defense by the state on behalf of the community—lethal, yet not intending death—then according to the reasoning set forth in the *Catechism* it could be considered lawful. Because the killing of the prisoner in case 2 is necessarily intended, a conception of capital punishment justifying this kind of killing must, it seems, be rejected. It follows that to the extent such a conception is ascribed to the kind of killing permitted in *Catechism* no. 2267, to that extent the judgment that the death penalty in certain rare instances is permissible—even as a kind of legitimate defense—must be rejected. The analysis I have defended does not rule out the kind of killing described in case 1, or in the case of a prison guard who, in protecting himself and others from imminent harm, shoots to death a violent prisoner. In both cases the killing can be unintended. To call either one a case of capital punishment would stretch the term beyond its breaking point.

The claim that capital punishment necessarily entails an intent to kill is challenged by some, who argue that it is possible to inflict the death penalty *as retribution* without ever, strictly speaking, choosing the criminal's death. The death penalty here is defended not as a *means* to restoring justice, or to defending society, or to anything else, but rather as a restoration of the order of justice itself. John Finnis once argued that the infliction of the death penalty need not entail an intent to kill: when its infliction is chosen under the precise specification of retribution (i.e., under the specification of the good of the restoration of the disturbed social order—a good that can be realized only by the due suppression of the criminal's will), then the criminal's death is chosen neither as an end in itself nor as a means to some further beneficial state of affairs.[63] "The choice to impose punishment is . . . 'referred to' the common good of justice, and as such is the choice of a good (and not of a bad as a means to that good)."[64]

The argument is that death is not freely chosen as a means to restoring the order of justice, but rather the restoration itself is what is freely chosen—as, say, a kiss is not a means to an expression of love, but *is* an expression of love, and a

teacher's comments on a student's writing are not means to correcting the student's mistakes, but rather *are* corrections of the student's mistakes. The analogies, for one thing, seem to me mistaken. One can grant that a kiss is not a means to an expression of love but still insist that it is a means. If it were not a means, then the kiss in itself would be the end: I kiss you not to say I love you, or I'm sorry, or you look lovely tonight, but simply *in order to* kiss you, which in most cases is ridiculous. Something similar could be said for the teacher's corrections.

This line of reasoning in the case of capital punishment also seems mistaken. If death were not chosen as a means, then either it would be chosen for its own sake (the question "*why* are you killing that criminal?" would be answered, "*in order to* kill him, *so that* he may be dead"), or else it would be a side effect of another intended end, namely, restoring the order of justice. In the latter case, the means would be the intended punishment of a particular criminal, and the criminal's death would be accepted as a foreseen, inevitable, but nonetheless unintended side effect. While the former case is not punishment but killing for killing's sake, the latter deserves a closer look.

At the time of sentencing (let us assume), the judge, jury, or other legitimate authority asks what form of punishment fits the crime in question; for this particular crime the judgment is made that no punishment less than death will redress the grave disorder the crime introduced. The lethal nature of the punishment is not ancillary to what is chosen; it *is* the measure of punishment chosen. *This* particular punishment is chosen for redressing *that* particular crime. Such reasoning admittedly begs the question of the nature of choice and intention, a discussion I take up in chapter 8. But at the level of conventional usage, we say that intention pertains to human plans of action, plans with desired ends (or goals, or purposes) that we endeavor to bring about through choice. Our plans include the close-in ends, or means, we judge adequate (and sometimes necessary) to bringing about those desired ends. We intend both ends and means. In the case at hand, then, the plan of action very clearly includes the criminal's death. Until the criminal is dead, the punishment is not complete nor is the disorder redressed. In other words, death is (among other things) what we are trying to bring about. In contrast, in a corporal punishment such as caning, the one who receives the prescribed number of strokes receives the punishment irrespective of the further (foreseen or unforseen) consequences upon health and well-being. One might in fact die from the strokes, but death is not per se the punishment, it is merely a side effect of the punishment. Capital punishment is different. The intent to kill cannot be separated from capital punishment, whatever other intentions accompany it.

CHAPTER 2

■

The Justification of Punishment

■

Appealing to human dignity as the rational basis for abolishing capital punishment, as I argue the *Catechism of the Catholic Church* is implicitly doing, differs in a fundamental way from other common arguments against the death penalty. Some hold that the justification for the infliction of any particular punishment lies in the verifiable tendency of that punishment to deter crime better than other less coercive or noncoercive measures; since the death penalty's superior deterrent value—superior, that is, to its nearest non-bloody alternative—is inconclusive, the death penalty is unjustifiable. Others conceive punishment as in essence a remedial measure inflicted with a view to restoring its beneficiary to an upright and stable personality; since the death penalty is never in this sense remedial, it is therefore unjustifiable. Still others conceive crime (or perhaps criminality) more in terms of a pathology than in terms of free and deliberate choosing. Criminals are sick, not guilty; they need treatment, not punishment. The death penalty is therefore never an appropriate response.

Such arguments are unsound, not in their conclusions but rather because they begin with unsound conceptions of punishment generally. In order to be clear what the *Catechism* is and is not affirming about the nature and aims of punishment when it implicitly teaches that the death penalty is morally wrong, it is important to consider its account of punishment in greater detail. I will argue that the account of punishment set forth in the *Catechism*—which identifies three justifying purposes for punishment (retribution, criminal reformation, and societal defense), prioritized, to be sure, yet held together in one account—is

theoretically superior to other influential accounts which single out and assign quasi-exclusive status to one or another of these justifying aims (for example, strict retributivism and utilitarian penal theories).

Punishment in the *Catechism*

Section 2266 of the *Catechism of the Catholic Church* (see chapter 1) treats the place and purposes of punishment in civil society. Its first sentence lays out the justification (we might call it the general *undifferentiated* aim) for the state's coercive activity, namely, *the safeguarding of the common good*. The second numbers among those activities the infliction of punishments. The final four sentences differentiate the general aim into three particular aims: redressing the disorder introduced by deliberate crime, contributing to the correction of the guilty party, and protecting people's safety.

The common good can be described as a broadly established set of social conditions in civil society which allow people, either individually or in collectives, as unhindered an access as possible to the pursuit and realization of ends, or aims (purposes), which correspond to authentic human fulfillment.[1] The realization and preservation of these conditions over time require three things: (1) respect for the "fundamental and inalienable rights of the human person";[2] (2) a commitment, particularly on the part of civil authority, to "*social well-being* and *development* of the group itself," that is, a commitment to making accessible to all basic necessities for leading a fully human life (food, clothing, education, work, and so on);[3] and (3) *peace*, that is, the stability and security of a social order which is fair and just;[4] we might describe this social order as one where benefits and burdens are distributed with relative (not arithmetical) equality across the community, where each able member fulfills his or her responsibility, and where no member or collection of members is arbitrarily excluded or limited in the fulfillment of duties or in the pursuit of human fulfillment. The exigencies of the common good in light of human sinfulness and the threat it poses to the maintenance of the fair system of cooperation in a community presuppose the lawfulness of certain efforts by legitimate authority to ensure the security of that fair system and to protect members against the deliberate plans and actions of those who would harm it.

Considering the three particular aims in light of the specific problem each is intended to address, we note that each of the three looks, as it were, in one of

two directions: backward at a crime already committed (the retributive aim), or forward to the prevention of crime not yet committed (the remedial and protective aims). But though punishment looks in both directions in regard to what it aims to bring about, punishment itself is only executed in response to the first. That is to say, only persons who commit crimes are punished.[5] The phenomena of crime and consequent guilt are what distinguish sanctions in the form of punishments from sanctions in the form of asylums for the insane, quarantines for the ill, curfews for minors, and so on. The *defining* purpose of punishment, therefore, is retribution. The *Catechism* acknowledges this by stating that punishment "has the *primary aim* of redressing the disorder introduced by the offense."[6]

The Primary Aim of Punishment—Retribution

The retributive purpose of punishment (or the notion of redressing disorder) can be construed in different ways. I consider here three of its more influential formulations.

John Finnis. The first formulation, typified in the penal theory of Catholic legal philosopher John Finnis, conceives the good order of society as essentially an order of fairness, that is, "a fairly (it is supposed) distributed set of advantages and disadvantages, the system of benefits and burdens of life in human community."[7] The disorder, he writes, is caused by the deliberate choice to indulge one's will for self-preference in opposition to that fairly established order. While most citizens restrict their wills (even at times against their preferences) within limits set by moral and/or positive laws–we might say they have "denied themselves" the personal advantage of indulging their wills in ways contrary to the common good—a criminal, by flouting ("whether by intention, recklessness, or negligence") a law he recognizes as binding, prefers his own interests to those of the common good.[8] Because the free exercise of one's will is an important human good, the criminal's choice for self-preference gains for him an "advantage" over those who have restrained themselves.[9] That advantage is "the exercise of self-will or free choice."[10] It is gained at the moment the criminal choice is executed, irrespective of the ultimate success of the proposal that directed that choice; it constitutes what retributivists refer to as criminal "guilt."[11] "If the free-willing criminal were to retain this advantage," Finnis states, "the situation would be as unequal and unfair as it would be for him to retain the tangible profits of his crime (the loot, the misappropriated funds, the office of profit . . .)."[12]

Punishment restores the fair order by removing the criminal's unfair advantage.[13] That advantage was gained by a deliberately inordinate *exercise* of freedom; it is removed by a proportionate *deprivation* of freedom. By means of some specified sanction (a monetary fine, incarceration, forced labor, and so forth), the criminal's will is "subjected" to the will of the authority it defied when it disregarded the law.[14] His will is forcibly restricted in its range of freedom (in the case of a monetary fine, restricted in the range of material benefits the offender is free to enjoy).[15] A criminal suffers something contrary to his will, just as he, by his offense, caused others to suffer contrary to their wills.[16] It follows that the measure of a punishment should be in proportion to the measure of the criminal's unfair willing. In this way the equality of justice may be respected.[17]

To say that punishment restores the order of fairness is not to say that the harm done (to the victim, the community, the order of fairness) is somehow erased. The proper sense of restoration is this: the relatively equal distribution of opportunities and responsibilities between members of a community, made unequal by someone's deliberate seizing of opportunities to which he is not entitled or deliberate disregard for or wrongful performance of duties for which he is responsible, is restored by the removal of the offender's ill-gotten gain (understood formally as a surplus, so to speak, of wrongful willing and not materially as a surplus of "stuff") through the coercive removal of opportunities or immunities normally guaranteed by the law. If justice is truly being served by the punishments a society inflicts, then after a period of time one should be able to look back and say that no one has been unfairly disadvantaged for making the choice to conform to morally relevant laws.[18]

G. W. F. Hegel. Retribution is construed somewhat differently by Hegel, who conceives it not so much as an equalization or balancing of a disturbed order of fairness, as a correction of wrong by the assertion, or rather reassertion, of right. Hegel conceives the good order of society as essentially an order of right. Crime (what he also calls *wrong*) is the "infringement of right as right," or "opposition to the principle of rightness."[19] We might say that crime disrupts the order of right (or rightness). To restore right, an exercise of force that annuls the force brought against it by crime is necessary. While the injury itself has a "negative existence" insofar as a criminal's act disregards a person's right— which is, Hegel says, absolute, unimpeachable and irrevocable—it also has a positive existence; as a purposeful act, the injury *exists* in the particular will of the offender. In order to annul the crime, this particular will must suffer injury.

Punishment is the "annulment" of the crime at its source, namely, in the criminal's will. Punishment is *right* striking back, as it were, at that which infringed it, "annulling" or "annihilating" the infringement.[20] "Retribution," Hegel writes, "is an 'injury of the injury.'"[21] To "injure [or penalize] this particular will . . . is to annul the crime."[22]

Hegel holds that it is the right of a criminal to be punished, "an embodiment of his freedom."[23] His reasoning is similar in this respect to Kant's. A criminal by his crime lays down a universal law under which, in consequence, he implicitly brings himself.[24] We might say that in committing a crime, a criminal declares, in a sense, "this in turn is to be done to me." Hence there is an "interconnection" (which Hegel also calls an "inner equality") between crime and punishment.[25] The crime "contains its negation in itself," and the external manifestation of this negation is punishment.[26] This intrinsic relationship between crime and punishment, between the laying down of a law—and hence the bringing of oneself under that law—and the external manifestation of the law's reflexive judgment in punishment, leads Hegel to conclude that punishment "contains" a criminal's right; punishment "honors" him as a rational being.[27]

It follows, for Hegel, that the measure of punishment must be derived from the offender's own act: a criminal is not duly honored "unless the concept and measure of his punishment are derived from his own act."[28] This (retributive) assertion, Hegel realizes, is liable to the criticism that it reduces "the retributive character of punishment" to "an absurdity (. . . an eye for an eye, a tooth for a tooth—and then you can go on to suppose that the criminal has only one eye or no teeth."[29] To overcome this objection, he introduces the notion of an equality of "value" between offense and penalty, a parity between the inner qualities of two things which externally may be quite different.[30] For example, robbery (which includes bodily injury) and theft (with no bodily injury) have punishments very different in external form—imprisonment and fines, respectively. But "in respect of their 'value' they are comparable." In fixing punishments for crimes, therefore, we must "look for something approximately equal to their 'value' in this sense."[31] It follows, for Hegel, that murderers deserve the death penalty. Since murder violates the full compass of one's existence, and no lesser value than the murderer's life can annul (negate) the crime, murderers should be put to death.[32]

Pope Pius XII. Pius XII's notion of retribution is not unlike Hegel's. Punishment is society's reassertion of the primacy of good over evil, the reaction of retributive innocence on criminal guilt, and the affirmation that justice and right always have the final word. "The punishment," Pius teaches, "is the re-

action, required by law and justice, to the crime: they are like a blow and a counter-blow. The order violated by the criminal act demands the restoration and reestablishment of the equilibrium which has been disturbed."[33] "And the fulfillment of this demand," he says, "proclaims the absolute supremacy of good over evil; right triumphs sovereignly over wrong."[34]

The difference between the Finnis account and the Hegel-Pius account, as I see it, lies in their different views of the notion of justice. The former invokes the idea of *justice as fairness*, the latter the idea of *justice as right*. In order for *justice as fairness* to produce an account of retributivism, the account needs to identify what there should be a fair distribution *of*, the balance of which is then restored by retributive punishment. Finnis' account answers that *benefits and burdens* should be fairly distributed. The idea of fairness is absent from the Hegel-Pius account, which regards "annulment" or "reaction" as sufficient to restore order. Yet in both accounts, the retributive good of punishment is conceived as the correction (i.e., redress) of injustice; and injustice in turn is conceived generally as the disturbance of right order caused by wrongful willing. And so, when the question of the determination of the measure of punishment is posed, both accounts, like the *Catechism of the Catholic Church*, answer that punishment should be proportionate to the gravity of the offense, the measure of gravity being relative to the criminal's wrongfully indulged will.

Secondary Aims of Punishment

Redressing the disorder brought about by crime is the *defining* purpose of punishment (what the *Catechism* calls the "primary aim" and Pius XII the "ultimate meaning" and "most important function").[35] However, that is not its only purpose. As noted above, section 2266 of the *Catechism* identifies two secondary purposes, namely, the medicinal (understood in reference to the criminal) and the protective purposes. By keeping the three purposes together, the *Catechism* avoids limitations that characterize purely retributive theories, on the one hand, and purely utilitarian theories, on the other. The former, by excluding empirical considerations, have problems when it comes to the assignment of concrete forms and degrees of punishment; the latter, by excluding formal considerations, are unable (when pressed) to answer the questions: why punish only the guilty? and what makes punishment *punishment?*

While never severing the causal connection between crime and punishment, the account in the *Catechism* allows for the recognition that the adaptation of punitive sanctions need not and should not be free from empirical

considerations. Whether a person is punishable indeed depends on retributive considerations, that is to say, the "who" of a given punishment always looks back to the deliberate act(s) of a specific person.[36] But the question whether in fact to punish him and, if so, the form, measure, time, place, and other relevant circumstances of the punishment may be influenced by a range of factors, including the remedial interests of the criminal, the impact on the overall crime rate, the safety of citizens, economic limitations, and so forth. None of these can be reduced to a simple derivation from abstract formulations. Rather, they depend primarily upon positive law and prudential judgment.

Criminal Reformation. Adapting a punishment with a view to the restoration of its beneficiary to reasonable participation in the community whose good order he disregarded is a way of acknowledging that his good, like any other, is part of the common good. Judicious effort spent toward his rehabilitation, therefore, should be seen as part of the wider public effort of defending and promoting the common good. In treating this idea, the *Catechism* singles out a specifically religious dimension. It speaks of the value of "expiation" (with its original sense of making satisfaction or atonement for a crime, or of purifying or purging by sacrifice) that punishment assumes when accepted willingly. Pope Pius XII teaches something similar. Addressing a congress of jurists, he said: "As long as man is on earth, such punishment can and should help toward his definitive rehabilitation."[37] He makes clear that this includes not only psychological and moral dimensions, but also and especially a religious dimension:

> if this final religious deliverance is not manifested to the culprit, or at least if the way to such is not pointed out or made smooth . . . then in such a case very little, not to say nothing, is offered to the guilty "man" in his punishment, however much one may talk of psychic [psychological] cure, or reeducation, of social formation of the person, or emancipation from aberrations and from enslavement to himself.[38]

Societal Protection. The other secondary purpose is derived, to borrow a phrase from Finnis, "from the 'psychology' of citizens,"[39] namely, the defense of the public order and protection of the community. Punishment serves to protect the community in three ways. First, it helps maintain the good faith of citizens. In order to prevent suspicion and promote confidence not only in the criminal justice system but in the whole order of public authority, law-abiding

citizens need to know that crime does not pay, that criminals are not free to enjoy the fruits of their unjust enterprises, and that being law-abiding does not set one at a disadvantage; in effect, citizens need to see that those who willfully break faith with the order of law are brought in judgment before that law and given reasonable penalties for their crimes. Second, it serves as a deterrent to future crime. Those inclined to engage in criminal activities need tangible disincentives, graphic displays of the consequences of doing so; in effect, they need to be "convinced" to abide by the law. Third, it protects the community against those who do in fact commit crimes (and would again if given the opportunity), either by imprisoning them or putting them to death.

Strict Retributivism

Immanuel Kant. At the heart of Kantian retributivism is the assertion that empirical considerations are to be excluded from the definition, assignment, and determination of concrete kinds and degrees of punishment. Punishment is pain inflicted on an offender *for his offense;* Kant insists that it be "inflicted upon him only *because he has committed a crime.*"[40] If one is not first judged "punishable," the penalty becomes merely a means for advancing extraneous goods and hence is immoral.

The penal law, Kant argues, is a categorical imperative which expresses itself in the *lex talionis* or *law of retribution* (which he also calls the principle of "like for like").[41] The maxim of an offender's purposeful act operates as a universal law establishing the conditions under which the criminal himself is to be brought, indeed, under which he brings himself. The form and measure of his punishment are therefore determined by his own act, an exchange of like for like suggesting equality both in quantity and in kind (or quality) of pain inflicted.[42] "All other principles," Kant states, "are fluctuating and unsuited for a sentence of pure and strict justice."[43] As for utilitarian considerations,

> woe to him who crawls through the windings of eudaemonism in order to discover something that releases the criminal from punishment or even reduces its amount by the advantage it promises, in accordance with the Pharisaical saying, "It is better for *one* man to die than for an entire people to perish." For if justice goes, there is no longer any value in men's living on the earth.[44]

This is not to say that the empirical benefits of punishment are excluded from consideration altogether, only that their considerations play no part in punishment's basic definition, assignment, or concrete determinations. For Kant these are determined by formal considerations alone. It follows that the foregoing or diminishing of a punishment for reasons of utility is forbidden. Even if the nature of punishment threatens to result in the multiplication of crimes, its infliction is required by justice.[45] In the case of one who commits murder, the required punishment is death: "every murderer—anyone who commits murder, orders it, or is an accomplice in it—must suffer death."[46] No possible substitute can satisfy the demands of justice, because there "is no *similarity* between life, however wretched it may be, and death."[47] Kant goes so far as to say that the people who fail to put to death a murderer "can be regarded as collaborators in this public violation of justice."[48]

This position is subject to a *reductio ad absurdum*. By excluding empirical considerations from the adaptation of criminal sanctions, one is left to rely solely upon the formal principle of retribution. And while Kant is willing to admit that occasions may arise when its application "is not possible in terms of the letter," he still requires that it be applied "in terms of its effect," that is, society should still seek to repay the criminal in pain proportionate to the pain he caused.[49] But even given this caveat, the *lex talionis* is unthinkable and impossible to apply to certain types of crime. How, for example, should rapists and traitors be punished, whose crimes have ramifications perhaps for generations, or murderers who add to their killing the further crimes of mutilation and torture? Or what if they commit multiple murders, or set out to commit a particularly heinous murder and are unsuccessful? Moreover, the *lex talionis* is inexpedient in certain circumstances, for example, when it makes a martyr of a revolutionary terrorist, or bankrupts a legal system, or risks civil war. Additionally, it can be argued that to commute the *lex talionis* into a more manageable form by looking for an equivalence in gravity, such as life imprisonment, is to subvert the whole Kantian position, since it admits the principle of exchange.[50]

John Conrad.　Conrad, too, proposes a strict retributivism. Punishment is the "proper immediate consequence of the criminal act."[51] "The crime itself justifies the punishment." It is "imposed as the legal consequence of guilt."[52] Beyond this it has no justification or aim, that is, none to which a criminologist or social scientist could reasonably point and say, "this justifies punishment." But Conrad adds an interesting twist. He insists that retribution *forbids* capital punish-

ment. This follows from his definition of retribution. Retribution is the reassertion of the moral law against one who has opposed it; it is the repudiation of a deliberate offense by the community against whom it was ultimately committed. It is also the reconciliation between an offender and his community as a result of the offender's willingness to atone for his crime.[53] "Reconciliation," Conrad writes, "becomes the final phase of retributive justice."[54] It expects authentic changes in acts and dispositions, "the consequences of remorse, introspection, or the desire for expiation."[55] It follows that the death penalty "conflicts with the true functions of retributive justice."[56]

Conrad's link between retributive purpose and reconciliatory effect is intelligible from a Christian perspective, but unfortunately this notion of retribution, however laudable, is unrealistic. If "reconciliation" waits upon criminals to own up to their crimes, confess their guilt, and undertake acts of expiation, the requirements of justice remain unfulfilled unless and until such a reformation occurs. Experience shows that in many cases, particularly those involving recidivist offenders, habits of mendacity and self-deception are developed and reinforced, making honest remorse and expiation unlikely. According to Conrad's thesis, the best we can hope for in such situations is a partial justice. Moreover, occasions may arise when the threat of imminent death becomes the very stimulus that precipitates remorse and repentance (think of the popular movie *Dead Man Walking*). In such cases the death penalty serves as an irreplaceable means for the completion of the final "phase" of Conrad's retributive justice.[57]

Utilitarian Accounts

For utilitarian theorists, punishment is justified to the extent that it contributes to the realization of a better state of affairs in society. Any retrospective glance, other than perhaps to determine guilt, is irrelevant, because crime once committed can never be undone. "Can the wailings of a wretch," Cesare Beccaria ridicules, "perhaps, undo what has been done and turn back the clock?"[58] The idea of redressing a disturbed social order is a retributivist fiction, one, to quote H. L. A. Hart, which "we may very well discard."[59] At the same time, most if not all utilitarians (including a pure utilitarian like Jeremy Bentham) hold that punishment is reserved for the guilty; to that extent, they say, crime justifies punishment.

These accounts have one difficulty. In the absence of a substantive conception of guilt, they are unable to show why the guilty and only the guilty ought to be punished. While purely retributive theories fail to weigh the importance of

empirical considerations and thus become unconvincingly abstract about nitty-gritty questions such as sentencing, theories with exclusively utilitarian aims hesitate when they attempt to explain what distinguishes punishment sanctions from other non-criminal sanctions imposed for reasons of social utility. Two questions put them to the test: why *punish* only the guilty? and why punish *only* the guilty?

Instead of punishment, why not reeducation? Why not send criminals to state universities for courses in civility? Why not offer financial handouts to improve the economic conditions in which their criminality was nurtured? Why not seminars with psychologists, occupational therapists, financial advisors, and the like? If any of a number of other possibilities could serve to diminish criminal behavior, why choose punishment?

And why punish only the *guilty?* Why not their parents and schoolmasters as well? Or why not punish the rich whose habits of hoarding produced the economic disparities that made criminal life attractive in the first place? Why only the guilty? The intuitive response is, because *they*, not the others, committed the crime. This invites the question: what about crime makes one punishable? The absence of a systematic answer is the heart of the theoretical weakness of utilitarian accounts.

In what follows, I briefly examine three influential utilitarian accounts: the first by the father of utilitarianism, Jeremy Bentham; the second by John Rawls in his dated but still influential paper "Two Concepts of Rules," delivered in April 1954 to the Harvard Philosophy Club; and the third by H. L. A. Hart, taken from his 1968 work, *Punishment and Responsibility.* After surveying these standard utilitarian accounts, I also consider two related accounts: reformism, and what I describe as a utilitarian account disguised in the language of retribution.

Jeremy Bentham. Bentham intends his "principle of utility"[60] to be the measure of just legislation. Laws, he maintains, should be designed to augment as far as possible the happiness of the community as a whole and prevent as far as possible actions that diminish it; in short, laws should "exclude mischief."[61] An act's mischief is measured by its propensity to diminish pleasure or produce pain; such an act he calls an "offense."[62] The idea of punishment presupposes the idea of an offense.[63]

Punishment is a tool for preventing mischief.[64] It does so by controlling human actions, both those of offenders and of others. It controls the former

either by *reformation* (by influencing one's will to choose non-offensive acts) or by *disablement* (by influencing one's physical powers).[65] It controls the latter by its deterrent effect. The harsh example of punishment, Bentham says, serves as a "moral lesson."[66] It singles out and stigmatizes certain acts, stamping them with ignominy. Punished people are inspired with feelings of aversion for the habits and attitudes which gave rise to these acts in the first place and hence are disposed toward better ones. Punishment therefore serves not only as a disincentive to crime but also as a motive for virtue. A collateral benefit (to be factored with great care into the utility calculus) is the pleasure or satisfaction that the punishment of criminals gives to the victims of crime.[67]

Punishment, as involving the production of pain,[68] is mischief in its own right.[69] Its employment, therefore, must be strictly subject to the principle of utility. If punishment is ever judged to be *groundless* (if the act in question contains no mischief), *inefficacious* (if it cannot prevent the mischief), *unprofitable* (if the mischief caused by it exceeds that which it prevents), or *needless* (if there is a cheaper way to prevent the mischief), then it is not worthwhile and should not be inflicted.[70]

A number of rules follow from this, among which Bentham includes the following: (1) A punishment should be designed in such a way as to make the crime it punishes unattractive; therefore the disvalue of a punishment should be greater than the profit gained by the offense. (2) In the case of resolute criminals, the punishment should be so designed as to induce them to commit the least mischievous offense suitable to their purpose; therefore when two offenses are in question the greater should have annexed to it a punishment sufficient to motivate the offender to choose the lesser. (3) Once a criminal has fixed his will on a given offense, punishment should be so designed as to dispose him to cause only as much mischief as is necessary to fulfill his designs and no more; therefore it should take into consideration the details of the offense and its severity be determined by those details; for example, one who gives you ten blows should be punished for ten, not five, and one who steals ten shillings punished for ten, not less; if for stealing ten shillings he is punished for only five, he will certainly steal the extra five. Finally, (4) punishment ought to be as economical as possible; therefore a given punishment should not exceed what is necessary to conform to the other three rules.[71]

Though Bentham insists that punishment is only worthwhile if grounded in criminal mischief, one may wonder what prevents the conclusion, based on his principle of utility, that punishment could be worthwhile in the absence of

mischief. If punishing someone who is innocent promises to augment the happiness of the community (for example, killing a Socrates or a Jeremiah because "he is inconvenient to us and opposes our actions" [Wisdom 2:12]) or promises to prevent large-scale unrest or violent conflict (for example, handing an innocent person over to a bloodlust-blinded lynch mob), what in principle prevents this action from being sanctioned if the decisions rest exclusively on an appeal to utility? Merely the idea of a possible offense and not an actual offense is sufficient to justify punishment.

Curiously, Bentham rejects the death penalty because, he says, it fails the utilitarian test for meet punishment. Certain properties, eleven in all, deriving from the four rules stated above, must be present to justify punishment according to utilitarian standards. Only three concern the issue of capital punishment. The first is *frugality*, predicated of a punishment that conforms to the fourth rule.[72] The second is *efficacy with respect to disablement.* The third is *remissibility*, namely, the property that allows a punishment to be remitted if later found to have been wrongfully inflicted.[73] Bentham praises capital punishment for its disabling efficacy, which, as he says, is always and everywhere certain. However, it is eminently un-frugal. Bentham offers no explanation for the latter claim. And it goes without saying that capital punishment fails the *remissibility* test; the death penalty is the "most perfectly irremissible" punishment. Therefore, other than in the most extreme cases, such as the threat of civil collapse, capital punishment should be avoided. "Chronicle" punishment is preferable, for instance, imprisonment, exile, or hard labor.[74]

John Rawls. In his "Two Concepts of Rules," Rawls set out to refute the claim that utilitarian views of punishment inevitably sanction the punishment of the innocent.[75] His basic conceptual tool is familiar to the literature of utilitarianism: a distinction between "justifying a practice as a system of rules to be applied and enforced," and "justifying a particular action which falls under these rules."[76] When seeking a justification for the practice of punishment as an institution, Rawls' account looks to utilitarian considerations, that is, to the argument that the justifying purpose of the institution of punishment is to advance the interests of society in the long run. When seeking to justify individual punishments, however, it looks to data supplied by retributive considerations.

According to Rawls, two offices correspond to the two justifications: the offices of (ideal) legislator and (ideal) judge. The legislator undertakes the duties of his office with society's future interests in mind; the judge looks back to a law

that was broken and accordingly assigns blame. Just as the former office is more fundamental than the latter—to the extent that judges carry out the will of legislators—so the utilitarian view (which justifies the institution of punishment in the first place) is more fundamental than the retributive.[77]

Does privileging the utilitarian premise mean that the conclusion about the retributive assignment of punishments is derivative? It does. Guilt, Rawls insists, plays *no* part in the justification of punishment. The "task of matching (penal) suffering with moral turpitude," he claims, is "improper, if not sacrilegious."[78] Rawls recognizes, however, that excluding all but empirical considerations from his definition of punishment makes his account vulnerable to the criticism he is so eager to avoid. He therefore argues that his retributive conclusion follows from sound utilitarian principles.

Rawls asks whether his rule-utilitarianism could ever justify an institution of punishment entirely free of retributive considerations. Could it, for example, justify an institution with authority to knowingly arrest, try, and convict innocent persons whenever officials felt that doing so would be to the benefit of the wider community? Rawls thinks not. Such an institution is an open invitation to abuse and deception and hence risks the loss of public confidence. In practice it promises more harm than benefit, and therefore its justification from the standpoint of utility is highly doubtful.

Rawls is convinced that a utilitarian account conceived in this way is invulnerable to the criticism that it justifies the punishment of the innocent. But in the end, his reasoning is no different from a thoroughgoing utilitarianism. Retribution is not a necessary condition for an institution of punishment, that is, it is not self-justifying. Retribution takes its justification from its promise to remain suitably useful and, like any conclusion derived from a calculus of benefits and harms, remains an element of punishment only so long as it makes good that promise. Thus Rawls' account (at least in principle) is committed to abandoning the retributive ingredient of punishment if doing so were to promise greater utility.

H. L. A. Hart.　　Like Rawls, Hart incorporates a retributive element into his utilitarian account of punishment. Punishment "must be of an actual or supposed offender for his offense."[79] Again, "only those who have broken the law . . . may be punished."[80] The retributive element "may figure among the conceivable justifying aims of a system of punishment,"[81] but is not what he calls the "general justifying aim." Calling it *an* aim simply means that justice in punishment cannot operate without retributive distribution, and therefore its presence in the

theory is in a sense self-justifying. The general aim of a system of punishment is to produce a better state of affairs in civil society. Hart argues that

> it is perfectly consistent to assert *both* that the General Justifying Aim of the practice of punishment is its beneficial consequences *and* that the pursuit of this General Aim should be qualified or restricted out of deference to principles of Distribution which require that punishment should be only of an offender for an offense. Conversely it does not in the least follow from the admission of the latter principle of retribution in Distribution that the General Justifying Aim of punishment is Retribution....[82]

What then, we might ask, grounds the presence of retributive restrictions or distribution in any sound account of punishment? Hart rejects Rawls' answer that they follow from utilitarian reasoning. Rather, they are valued "not as the Aim of punishment, but as the only fair terms on which the General Aim (protection of society, maintenance of respect for law, etc.) may be pursued."[83] Their presence, in other words, is independently justified on grounds of *"fairness* or *justice."*[84] And fairness protects individuals from the kind of harm that could be caused by an unqualified application of utilitarian reasoning.[85]

If social utility alone and not retribution is the general aim of punishment, why is it always wrong to punish the innocent with coercive restrictions when it may well be legitimate to impose on them similar restrictions for other reasons?[86] In other words, what makes punishment *punishment?* As with Rawls, Hart's failure to recognize that the infliction of just punishment itself realizes an authentic human good (redressing social disorder, annulling crime, respecting human freedom, and so forth) leaves important questions unanswered.

Reformism

A special subset of utilitarian accounts singles out criminal rehabilitation as the sole aim of punishment. While some reformists make the more moderate claim that courts are ill-equipped to determine criminal responsibility, and others the more radical claim that criminal behavior is merely a symptom of deeper individual or social pathologies, most modern reformists agree that *laws* of criminal responsibility are inadequate.[87] Moderate reformist Giles Playfair, for example, complains that the traditional method for determining criminal responsibility (i.e., by a "strict legal test, which defines sanity as the ability to make an intellectual distinction between what is right and wrong") is archaic and allows "psy-

chopaths and other grossly abnormal people to be held fully responsible to the law." Abnormal persons who are judged responsible by courts, after serving non-curative sentences, are merely liable to commit further and worse offenses. The appropriate response to sickness is treatment, not punishment. Offenders of this sort, even the most violent, should be committed to "custodial non-punitive institutions" until they die or are cured. "The practice of punishing rather than treating these people, who are incapable of helping themselves, does worse than violate the rights of the individual: it threatens public safety."[88]

It is important to note that the juridical procedure of determining criminal responsibility is a tenuous business and that human freedom is obstructed by various factors. However, reformism, at least in its stricter guise, must ultimately be rejected. For to undermine the moral preconditions for blame is likewise to undermine praise and in the end to doubt freedom altogether. By what logic is reformist determinism limited to those who commit crimes? If I am not free when I shoot you, why am I free when I marry you, borrow your car, or baby-sit your child?

The reformist position also leaves us with the problem of the irreformable. Plato, Clement of Alexandria, and Aquinas each said that grave malefactors who were irreformable, that is, who remained intransigent in their wickedness, should be put to death. At the same time, they had no problem with the notion of responsibility.[89] They believed (perhaps sometimes naively) that a criminal's crimes and his intransigence were freely chosen. Hence they could say that he *deserved* to die. But to many reformists the notion of desert is primitive and passé.[90] The intractably wicked are really only irremediably ill. So what, we might ask, should society do with them? One alternative was offered above: offenders should be committed to criminal hospitals until they die or are cured.[91]

In reformist accounts we find the same theoretical limitation as in other utilitarian accounts, namely, the inability to distinguish in principle between penal sanctions and sanctions imposed by other coercive social systems.

Retribution as a Moral Feeling—Disguised Utilitarianism

Exacting retribution has at times been equated with taking revenge. To say crime *deserves* punishment is another way of saying people *feel* criminals should suffer. Ernest van den Haag, for example, a longtime defender of the death penalty, argues that restraint from antisocial behavior is in large measure due to the threat of punishment. If such restraint is to continue, the law-abiding must not be made to feel that threats are empty lest they become convinced that crime

pays, and they too want to benefit from it. "If criminals could break the law with impunity," he writes, "the self-restraint of non-criminals would have been in vain."[92] "For if crimes are profitable, refraining from them is not."[93] Moreover, if the law failed to punish criminals, citizens would begin to take punishment into their own hands.

Retributivism is not a theory, van den Haag insists, but "a feeling articulated through a metaphor presented as though a theory." The only thing it "offers as evidence for its conclusion [that punishment is justified because deserved] is feeling."[94] And because it is only a feeling, "and feelings just are," it cannot be right or wrong.

A somewhat similar view is expressed in the plurality opinion of the 1976 U.S. Supreme Court decision on the death penalty, *Gregg v. Georgia*. Capital punishment, according to *Gregg*, serves "two principal social purposes; retribution and deterrence of capital crimes by prospective offenders."[95] In regard to the first, capital punishment "is an expression of society's moral outrage at particularly offensive conduct. This function may be unappealing to many, but it is essential in an ordered society that asks its citizens to rely on legal processes rather than self-help to vindicate their wrongs."[96] Retribution, moreover, "is an expression of the community's belief that certain crimes are themselves so grievous an affront to humanity that the only adequate response may be the penalty of death."[97] Quoting the 1972 death penalty decision in *Furman v. Georgia*, *Gregg* states:

> The instinct for retribution is part of the nature of man, and channeling that instinct in the administration of criminal justice serves an important purpose in promoting the stability of a society governed by law. When people begin to believe that organized society is unwilling or unable to impose upon criminal offenders the punishment they "deserve," then there are sown the seeds of anarchy—of self-help, vigilante justice, and lynch law.[98]

And again, quoting Lord Justice Denning of the British Royal Commission on Capital Punishment:

> it is essential that the punishment inflicted for grave crimes should adequately reflect the revulsion felt by the great majority of citizens for them. It is a mistake to consider the objects of punishment as being deterrent or reformative or preventive and nothing else. . . . The truth is that some crimes

are so outrageous that society insists on adequate punishment, because the wrong-doer deserves it, irrespective of whether it is a deterrent or not.[99]

Whether retribution, according to *Gregg*, is the satisfaction of nonrational sentiment, i.e., is an emotivist retributivism, or whether it is the correction of injustice, claiming an emotional correlate, is unclear. The latter in principle would pose no problem for the account of punishment outlined in the *Catechism of the Catholic Church*. To say that the (rationally identifiable) disorder brought into being by crime has an empirical correlate in the feelings of men and women is no more than to admit that people have a natural sense of justice. However, when retribution is collapsed into a feeling, punishment loses its rationality.[100]

A purely emotivist retributivism should be rejected not only because it is incompatible with Christian morality, but also because it is not properly retributive at all. To the extent that the purposes of punishments corresponding to these emotions are exclusively empirical (for example, to mollify citizen outrage, prevent vigilante justice, or maintain faith in the criminal justice system), these accounts of punishment are utilitarian.

■

The principal question that a purely retributive theory puts to any competing theory of punishment is, how does that theory account for human responsibility in light of human rationality and freedom? The principal question that a purely utilitarian theory poses is, can that theory show that punishment is justifiable to the extent that it contributes to improving the state of affairs in civil society? I have tried to show that the account of punishment outlined in the *Catechism of the Catholic Church* provides lucid answers to both questions. By giving priority to retribution it acknowledges that deliberately wrongful acts, chosen and carried out, are the necessary and defining grounds of punishment. That is to say, where sufficient reflection or full consent of the will is lacking, or where an act freely and deliberately chosen is not harmful to the community, there is, strictly speaking, no question of punishment. Yet this is not the whole story. The *Catechism's* account, which maintains at all times the causal connection between crime and punishment, also recognizes that punishment should make an improvement in the state of affairs in civil society. It therefore acknowledges that empirical considerations such as criminal rehabilitation and societal defense are also authentic, albeit secondary, aims of punishment. So

while the question whether one *may* be punished depends exclusively on whether one has committed an offense (i.e., only offenders are rightly punished), the question *to* punish and, if so, *how* depends on factors related to the empirical well-being of the community, including the interests of the criminal, the impact on community safety, and so on. By prioritizing retribution but not losing sight of other empirical aims, the account in the *Catechism* avoids limitations of accounts that assign quasi-exclusive status to retributive or utilitarian aims. It thus lays the foundation for a theory of punishment with a theoretical coherence and unity that are lacking in such accounts.

PART II

THE HISTORY OF THE CHURCH'S TEACHING

CHAPTER 3

■

The Death Penalty and Scripture

■

My conclusion in chapter 1, that the format and content of the teaching in the *Catechism of the Catholic Church* on the death penalty prepare the way for a development of doctrine in the Church's moral teaching on the subject, naturally gives rise to the question of the relationship of this potential development to antecedent Catholic teaching. In chapters 3 through 6 I undertake a roughly chronological survey of scriptural teaching and the most significant authoritative statements of the Church on the morality of capital punishment. By "authoritative" I mean not only propositions asserted in formally authoritative ways, such as the statements of popes *qua* successors of Peter and of ecumenical councils, but also propositions which are *de facto* authoritative by virtue of the influence and import of the works in which they are expressed—for instance, the *Decretum Gratiani* and *Dictionnaire de Théologie Catholique*—or by virtue of the influence and import of the authors who asserted them, including the Church Fathers and St. Thomas Aquinas. Only after the tradition has been surveyed can we accurately identify those propositions on the morality of capital punishment that constitute the "traditional teaching" of the Catholic Church. The present chapter addresses the contributions of the Bible. Chapter 4 is devoted to those of the Fathers of the early Christian centuries. Chapter 5 surveys those of theologians and councils of the medieval Church, and the first part of chapter 6, those of representative Catholic writers from the Council of Trent to approximately Vatican II. In view of the Catholic doctrine of infallibility, the question of the relationship of the present teaching on capital punishment to its antecedents depends in part on the question whether any statements in the

traditional teaching, or the traditional teaching as a whole, have been proposed infallibly. I raise this question in chapter 7.

From the earliest days of the Church to the twentieth century, Christian writers have appealed to the Bible as a theological ground for the basic legitimacy of the death penalty. For most of them, even those who held capital punishment in deep disdain, the frequency with which death is prescribed as a punishment for sin in the Old Testament and the apparent defense in the New Testament of the right of civil authority to kill malefactors has provided sufficient reason both to accept it and to defend it from its critics.

My purpose in this chapter is not to propose *the* scriptural teaching on capital punishment. The critical resources for such an undertaking are beyond the scope of this work. My aim is rather to review the biblical landscape surveyed by the Fathers of the early Christian church and later generations and hence to aid our understanding of why a majority of Christians throughout history have believed that the right of civil authority to kill malefactors is of divine origin.

Old Testament

Death is prescribed more than forty times and for over twenty offenses throughout the various law codes of the books of the Pentateuch.[1] Serious crimes against religion, the order of the family and community, and human life were all punished with death. For example, blasphemy (Lev. 24:16), sacrifice to foreign gods (Ex. 22:20, 32:21–27, Deut. 13:6–10, 17:2–7), and working on the Sabbath (Ex. 31:12–14, 35:2) were capital crimes; so, too, were false prophecy, the idolatrous dreaming of dreams, and sorcery and wizardry (Deut. 13:5, Lev. 20:27, Ex. 22:18). A priest's daughter who played the harlot (Lev. 21:9), one who acted presumptuously by not obeying the words of a priest or judge (Deut. 17:12), or anyone unlawfully expropriating the spoils of battle (Deut. 13:17) deserved death; sexual offenses such as adultery (Deut. 22:22, Lev. 20:10), homosexual acts (Lev. 20:13), incest (Lev. 20:11, 12, 14), bestiality (Ex. 22:19, Lev. 20:15–16), premarital sex for women (Deut. 22:20–21), and the seduction of a betrothed virgin in the open country, out of hearing of others (Deut. 22:25–27),[2] were likewise capital crimes; kidnappers (Ex. 21:16), perjurers (Deut. 19:16–19), rebellious and incorrigible sons (Deut. 21:18–21), those who cursed or struck their parents (Ex. 21:15, 17, Lev. 20:9), owners of oxen guilty of recidivist goring (Ex. 21:29), and all who afflicted widows and orphans (Ex. 22:22–24) should by law be put to death.

A most serious crime in Israel, one against both the community and its religion, was the intentional killing of the innocent or intentional injury resulting in the death of the innocent (Gen. 9:6, Ex. 21:12, Lev. 24:17, 21, Num. 35:16–20, Deut. 19:11–13).[3] To the ancient Hebrews, human life drew its value from the fact that humans were made in the image of God (Gen. 1:26). As such, the human person stood in a unique relationship to God, sharing with God dominion over the earth (Gen. 1:26–30).[4] But God alone enjoyed dominion over the life and death of man (Deut. 32:39). Since human life was literally identified with blood (Gen. 9:4–5, Lev. 17:11, 14, Deut. 12:23), the unauthorized shedding of blood was not only an injustice against the one slain, it was also a crime against God himself, a sacrilege, like defacing the temple (1 Mac. 1:37). Slain innocent blood defiled not only the murderer (Deut. 19:13) but also his larger household (Deut. 22:8); it polluted his city and his land (Deut. 19:10, Num. 35:33, 2 Sam. 21:1–2, Jer. 26:15, Ps. 106:38) and even rendered barren the soil on which it was spilt (Gen. 4:11–12).[5] The evil deed required expiation, and only the shed blood of the murderer would suffice (Num. 35:33).[6] Capital punishment thus served a purpose similar to that of the ritual blood sacrifices of Leviticus, namely, purging evil from the community and purifying guilt.[7]

The ordinary mode of execution was stoning (Ex. 19:12–13, Lev. 20:1–2, 27, Deut. 13:10, 22:24, Josh. 7:25). At least two witnesses were needed to substantiate a capital charge (Deut. 17:6). If after careful examination the charges were sustained, the offender was taken outside the city (Lev. 24:14, Deut. 17:5, 22:24), the witnesses placed their hands on his head (Lev. 24:14) in a way similar to the scapegoat ritual (Lev. 16:20–22), and they were required themselves to cast the first stones (Deut. 17:2–7). The whole community followed in turn, making the execution both symbolically and in fact an act of the entire community (Lev. 20:2, 24:14–16). If a criminal was caught in the act, the stoning might proceed without the deliberations and judgments of a court.[8] Another common form of execution was burning (Gen. 38:24, Lev. 20:14, 21:9); less common forms included the use of the sword (Ex. 32:27, Deut. 13:15, 2 Kgs. 6: 22), spear (Num. 25:7–8), arrow (Ex. 19:13, 2 Kgs. 6: 22), hanging (Num. 25:4, Deut. 21:22–23), and beheading, which seemed to be reserved for those who affronted royalty (2 Sam. 16:9, 2 Kgs. 6:30–31).

In cases of murder, the normal legal procedure from Israel's earliest times (Gen. 4:23–24) to the monarchy (1 Sam. 25:33) was "blood vengeance." A relative of the slain, usually his closest responsible kin, served as the "avenger of blood"(Num. 35:19–21). His strict duty was to shed the blood of the murderer, and even after the development of organized legal procedures in Israel, the

actual execution of the murderer was his domain; the king or other public authorities limited themselves to inquiry and judgment.[9]

Israel, particularly after the exile, was a political entity, a theocratic nation. The Law was Israel's legal code, and "God was Israel's legal and political sovereign."[10] Obedience to the Law was at once obedience to God as well as fidelity to the community whose identity it shaped, while its violation was an act of rebellion against God as well as hostility against the community. Since the Law was given to the nation as a whole—to Israel as to a "first-born son" (Ex. 4:22)—the whole community was bound to its ordinances (Lev. 20:22). Hence violations involved the whole community in guilt.[11]

But purging evil from the community in the person of the evildoer served more than the retributive function of expiating guilt. It also removed a harmful influence from Israel. The infamous *herem* or so-called war-ban command of Deuteronomy 7:1–26, God's command to Israel to utterly destroy the tribes occupying its promised land, illustrates this graphically. Whether or not the ban was carried out, it was nonetheless intended as a deadly prophylactic against communal impurity, by preventing the corrupting and licentious influences of pagan worship.[12] The death penalty also served the pedagogical role of stirring within the community a fear of disobedience (Deut. 13:11, 17:13, 19:20, 21:21), as well as reminding Israel of the faithfulness and power of God (Deut. 3:21–22). When the command was directed against foreign nations, it served as a warning that the God of Israel (Deut. 2:25) was greatly to be feared.

Scholars generally agree that by the end of the Second Temple period there was a widespread reluctance in Israel to impose the death penalty.[13] A celebrated Rabbinical passage reflects the attitude of Hebrew law toward capital punishment in the middle of the second century AD:[14]

> A Sanhedrin which executes once in seven years is known as destructive. Rabbi Eleazar Ben Azariah says, "once in seventy years." Rabbi Tarfon and Rabbi Akiba say, "if we were in Sanhedrin no man would ever have been executed" [Makkot 1, 10].[15]

Bernhard Schöpf has observed that despite the reluctance to impose capital punishment, for the ancient Israelites the question "from whence does the state take the right to destroy human life?" simply did not arise. God, the Lord of life, had commanded Israel in the sacred Torah to shed the blood of offenders; hence its legitimacy was not questioned.[16]

New Testament

Christ's moral teaching arose in a complex political situation. The Jews, a people free because of their relationship to God and to his Law (John 8:33), were simultaneously a people under foreign rule. The issues of political morality that characterized pre-exilic texts when Israel was an independent political entity— for example, how leaders should live their lives and govern the community (Is. 56:9–12), and issues dealing with juridical structures and the carrying out of punishments (Deut. 17:2–7)—were largely absent from Israel's literature under its successive occupations. This may be one reason why the moral teaching of the New Testament is more concerned with personal conversion and the moral transformation of the lives of Christians and relationships within the Christian community, than with changing the existing political order.

The New Testament has little to say directly about the death penalty, but there can be hardly any doubt that the practice was considered legitimate by New Testament authors. The picture we invariably receive when the New Testament narrates encounters with civil authorities where death is at stake is that of a normal judicial practice, which is questioned only when it is thought to be exercised unjustly. When St. Paul, for example, insists on a Roman trial before the emperor, he says to Festus, "If then I am a wrongdoer, and have committed anything for which I deserve to die, I do not seek to escape death; but if there is nothing in their charges against me, no one can give me up to them" (Acts 25:11). In his defense before King Agrippa in Acts 26 he recounts how he had collaborated in the executions of Christians. However, he neither states nor implies that the institution in which he once collaborated was itself wrong. In St. Luke's crucifixion narrative, the Evangelist allows the words of the "good thief" that he and his partner are "justly . . . receiving the due reward" for their crimes (Luke 23:41) to go unchallenged by Jesus, and the writer of the fourth Gospel does the same with the words of the wrathful Jews, "We have a law, and by that law he ought to die" (John 19:7). When Peter and the Apostles are tried before the high priest and the council for preaching the good news, they apparently know that death is a possibility (Acts 5:33); Peter, however, responds not by arguing against the justice of the potential punishment, as we would expect if he believed capital punishment were wrong, but rather by arguing against disobeying the command of God to preach the message of Christ (Acts 5:29–31).

In spite of this picture of tacit acceptance, a number of New Testament passages have been put forward as proof texts against the death penalty. The

most common is the account in John 8 of the woman caught in adultery. When the Pharisees condemn her in the presence of Christ and demand the penalty prescribed under the Law of Moses, Jesus turns their accusations back on themselves by confronting them with their own guilt. Far from approving her penalty, he overrules it by forgiving her. The passage, however, can be taken in the opposite way, because neither does he deny the justice of the sentence. The parable of the wheat and tares is another common proof text. According to one interpretation, the Lord, in the person of the householder, by restraining his servants who are inclined to uproot (understood as capital punishment) the weeds growing alongside the wheat (understood as evildoers among the good), apparently counsels deferring punishments of an ultimate nature to the Last Judgment (Matthew 13). Other passages include Matthew 5:21–22, "But I say to you that every one who is angry with his brother . . ."; Matthew 5:38–39, "But I say to you, Do not resist one who is evil . . ."; and Luke 23:34, where Christ calls out, "Father, forgive them; for they know not what they do." These passages exercised considerable influence on the conduct and beliefs of early Christians, although, as we will see in chapter 4, they failed to convince the early Church to question the legitimacy of the death penalty in principle.

Romans 13:1–7

The most influential passage in the New Testament that addresses the relationship of Christians to civil authority is Romans 13:1–7:

> [1]Let every person be subject to the governing authorities. For there is no authority except from God, and those that exist have been instituted by God. [2]Therefore he who resists the authorities resists what God has appointed, and those who resist will incur judgment. [3]For rulers are not a terror to good conduct, but to bad. Would you have no fear of him who is in authority? Then do what is good, and you will receive his approval,[4]for he is God's servant for your good. But if you do wrong, be afraid, for he does not bear the sword in vain; he is the servant of God to execute his wrath on the wrongdoer. [5]Therefore one must be subject, not only to avoid God's wrath but also for the sake of conscience. [6]For the same reason you also pay taxes, for the authorities are ministers of God, attending to this very thing. [7]Pay all of them their dues, taxes to whom taxes are due, revenue to whom revenue is due, respect to whom respect is due, honor to whom honor is due.

This passage, especially verses 1–4, has been taken by Christians since the time of the early Church to be a sound biblical basis for establishing the right of civil authority to kill criminals. But should it be taken as such? Is Sacred Scripture affirming here a timeless truth about the nature and powers of civil authority? It may be possible to answer this question by appealing to a foundational premise of scriptural interpretation affirmed by Vatican II, namely, that whatever the biblical authors *intended to assert* by particular statements and by the use of different literary genre is to be taken as the assertion of the Holy Spirit.[17] A brief consideration of this premise is in order.

Propositions and Assertions. A proposition is a content of human intelligence—an idea—which is capable of being either true or false. When it is advanced as true, i.e., when someone says that something is (or is not) the case or ought (or ought not) to be done, that proposition is *asserted*. Three points are important to note regarding propositions and assertions: (1) the language of a proposition (or the statement or sentence by which a proposition is expressed) and the proposition itself are analytically distinguishable; (2) not all statements are propositions; and (3) not all propositions are asserted and not all statements, even those in the indicative mode, are assertions. Let us consider each point in turn.[18]

Propositions can be distinguished from the statements in which they are expressed. The same propositional truth can be expressed in two or more different statements and in different languages. For example, the statements, "The university choir is singing in Magdalen tower today," "*chorus academiae hodie in turre Magdalenae cantat,*" and (speaking exactly one year later), "Last year on this very day the university choir sang in Magdalen tower," express the same proposition.[19] In examining Scripture, therefore, the propositional truths being taught can be distinguished from the particular human language statements by which those truths are being expressed.

Because language can be used in ways other than to express truth or falsity, not every statement is a proposition. For example, "Thank heavens for a sunny day," or "Rosie, come here right now!", or "Good-bye, Mrs. Godfrey, and God bless you" do not express propositions. Nor for that matter do many sentences in the Bible, for example, expressions of feeling, petitions, and ejaculatory utterances, such as "Glory to God in the Highest!"

Not every spoken or written proposition is asserted. One can quote another's idea without asserting it. For instance, I can state, "John thinks the 1998

Chicago Bulls are the greatest basketball team in NBA history," without assert-
ing it myself. Nor does the statement necessarily reveal whether or not the
speaker or writer has asserted something. I can hear someone say, "The 1998
Chicago Bulls are the greatest basketball team in NBA history," and not know
whether he is quoting a newspaper editorial or asserting it himself; similarly, I
may hear my professor say, "*fiat justitia ruat caelum*," and not know whether he
is quoting the Stoics or a tittering Machiavelli, ridiculing the proverb, or *assert-
ing* it as a rule for moral conduct. Many propositions expressed in biblical nar-
ratives are not the assertions of the biblical author. For example, the Book of
Job contains and sets forth numerous propositions, and while they may be un-
derstood to be the assertions of the characters in the narrative—Job, Job's wife,
Eliphaz the Temanite, Bildad the Shuhite, for example—few, properly speaking,
are the biblical author's assertions.[20] So when asking what truth (or whether a
truth) is being taught in a biblical pericope, the place to look, according to Vati-
can II, is the proposition being asserted by the biblical author.

Returning to the topic at hand, we must ask, then, did St. Paul intend to as-
sert something about the morality of capital punishment inflicted by public au-
thority when he wrote the first verses of Romans 13, in particular, verse 4? A
fundamental premise of critical biblical studies over the past hundred years is
that the meaning of a text lies partly in the historical and literary conditions of
its composition. If we wish to understand an author's intended meaning, we
should ask what he had in view when he wrote what he did. What was Paul's his-
torical and cultural situation, and in particular, what was the situation of those
he was addressing? What is the literary context for this passage within the Let-
ter to the Romans as a whole? And finally, and most pointedly, what is Paul's in-
tended meaning for the metaphor "the sword"?

Literary Context. Verses 1–7 of Romans 13 are situated in the middle of a
wider exhortation by St. Paul to Roman Christians (beginning in 12:1 and ex-
tending to 15:13)[21] on the life and duties of Christian discipleship within and
outside the community of believers. These ethical admonitions follow from the
doctrinal principles set forth in chapters 1–11 on the justifying righteousness of
God and humanity's salvation in Christ by grace through faith. In Romans
12:1–13, Paul specifies duties Christians owe to those within the Christian com-
munity, particularly duties of charity and humility, and he extends those duties
in verses 14–21 to all people, including one's enemies. He ends chapter 12 with
the specific admonition to eschew, in all instances, seeking vengeance for
wrongdoing received. Paul understandably inserts at this point a consideration

of the relationship of Christians to the secular powers. (Brendan Byrne notes that Romans 13:1–7 "naturally extends and specifies the command to 'live peaceably with all' [12:18].")[22] Moreover, having enjoined forgiveness and forbidden vengeance for wrongdoing received, Paul is answering a question which is bound to have arisen in the minds of his readers, namely, how in the face of the persistence of human evil in this life is the civil order to be preserved?

Historical Factors. Given the approximate dating of the Letter to the Romans to sometime between AD 54 and AD 59,[23] we can identify several historical and social factors which explain why Paul might insist on subjection to political authority.[24] Paul, we may presume, was conscious of the tenuous nature of Jewish-Roman relations in the capital city of the empire and of the fact that Christianity in Rome was widely regarded as no more than an eccentric Jewish sect.[25] Turbulent political conditions in the city had led the Emperor Claudius (AD 41–54) to publish an edict in AD 49 expelling all Jews—including Jewish Christians—from Rome, leaving behind in the Christian community a gentile minority.[26] Less than a decade later, Paul is writing to a primarily gentile Christian community (see Rom. 1:13, 11:13), implying a rapid growth of gentiles among Roman Christians during the expulsion period. With Nero's succession at the death of Claudius in AD 54, the edict lapsed, whereupon it is safe to presume that many Jews and Jewish Christians returned to Rome. This may have been responsible for drawing the attention of existing authorities to the new sect in three ways. First, there were probably tensions between returning Jewish Christians and gentile Christians over questions of governance within the Christian community—tensions which may not have gone unnoticed; second, renewed hostility toward Christians was likely from non-Christian Jews returning from exile and straining to reestablish their religious identity in the capital city; and third, there would have been an obvious population growth in the Christian community as Jewish Christians returned, increasing the size and perhaps the number of house-churches in the city.[27] F. F. Bruce notes that the name "Christian" already had subversive connotations in Rome, given the riots evoked by the introduction of Christianity eight or so years before the writing of Paul's letter.[28] And "some at least remembered that the founder of the movement had been executed by sentence of a Roman judge on a charge of sedition."[29] In addition, unfair tax collection practices had caused civil unrest among Romans in the late 50s. Things came to a head in AD 58, when Nero considered abolishing indirect taxes but was persuaded otherwise by advisors who urged him to curb the abuses, not eliminate the taxes altogether.[30] For this

complex of reasons, we may infer that the Apostle, who was instructing the young church on its dealings with the existing authorities and who wished to obviate potentially harsh reprisals against imprudent Christian decisions, adapted his instruction with a view to commending those attitudes which were most appropriate given the historical situation, namely, respect for and docility toward earthly rulers.[31]

Jewish Tradition. When Paul took up the issue of the relation of Christians to political authority, there was already a well-established tradition in Judaism teaching respect for, and the divine origin (and accountability) of, earthly authority. As a converted rabbi, Paul was no doubt familiar with scriptural passages that support this tradition, among them the following:

> By me kings reign, and rulers decree what is just; by me princes rule, and nobles govern the earth. (Prov. 8:15–16)

> My son, fear the Lord and the king, and do not disobey either of them; for disaster from them will rise suddenly, and who knows the ruin that will come from them both? (Prov. 24:21–22)

> Hear, therefore, kings, and understand; learn, you magistrates of the earth's expanse! Hearken, you who are in power over the multitude and lord it over throngs of peoples! Because authority was given you by the Lord and sovereignty by the Most High, who shall probe your works and scrutinize your counsels! (Wis. 6:1–4)

> But seek the welfare of the city where I have sent you into exile, and pray to the Lord on its behalf, for in its welfare you will find your welfare. (Jer. 29:7)

Moreover, the parallel but independent biblical instruction in 1 Peter 2:13–14 commands, "Be subject for the Lord's sake to every human institution, whether it be to the emperor as supreme, or to governors as sent by him to punish those who do wrong and to praise those who do right," suggesting that respect for earthly authority was the common view among early Christian communities.[32] Paul was probably familiar as well with the oral tradition of Jesus' famous reply to the question about the payment of taxes, recorded in Mark 12:14–17.[33]

Extra-biblical sources witness to the same tradition. The Jewish historian Josephus, for example, states that the Essenes, a Jewish sect, held that "no ruler attains his office save by the will of God."[34] And a Hellenistic Jewish document of the first century BC, the *Letter of Aristeas*, states that "it is God who bestows on all kings glory and great wealth, and no one is king by his own power."[35]

An Interpretation of Romans 13:1–7

Paul begins Romans 13 by admonishing the believers in Rome to subordinate themselves to the governing authorities. This is because political authority—in fact, *all* authority—has been instituted by God, hence to resist the powers which God has ordained is ultimately to resist the authority of God. Political authority, according to verses 2–4, has been instituted for the purpose of passing judgment. Those who do good in its sight can expect a judgment of approval, and those who do wrong should fear a judgment of wrath. Paul elaborates the latter with the words, "be afraid, for he does not bear the sword in vain," "he," of course, referring to the bearer of public authority.

What does Paul have in mind when he writes this phrase in the context of verses 1–4? Does he mean to propose a doctrine of the nature of state authority which includes the right of the state to execute malefactors? He clearly means to identify the origins of earthly authority with the purposes of God. But does he put these ideas forward with a view to establishing a political principle, or does he repeat them as a piece of cultural wisdom in order to assert something else?

Verse 5 repeats the command to be subject to the ruling powers.[36] However, verses 6 and 7 introduce a selective context for applying this command:

> For the same reason you also pay taxes, for the authorities are ministers of God, attending to this very thing. Pay all of them their dues, taxes to whom taxes are due, revenue to whom revenue is due, respect to whom respect is due, honor to whom honor is due.

We may recall the unwelcome attention the Christian community was receiving in the mid-50s and the wider civil agitations in the late 50s due to imperial tax collection practices—in which Nero involves himself around the date of Paul's letter to the Romans. It is possible that St. Paul, solicitous to prevent confrontations with the Roman government, intended in verses 1–5 to set the stage for the specific charge in verses 6–7 to render to the proper authorities their due taxes

and revenues.[37] On this hypothesis, Paul enjoins fear (*phobos*) and respect (*timē*) as proper motives for doing so, given that tax collectors, like other public officials, are ministers of God, authorized by their public offices to enforce the carrying out their duties with coercive force. If we understand the passage this way, the answer to the question posed above would seem to be negative. Paul is not intending to assert a timeless doctrine regarding the nature of state authority, but rather is exhorting Roman believers to subject themselves to the ruling powers by rendering to them what is their due, specifically in the form of the payment of taxes. And the insights Paul draws upon for framing this exhortation are long-standing Jewish ideas regarding the origins of legitimate authority. It follows that Paul has in mind the local and regional concerns of Christians in Rome,[38] and thus to infer from verses 1–7 a doctrine of state authority is unwarranted.[39]

St. Paul's ideas on the origin and nature of public authority and the Christian's relationship to it derive from the Hebrew Scriptures, from the wider context of ideas stemming from first-century Hebrew culture, and perhaps also from an oral tradition arising from the teachings of Jesus. Paul's motive for putting his ideas forward in his letter to the Romans is to protect Christians in Rome from unnecessary confrontation with Roman authority. What does he intend to assert in Romans 13:1–7 on the question of the nature of political authority? First, legitimate authority, including governmental authority, derives from God for purposes of maintaining the good order of communities. Second, political authority deserves respect, and the payment of lawful taxes is a way of rendering due respect. Finally, those who comply will receive the approval of the governing powers, and those who fail to do so risk harsh retributive measures which the powers are authorized to inflict. Should we also conclude that Paul is asserting the ethical principle that civil authority has the right to inflict the death penalty on malefactors? Given the context as I have stated it, it seems not. The phrase "bear the sword" could be a symbol for the state's power to inflict the death penalty, but it is more likely intended as a symbol for the coercive authority of the police, whose duty it was to enforce the serving of writs and collections of taxes,[40] or possibly as a symbol of the authority of the military for purposes of quelling resistance.[41] While most contemporary biblical scholars interpret "bear the sword" as a metaphor for the coercive authority of the state, few interpret it as a straightforward reference to the authority to inflict capital punishment.[42]

It is instructive to note that Pope Pius XII, in an address to Catholic jurists in 1954, explicitly denied that Romans 13:4 refers to a specific rule of action.

Speaking about the "abiding validity" of the teaching of divine revelation regarding "the coercive power of legitimate human authority," the pope asserted:

> the words of the sources [of Revelation] and of the living teaching power *do not refer to the specific content of individual juridical prescriptions or rules of action* (cf. particularly Rom. 13:4), but rather to the essential foundation itself of penal power and of its immanent finality.[43]

In essence, the pope stated that if we want to know what is enduringly relevant in the teaching of revelation on the coercive power of civil authority, the place to look is *not* in specific juridical prescriptions—he singles out Romans 13:4—but rather in the basic nature and purposes of the penal power of public authority.

■

In light of these considerations, does Scripture assert that capital punishment is fully consistent with God's will for humankind? By way of an answer I propose three points. First, the moral teaching of the New Testament does not reaffirm the whole moral teaching of the Old Testament. Not only is there no reaffirmation of the Mosaic prescriptions, but in the case of legislation on marriage and divorce, at least one Mosaic prescription is explicitly repudiated (Deut. 24:1–4, Mt. 19:3–12); the six "antitheses" illustrating the true understanding of the law in Matthew 5:21–48 ("You have heard it said . . . But I say to you . . .") carry much the same force. We might also look to the Patristic distinction taken up by Aquinas between the "moral" precepts of the Old Law and its "ceremonial" and "judicial" precepts. Moral precepts (*praecepta moralia*), Aquinas says, pertain by their very nature to good morals. If a moral precept is taught in the Old Law, that precept by nature belongs to good morals and hence to the natural law.[44] The moral precepts of the Old Law are reducible to the precepts of the Decalogue. These differ from other Old Testament precepts—what Aquinas calls "ceremonial and judicial precepts"—because "God Himself is said to have given the precepts of the Decalogue to the people, whereas he gave the other precepts to the people through Moses."[45] If this distinction is sound, then the precepts taught in the legislative part of Deuteronomy, in the Covenant Code, and in the Priestly and Holiness Codes, i.e., in most of the passsages in the Pentateuch where death is prescribed, are either ceremonial or judicial precepts.

Second, even if the Patristic distinction is rejected (as Jews reject it), an argument could still be made that the mode in which the precepts of the Old Law

were given, namely, through divine command, was sufficiently unique to justify behavior that otherwise would not be justifiable. Aquinas, for example, thinks that the presence of a divine command changes the nature of some acts, rendering upright certain kinds of deliberate behavior that would otherwise be forbidden. For example, the acts of the Hebrews in despoiling the Egyptians were not acts of theft, and Abraham's consent to slay Isaac was not a consent to murder.[46] Since all the commands to kill in the Old Testament, whether in the form of punishments, *herem*, or wars of aggression, were understood in terms of divinely given precepts, one need not, and in some cases one ought not, hold that the same kinds of deliberate behavior would be legitimate in the absence of a particular divine command. Further, it could be argued that the social conditions in which the precepts to kill were exercised, that is, in the context of an independent, theocratic nation, are sufficiently incommensurable with the conditions under which capital punishment has been practiced in the Christian era as to render those precepts inapplicable outside the theocratic community in which they were received.

The third point concerns the important Old Testament precept of the Noachic Covenant requiring that the blood of murderers be shed by human agents (Gen. 9:5–6). Notwithstanding the first two points, this passage suggests a rather different conclusion:

> For your lifeblood I [God] will surely require a reckoning; of every beast I will require it and of man; of every man's brother I will require the life of man. Whoever sheds the blood of man, by man shall his blood be shed; for God made man in his own image.

Death was introduced in the first chapters of Genesis (2:17, 3:19) as mankind's fated punishment for sin; there, the biblical author illustrates God's justice as expressed through the inevitability of human mortality. Here, in this early precept against murder, humans are described as having a mediating role in the execution of divine justice. As a consequence of murder, other humans should shed the blood of the murderer. For support, the biblical author appeals to the pre-Fall account of man and woman as created in the image of God. What, if any, enduring relevance does this precept have for the problem of capital punishment?

With respect to its *lex talionis* prescription for murder, this precept has little or no relevance. While such a prescription may have been relevant within the political conditions of the ancient Hebrew community, strict conformity to such a

prescription would demand in justice that *all* murderers be killed. This in turn would imply that granting clemency is wrong, since if clemency were granted, justice would not be effected. This has never been taught by the Church. Nor has such a view been taken seriously in the Western political tradition by more than a small number of theorists (among them, Kant). Further, even granting that before Christ the spilling of human blood was required as a corrective for some sins—something this passage implies and Leviticus 17:11 directly asserts—the death and resurrection of Christ has effected a change in the moral order that eliminates the need for the spilling of blood. His bloody sacrifice made adequate atonement for human sins until the end of time (Rom. 3:24, Rev. 1:5). The old covenant, inaugurated through blood (Ex. 24:8) and requiring the continual re-spilling of blood for its operations of worship (Lev. 1:1–17) and for the remission of sin and guilt (Lev. 4–6), has been replaced by the new and eternal covenant sealed by the blood of Christ (Luke 22:20, 1 Cor. 11:25), which has effected the perpetual remission of sins (Heb. 8:1–10:39). The re-presentation in the Eucharist of that timeless sacrifice is an august reminder of the fact that blood (human or otherwise) need no longer be spilt for the expiation of sins.[47]

But the passage in Genesis 9:6 seems to affirm that human agents have a mediating role in the justice of God which includes as a consequence, in some cases, the infliction of death. The passage seems to me to warrant at least a provisional conclusion that the biblical author *intended* to refer to a role belonging to humans as such by reason of the relationship of human authority to divine authority. A closer analysis of this text would require biblical exegesis beyond the scope of the present work, and therefore, the problem it poses to the interpretation of the *Catechism* set forth in chapter 1 will be left standing.

CHAPTER 4

■

The Patristic Consensus

■

For the Fathers of the early Church, the authority of the state to kill malefactors is taken for granted. Opinions differed on whether Christians should hold offices whose responsibilities include the judging and carrying out of capital punishments—pre-Constantinian authors said they should not, those writing after AD 313 said they should—but the principled legitimacy of the punishment itself is never questioned.

In this chapter I examine selected Patristic texts (writings of Church Fathers, statements of regional synods, and so forth) that deal with the question of capital punishment, beginning with Justin Martyr in the second century and ending with Pope Gregory I in the seventh. My intention is to set forth as simply and clearly as possible what Patristic writers held to be true about the morality of capital punishment, and, to the extent it can be discerned, why they held what they did.

Given the influence of Plato and Seneca on Patristic (and medieval) Christian writers, a brief word on their ideas concerning punishment is in order. In Plato we find two classes of offender, those for whom hope of reform is reasonable, and those who are beyond cure, or at least judged to be so. The purpose of punishment for the former is *reformation*—they endure the suffering of punishment for their improvement, namely, to become better persons and ideally to come to a thoroughgoing love of right. The incurable evildoer, however, is "a plague to the city."[1] For such a one, "longer life is no boon . . . and his decease will bring a double blessing on his neighbors; it will be a lesson to them to keep themselves from wrong, and will rid society of an evil man."[2]

Seneca employs medical imagery to describe the relationship of the criminal to civil authority. Dangerous sinners are like diseases to the community; and

civil magistrates, charged with the community's welfare and hence with executing judgment against evildoers, are like physicians. "In only one particular," Seneca writes, "will he [the civil leader] differ from the physician. For while one supplies to the patients to whom he has been able to give the boon of life an easy exit from it, the other forcibly expels the condemned from life, . . . not because he takes pleasure in the punishment of anyone . . . but that they may prove a warning to all."[3] Medical imagery recurs again and again throughout the Christian tradition, entering through the writings of Clement of Alexandria and finding its clearest and most influential expression in the writings of Aquinas.

Pre-Constantinian Writings

The second- and third-century Fathers rarely address the morality of the death penalty directly. Hence, we must need to draw out their ideas by inference. Three convictions discernable in Patristic texts as early as the second century merit attention: (1) that civil rulers have morally legitimate authority over life and death; (2) that this authority has been conferred by God and is testified to in Scripture; and (3) that Christian discipleship is incompatible with participation in violence and bloodshed. By the early third century these convictions coalesce into what I refer to as the "bifurcated teaching" of the pre-Constantinian Church on the morality of participation in bloodshed: it sanctions the actions of non-Christians in carrying out capital punishment, as well as their participation in public offices whose duties these include, but it expressly forbids the same roles to Christians and those aspiring to full membership in the Christian community.

Justin Martyr (d. ca. 165) is one of the first Fathers to give us a glimpse into what he thinks about capital punishment. Though he never states in his correspondence with the Antonine emperors that imperial authority extends to the taking of human life, we infer from what he says that he takes it for granted. In chapter 2 of his *First Apology*—a work protesting the imperial power's unjust capital punishment of Christians—he writes: "As far as we [Christians] are concerned, we believe that no evil can befall us unless we be convicted as criminals or be proved to be sinful persons. You, indeed, may be able to kill us, but you cannot harm us."[4] Later he writes, "do not impose the death penalty against those who have done no wrong, as you would against your enemies."[5] In demanding due process for condemned Christians, Justin states that evildoers

who are *rightly* convicted should be duly punished: "we demand that the accusations against them [the Christians] be probed, and, if these be shown to be true, they be punished, as any guilty persons should be."[6] Yet he knows full well that death is the punishment for the crimes for which Christians are being accused: "we know well that for such a profession of faith the punishment is death."[7] Notwithstanding Justin's obvious use of rhetoric, we would do him a disservice to think he would commend by implication capital punishment for the guilty if he believed it to be wrong. The reflections on civil authority of Irenaeus (d. ca. 200) in *Against Heresies* reveal a similar position.[8]

The converted Athenian philosopher Athenagoras (second century), in *A Plea for the Christians,* mounts a defense, not unlike Justin's, against the unjust slaughter of Christians at the hands of false accusers.[9] Like Justin, he demands that charges against Christians be thoroughly investigated, and, if sustained, Christians should be duly punished: "If, indeed, any one can convict us of a crime, be it small or great, we do not ask to be excused from punishment, but are prepared to undergo the sharpest and most merciless inflictions."[10] He clearly takes the legitimacy of the death penalty, inflicted at the hands of the Romans, for granted when he writes, "if these charges are true [of atheism, cannibalism, and incest], spare no class: proceed at once against our crimes; destroy us root and branch, with our wives and children, if any Christian is found to live like the Brutes."[11] But when he speaks about Christian participation in bloodshed, his language is completely different:

> For when they [our accusers] know that we [Christians] cannot endure even to see a man put to death, *though justly,* who of them can accuse us of murder or cannibalism? . . . But we, deeming that to see a man put to death is much the same as killing him, have abjured such spectacles. How, then, when we do not even look on, lest we should contract guilt and pollution, can we put people to death?[12]

In a similar manner, a Latin Father, Minucius Felix (second to third century), refuting the common charge that Christians drink the blood of murdered infants, writes in his *Octavius*: "We [Christians], however, are not allowed either to witness or to hear of human slaughter, and the awe we have of human blood is so great that we do not even taste that of animals for food."[13]

Tertullian (d. ca. 220) takes a step further and declares that Christians should be forbidden entirely from occupying offices that require sitting in judgment over people's lives or characters—"neither condemning nor fore-

condemning; binding no one, imprisoning or torturing no one."[14] When asked if a soldier may be admitted to the Christian community, he answers, only the one "to whom there is no necessity for taking part in sacrifices or capital punishments."[15] The soldier who becomes a Christian must either abandon military service altogether—lest he be forced to "resort to all kinds of excuses in order to avoid any action which is also forbidden in civilian life, lest [he] offend God"— or if he remains, must be prepared to undergo suffering and martyrdom similar to his non-military brethren, for the "Gospel is one and the same for the Christian at all times whatever his occupation in life."[16] "Will a Christian," he writes, "taught to turn the other cheek when struck unjustly, guard prisoners in chains, and administer torture and capital punishment?"[17]

Yet the punishments inflicted by lawful authority, Tertullian insists, are legitimate and even good. "It is a good thing when the guilty are punished. Who will deny this but the guilty."[18] The Apostle Paul, he recalls, admonished the Romans to be subject to the ruling power, because "there is no power but of God, and because (the ruler) does not carry the sword without reason, and is the servant of God, nay also, says he, a revenger to execute wrath upon him that doeth evil."[19] Rulers are "handmaids of the divine court of justice, which even here pronounces sentence beforehand upon the guilty."[20] Tertullian makes clear in *De Anima* that the just punishments of civil authority include capital punishment. Speaking of the circumstances endured by human souls after bodily death and before resurrection, he writes, "those who die by violence, are also believed to be kept from Hades, especially those who die by cruel tortures, the cross, the axe, the sword, and wild beasts. But, death that comes from the hands of justice, the avenger of violence, *should not be accounted as violent.*"[21]

Despite his acceptance of the institution, Tertullian shares the age-old disdain for the office of the hangman. In his Montanist writing, *De Resurrectione Carnis,* he notes that inanimate vessels and instruments share in the merits or disgrace of those who use them. The sword of a good and brave soldier, for example, secures a kind of praise by being a consecrated instrument. However, a cup "infected with the breath of . . . a hangman" (i.e., used by a hangman) is likely to be condemned (*damnare*) as vigorously as if it were the hangman's very kisses.[22] He also rails in the *Apologia* against inordinately harsh capital laws. Recalling a time when laws allowed creditors to "cut in pieces" convicted debtors, he remarks: "Yet, by common consent, this cruel stipulation was later abrogated, and capital punishment was exchanged for a mark of disgrace. Proscription of a man's goods was intended to bring the blood to his cheeks rather than to shed it."[23]

A similar sentiment is expressed in the *Didascalia Apostolorum*, dating from the middle of the third century. In book 4, bishops are warned against receiving offerings from ones whose lives are incompatible with the call to discipleship in the Christian community. A list that includes thieves, unjust judges, makers of idols, and murderers also includes those who oversee executions, i.e., hangmen.[24]

Similar examples of the opposition of the early Christian community to involvement in bloodshed and capital judgments are found in the *Apostolic Tradition*, attributed to the theologian and pupil of Irenaeus, Hippolytus of Rome (d. ca. 236), and in the writings of the fourth-century Spanish Synod of Elvira (ca. 303). In the former we find a list of crafts and professions forbidden to Christians, among which are included various kinds of service to the pagan state: (1) "A soldier who is in authority must be told not to execute men; if he should be ordered to do it, he shall not do it." (2) "A military governor [literally, according to a footnote, "one who has authority over the sword"] or a magistrate of a city who wears the purple, either let him desist or let him be rejected." (3) "If a catechumen or a baptised Christian wishes to become a soldier, let him be cast out. For he has despised God."[25] Canon 73 of the Synod of Elvira teaches that if anyone through accusation or denunciation causes another to be exiled or sentenced to death, he is to be refused the sacraments at the end of his life.[26]

Clement of Alexandria (d. ca. 215) is the first Church Father to think systematically about punishment. While he draws on ideas in classical philosophy, particularly those of Plato, Clement adopts only those that he thinks are compatible with divine revelation. And believing, as he did, that many of the ideas of Hellenic philosophy were plagiarized from Hebrew Scripture (see *Stromateis*, bk. 5, ch. 14), he has little scruple employing them for his own purposes. We might say that he used Greek philosophy to disarm philosophers who sought to discredit Christianity.

The principal questions he asks concern the reason and purposes of punishment. Punishment serves two main purposes, the correction of the one punished and the general protection of society. The former is more important to Clement: "The greatest, most fulfilling blessing of all is to be able to turn a person from wrongdoing to virtue and good deeds. The Law does this."[27] "Punishment inflicted for the greater good and for the advantage of the one punished is a corrective"; for "many passions are healed by punishment."[28] It is not surprising in this context that Clement employs Seneca's analogy between punishment and medicine, between the role of the physician and the role of penal laws.

Chastisements, according to Clement, are like "surgery performed on the passions of the soul; the passions are like a disease of truth, which need to be removed by the surgeon's knife."[29] He develops his medical imagery in the *Stromateis*. As physicians administer unpleasant treatments like lacerations and bitter draughts to drive away bodily disease, so the law prescribes penalties to free the soul from wickedness. When a doctor amputates a limb, he "is following the rationale of his profession," avoiding the infection of healthy members because of the presence of diseased ones. The stakes are higher with disease that infects the soul: "shall we not [then] submit to exile, the payment of fines, or prison, if only there is a chance of replacing unrighteousness with righteousness?"[30]

Although punishment's highest aim is to reform its beneficiary, it must look also to the well-being of the larger community. For Clement, "when [the law] sees a person in a seemingly incurable state, plunged up to his neck in crime, then in concern that the others may be infected by him, as if it were amputating a limb of the body, it executes him for the greatest health of all."[31] Such punishment serves also to check the wayward tendencies of others: "It is a great education when a malefactor sees a criminal punished, . . . the fear of the Lord breeds wisdom."[32] Clement goes so far as to claim that the death penalty is a good for its beneficiary: "when a person is taken prisoner by criminal greed for gain and falls into irreparable vice, one who kills him would be doing him a benefit."[33] Thus, laws that inflict death act as a "benefactor."[34]

Curiously, Clement mentions nothing (explicitly) about punishment's retributive aim. The purposes he mentions are all forward-looking. Should we conclude from this that he rejects the notion that persons are punished, not just for improvement or to protect society, but because *they did something wrong?* Not necessarily. Looking more closely, we see that his account implicitly acknowledges the centrality of retribution. In the *Paidagogos* he says that the "punishment that God imposes is due not to anger, but to justice."[35] Justice entails punishing those who deliberately choose evil and assigning punishments in due measure to the deserving. "It is each one of us who makes the choice to be punished, for it is we who deliberately sin."[36] And God, he continues, quoting Deuteronomy, "will render vengeance to [his] enemies, and . . . vengeance to them that hate [him]."[37] The concepts of justice, desert, and requital are all retributive terms. Granted, Clement uses them here in reference to divine punishments. But for Clement the aims of human punishment parallel the aims of divine punishment, and he consistently correlates the two throughout the *Paidagogos*. Moreover, he says in the *Stromateis* that we are punished "not that the sins which are done may be undone, but because they were done."[38]

Origen (d. ca. 254), too, asks questions about the nature and purposes of punishment, echoing several ideas of Clement, his teacher and predecessor at the Alexandrian School. In his twelfth homily on Jeremiah he likens a wise judge to a doctor who hastens to amputate a festering limb before it spreads disease to the whole body; by refusing to spare one member, he spares many others. But consider the doctor, says Origen, who, fearing to make his patient suffer, delays a necessary amputation; his misplaced pity will surely bring greater harm to the body. A judge, therefore, must always be mindful of the welfare of the community when faced with the decision to spare a criminal. Origen gives an example of a judge charged with the case of a condemned young murderer; the judge is approached on the one side by the man's mother who intercedes that he pity her old age and spare her only son, and on the other by the condemned man's wife and soon to be orphaned children, who tearfully implore him to have pity. What should the judge do? Origen is clear: if he spares the man he disregards the good of the city and sends a murderer back to his evil. But if, with rational deliberation and without excess of either mercy or cruelty, the far-sighted judge considers the harm the man has done, there is no doubt he will eject him from the community of the living: if the judge "remains firm in judicial severity, one man will die, and provision will be made for the whole people."[39] Origen, like Clement, sees two goods to be gained for the community in following this course of action; on the one hand it frees the community from a harmful influence, and on the other it deters fellow members from similar evildoing.

Origen, who is unique among the early Fathers for his systematic use of Scripture in his theology, develops a fascinating notion of capital punishment as expiatory. In his eleventh homily on Leviticus he says that one who suffers death for a crime, presuming no other sin condemns him, will receive no further punishment for that crime after death: "the Lord will not punish twice for the same crime; [malefactors in this way] have received back for their sin, and the punishment for their crime has been purged."[40] In his fourteenth homily he says that death imposed as a punishment "is a purgation of the sin itself for which it is ordered to be imposed. Therefore, the sin is absolved through the death penalty" and nothing of it survives to testify against a man on his day of judgment.[41] The capital commands of the Old Testament therefore are not cruel, as heretics complain, "but full of mercy" (*plenum misericordiae*), since those who suffer under them are more purged from sin than they are condemned.[42]

It would be a mistake to interpret Origen's reflections on Leviticus and Jeremiah as having relevance only to the civil powers of the ancient Jewish state.

For Origen the same power inheres in the Roman emperor and lower magistrates. In *Contra Celsum* he holds that St. Paul's teaching in Romans 13 implies that civil authority has legitimate power over life and death:

> We are not *mad*, nor do we *deliberately rush forward to arouse the wrath of an emperor or governor which brings upon us blows and tortures and even death.* For we have read the precept: "Let every soul be subject to the higher powers; for there is no power except by God's permission; the powers that be are ordained of God; so that those who resist the power resist the ordinance of God."[43]

Whether Origen believed that the power was passed from the Jews to secular authorities with the advent of Christ, or always inhered in the latter, is not clear. What is clear is his belief that with the passing of John the Baptist and the coming of Christ, the power receded from the Jews and was left in the hands of civil authority. In his commentary on Matthew he writes:

> It seems to me that, just as the law and the prophets remained secure down to John the Baptist, after whom the prophetic grace receded from the Jews, so too the ruler's power to kill those judged worthy of death prevailed down to John; with the last of the prophets killed by Herod, and impermissibly at that, the king of the Jews was deprived of the power to kill. For unless the power had fallen from Herod, Pilate would not have condemned Jesus to death, but Herod, with the advice of the priests and elders of the people, would have been sufficient to do it.[44]

Origen also states in his commentary on Romans that the Old Law was rendered a dead letter when the Son of God took flesh. "The earthly Jerusalem has been overturned, together with the temple and altar and everything which went on there. . . . It was not possible to punish a murderer, nor to stone an adulteress, since the power of the Romans reserved these things for themselves."[45]

Although the power to punish receded from the Jewish community, it did not pass, Origen makes clear, to the ecclesiastical authorities of the Church. In his eleventh homily on Leviticus he writes:

> Among Christians, however, if adultery is committed, there is no precept that the adulterer or adulteress be punished with bodily death; nor has the

power to condemn an adulterer to physical death been given to a bishop of the church as was done, according to the prescriptions of the Old Law, by a priest of the people.[46]

Despite his outspoken defense of capital punishment justly inflicted by civil authority, Origen, like his predecessors, thinks differently when it comes to Christian participation. In fact, in Origen's case the "bifurcated teaching" of the pre-Constantinian Church could not be more pronounced. In book 7 of *Contra Celsum*, Origen asks whether the manner of life of the Jews under the Mosaic law was compatible with the manner of life enjoined by the Gospel of Christ. His answer is that Jewish life could not remain as it was without modification because, among other things, "It was impossible for Christians to follow the Mosaic law in killing their enemies or those who acted illegally and were judged to be deserving of death by fire or by stoning."[47] The basis for this bifurcation in Origen's mind is found toward the end of the work. Celsus has argued that loyal citizens, hearkening to the king's command, should take up arms in defense of the state. Origen's response refers explicitly to warfare, but its logic can be extended to the death penalty:

> We would also say this to those who are alien to our faith and ask us to fight for the community and to kill men: that it is also your opinion that the priests of certain images and wardens of the temples of the gods, as you think them to be, should keep their right hand undefiled for the sake of the sacrifices, that they may offer the customary sacrifices to those who you say are gods with hands unstained by blood and pure from murders. And in fact when war comes you do not enlist the priests. If, then, this is reasonable, how much more reasonable is it that, while others fight, Christians also should be fighting as priests and worshippers of God, keeping their right hands pure and by their prayers to God striving for those who fight in a righteous cause and for the emperor who reigns righteously, in order that everything which is opposed and hostile to those who act rightly may be destroyed?[48]

We see here two standards, one for Christians who ought to be treated as priests making intercession on behalf of the community, the other for righteous pagans, including the king. Christians may not stain their hands with blood lest their sacrifices of prayer (on behalf of the "righteous" bloody exploits of the king!)

be unacceptable to God; but non-Christians, presuming their cause is righteous, are not forbidden from shedding blood.

Cyprian of Carthage (d. ca. 258) likewise expresses the early Patristic bifurcation. In a letter to the exiled bishop of Rome, Cyprian writes:

> [Christians] do not even fight against those who are attacking since it is not granted to the innocent to kill even the aggressor, but promptly to deliver up their souls and blood that, since so much malice and cruelty are rampant in the world, they may more quickly withdraw from the malicious and the cruel.[49]

At the same time, Cyprian implies elsewhere that he accepts the legitimacy of the death penalty. In a letter criticizing the unjust killing of Christians, Cyprian writes, "to be a Christian either is a crime or it is not. If it is a crime, why do you not kill him who confesses it? If it is not a crime, why do you persecute the innocent."[50] He argues that if he had lied about his Christian faith under interrogation, he would warrant for himself the severest treatment: "If out of fear of your punishment I concealed [it] with lying deceit . . . then I ought to have been tortured."[51] In a letter expressing his disgust and general horror at all bloodshed, in particular the bloodshed of the Roman games, he implies that the games would be less reprehensible if men were fighting not for a kind of sanguinary glory, but because they had been condemned for crimes: "What is this, I ask you, of what nature is it, where those offer themselves to wild beasts, whom no one has condemned?" And again: "They fight with beasts *not because they are convicts* but because they are mad."[52]

Lactantius (d. ca. 320), writing at the dawn of the Constantinian age, is perhaps the last Church Father to exhibit the bifurcation we have been examining. Writing on the familiar topic of the bloody games in the arena in his great treatise on the Christian faith, the *Divine Institutes*, Lactantius argues:

> when God forbids us to kill, he not only prohibits us from open violence, which is not even allowed by the public laws, but he warns us against the commission of those things which are esteemed lawful among men. Thus it will be neither lawful for a just man to engage in warfare . . . nor to accuse any one of a capital crime, because it makes no difference whether you put a man to death by word, or rather by the sword, since it is killing itself which is prohibited. Therefore, with regard to this precept of God, there

ought to be no exception at all; but that it is always wrong to kill a man whom God willed to be an inviolable animal [*sacrosanctum animal*].[53]

We might conclude from this passage that Lactantius rejects every form of homicide. But what he says elsewhere militates against such a conclusion. In the paragraph preceding this passage, Lactantius refers to the victims of public executions as having been "justly condemned." In his *Treatise on the Anger of God* he considers the argument that if God "ought to be called injurious [because he] visits the injurious with punishment," it follows that human laws "which enact punishment for offenders" should likewise be called injurious, as should human judges who "inflict capital punishments on those convicted of crime." Lactantius rejects these conclusions: "But if the law is just which awards to the transgressor his due, and if the judge is called upright and good when he punishes crimes . . . it follows that God, when he opposes the evil, is not injurious."[54] The exceptionless prohibition against killing that Lactantius defends in the *Divine Institutes* clearly applies only to the members of the Christian community.

Post-Constantinian Writings

If we grant two Patristic assumptions, namely, that political power is divinely instituted and that inherent in that power is the right to kill malefactors, then the idea that the exercise of political power is incompatible with membership in God's special community, the Church, suffers from an obvious tension. It is therefore not surprising, given the unique state of affairs brought about by the conversion of Constantine, that a development took place in the traditional teaching. Both the need (or perceived need) for Christians to accept a share in the duties and prerogatives of political power, and the baptismal candidacy of those who already had a share, forced a reappraisal of the question of the relationship of Christians to the exercise of earthly authority. History shows the results of that reappraisal: Constantine, the first Christian ruler, rather than being an anomaly in an otherwise unbroken tradition, becomes the harbinger of a new tradition. And as we might suspect, with the new tradition comes a new set of convictions and practices surrounding the sensitive topic of lawful killing, the most noteworthy being that clerics begin to express the self-conscious conviction that it is their business *qua* clerics to exhort the faithful in positions of political authority to follow the example of the Gospels and desist from harsh punishments, particularly from capital punishments. In this conviction we find

an antecedent to the later position of the medieval Church, which will formally and juridically teach that clerics may have no part in the judging and carrying out of capital punishments.

John Chrysostom (d. 407), archbishop of Constantinople from 398, offers a unique illustration of this development. Early in his priestly ministry an event in Antioch forced Chrysostom to confront in a practical way the problem of the death penalty. Certain inhabitants of the city, stirred to anger by the levy of a new imperial tax, toppled and dragged through the city the imperial monuments of Emperor Theodosius (r. 379–392), his wife Flacilla, his father, and his two sons. The seditious act was put down by archers, and an imperial investigation into the event was launched from Constantinople. When passions cooled, the citizens of Antioch, reflecting on the treasonous act, grew fearful of a harsh requital. With the circulation of a rumor that the Emperor planned to raze the city to the ground and put all its citizens to the sword, the terrified citizens of Antioch turned to the newly ordained priest Chrysostom for guidance and comfort.[55] In Lent of that year (AD 387), Chrysostom delivered a lengthy series of homilies, which come down to us as the *Sermons on the Monuments*.[56]

In homily 6, Chrysostom, discussing the "fear" Christians should have of civil leaders, warns his listeners that if one were "to deprive the world of magistrates, and of the fear that comes of them, houses at once, and cities, and nations, would fall on one another in unrestrained confusion, there being no one to repress, or repel, or persuade them to be peaceful, by the fear of punishment!"[57] This sentiment runs throughout the homilies. The wrath of the emperor toward the city is deserved, and the faithful ought to rue the immoderate actions of their fellows, whom Chrysostom refers to as "vile, yea, thoroughly vile persons."[58] Nowhere does he question the legitimacy of the emperor to punish the city.

Chrysostom recalls the forbearance of the emperor, who, in the past, out of respect for the season of Lent, had released a number of men sentenced to be executed. Praising the emperor's benevolence, Chrysostom nevertheless adds that the executions would have been a "justifiable slaughter."[59] In homily 13, recalling the words of an envoy sent to plead the city's case before the emperor, Chrysostom states: "although you [the emperor] were to overthrow; although you were to burn; although you were to put to death; or whatever else you might do, you would never yet have taken on us the revenge we deserve."[60] Notwithstanding the rhetorical context, these are hardly the words of one who rejects the imperial prerogative of employing not only punishment but capital punishment.

At the same time, Chrysostom makes every effort to see that the innocent and guilty alike are relieved from the sanguinary threat of punishment. The

priesthood, he maintains, is like civil authority; although employing different means, it too is divinely sanctioned for the well-being of society. God provides for the safety of the community in two ways, through the fear of rulers and the consolation of priests. While rulers rightfully

> make you afraid, and render you anxious, the Church, which is the common mother of us all . . . administers daily consolation. . . . He Himself [God] hath armed magistrates with power; that they may strike terror into the licentious; and hath ordained His priests that they may administer consolation to those that are in sorrow.[61]

A striking illustration of Chrysostom's ideas in action is found in homily 17, where he gives a moving account of the role that certain monks played in turning the emperor's wrath to mercy. Having heard of the impending calamity, they descended from their mountain dwellings, entered the city, and interposed themselves between the people and the emperor's magistrates. Without minimizing the gravity of the crimes—"We [monks] confess that the crimes committed are very heinous"[62]—they urge clemency on behalf of the Antiochenes: "We will not give you leave, nor permit you to stain the sword, or take off a head. But if ye do not desist, we also are quite resolved to die with them."[63] To kill the condemned would be to "put to death the image of God," which, unlike toppling the imperial statues, is irrevocable; "how will ye be again able to revoke the deed! or how to reanimate those who are deprived of life, and to restore their souls to their bodies?"[64] Yet in all this the monks neither condemn the threatened penalty nor question the emperor's right to command what they are willing to die to prevent.

The position expressed in Chrysostom was already being taken for granted a half century earlier by Eusebius (d. ca. 340), bishop of Caesarea. Praising the first Christian emperor for his paternal mildness in the exercise of justice, Eusebius writes: "throughout the reign of Constantine the sword of justice hung idle everywhere, and both people and municipal magistrates in every province were governed rather by paternal authority than by any constraining."[65] Yet he does not refrain from praising the Emperor for his swift execution in the cause of justice. Reporting on the execution of Constantine's imperial rival, Licinius, Eusebius writes: "Accordingly the tyrant himself, and they whose counsels had supported him in his impiety, were together subjected to the just punishment of death."[66]

We find something similar in Gregory of Nazianzus (d. 389). Urging an angry Christian magistrate to exercise moderation in punishment, Gregory

notes that it is "with Christ that you bear your authority and with Christ you administer your office of governance. From him you have received the sword, not so much that you may use it, as that you may threaten and deter."[67] Like Chrysostom's monks, Gregory exhorts the magistrate: "You are the image of God and you command God's truth also to those who are made in God's image. . . . Let the fact of our common nature persuade you [to mildness]; let your own likeness move you; yoke yourself to God, not to the prince of the world; to the kindly Lord, not to the harsh tyrant."[68] "The Romans have their laws," he says elsewhere, "we have ours. But their laws exceed measure and are harsh, and go as far as capital punishments; our laws in turn are benign and human and do not make use of power in madness against those from whom we receive injury."[69]

Despite his obvious dislike for capital punishment, however, Gregory takes its legitimacy for granted. In a letter to the citizens of Nazianzus he writes: "let us not act in such a way that on account of our crimes we become objects of the law's hatred and be *due* for the avenging sword."[70]

The position of the great fourth-century bishop of Milan, Ambrose (d. 397), is epitomized in his letter to Studius, a Christian judge who had sought advice on how he ought to approach the death penalty.[71] If it were not for the words of the Apostle (Romans 13:4), Ambrose writes, he would fear to venture a response. We praise magistrates who, having exercised capital punishments, abstain from the sacraments of the Church, but in light of the authority of the Apostle, "we dare not deny them communion."[72] Ambrose continues:

> Authority, you see, has its rights; but compassion has its policy. You will be excused if you do it; but you will be admired if you refrain when you might have done it. And, as a priest, I have no more enthusiasm for leaving people to rot in noisome dungeons without trial, only to set them free later. It might transpire, after all, that once the case had been tried, the convicted person could sue successfully for pardon or, at any rate, better conditions in which to "live out his days in jail" (a quotation, I can't think from whom). Yet I know that pagan governors have sometimes made a boast of returning from their tour of duty without a drop of blood on their blade. If pagans can do as much, what should Christians be doing?[73]

Ambrose obviously believes that not only Christians share a distaste for bloody punishment; otherwise, why would he have commended the example of the pagans? Nevertheless, Christ's example is the real basis for his position. He

recalls Christ's response to the woman caught in adultery.[74] Christ's example, Ambrose argues, is a fitting one for Christian magistrates to follow. So long as clemency supplants severity, opportunity exists for the guilty to do penance and receive the remission of sins.[75] Reflecting on the logic of Cain's sentence in *On Cain and Abel*, Ambrose writes: "The person, therefore, who has not spared the life of a sinner has begrudged him the opportunity for the remission of his sins and at the same time deprived him of all hopes of remission."[76] Further, "God in His providence gives this sort of verdict so that magistrates might learn the virtues of magnanimity and patience, that they may not be unduly hasty in their eagerness to punish or, because of immature deliberation, condemn a man in his innocence."[77] Moreover, "God, who preferred the correction rather than the death of a sinner, did not desire that a homicide be punished by the exaction of another act of homicide."[78] It follows for Ambrose that Christians, who should refuse to despair of the salvation of anyone, should *never* deprive another of the opportunity of repentance, which is precisely what capital punishment does.

> From the point of view of our faith, no one ought to slay a person who in the course of nature still would have time for repentance up to the very moment of his death. A guilty man—provided a premature punishment had not deprived him of life—could well procure forgiveness by redeeming himself by an act of repentance, however belated.[79]

But what if the defense of society requires a criminal on account of some sin to die? Then, says Ambrose, "See to it that Christ is infused into the act of slaying an impious man and that sanctification accompany and be part of your attempt to abolish what is abominable."[80]

For Ambrose, like Chrysostom, the roles of priest and magistrate are complementary. In *Cain and Abel* Ambrose writes: "Sins are forgiven by the priest in his sacred office and ministry. They are punished, too, by men who exercise power temporarily, that is to say, by judges."[81] Regarding capital punishment, the roles exist in tension. As Ambrose's letter to Studius illustrates, the ministry of priesthood entails not merely forgiving sins, but also pressing for clemency for the condemned. Priests ought to have nothing to do with capital punishment. Why not then reject the death penalty altogether? For Ambrose the answer is plain: deny its legitimacy and you deny a teaching of Scripture. Hence, like other fourth-century Fathers, we find built into his account a tension between the urgings of Christian mercy and the prerogatives of legitimate authority.

A decree issued by the Council of Rome (382) during the pontificate of Damasus I illustrates this tension. Canon 13 of the decree states:

> Moreover, it is obvious that those who have obtained secular power and administered secular law cannot be free from sin. For while the sword is un-sheathed either unjust judgment is conferred, or tortures administered in the prosecution of cases, or they plan for executions to be titillating, or de-rive titillation from them when they are planned; such men, associating anew in these things themselves which they have renounced, change the practical teaching which has been handed down.[82]

The Latin is obscure.[83] It is unclear to what extent the canon should be under-stood as asserting that those who exercise capital punishment, as distinct from other punishments, "cannot be free from sin." What is the "practical teaching" such men change? This is also unclear. What is clear, however, is that the canon reflects the concern of the early Church in relation to the duties and office of the public magistrate.

We hear in canon 13 the echo of a tradition that is already being replaced. By the time Pope Innocent I (r. 401–417) addresses a letter to the bishop of Toulouse, twenty-three years later (405), the echo is more faint. Responding to a query about civil officers who carry out judicial tortures or capital punish-ment after their baptism as Christians, the pope states:

> About these things we read nothing definitive from the forefathers. For they had remembered that these powers had been granted by God and that for the sake of punishing harm-doers the sword had been allowed; in this way a minister of God, an avenger, has been given. How therefore would they criticize something which they see to have been granted through the authority of God? About these matters therefore, we hold to what has been observed hitherto, lest we may seem either to overturn sound order or to go against the authority of the Lord.[84]

Saint Augustine (354–430) picks up where canon 13 leaves off. In many ways his immensely influential ideas epitomize the fourth-century views we have been considering. For nearly four decades—virtually the entire period of his tumultuous engagement with the Donatists—he defends the view of his fa-ther in faith, Ambrose, that public authority possesses the right to kill malefac-tors, but that Christian faith, never losing hope for the repentance of a sinner, urges otherwise.[85]

In an early dialogue, *De Libero Arbitrio*, begun within a year of his conversion, Augustine puts the following words into the mouth of his interlocutor, Evodius: "If murder means taking the life of a man, this can sometimes happen without any sin. When a soldier slays the enemy, when a judge, or his deputy, executes a criminal . . . I do not think that these are guilty of sin in killing a man." Augustine responds, "I agree, but such men are not usually called murderers."[86] In his *Commentary on the Sermon on the Mount*, written five years later (around the time he begins active engagement with the Donatists), he reaffirms this view. Conscious of the Marcionite and Manichaean rejection of the Old Testament accounts of corporal punishment, especially capital punishment, Augustine argues that "noble and saintly men [*viri sancti*] inflicted death as a punishment for many sins . . . so that the living would be struck with salutary fear."[87] He is referring, of course, to the men of the Old Testament. These men exercised capital punishment not only as an example to others, but also as a benefit to those who are killed, whose sufferings, because of sin, "might have become worse if they had continued to live." Augustine says very clearly that the authority by which these men exercised the death penalty was God-given and "not exercised rashly."[88] If there were any doubt as to whether the same authority has endured into the Christian dispensation, Augustine dispels it by recalling the story of Ananias and Sapphira (Acts 5:1–11),[89] who collapse and die when Peter charges them with lying to God. "Accordingly," Augustine writes, "such [capital] punishments were not entirely lacking even after He [Christ] had taught them [the disciples] the meaning of loving one's neighbor as one's self. . . . However, such punishments were then much less frequent than in the Old Testament."[90]

Augustine's confidence in the duties and prerogatives of civil authority, like the confidence of so many of the Fathers, is rooted in his interpretation of Romans 13. Writing to the schismatic Emeritus, who claimed that Christians should treat no one, not even the wicked, with severity, Augustine responds: "Very well, suppose it is not allowed; does that make it right to oppose the powers which are set up for that purpose? Or shall we erase the Apostle? Do your books contain what I quoted a while ago [Rom. 13:2–4]?"[91] Augustine says (or at least implies) repeatedly that the institution of earthly authority includes the power over life and death:

> Surely, it is not without purpose that we have the institution of the power of kings, the death penalty of the judge, the barbed hooks of the executioner, the weapons of the soldier, the right of punishment of the overlord,

even the severity of the good father. All those things have their methods, their causes, their reasons, their practical benefits.[92]

On the topic of self-defense, Augustine writes:

> In regard to killing men so as not to be killed by them, this view does not please me, unless perhaps it should be a soldier or a public official. In this case, he does not do it for his own sake, but for others or for the state to which he belongs, having received the power lawfully in accord with his public character.[93]

Again, speaking of Moses' slaying of the Egyptian in his *Reply to Faustus the Manichaean*, Augustine says: "In the light, then, of the eternal law, it was wrong for one who had no legal authority to kill the man, even though he was a bad character, besides being the aggressor."[94] The Lord's rebuke to Peter to put away his sword (Matthew 26), Augustine adds, was because Peter did not hold properly constituted authority: "To take the sword is to use weapons against a man's life, without the sanction of the constituted authority."[95] Augustine held this conception of civil authority to the end of his life. In his greatest and most mature work, *De Civitate Dei*, finished four years before his death, he writes:

> The same divine law which forbids the killing of a human being allows certain exceptions, as when God authorizes killing by a general law. . . . Since the agent of authority is but a sword in the hand, and is not responsible for the killing, it is in no way contrary to the commandment, "Thou shalt not kill," to wage war at God's bidding, or for the representatives of the State's authority to put criminals to death, according to law or the rule of rational justice.[96]

Given Augustine's theology, rejecting the death penalty would have been tantamount to rejecting the words of the Apostle, as well as making an important concession to Marcionism or Manichaeism. But there is no question that Augustine hated capital punishment and, given the chance, would have ended it completely, at least in North Africa. Like Ambrose and Chrysostom, he believed that his vocation as a priest and bishop was to prepare the way for men and women to come to Christ—in the words of the pagan Nectarius, "to secure salvation for men, to be their advocate on the better side in their trials, and to

merit from Almighty God pardon for the sins of others."[97] It was "part of [his] priestly duty to intercede for condemned persons" because, he says, we priests "are forced by our love for humankind to intercede for the guilty lest they end this life by punishment, only to find that punishment does not end with this life."[98] He illustrates these sentiments in a series of letters to Christian magistrates (dating from approximately the turn of the fifth century to AD 415), in which he argues in the strongest possible language for clemency on behalf of capital offenders. In *Letter 86* (AD 405), referring to "the bold presumption of the heretics," he says: "And by the help of the Lord our God you will undoubtedly take measures to cure the swelling of this accursed pride, by the repression of fear, so as not to have to cut it out by measures of vengeance."[99] In *Letter 100* (AD 409), written at the height of the Donatist controversy to a proconsul of Africa, Augustine says that he fears the magistrate will punish the outrages of the heretics "with more regard for the gravity of their crimes than for the exercise of Christian clemency."[100] "[W]e wish them to be restrained, but not put to death"; "we do want public authority to act against them, but not to make use of the extreme punishment which they deserve."[101] "Act against their offenses so that some of them may repent of having sinned."[102] In *Letter 104* (AD 409) he maintains that Christians punish "out of kindness and to their [the criminal's] own benefit and improvement."[103] Challenged to moderate his own wrath lest in judging he be found to condemn the innocent, Augustine responds: "Have no fear, then, that we are plotting destruction for the innocent; we do not even wish the guilty to suffer a fitting punishment, restrained as we are by that mercy which, together with truth, we love in the Lord."[104] And in *Letter 139* (AD 412) he entreats that certain malefactors be punished with "something short of death"; this, he argues, would serve as "an example of Catholic moderation."[105]

Augustine could be persuaded that the coercion of heretics to right belief was an appropriate use of secular power.[106] Yet the more he is willing to concede and even promote its use, the more he inveighs against the death penalty. Although coercion might be effective for returning the erring to the faith, killing heretics is shedding men's blood in defense of the Church, something which must never be done.[107] Two consecutive letters to Christian magistrates, *Letter 133* and *Letter 134* (AD 412), concern an incident in which two priests suffered wrongly at the hands of angry Donatists (one priest was killed, the other maimed). In both letters Augustine mentions the deep anxiety he experiences lest the culprits, called to suffer "in proportion to their deeds," be sentenced to death.[108] In both he acknowledges the magistrate's authority to inflict punishment, in *Letter 134* implying that this includes the authority to inflict death;[109] in

both he rejects retaliation and revenge as a motive for punishment; and in both, appealing to the faith of the Christian judges, he urges that the punishment be carried out in such a way as to hold out for the offenders hope of repentance. In *Letter 134* he writes: "If I were making my plea to a non-Christian judge, I should deal differently with him," although, he says, he would still present the case for Christian mercy. "But now, since the matter is being brought before you, I follow another method, another argument. We see in you a governor of exalted power, but we also recognize you as a son with a Christian idea of duty."[110] If there is any possibility of emendation for evildoers, Augustine entreats, may "you spare them, now that you have arrested, summoned, and convicted them. . . . [May] you lengthen the span of years for the living enemies of the Church that they may repent."[111] What if such men are found to be incorrigible? Augustine replies,

> extreme necessity might require that such men be put to death, although, as far as we are concerned, if no lesser punishment were possible for them, we should prefer to let them go free, rather than avenge the martyrdom of our brothers by shedding their blood. But, now that there is another possible punishment by which the mildness of the Church can be made evident, and the violent excess of savage men be restrained, why do you not commute your sentence to a more prudent and more lenient one, as judges have the liberty of doing even in non-ecclesiastical cases?[112]

Augustine is not above using threats in order to limit the infliction of the death penalty. A fascinating example is a letter from Augustine to the bishop of Thagaste in AD 422. A serious problem had broken out in North Africa from slave dealers, who were "draining Africa of much of its human population and transferring their 'merchandise' to the provinces across the sea."[113] Augustine urges the local bishop to eschew the unusually harsh capital laws inflicted for such crimes. If Christian moderation is not expressed by the local bishop, Augustine warns, he himself might cease helping to apprehend the pirates for fear that, if apprehended, they would be put to death. The result would be that more unfortunate victims are carried off into servitude. Augustine strongly recommends that the bishop work for the promulgation of new laws annexing financial rather than capital penalties to such crimes.[114]

Leo the Great, writing thirty years later, is more sanguine about harsh penal laws. Like ecclesiastical writers in the Middle Ages, he thinks the Church should have nothing directly to do with capital punishment. Nevertheless, the

harsh decrees of secular rulers can work in cooperation with the Church's pastoral ministry. For Leo,

> this severity was for a long time an assistance to the mildness of the Church which, though relying upon priestly judgment and shunning bloody punishments, nevertheless is assisted by the stern decrees of Christian rulers at times when men, who fear bodily punishment, will have recourse to merely spiritual correction.[115]

A much later passage from Gregory the Great (d. 604), in contrast, illustrates the characteristic mildness of Ambrose and Augustine. In a letter to the deacon Sabinianus, Gregory addresses the false charge that a certain bishop named Malchus had been "put to death in prison for money," with the implication that the pope himself abetted the cruel deed. Gregory responds,

> if I their servant had been willing to have anything to do with the death of Lombards, the nation of the Lombards at this day would have had neither king nor dukes nor counts, and would have been divided in the utmost confusion. But, since I fear God, I shrink from having anything to do with the death of any one.[116]

M. B. Crowe, in an influential article on the death penalty published in 1964, claims at the outset of his examination of the writings of the Fathers that "no consensus of the Fathers and ecclesiastical writers emerges."[117] How does Crowe's assertion correspond to our findings? Throughout the Patristic period, as we have seen, texts that question the prerogative of civil authority to exercise the death penalty are notably absent. In those accounts that address the question directly we find a virtually unanimous acceptance of such authority. Where reasons are elaborated, this acceptance is invariably grounded in an appeal to Scripture, in particular, Romans 13. Although opinions diverge between pre- and post-Constantinian authors over the question of admitting Christians to the office and prerogatives of civil magistrate, a consistent thread runs throughout: both before and after the Edict of Milan, Patristic writers perceived an incongruity between Christian discipleship and taking part in the execution of criminals. Admittedly, this common theme plays itself out differently in the two periods. But given the Patristic presuppositions concerning the nature of civil authority, together with the dramatic historical turn at the beginning of the fourth century, there is more agreement than disagreement between the two

positions. Given all this, there seems to be (*pace* Crowe) sufficient warrant for speaking of a Patristic consensus.

Francesco Compagnoni has held that the Church's acceptance of Christians into the office and prerogatives of the civil magistrate was little more than a capitulation to the structures of an increasingly Christianized Empire.[118] This seems to me simplistic. Although a charge of uncritical acceptance might be leveled against Eusebius, taken up as he is with the enthusiasm of the Constantinian moment, such a charge is hard to sustain against Church Fathers like Ambrose and Augustine. For them the issue hinged as much on conscientious theological reflection as it did on circumstances. The precepts of the Old Testament, together with the commonly accepted interpretation of Romans 13:1–4, provided a knockdown argument against rejecting the death penalty. The question of Innocent I, "How therefore would they criticize something which they see to be granted through the authority of God?" no doubt weighed heavily on the minds of the Church Fathers. Paul, they believed, had taught that the authority to punish (or at least to threaten) with death was necessary for the preservation of the social order. The empire was gradually becoming Christian, yet evildoing, whether by violent heretics or barbarian marauders, was obviously not abating. Paul's teaching must have seemed as relevant as ever. They had both theological and practical reasons not to abandon their interpretation of Romans 13. It is not surprising that when circumstances after AD 313 made it virtually impossible for Christians to avoid involvement in civil administration, the Church acquiesced to the idea that Christians could legitimately share in duties once reserved to pagans. At the same time, the faith that Christian magistrates confessed made forceful claims, as Augustine makes clear, on the practical carrying out of those duties.

CHAPTER 5

∎

The Medieval Testimony

∎

Medieval Catholic views on the morality of capital punishment share much in common with those of the later Patristic period. However, there are significant differences. The Fathers after AD 313 were conspicuous for their energetic intercessions for clemency on behalf of the condemned; in the Middle Ages interventions of this sort are uncommon. The hesitation about capital punishment which so characterized the teachings of the Fathers is replaced in the Middle Ages by an interest in spelling out the parameters for its lawful infliction. As for the bifurcation we saw in the early Patristic teaching, we find it again in the medieval period, with a new set of characters. Once, all Christians were forbidden from accepting duties and offices that involved the shedding of human blood; now, only the clergy are forbidden. Once, non-Christians took responsibility for the judging, sentencing, and inflicting of capital punishment and did so without opposition from the Church; now, Christian laymen judge, sentence, and inflict capital punishment—without opposition from the Church.

The Clergy Prohibition

An early formulation of the clergy prohibition is found in the writings of the seventh-century Council of Toledo. According to the council, "Because priests are chosen by Christ for a life-giving ministry, they may if requested by temporal rulers consent to become judges provided a remission from the oath of punishment—i.e., from the need to prepare for capital punishments [*discriminis sentencia*]—is promised them."[1] Another council of Toledo, forty-two years later, states the prohibition more forcefully:

It is not licit for those by whom the sacraments of the Lord are to be performed to carry out a judgment of blood. Therefore such excesses are to be greatly prohibited, lest after being agitated by the impulses of irrational presumption, they either presume to judge by their own sentence that something is punishable, or they carry out themselves, or order the carrying out of mutilations on anyone. But if anyone, unmindful of these precepts, has done anything of the sort to members of his church or to any other persons, he is to be deprived of the honor and place of his granted order.[2]

In the tenth century, Atto, canonist and bishop of Vercelli, formulates the prohibition as follows:

For since it was forbidden to David to build the visible temple because he had frequently shed blood in war, how may clerics engage in war or battle—even on behalf of their own justice—who ought to concern themselves with building up the Lord's temple, i.e., with teaching the Church of God?[3]

And in the middle of the twelfth century, Pope Alexander III states:

According to the Council of Toledo it is not licit for clerics in sacred orders to have anything to do with a judgment of blood. We therefore forbid them either to perform mutilations themselves or to command them to be carried out. But if anyone has done such a thing let him be deprived of honor and place. We also order under threat of excommunication, that no priest should have the office of viscount or of secular ruler.[4]

Perhaps the strongest statement of the medieval Church on the subject is made by the Fourth Lateran Council (1215) in constitution 18:

No cleric may decree or pronounce a sentence involving the shedding of blood, or carry out a punishment involving the same, or be present when such punishment is carried out. . . . A cleric may not write or dictate letters which require punishments involving the shedding of blood; in the courts of princes this responsibility would be entrusted to laymen and not to clerics.[5]

The clergy prohibition, variously formulated, endured through the High Middle Ages.

Changing Attitudes

There are a few early exceptions to the developing consensus on capital punishment, and these deserve mention here. The teachings of two ninth-century clerics still express the Patristic opposition to Christian participation in bloodshed. An Eastern monk, Theodore the Studite (d. 826), in a letter responding to the charge that the Church is indifferent to the killing of Manicheans, forcefully asserts that the Church is *opposed* to the killing of heretics. "The church [in which he includes Christian magistrates] does not punish with the sword."[6] Spiritual crimes such as heresy should be punished with spiritual penalties, such as excommunication, not with corporal penalties. Theodore so vehemently opposed the bloody practice that when the emperor sought his approval for the killing of certain Manicheans, the Byzantine monk retorted, "I would give my head before I would consent to such things."[7] And in a ninth-century letter, Pope Nicholas I says simply: "The holy church of God is not constrained by the laws of the citizens of the world; She has only a spiritual sword; She kills not, but rather gives life."[8] However, neither Theodore nor Pope Nicholas's teachings find a counterpart in the later orthodoxy of the medieval Church. Their views are explicitly contradicted by what will become, in the High Middle Ages, the Western orthodox doctrine of political authority.[9]

What accounts for the change in attitude and practice with respect to capital punishment that takes place between the Patristic and medieval periods? The reasons do *not* include any decrease of interest in, or commitment to, matters of political morality in the latter period. This is evident from the abundance of tracts from the seventh century on, addressed to kings (princes, rulers) on how to conduct their personal lives and royal duties.[10] The reasons have rather to do with the political landscape in Christian Europe. By the time Charlemagne was crowned first emperor of the Holy Roman Empire, four hundred years of barbarian invasions had resulted in a grossly fractured political landscape. Charlemagne's attempt in the early ninth century to restore institutions of civilized government in the empire was successful but fleeting, dependent as it was on his own political adeptness. Philip Hughes comments: "The empire [at this time] was a mosaic of a thousand motley pieces. One thing alone kept it together—the genius of the first emperor."[11] Within a few decades of Charlemagne's death, the fragile unity secured under his rule was lost.

The general political decline and decentralization of authority in Europe in the early Middle Ages was perpetuated by the rise of feudalism. Major landown-

ers gradually began exempting themselves from the authority of the royal officers, transferring the care and expense of government from the hands of the king or prince into their own, and effectively expropriating political power. The obedience of a majority of the king's subjects at length was no longer to the king directly but rather to a mix of great landowners—barons, bishops, abbots. Consequently, assuring the obedience of these powerful men became a high priority for kings and emperors. Hence we see the rise of the lay investiture controversy which so plagued the Church in the Middle Ages.

The urgent need to oppose the lawlessness of society as well as the arbitrary rule and baronial cronyism troubling the Church, both within and without, impelled scholars—ecclesiastical and secular—to turn their energies to the restoration of the rule of law as a well-defined and impartial norm for the ordinary exercise of civil authority. The principle that just government is secured by the force of unprejudiced law became a preoccupation of medieval scholars.

The rule of law is a dominant theme in the political writings of the twelfth-century philosopher and churchman John of Salisbury. In book 4 of his work *Policraticus*, John insists that the prince is the servant of law and equity. In matters pertaining to justice, "the interpreter *is law*, inasmuch as law makes known the will of equity and justice."[12] Since, therefore, the prince "is obedient to law, . . . [he] ought to imagine himself as permitted to do nothing which is inconsistent with the equity of justice."[13] Law, John writes, "is a sort of discovery and gift from God, the teaching of the wise, the corrective to excesses of wilfulness, the harmony of the city, and the banishment of all crime."[14] Not only the prince, therefore, but "all are, for this reason, obligated to be restrained by the necessity of observing the laws."[15] Since the prince's duty is to procure the utility of the republic and in all matters to prefer the advantage of others to his own private will, when the health of the republic requires it, law and equity demand that he impose the severest penalties. When he slays justly, he does so innocently; and "the sword with which blood is shed innocently is . . . not borne without cause, so that one may frequently kill and still not be a man of blood nor incur the accusation of murder or crime."[16] Such a sword, John says, is "the sword of the dove, which quarrels without bitterness, which slaughters without wrathfulness and which, when fighting, entertains no resentment whatsoever."[17] Those who fall under it are punished, "not according to some wrathful motive, but by the peaceful will of law."[18]

Conformity to law as a condition for the legitimate infliction of the death penalty is emphasized by writers throughout the Middle Ages. Hincmar of

Rheims, for example, in his ninth-century tract *On the Person of the King and the Royal Ministry*,[19] writes:

> To kill a man is not always criminal. But to kill not by the law but with malice is criminal because in such things, not the behavior—because sometimes it even is done rightly—but the mind, having passed its sentence in an evil way, is to be condemned.[20]

In *Policraticus* and again here, *law* is personified as impartial and equanimous in contrast to the biased passion that motivates unlawful punishment. Pope Innocent III in the early thirteenth century says something similar: "because the law, not the judge, puts to death," it is possible for secular authority to "carry out a judgment of blood without mortal sin . . . so long as the punishment is imposed, not in hatred, nor rashly, but with deliberation."[21] Along similar lines, the twelfth-century writings of the Bolognese monk Gratian state that it is "by the authority of the law itself" that the public powers legitimately kill offenders; anyone doing so by his own authority is a murderer.[22] Even if a judge's attendant kills someone whom the judge has ordered to be killed and whom he knows ought to be killed, but does so without a lawful command from a judge, he kills on his own initiative and hence is a murderer.[23]

The political reform that took place in the Carolingian period was essentially a conservative movement, an attempt to *return* to the rule of law. The first task, therefore, was to rediscover the meaning of law. In so doing scholars appealed *inter alia* to sources they considered most authoritative. For ecclesiastical writers this principally meant the decrees of Roman pontiffs, writings of Church Fathers, and the canons of earlier councils. Efforts were made to gather together into source books as many of these authoritative judgments (also called "decretals") as possible and on as many points of doctrine and discipline as possible. These early collections were the antecedents of the texts of canon law in the High Middle Ages. Far and away the most influential of these early collections was the *Decretum Gratiani*, or Decretals of Gratian. A brief examination of its treatment on capital punishment is in order.

The *Decretum Gratiani*

The second part of Gratian's *Decretum*[24] is divided into sections called *Causae*, which treat problems specific to the Christian faithful. *Causa XXIII* contains

eight questions related to the legitimate exercise of the state's coercive authority. *Questio V*, on killing in general, and *Questio VIII*, on clerics and the use of force, are most relevant to our discussion.

Gratian begins each question by raising counterarguments to the position he intends to defend. *Questio V* begins with an argument that the scriptural precept "Thou shalt not kill," *"non occides,"* and Christ's words to Peter, "He who lives by the sword will die by the sword," clearly teach that it is never lawful to kill another person.[25] In various ways, and by appeal to numerous sources, Gratian defends throughout forty-nine (short) chapters the traditional view that killing, although forbidden to private individuals, is permitted to public authority. He summarizes his views in chapter 48:

> If therefore holy men and public powers [who were] waging war were not transgressors of that mandate "Thou shalt not kill," although they killed some criminals who deserved to die; if a soldier obeying his superior is not accused of murder when at the superior's command he kills any criminal; if it is not the pouring out of blood to punish murderers and poisoners, but the ministry of the laws; if the peace of the Church is the consolation over the sadness of the lost; if those who, rising up in the zeal of their Catholic Mother [i.e., the Church], kill excommunicates are not judged murderers; it is evident that it is not only licit to scourge evil-doers but also to kill them.[26]

Gratian repeats the same principle constantly throughout *Questio V*.[27]

Gratian's teaching is both traditional and novel. Like the Fathers, he maintains that the death penalty is lawfully inflicted only by public authority, by which he means secular (in the sense of non-ecclesiastical) authority.[28] Also, like the Fathers, he grounds this view in the teaching of Scripture. "For all except him who possesses his authority by legitimate power, who, as the Apostle says, does not bear the sword without cause, . . . all, I repeat, who take up the sword without this authority will die by the sword."[29] He likewise repeats the traditional medieval teaching that clergy are forbidden from taking part in violence and bloodshed.[30]

Yet Gratian sees nothing inconsistent about teaching that ecclesiastical authorities lawfully summon the Christian faithful to take part in bloody exploits. Both royal and priestly authority, he argues, are called to defend what pertains to the Church's confession of faith.[31] It is therefore legitimate for the hierarchy to call on the secular powers to defend the Church with coercive means, and even to urge Christian laymen to take up arms on behalf of the Church. Pointing as a precedent to the actions of Gregory the Great, Gratian writes:

In the register one reads that St. Gregory ordered the citizens of Tuscany to arm themselves against the Lombards, and that he decreed stipends for the knights. From this example and the cited authorities it is therefore clear that priests, although they should not take up arms with their own hands, can either persuade those to whom such offices are committed or order anyone [other than the legitimate ruler] by their own authority to take them up.[32]

And again:

It is therefore licit for prelates of the church, following the example of St. Gregory, to summon the emperor or any leader to defend the faithful. It is also licit, as St. Leo shows, to manfully urge people to defend the church against enemies of the faith, and to summon them to keep the force of infidels at a distance.[33]

Gratian's teaching is repeated by the Third Lateran Council (AD 1179), which speaks of the assistance the Church receives from harsh penal laws:

Although the discipline of the Church [*ecclesiastica disciplina*] should be satisfied with the judgment of the priest and should not employ bloody punishments, yet it is helped by the laws of Catholic rulers so that people often seek a salutary remedy when they fear that corporal punishment is coming upon them.[34]

This view of the church-state relationship is arguably open to criticism. Yet it expresses something important about the Church's perennial conception of itself, namely, that as the body of Christ, the Church, personified in her ministers, is called to be holy and called to incarnate the mercy of Christ on earth; and that as His bride, the Church is called to be pure and undefiled. The shedding of human blood, be it in war or by capital punishment, may hold a necessary though regrettable place in the maintenance of the peace of the earthly city. But the Church's business is to build the heavenly city, and therefore such actions are unbecoming. The early Church envisaged this "consecration" as extending to all Christians, while the medieval Church extended it only to clerics. But throughout, the sense remains that Christian faith speaks a moderating word to those who would be involved in the violence of bloodshed.

Pope Innocent III and the Waldensian Oath

Pope Innocent III's famous statement in the Waldensian oath that it is possible for civil authority to administer the death penalty without mortal sin is unquestionably the most influential ecclesiastical statement on the morality of capital punishment in the Middle Ages (and arguably in Church history). Both the statement itself and the circumstances prompting its inclusion in the oath of reconciliation make a precise determination of its meaning problematic. Some historical background on the Waldensian movement is necessary before examining the statement itself.

An anonymous twelfth-century chronicle reports that in 1173 a wealthy and unscrupulous Lyonnais merchant named Waldes, prompted by the words of a minstrel, underwent a conversion not unlike that of Francis of Assisi. He sold his possessions and vowed to God "never to possess either gold or silver or to take thought for the morrow." After making restitution for his wrongs and setting up provision for his wife and two daughters, he went about serving the poor and preaching a message of evangelical poverty. Soon he gathered followers, and together they began publicly inveighing against their own sins and the sins of others. His group came to be called the Poor of Lyons, or Waldenses (Waldensians).[35]

The issue that led to the conflict and eventual break between the Waldenses and the Church had little to do with the question of the coercive prerogatives of public authority. It concerned rather the right of laymen to preach.[36] Canon law had restricted preaching to clerics, with limited exceptions. Waldes, moved by what he believed to be a divine call to preach the pure and undiluted gospel, commissioned a vernacular translation of Scripture, turned a deaf ear (at least at first) to criticisms made against him and his followers by Lyonnais clergymen, and with his disciples, most of whom were self-educated in the Bible, set about preaching to anyone who would listen.

Encountering ecclesiastical resistance at the local level, members of the sect sent to Rome to supplicate the pope. At the Third Lateran Council they made an urgent appeal to Pope Alexander III to grant them permission to preach.[37] The anonymous chronicle describes the outcome: "The pope embraced Waldes, approving his vow of voluntary poverty but forbidding preaching by either himself or his followers unless welcomed by the local priests."[38] Despite the papal warning, the Waldenses "remained obdurate and were finally judged to be schismatics."[39]

In December 1208 Pope Innocent III accepted from a small group of Waldenses, led by a former priest, Durand of Huesca (Osca), a profession of faith intended to facilitate their reconciliation with the Church. The profession was taken directly from an oath prepared in 1180 (or 1181) by Waldes himself, at a time when he had presented himself to certain members of the Lyonnais hierarchy to declare his orthodoxy.[40] Waldes' oath made no reference to the rights or responsibilities of secular authority, nor to any topics involving violence or bloodshed. It principally concerned aspects of Christology and Trinitarian theology as well as propositions repudiating the Cathar doctrine that sinful priests do not validly administer the sacraments. Similarly, the 1208 profession made no reference to the prerogatives of secular authority or to bloodshed.[41]

In July 1209, after receiving complaints that the recently reconciled group of Waldenses, now called Poor Catholics, were failing to make good on their promises, Innocent dispatched another letter to Durand, this time more severe. The first paragraph lists several new charges against Durand and his followers. The final charge reads: "And, above all, some of you assert that no secular authority can, without mortal sin, impose a judgment of blood."[42] The pope insisted that the recidivists recommit themselves to their prior promises and admonished them on several practical points of doctrine, including the following:

> Let none of you presume to assert the following: that the secular power cannot carry out a judgment of blood without mortal sin. This is an error because the law, not the judge, puts to death so long as the punishment is imposed, not in hatred, nor rashly, but with deliberation.[43]

In May 1210 a new profession of faith was composed using the printed text of the 1208 profession and new propositions drawn from Innocent's "severe" letter of 1209. Among the new propositions is a slightly revised version of the proposition just quoted:[44]

> We declare that the secular power can without mortal sin impose a judgment of blood provided the punishment is carried out not in hatred but with good judgment, not inconsiderately but after mature deliberation.[45]

This final form is what comes down to us as Innocent's authoritative teaching on the morality of capital punishment.

It is important to distinguish between Innocent's proposition and three similar propositions. His is of the form: (1) I declare that it is possible for A under conditions Y and Z to do X without mortal sin. This is different from: (2) I declare that for A to do X under conditions Y and Z is not a mortal sin; (3) I declare that for A to do X under conditions Y and Z is not sinful; and (4) I declare that to do X under conditions Y and Z is not (gravely) evil. At face value, Innocent's statement asserts only that it is *possible* for public authority to kill malefactors without mortal sin, provided the act proceeds not from hatred but from a mature and deliberate judgment. Whether he intended to assert more is open to conjecture. How are we to decide? It is revealing to take a deeper look at the Waldenses' belief and teaching that prompted Innocent to include this statement.

That the Waldenses maintained a doctrinal position of nonviolence from their beginnings is well established.[46] Their views about public authority and capital punishment are not as well documented. Four concise passages by thirteenth-century authors written after or contemporaneous with Innocent's 1209 letter may shed light on the matter. The first comes from a manuscript thought to be written by a companion of Durand of Huesca between 1208 and 1213. Detailing the tenets of Albigensian and Waldensian beliefs, the manuscript records the following:

> They [the Waldenses] also believe and say that one sins criminally in inflicting or approving the infliction of bodily punishment on malefactors; so also does one who takes an oath.[47]

The second passage, taken from a short work on the tenets of the Waldensian and Cathar heresies written by a mid-thirteenth-century Church inquisitor and erstwhile Cathar heresiarch, describes the Poor of Lyons:

> The first group, that is the Ultramontane Poor, maintains that all oaths and swearing are forbidden by the New Testament and are mortal sins. And they say, concerning temporal justice, that kings, princes, and officials are not permitted to punish malefactors.[48]

The third passage, from a lengthy handbook on contemporary heresies entitled the *Passau Anonymous*, written by a Bavarian cleric of the diocese of Passau in the 1260s, relates this about the Waldenses:

They condemn judges and princes and claim that malefactors are not condemned. Their occasion for this is that princes and judges are tyrants . . . and that justice is venal in the tribunals of laity and clergy alike. They say that taking oaths is a mortal sin.[49]

Finally, a young Cistercian polemicist, describing errors of the Waldensians, states that

their error consisted chiefly in four things: to wit, in the wearing of sandals after the fashion of the apostles; in their refusal, under any circumstances, to swear an oath; [their refusal] to take life; and in their claim that any one of them in case of necessity . . . may perform the sacrament of Eucharist even though he may not have been ordained by a bishop.[50]

The four sources say no more about what the Waldenses believed about punishment or political authority.

Admittedly, none of these passages explicitly mentions the death penalty. The first two indicate that the heretical sect condemned the (bodily) punishment of malefactors in general, the third that it condemned secular and ecclesiastical authority entirely, and the fourth that the Waldenses refused to take life. Nevertheless, together they at least confirm that by the end of the first decade of the thirteenth century the Waldenses were taking issue with the coercive prerogatives of public authority and were teaching against the taking of life.

What accounts for this? We may find a clue in the fact that in each of the four passages, the Waldenses' views about public authority (or the taking of life) are mentioned in conjunction with their condemnation of oath-taking. This invites a comparison with the Cathars of the same period. Already in the late twelfth century, as Malcolm Lambert points out, the Cathars were rejecting oath-taking and the shedding of blood.[51] And according to the thirteenth-century inquisitor, the Cathars also believed "that the secular powers sin mortally in punishing malefactors or heretics."[52] Lambert suggests that competition arose between the two sects, both of whom claimed to base their teachings on a literal interpretation of Scripture: "The Cathars wholly rejected lies, oaths, and the shedding of blood: could the Waldensians afford to seem less Biblicist on these issues than the Cathars were?"[53] It is plausible to conclude that this combination of factors—namely, a literal interpretation of the words of the Bible, in particular the words of Jesus about oaths and living by the sword, and com-

petition with their heretical coreligionists, who taught the grave immorality of punishing malefactors—influenced the Waldenses to teach that punishing and/or killing malefactors was mortally sinful. Lambert is confident that by the end of the twelfth century certain Waldenses, moved by their commitment to a literal conformity to the texts of the Gospels, argued that "all lies were to be treated as mortal sins, and oaths and shedding of blood forbidden in all circumstances."[54]

Why Innocent singles out *bloody* punishment in the Waldensian oath rather than punishment in general is unclear. His reason for framing his statement in terms of mortal sin and not in terms of the moral matter of the deliberately chosen act is less problematic. He must have adopted the language of subjective culpability because the Waldensians framed their teaching in the language of subjective culpability. They taught, or he thought they taught, that public authority could not carry out a judgment of blood without mortal sin; he declared that under certain circumstances public authority can do so without committing a mortal sin.

Innocent's inclusion of the condition that the motivation for bloody punishment must be of a certain sort does not appear to have stemmed from a teaching of the Waldensians. More likely the pope was handing down the classic teaching of Augustine on the requirement of proper motivation, namely, the exclusion of hatred in regard to killing in a just war. The same condition was specified by Hincmar in a passage (quoted earlier) from *On the Person of the King:* "to kill not by the law but with malice is criminal . . . [and] the mind, having passed its sentence in an evil way, is to be condemned."[55]

The similarity between the ideas of Hincmar and those of Innocent III may help us to further specify the pope's intention in his statement. Both writers limit the right of public authority to kill criminals by the requirement of an upright motive; for Hincmar the act must be without malice, for Innocent, without hatred (*non odio*). And both emphasize the centrality of law; Innocent says in 1209 that "the *law*, not the judge, puts to death"; Hincmar insists that rightful killing must be "*by the law.*" Innocent suppresses the reference to law in his developed statement of 1210. But if that statement is read in light of his phrase, "the law, not the judge, puts to death," it seems probable that Innocent's developed statement should be understood, like Hincmar's, as asserting the limited uprightness of the death penalty. That is, Innocent should be understood as asserting the proposition that under the prescribed conditions, choosing to impose the death penalty is itself not always wrong.

Thomas Aquinas

The statement of Innocent III is the most influential ecclesiastical pronouncement on capital punishment during the Middle Ages; the treatment by Thomas Aquinas (1225–1274) is far and away the most influential systematic one. I follow John Finnis in broadly referring to Aquinas' account of punishment as "medicinal."[56] This description may seem infelicitous, given that Aquinas refers in places to punishment as a medicine precisely in order *to distinguish it* from another sense, namely, punishment as inflicted for the restoration of the equality of justice.[57] Moreover, in some passages Aquinas uses *medicina* to refer exclusively to the forward-looking aspects of punishment, such as the restoration of virtue in the soul of an offender.[58] But Aquinas does not always maintain a strict distinction between these two senses of punishment. In his *Commentary on the Sentences* he maintains that punishments are for the healing of some *defectus* (fault), but he construes *defectus* broadly to include not only a fault in the one punished, but also a fault in the order of the universe or in the order of justice in civil society.[59] His use of "medicinal" extends even further than this. Punishments, he maintains, are not only medicinal for the one punished and for the order of justice in civil society, but also for all others who, in witnessing the punishment of another, are deterred from sin and encouraged in virtue.[60] In light of this it is reasonable to say that for Aquinas, punishment is medicinal to the extent that it broadly contributes to three things: the emendation of the one punished, the deterrence of others from wrongdoing, and the restoration of the order of justice.[61]

The first two are relatively straightforward, but the third deserves some comment. Punishment, Aquinas says, "is essentially related to a privation of order."[62] This order is sometimes referred to as an "order of justice"[63] and at other times as an "equality of justice."[64] Equality in this sense seems to be a sort of distributive equality between members of a community based on the requirements of justice, although Aquinas is not at all clear precisely what there is a distribution *of*, the balance of which is restored by punishment.[65] The nature of crime is that a person, in deliberately choosing a wrongful act, "exceeds the due degree of his measure when he prefers his own will to the divine will by satisfying it contrary to God's ordering."[66] Aquinas holds that the criminal "has exceeded in following his own will,"[67] "has been too indulgent to his will,"[68] or has been "inordinate [in his] affection."[69] He thus becomes "deserving of punishment."[70]

Since the nature of the offense is the wrongful satisfaction of the will, the nature of punishment is the subjection of that will to something contrary to it. Aquinas writes, "the nature of punishment consists in being contrary to the will, painful, and inflicted for some fault."[71] The result is the "restoration of the equality of justice."[72] The excessive willing of the offender, which set him in a position of inequality relative to all other members of the community, is corrected by the proportionate suppression of his will in just punishment. Aquinas summarizes this dimension of punishment (i.e., its retributive dimension) as follows: "by means of punishment the equality of justice is restored insofar as he who by sinning has exceeded in following his own will suffers something that is contrary to his will."[73]

Aquinas' notion of proportionate suppression is important because it highlights the fact that the magnitude of a punishment corresponds to the magnitude of the fault and not to the external harm resulting from the fault.[74] "Punishment should proportionally correspond to the fault."[75] If a greater punishment is not given to one who sins more, equality would not be preserved.[76] It follows that only offenders are rightly punished.[77]

How does Aquinas treat capital punishment? His most famous discussion occurs in his treatise on the virtues in the *Secunda Secundae* (*Summa Theologiae* II-II). Under the topic of vices opposed to commutative justice, in question 64, he treats eight articles concerning the lawfulness of homicide. He argues that the norm against intentional killing admits no exception in three cases: the intentional killing of the innocent, the killing of oneself, and all other acts of intentional killing carried out by private persons.[78] Persons holding positions of public authority, however, acting on behalf of the common good, are not prohibited from intentional killing. If the welfare of the community is seriously threatened by the sinfulness of one of its members, public magistrates charged with maintaining the community's welfare can lawfully put that individual to death.[79] Aquinas' argument for this position is drawn from his conception of the relationship of a part to its corresponding whole:

Now every part is ordered to the whole as imperfect to perfect. And therefore every part is naturally for the sake of the whole. On account of this we see that if it is useful [*expediat*] to the health of the whole body of a man to cut off one of his members, as when it is putrid or corrupting of the other members, it will be praiseworthy and salubrious for it to be cut away. Now every individual person is compared to the whole community just as a part to the whole. Therefore if any one is dangerous and corrupting to the

community on account of some sin, it is praiseworthy and salubrious that he be killed, in order to preserve the common good.[80]

Aquinas' reasoning and imagery are drawn from Aristotle, who maintains that because a whole is necessarily prior to its parts, the city, understood as a social whole, is by nature prior to every individual.[81] A whole, for Aristotle, implies self-sufficiency. Neither individuals nor families can claim such a status, for none can live well on their own; only cities are self-sufficient. And although the good is the same for the city as for the individual, the good of the whole is a greater and more complete good.[82] Hence it is finer and more godlike to acquire and preserve the good of the whole.[83] Consequently, the good of the individual (and family) is subordinate to the good of the whole community. The influence of Aristotle's argument on Aquinas is obvious. Both hold that the being of a part depends in a radical sense on the being of the whole.[84] Aquinas even borrows Aristotle's language of a "more godlike good" to describe the good of the state relative to that of the individual.[85]

When confronted with the objection that the death penalty is an evil means to a good end because it violates personal dignity—and thus, killing a man whom we are bound to hold in charity can never be a suitable means of bringing about the good end of preserving the order of justice (or advancing any other good, for that matter)—Aquinas responds:

> By sinning man departs from the order of reason, and therefore falls away from *human dignity* [*dignitate humana*], insofar as man is naturally free and exists for his own sake, and falls somehow into the slavery of the beasts, so that he may be disposed of according to what is useful to others. . . . Therefore, although it be evil in itself to kill a man who preserves his *human dignity*, nevertheless to kill a man who is a sinner can be good, just as it can be good to kill a beast; for an evil man is worse than a beast.[86]

From this account we might conclude that human dignity, which otherwise stands, so to speak, as an unbreachable moral barrier between each person and every intentional killing, is compromised by serious sin, leaving a person open to being legitimately killed. Public authority, as the guardian of the community, alone is permitted to plan and carry out such killings.

But public authority in this sense includes only secular authority. Aquinas is clear that neither clerics nor the Church (or rather, the Church's ecclesiastical law) may legitimately inflict the death penalty.[87] He gives two reasons. First, be-

cause clerics are ministers of the sacrament of the Lord's passion and death, they are required to imitate their master, "who when he was struck did not strike (1 Pet. 2:23)"; it is therefore not fitting for them to kill or even strike another person. Second, because they are appointed ministers of the New Covenant, in which no provision is made for the killing of evildoers, they should abstain from such things "in order that they may be fitting ministers of the New Testament."[88]

Aquinas poses an objection based on the unstated premise that a greater ruling power possesses by nature the powers of ruling of a lesser power. Spiritual power, being more nearly united to God than secular power, is greater, therefore it possesses whatever powers of ruling are proper to secular power. Since Romans 13:4 tells us that public magistrates, as God's ministers for the common good, lawfully put evildoers to death, it follows that clerics, who are much more God's ministers than secular magistrates, may also lawfully put evildoers to death.[89] To this Aquinas responds: "The ministry of clerics is concerned with better things [melioribus] than corporal slayings, namely with things pertaining to spiritual welfare, and so it is not fitting for them to meddle with minor matters."[90]

John Duns Scotus

Within thirty years of Aquinas' death, the British Franciscan, John Duns Scotus (1266–1308), advanced a unique defense of capital punishment in his *Commentary on Book IV of the Sentences of Peter Lombard*.[91] Working on the premise that the precept *Non occides* prohibits without exception the killing of a human person,[92] Scotus considers whether there might be cases where one could ever be called a "just killer."[93] He adopts a position which he ascribes to Augustine, namely, that whoever kills a man is to be charged with murder unless he has been excepted from the prohibition in one of two ways, either by a just law in general or by a direct command of God in particular. A "just law" is one which descends from divine law, like a practical conclusion from practical principles, or which is consonant with divine law, or which at least does not conflict with divine law.[94] Effectively, this translates, for Scotus, into a position that permits killing only for those crimes for which death was the prescribed penalty in the Old Testament and, unlike adultery, whose penalties have not been abrogated by Christ in the New Testament. In other words, to override the definitive nature of the precept against killing, a direct command from God, verifiable in

Scripture, is necessary. For example, the crimes of murder and blasphemy, singled out as capital offenses in the Pentateuch, may be legitimately punished with death. Scotus forcefully argues, however, that in the absence of a special "bull" descending from heaven to the contrary (*bulla super hoc descendente de Coelo*), a crime such as theft, which is not deemed a capital offense by God, should not to be punished with death.[95]

We are warranted in speaking of a "Catholic consensus" on capital punishment thus far in the Church's history. Points in common between the Patristic and medieval ages that contribute to that consensus include the principled defense of the right of civil authority (and only civil authority), as the divinely instituted guardian of the public good, to inflict punishments on evildoers including the punishment of death; the appeal to Scripture, particularly Romans 13, as a ground for this right; and the idea that the death penalty is medicinal insofar as its infliction protects the community from a harmful influence and deters others from serious crime. The medieval tradition adds to that consensus the prohibition of clerics *qua* clerics from judging and carrying out capital punishment, and the requirement of a proper motivation for the lawful infliction of the death penalty. One point not carried over from the Patristic to the medieval period is the Patristic teaching that the gospel makes a general claim on the followers of Christ that excludes, or at least limits, Christian participation in judging, sentencing, and carrying out capital punishment. As I have shown, medieval Church writers show little interest in limiting the role of Christian laymen in the lawful infliction of the death penalty.

CHAPTER 6

∎

Sixteenth Century to the Present

∎

The first part of this chapter takes up the traditional teaching on the morality of capital punishment in Catholic texts from genres as diverse as moral manuals, catechisms, periodical literature, and apologetic tracts dating approximately from the Council of Trent in the sixteenth century to Vatican II in the twentieth. I select authors and texts with the widest possible influence, and whose ideas best represent the continuity and variety of thought on capital punishment during the centuries in question. As before, the analysis is primarily expository, engaging in historical commentary, dialectic, and critique only to the extent these serve to illuminate the meaning of texts.

In the second part of this chapter I consider stages in the turn toward opposition to the death penalty by the Catholic Church, with special attention to factors instrumental in precipitating the change. This brief historical survey is not intended to be comprehensive. It aims at painting in broad strokes the rise and development of organized opposition to capital punishment within the Church and in particular within its hierarchy. Constraints of space and time allow only passing references to the secular origins of the campaign against the death penalty in Western Europe, beginning in the eighteenth century.[1]

The Traditional Teaching: Consolidation and Development

Much of what we find on the death penalty in Catholic writings from the Council of Trent to Vatican II is a rearticulation of principles held and taught to be

true throughout the Middle Ages. Most teach that public authority alone has the right to inflict the death penalty, that it is only lawfully inflicted on evildoers who are harmful to the community, and that the authority derives from God and is witnessed to in Scripture. Some repeat the traditional clergy prohibition, still others the requirement of an upright motive.

Several additional points are worth noting. The first is the enormous influence of Thomas Aquinas. Nearly every Catholic author concerned with capital punishment from Trent to Vatican II refers to his defense as an authority, in particular, his part-to-whole and putrid limb analogies. Second, authors for the first time begin to defend the authority of the Church to kill criminals, usually framing their defense in terms of the right of the Church to kill heretics. And finally, the retributive purpose for the death penalty becomes central to its wider justification.

Sixteenth-Century Commentaries

Much of the debate on the death penalty in the sixteenth century surrounded issues raised by the politics and theology of the Reformation. One issue in particular was the question of the effects of original sin on the capacities of human nature. Reformers to varying degrees viewed the effects of original sin as the darkening and corrupting of human reason and will, in contrast to the view of the Catholic Church, which taught that human nature is weakened by sin but is not thoroughly corrupted. Various Counter-Reformation writers, recognizing the implications of certain Reformation views for natural law morality, and particularly on the ability of reason to recognize moral norms and act in accordance with them, resolutely defended reason's capacities and opposed criticisms, or perceived criticisms, of natural reason. This is best illustrated in their vigorous deployment of the theology and philosophy of Aquinas. Some of the most influential Thomistic commentators appear in the sixteenth century, including Cardinal Cajetan, O.P. (1469–1534), Leonardo Lessius, S.J. (1554–1623), and the impressive list of Salamancan Dominicans: Francisco de Vitoria, O.P. (1492–1546), Dominic Soto, O.P. (1494–1560), Melchior Cano, O.P. (1509–1560), and Bartholomew Medina, O.P. (1527–1580).[2]

Perhaps the best known commentary on Aquinas' *Summa Theologiae* is that of Thomas de Vio Cajetan, O.P.,[3] written between 1507 and 1522 when Cajetan was superior general of the Dominican order.[4] His ideas on capital punishment combine a simple rearticulation of the ideas of Aquinas with considerations

that go beyond those of his medieval master. He appeals to Aquinas' part-to-whole and putrid limb analogies to argue for the lawfulness of killing persons harmful to the community, and he confronts the objection that the death penalty is contrary to charity—which requires that we want and will our neighbor to live—by arguing that serious evildoers pass into the order of beasts and are therefore lawfully treated in a way that best befits the welfare of the community.[5] He then proposes that charity properly ordered *prefers* (*diligit magis*) the good of the community to the temporal life of sinners and therefore prefers the temporal destruction of sinners to the destruction of the common good,[6] something Aquinas also says.[7]

The notion of the welfare of the community or "safety of good men and women" (*salus bonorum*) is important in Cajetan.[8] It is this, he says, which determines whether evildoers are to be spared or destroyed.[9] "When the safety of good men demands the killing of evildoers, they may be killed, and when it does not, they may not."[10] This is precisely what our Lord teaches in the parable of the wheat and tares. Wording the principle differently, he writes, "the universal foundation from whence the punishment of bodily death may be justly inflicted by human law [is this]: when a crime is gravely harmful to others."[11] In this respect, Cajetan stays close to his teacher. While maintaining, like Aquinas, a retributive notion of punishment in general (see Cajetan's lengthy discussion of *ST*, II-II, q. 108, a. 2 on whether *vindicatio* is an act of virtue), he never speaks about the punishment of death as retributive. The death penalty is spoken of only in terms of defending the community.

Cajetan, like Aquinas, also raises a doubt concerning the right of prelates, who jointly hold spiritual and temporal authority, to inflict the death penalty.[12] Because spiritual power is of a higher order than secular power, and because individuals endowed with the latter can lawfully inflict capital punishments, it would seem that the former likewise are permitted to do the same.[13] In response Cajetan argues that since the ignoble is subordinated to and limited by the noble, temporal rule is limited by spiritual rule. Therefore a prelate who is simultaneously a temporal ruler rightly carries out only those duties of temporal rule which are not unbefitting his spiritual office. Since inflicting capital punishment (as well as waging war and even hunting) is unbefitting the office of a bishop, the bishop-lord cannot rightly carry them out.[14]

The conclusions of the great Spanish Dominican, Francisco de Vitoria, are essentially the same.[15] Four propositions, according to Vitoria, define the scope of the fifth precept of the Decalogue. First (*pace* Scotus), the precept forbids

those and only those homicides that are of themselves evil. Second, the precept permits the intentional killing only of persons who are harmful to the republic, never ones who are innocent or who are not otherwise harmful or dangerous.[16] Third, because it pertains to public authority to care for and defend the community, public authority alone may inflict death.[17] Finally, every other intentional homicide according to natural law is evil and is therefore forbidden by the precept.[18] In conclusion, Vitoria asserts that "it is lawful to kill only a dangerous man and only by public authority."[19] His justification draws on Aquinas: "just as when a hand is harmful to the whole body it is lawful to cut it off, so it is lawful to kill a man who is dangerous and harmful to the community."[20]

The salient themes of Aquinas' account are carried forward in the theology of a prominent Flemish Jesuit, Leonard Lessius.[21] In his work *De Iustitia et Iure*,[22] written at the turn of the sixteenth century, Lessius reasons that because a part is ordered to its whole, sinners harmful to the community, of which they are a part, may be killed for the sake of the welfare of the whole.[23] As guardians of the community, public authority alone is authorized to inflict the death penalty,[24] but only on the guilty and never on one whose death is not otherwise required to preserve the order of law.[25] Lessius, too, stresses that killing a criminal, like amputating a limb, is not lawful "except on account of the good" of the whole body.[26]

Another response to Reformation anthropology is seen in the sixteenth-century theologians' preoccupation with the divine command theory of Duns Scotus. Presumably they thought it lay behind the ostensible divine command positivism fueling Reformation divisions. Scotus had argued that the command *Non occides* absolutely prohibits the killing of humans. To override its categorical nature, a direct command from God, verifiable in Scripture, is necessary. Cardinal Cajetan, perceiving the implications for natural law morality, argued, as did Aquinas, that the precepts of the Old Law, inasmuch as they are judicial precepts, ceased with the passion of Christ, but inasmuch as they are moral precepts, are eternal. Natural reason, considering their normativity, discerns and defines the scope of their application.[27] So whether an instance of homicide is or might be lawful depends not so much on a divine exception as on whether the kind of harm the instance entails falls under the norm against killing. And such a determination is the proper domain of moral reason. It follows for Cajetan that killing "is not a sin because it is prohibited, rather it is prohibited because it is evil." All wrongful killing, Cajetan insists, "is prohibited by God through that precept *Non occides*. When, however, it is not evil, it is not prohibited by God through the precept."[28] Scotus argued that simple theft should not be

punished with death because it had not been excepted by God in Scripture; Cajetan replies that the question depends exclusively on whether or not the thief is destructive to the public peace.[29]

Vitoria builds on this position. He argues that what is by nature good and laudable (*bonum et laudabile*) is not forbidden by divine law. Aquinas makes clear that killing dangerous men is of itself good and laudable. It is therefore wrong to say that the Fifth Commandment of the Decalogue forbids it.[30] Moreover, before the law was given to Moses we know that some killing was lawful, for instance, killing a traitor and a murderer. This was obviously not so because of a divine exception, since the law had not as yet been given. Furthermore, even Scotus admits that the precept against killing is part of the natural law.[31] But if every kind of killing is prohibited by the Fifth Commandment, then a divine exception is an exception to the natural law. But this cannot be true, since neither the Old Law nor the New Law is an exception from the law of nature.[32] Therefore, not all kinds of killing are forbidden by the Commandment.[33]

Sixteenth-Century Catechisms

The preparation and widespread distribution of manuals of Christian instruction were important parts of the reform efforts of the Catholic Church in the sixteenth century. The three most influential were the catechisms of Peter Canisius, S.J., and Robert Bellarmine, S.J., and the *Roman Catechism*. Although Canisius' influential work has no explicit treatment of capital punishment,[34] the other two treat it in some detail. Their enormous contribution to the religious instruction and hence the formation of conscience of the Catholic faithful in the sixteenth century and following centuries make them important gauges of what "every Catholic held and taught to be true" during and after the Counter-Reformation.

The *Roman Catechism*, issued in 1566 by order of Pope Pius V at the recommendation of the Council of Trent,[35] locates its teaching on the death penalty in Part III in a section devoted to the Commandments of the Decalogue. The treatment of the Fifth Commandment is divided into two parts, the prohibitory (what the commandment forbids) and the positive (what it enjoins). Under the former, before specifying prohibitions, the catechism itemizes five "exceptions," the second of which is the "execution of criminals."[36] What follows is little more than a string of traditional propositions. The catechism teaches that the "power of life and death" is entrusted to the "civil authorities . . . who are the legitimate avengers of crime," that the power is lawfully exercised only in the punishment

of the guilty, only in accord with law, and only with careful deliberation, and that its purpose is to "give security to life by repressing outrage and violence."[37] Adding its own twist, the catechism states that the death penalty, when justly inflicted, "far from involving the crime of murder, is an act of paramount obedience to the Commandment which prohibits murder [insofar as] the end of the Commandment is the life and safety of men and women" (*hominum vitae salutisque*).[38]

The treatment in the catechism of Robert Bellarmine is more interesting.[39] Composed in the form of a dialogue between a teacher and a scholar, with the latter proposing questions and the former answering,[40] the catechism begins its discussion of the death penalty with the teacher explaining that the fifth precept of the Decalogue forbids only the killing of men and women, not the killing of other living things. Other creatures, according to the teacher, were created by God to be used by man and therefore may be lawfully killed whenever such would serve the needs of man. But men were created only for God, not for other men. It is therefore forbidden for one man to kill another.[41] The scholar protests that it is common practice for princes and judges to put criminals to death and yet it is not counted against them as evil, but rather on their behalf as good. To this the teacher responds that the commandment applies only to killing by private authority. Princes and rulers and others who put evildoers to death do so,

> not as masters of men's lives, but as ministers of God. . . . Because God willeth and commandeth that malefactors be punished & killed, when they deserve it, that good men may be safe and live in peace. And for this purpose God hath given the sword into the hands of Princes and Rulers to do justice, in defending the good, and chastising the bad.[42]

At first glance this passage may seem to contain only traditional themes, but a closer look uncovers something more. While mentioning the defensive aim of capital punishment—"that good men may be safe"—the passage also implicitly acknowledges the retributive dimension of the death penalty. The sword of *justice*, laid by God into the hands of the prince, punishes those who are *deserving*. Bellarmine develops this line of reasoning in his famous work *De Controversiis*,[43] in a section on the laity, *De Laicis*, sometimes called "The Treatise on Civil Government."[44] Chapter 13, a relatively lengthy defense of the proposition "it is lawful for a Christian magistrate to punish disturbers of the state with death," contains some of the sixteenth century's most forceful articulations of

the retributive nature of the death penalty.[45] Commenting on Christ's words to Peter in Matthew 26:52 that "All that take the sword shall perish with the sword," Bellarmine writes, "these words cannot be rightly understood except in this sense: Every one who commits an unjust murder ought in turn to be condemned to death by the magistrate."[46] Moreover, "when Our Lord says, 'You have heard that it hath been said of old, an eye for an eye,' etc. [Matt. 5:38], He does not condemn that law, nor forbid a magistrate to inflict the *poena talionis*, but He condemns the perverse interpretation of the Pharisees, and forbids in private citizens the desire for and the seeking of vengeance."[47] Bellarmine then comments, "God promulgates the holy law that the magistrate may punish the wicked by the *poena talionis*."[48] Bellarmine widens this retributive account with the standard medicinal account when he states that civil magistrates, entrusted with care for the common good, attend to the community's welfare by carefully watching for harmful members—"which exist for the sake of the whole." And if the unity of the whole is threatened, not only *may* a ruler, but "it is the duty of a good ruler," to "cut off" the one for the sake of the whole.[49]

The Church and the Killing of Heretics in the Seventeenth Century

Death had been considered a proportionate punishment for obstinate heresy since the High Middle Ages. However, the question of the right of the Church to punish heretics with death became especially relevant in the sixteenth and seventeenth centuries. The broad acceptance of killing as a permissible punishment by the medieval Church was the result of the judgment that there was no less harmful way to defend the good order of civil society. By attacking the purity of the Christian faith, the heretic was striking at the foundation of the social order. The 1911 *Catholic Encyclopaedia* sets forth baldly the past perspective of the Church on the issue:

> The Church's legislation on heresy and heretics is often reproached with cruelty and intolerance. Intolerant it is; in fact its *raison d'être* is intolerance of doctrines subversive of the Faith. But such intolerance is essential to all that is, or moves, or lives, for tolerance of destructive elements within the organism amounts to suicide. . . . The charge of cruelty is also easy to meet. All repressive measures cause suffering or inconvenience of some sort: it is their nature. But they are not therefore cruel. The father who chastises his guilty son is just and may be tender-hearted. Cruelty only comes in where the punishment exceeds the requirements of the case. Opponents say:

Precisely; the rigors of the Inquisition violated all humane feelings. We answer: they offend the feelings of later ages in which there is less regard for the purity of faith; but they did not antagonize the feelings of their own time, when heresy was looked on as more malignant than treason.[50]

The increase of heresy in the Middle Ages had torn Christianity apart, and the Church saw the same situation repeating itself at the Reformation. Already in 1520 Pope Leo X had condemned a proposition ascribed to Martin Luther: "That heretics be burned is against the will of the Spirit."[51] Important Church writers took up the question, and it was during the seventeenth century that some of the strongest defenses for the Church's right were published.

The influential Jesuit philosopher-theologian and successor of Vitoria at Salamanca, Francisco Suárez, dedicates several disputations to the question in his lengthy polemic against the King of England, *Defensio Fidei* (1613).[52] In disputation 23 he asks whether it is lawful for the Church to punish heretics with death.[53] He responds confidently that it is, and that this is the conclusion of the leading theologians of his time. He provides arguments from Scripture, the practice of the Church, and reason.

The Old Testament, Suárez argues, explicitly teaches that false prophets should be killed, and the New Testament, while not commanding it, suggests it. Recall that Christ refers to heretics as "thieves and marauders" and as "ravenous wolves" (John 10:8, Matt. 7:15). Thieves and marauders ought to be punished with death, and dangerous wolves should not only be banished but, if at all possible, killed.[54] Suárez raises a possible objection, namely, that because Christ did not explicitly teach the uprightness of killing heretics, he therefore opposed it. To this Suárez replies that the truth is the other way around. Its uprightness is assumed from the negative authority of Christ. He did not need to teach it; it is enough that he did not prohibit it.[55] Christ's admonitions to "be attentive" and "beware" of false teachers surely imply the authority to undertake the necessary means to suppress and avoid their influences. And what else could the Lord have meant in John 15:6 when he says that branches not remaining in him, the Vine, were to be cut off and thrown into the fire, or when he cursed the evil tree in Matthew 21:19 for bearing no fruit? In these passages the Lord makes clear what the Church ought to do in such matters.[56]

The custom of the Church, Suárez maintains, reveals the same. Granted that Christians stood before emperors and judges, the Church Fathers labored more to restrain bloody judgments than to justify them. In time, however, it became clear that not only mild but also severe penalties were necessary to check

the spread of heresy. Christian emperors thus had recourse to the "ultimate remedy."[57]

Finally, natural reason supports the same conclusion. When we consider the gravity of the offense we recognize at once that the crime of heresy is very grave indeed. But lesser crimes are lawfully punished with death, therefore punishing heretics with death is also lawful.[58] Moreover, heresy is a threat to the life of the Christian republic.[59] But whatever is necessary for the preservation of the republic belongs to those who are responsible for its care. It is evident that the preservation of good government and the safety of the community require the power to punish malefactors, if need be, with death.[60] If from natural reason we understand that such a power is proper to civil authority, much more do we conclude that the Church—a more perfect republic (*respublica perfectior*)—possesses it by the authority of Christ.[61] For Christ, Suárez says, did not fail to provide for his Church in her necessity. He therefore included the authority over life in the power given to St. Peter, as demonstrated when Ananias and Sapphira fell dead in response to Peter's words (Acts 5:1 ff.).

Suárez distinguishes between the retributive and medicinal functions of the death penalty. He begins by distinguishing between punishment (*punitio*) and coercion (*coactio*). The former is inflicted for a sin already committed, whereas the latter looks to the future that a sinner "may come back to his senses."[62] But one penalty (*poena*) may serve both purposes (i.e., *punitio* and *coactio*). In such a case, the coercion, intended for the good of emendation, is lawful presupposing that the punishment is just. The goodness of the one adds to the goodness of the other and results in a "better" act, whence the penalty ought to be considered not only an act of justice, but one of piety and mercy. It happens that certain sins, because of their gravity, deserve to be punished with death. Such is the case with the sin of heresy, which is worthy of death no less than the crime of high treason.[63] In this case the ultimate penalty, inflicted to meet the demands of retribution, also serves an emendatory (or medicinal) function, not of course because it serves the emendation of the criminal, but rather because it preserves the welfare of the community. The death penalty therefore is not only just insofar as it meets the just exigencies of retribution, but also necessary insofar as it is said to be medicinal with respect to the community.[64]

Who in the Church holds the authority, civil magistrates or ecclesiastics? Suárez responds that both hold it but in different ways. Because heresy is an ecclesiastical crime, the power of punishing it belongs to the pastors of the Church:[65] "It resides principally in ecclesiastical magistrates, especially the pope."[66] With

kings and emperors, their ministers, and all others who are subordinate to the spiritual power, it pertains in a "related [*proxime*] way."[67] We know this because the killing of malefactors has always been carried out by the civil laws.[68] Likewise, from reason we know that punishing heresy is necessary for the "spiritual good" and the "temporal peace" of the Christian republic. Therefore "each power [civil and ecclesiastical], in ordered pursuit of its own proper end, may impose such a penalty."[69] Because temporal welfare is subordinate to spiritual welfare, the power to kill heretics, although "in the secular ruler," is ultimately subordinated to spiritual power proceeding from the latter to the former. But it resides truly (*vero*) in the pope. This is taught by Pope Boniface VIII in his bull *Unam Sanctam* and by Bernard of Clairvaux when he speaks about "the two swords of the Church and the Pope, i.e., the spiritual and temporal."[70] The Church wields the spiritual sword herself, while the temporal sword is wielded through the secular powers. And so, although "civil laws expressly impose and command that the crime be punished with death, canon laws only order that heretics in certain designated cases be handed over to a secular court."[71]

The Common Good, Consequentialism, and Hell

The duty of civil authority to preserve and defend the common good has been an integral part of the teaching on the lawfulness of capital punishment since the earliest days of the Church. The eminent seventeenth-century Spanish Jesuit Juan De Lugo,[72] in the work upon which his fame chiefly rests, *De Justitia et Jure*, refers to this duty in two interesting and somewhat novel arguments.[73] The first amounts to an argument against consequentialism. De Lugo begins by raising an objection against the death penalty: in effect, just as we see God, the most wise judge and governor of the universe, tolerate evildoers, not inflicting immediate punishment but waiting lest by chance they be converted, so, too, prelates and governors should tolerate and not kill evildoers in hope one day of seeing them converted. De Lugo's response to this argument is that we cannot argue from the actions of God to those of the judge. For God wisely tolerates evildoers for ends which only he knows but which are, in advance, opaque to us. But earthly judges and rulers, not having access, we might say, to the providential realm, "ought only intend the tranquillity and peace of the community entrusted to their care" and therefore should not ignore and tolerate evildoers when their evil doing is a hindrance to those ends.[74]

The second argument is related to the first. Should a judge, De Lugo asks, proceed with the death penalty notwithstanding a criminal's moral intransi-

gence and risk sending him straight to hell? De Lugo replies: if an offender is not right before God and is unwilling to undertake the measures necessary to put himself right, then a judge should go ahead and kill him even if in so doing the man is damned for ever. The reason? Because the judge's duty is to attend in the first place not to the welfare of the condemned but rather to the welfare of the community to whom the malefactor is a bitter enemy.[75] It follows that killing malefactors is only licit when doing so is for the sake of the common good, just as it is only licit to amputate a limb when doing so is for the health of the body. And because it pertains to public authority to guard the welfare of the community, to public authority alone belongs the power to kill malefactors.[76] And this authority, De Lugo maintains, derives not from the state but from God.[77]

The Eighteenth Century

The eighteenth century is famous indeed for its treatises on the death penalty, but not for treatises defending it so much as for those opposing it. This was the century of the rise of public movements for abolishing capital punishment, the century of Beccaria's "On Crimes and Punishments" and Voltaire's caustic satires against medieval Catholic autos-da-fé. In Catholic ecclesiastical circles, in contrast, the doctrine on lawful killing was being handed down more or less as it had been for centuries. Two important eighteenth-century monographs suffice to illustrate this fact.

The first is the monumental *Cursus Theologiae*[78] by a Belgian Dominican, Charles-René Billuart (1685–1757). His treatment of the death penalty, which begins with the familiar polemic against Scotus, proceeds largely as did the others: the commandment *Non occides* does not forbid all killing but only "undue" killing, for example, killing the innocent;[79] the death penalty is lawfully inflicted only by public authority;[80] the authority derives from God and is known through the natural law inscribed in men's hearts;[81] it is lawful because the good of a part is subordinated to the good of the whole;[82] and so forth. However, when Billuart discusses Aquinas' criteria for judging *which* evildoers may be lawfully killed, he says something unique.

Billuart notes that Aquinas, in approving the killing of "sinners who are dangerous to the republic, attends not to the gravity or malice of the sinner in himself, but rather to the harm that the sinner brings to the republic."[83] It follows that certain capital laws are instituted not "for the purpose of judging injustice" but rather for the prevention of crimes that threaten "very grave harm

to the republic," even when those crimes in themselves are relatively minor. Billuart gives examples from military law: briefly napping at one's watch post, deserting one's station, small acts of disobedience, and minor deceptions.[84] Remarkably, Billuart distances himself from the retributive dimension of punishment, not to limit the lawful scope of the death penalty, as the *Catechism of the Catholic Church* does in distancing itself from retribution, but rather to defend a *wider* possible scope for its infliction!

Billuart also says something unique in his discussion of *why* evildoers are lawfully killed. Conscious of the objection in the *Summa* that, because we are bound to love all men and women, it is never lawful but rather in itself evil to kill any person,[85] Billuart (with Aquinas) replies that "one who sins falls from human dignity" and therefore may be treated like a beast. Billuart then offers an objection. Because each person is made in the image of God, and this image remains even in sinners, surely it is unlawful to kill any man, including a criminal. Billuart's response is a traditional appeal to Scripture and natural reason:

> But although this image of God remains in one who is harmful to the common good, nevertheless, God has willed that he be punished with death. This is evident to us both from the scriptural precept, *Malefactors ought not be permitted to live,* and the natural law which—as is said—is inscribed on our hearts.[86]

Another eighteenth-century work, the *Theologia Moralis* of Alphonsus de Liguori, a celebrated Italian cleric and patron saint of moral theologians,[87] is typical for its measured rearticulation of the Church's traditional teaching. Liguori identifies capital punishment as one of two forms of legitimate homicide.[88] Public authority is necessary for its infliction, but even public authority sins if it is motivated not from "zeal for justice but from hatred or private revenge."[89] Criminals ordinarily should be first accused and tried,[90] and the presiding judge has the grave duty to grant the condemned an opportunity to celebrate the Sacrament of Penance and receive Holy Communion.[91] Finally, if a cleric holds a position of civil authority, he may not pronounce a capital sentence unless he receives a special dispensation to do so from the pope.[92]

When Liguori teaches that criminals may be killed "if it is necessary for the defense of the republic,"[93] he appears to be using the principle of "necessity" as it is used in the *Catechism of the Catholic Church* and *Evangelium Vitae*. But his further statement that "beyond the cause of necessary defense, it is never licit [to kill malefactors], *except* by public authority and in order to preserve the

order of law" makes a distinction between "necessary defense" as self-defense (as in the *Catechism,* no. 2267) and the killing necessary for "preserving the order of law."[94]

The Nineteenth and Twentieth Centuries

Moral Manuals. For samples of traditional teaching in relatively recent times, I turn to standard reference works of Catholic theology dating from the nineteenth and early twentieth centuries, including fifteen manuals of moral theology,[95] a dictionary of moral theology and canon law,[96] a textbook of canon law,[97] and a treatise on dogmatics.[98] These manuals and other works are a representative sample of the positions held and taught by members and scholars of major Catholic religious orders, including the Jesuits, Dominicans, and Redemptorists. They served as episcopally mandated and approved sources for the formation of Catholic consciences for clergy and laity alike. Several are even published with letters of commendation for the author from the reigning pope.[99] Thus, although their contents are not necessarily authoritative de jure, their wide influence and distribution make their teachings effectively authoritative.

The first thing a reader notices in these works is the overwhelming consensus on the morality of capital punishment.[100] Many recurring principles are the same ones that were held and taught to be true in the Middle Ages. For example, all teach that proper authority is a necessary condition for the lawful infliction of the death penalty. For most authors this means civil authority.[101] And all teach that capital punishment is needful for maintaining and defending the common good.[102] The concept of need or necessity, however, is variously expressed. McHugh and Callan state that killing "is lawful when the common safety requires that the State inflict death for a crime."[103] According to Noldin and Schmitt, "The right of determining and inflicting capital punishment is necessary to supreme authority."[104] Genicot writes, "It is lawful for public authority to kill a malefactor insofar as it is necessary for the welfare of the whole community."[105] For Gury, "God gave this necessary power to public authority as a necessary means for defending and caring for the life and common good of civil society."[106] Cathrein writes, "Civil authority has the right to inflict capital punishment on evildoers for atrocious crimes if this punishment is necessary for effectively preventing the same crimes. And it is necessary."[107] According to Sabetti and Barrett, "God, the author of society, is said to have conferred upon society the absolutely necessary means for preserving itself and administrating

the common good, among which must be numbered the death of . . . malefactors."[108] And so on.

Although the concept of necessity appears frequently, there are no instances in these manuals where the term is used as it is in the present *Catechism*, namely, as "necessary defense"—construed as "collective self-defense"—of society.[109] Sometimes it refers to the necessity to deter crime, sometimes to the necessity to vindicate crime, but most often it is used in a very general way, as in "necessary for the welfare and preservation of the republic"[110] or "necessary for the common good."[111] When the term "necessary defense" (or a related term) appears, it is invariably in arguments not for the morality of the death penalty, but rather for the uprightness of killing aggressors by private persons in self-defense.[112]

The manuals and textbooks appeal to the testimony of Scripture,[113] Church tradition, the practices of diverse peoples and legislations,[114] and precepts of human reason[115] as premises from which to argue for the legitimacy of the death penalty. Most of the arguments are familiar. However, the texts also put forward principles articulated for the first time in the Post-Tridentine/Modern period. For example, in several of the works dealing with the lawfulness of killing heretics, "proper authority" refers not to secular authority but specifically to ecclesiastical authority. For example, the Servite father, Henri Marie Lépicier, asks in his work *De Stabilitate et Progressu Dogmatis*: "How must we deal with heretics? are they to be tolerated, or altogether exterminated? and has the Church the right of punishing them with death?"[116] After defending the right on behalf of the Church and the state, he remarks:

> I am aware that there are many who think that the Church has no right to sanction the death penalty, whether for heresy or for any other crime. But their decision cannot be called probable, since it does not appear plainly how this negation is compatible with the constitution of the Church or with historical facts.[117]

The retributive justification for capital punishment, rarely found in texts before the Council of Trent, is now standard in moral manuals. We find it illustrated in numerous phrases: "to kill malefactors for a crime of proportionate gravity,"[118] "killing those who commit very grave crimes,"[119] "a crime worthy of the death penalty,"[120] "crime . . . legally deserving of the supreme penalty,"[121] "without the death penalty, murders and other most grave crimes could not be sufficiently vindicated,"[122] "certain crimes are so heinous that all agree that the violated order is not adequately restored except through a very severe pun-

ishment (like the death penalty),"[123] and so forth. An interesting contrast is Cathrein, who clearly wants to distance himself from a *strict* retributivism. After setting forth the argument that there are some crimes for which no penalty other than death is proportionate, he responds: "I abstain from this argument; for it presupposes a theory of expiation which adduces a principle for human judgment which is too vague."[124]

The influence of Aquinas is evident in nearly every moral manual. Several are even explicitly dedicated to his thought.[125] Some also speak of the state's authority to kill malefactors in terms of a "right,"[126] describing this right as God-given, and use the term "direct" to describe the kind of killing that the death penalty entails.[127]

Catholic Encyclopedias. The English-language *Catholic Encyclopaedia* (1911) offers a non-polemical treatment of the death penalty, beginning with a brief history of its use from Old Testament times through the present day, and devoting almost as much space to the rise of efforts to abolish it as to the rest of recorded history. Its treatment of authors like Beccaria and Bentham is fair, if not generous. Nevertheless, when describing the Church's judgment on the morality of capital punishment, it asserts that "the infliction of capital punishment is not contrary to the teaching of the Catholic Church, and the power of the State to visit upon culprits the penalty of death derives much authority from revelation and from the writings of theologians."[128]

Similarly, the 1929 edition of the eminent French *Dictionnaire de Théologie Catholique* poses the questions: "Has Social Authority the right to condemn a criminal to capital punishment? In other words: Are there any exceptions to the divine commandment: *Non occides?*" Its reply is that "without denying that progress happily softens penalties, . . . without denying either that one will never gather enough information and take enough precautions before sentencing someone to death, we must admit that social authority has the right to carry out this sentence."[129] Whereas its English counterpart offers no systematic defense of capital punishment, the French encyclopedia offers a relatively lengthy defense, arguing from reason and revelation and making specific mention of the accounts of Aquinas and Innocent III. It offers perhaps the clearest articulation of the retributive justification of the death penalty found in any work considered thus far:

> Justice demands that these sanctions be proportionate to the crimes. But it came clear to public conscience that some crimes such as murders, parricide,

treason, etc. . . . are so abominable and harmful to society that no punishment seems to be proportionate to them: nothing but death can punish such crimes. Then, the death penalty seems to be the only possible reparation a criminal can offer. . . . At this price, the wounds inflicted on social order (wounds that could kill it if they were multiplied) by the crimes will be healed.[130]

But retribution is not the only purpose noted. The French encyclopedia also argues that death can be used as an effective means of social protection:

since the first mission of authority is to protect good citizens, its duty to provide *legitimate defense* must concern [literally, "spread out towards"] not only its past or present, but also its future. In practice, only capital punishment is an effective means of social protection. Indeed, other punishments, such as jails or perpetual detention, do not scare the pervert as much as death, "the king of fright."[131]

This rather early use of the term *légitime défense* is worth noting. As discussed earlier, numbers 2263–2267 in the 1992 French edition of the *Catechism of the Catholic Church* make up a section entitled *La légitime défense*. There, as here, the term is broadly construed to include the three aims of punishment: criminal reformation, societal defense, and redress of the disorder caused by the offense. But unlike the French encyclopedia, the *Catechism*, at least in its *editio typica*, justifies capital punishment in terms of societal defense alone. The French encyclopedia, however, is clear that the death penalty can and ought to be inflicted for purposes of retribution.

Papal Writings and Periodical Literature. Papal writings and periodical literature of the nineteenth century continue the traditional teaching. For example, in 1853 and again in 1860 the distinguished Jesuit journal *Civiltà Cattolica* reviewed books by abolitionist authors. In each case the Catholic reviewer, opposing the book's thesis, states frankly the Church's belief that the death penalty is morally legitimate.[132] Arguments in defense of the death penalty appeal to revelation,[133] Church tradition,[134] reason, common sense, and human experience.[135] The aims of the death penalty are said to be retributive,[136] protective,[137] and reformative.[138] Despite this confident reassertion of traditional principles, it is interesting to note a new, albeit subtle, openness to the ideas of reduction and effective abolition of capital punishment.[139]

One hundred years later, the same confidence in the Church's perennial position is expressed in the same journal. In 1960 the Jesuit father Antonio Messineo, S.J., wrote: "The respect for the human person has, from the Church Fathers to Thomas Aquinas and up to the present day, with unchanged unanimity, always supported the legitimacy of capital punishment and, following from that, the power of the state to impose it for some well defined and especially serious crimes which have been singled out by positive law."[140]

From the little the Catholic pontiffs of the nineteenth and first half of the twentieth century say about the death penalty, we may confidently conclude that doubts about its basic legitimacy do not occupy their minds. In 1891 Leo XIII, in a pastoral letter on dueling, states that natural reason and divine revelation strictly forbid "killing or wounding of anyone *outside a public cause,* except when one is forced by necessity to defend one's own life."[141] Pius XI in *Casti Connubii* (1930) says, "no one has the power, not even the public authority, to destroy [life]. It is of no use to appeal to the right of taking away life for here it is a question of the innocent, whereas *that right has regard only to the guilty.*"[142] Where "no crime has taken place and there is no cause present for grave punishment, [public magistrates] can never directly harm, or tamper with the integrity of the body."[143] Aquinas, Pius adds, says precisely this when asking whether civil magistrates have the authority to inflict punishments for purposes of deterrent: "St. Thomas teaches . . . that the power indeed exists as regards certain other forms of evil, but justly and properly denies it as regards the maiming of the body. 'No one who is guiltless may be punished by a human tribunal either by flogging to death, or mutilation, or by beating.'"[144]

Pius XII, in his numerous addresses in the 1950s on punishment and related topics, mentions the death penalty several times, indeed, enough to assure us that he takes its legitimacy for granted. Yet like his predecessors, he never systematically raises the question of its morality. In an address in 1954 to an Italian association of Catholic jurists, Pius says that "no conscientious judge" who, after investigating the facts of a case, still entertains serious doubts about the status of the accused, "will proceed to pronounce a sentence of condemnation, all the more so when there is question of an irrevocable punishment, such as the death penalty."[145] Although punishments "concerning honor, . . . personal freedom, body and life" are common penalties,[146] reactions to them differ "depending on whether there is question of a long punishment, or of a short punishment, short in time, but surpassing in height and depth all time-measure—the pain of death, for example."[147] In 1957, again addressing Italian jurists, he says, "The penal justice of the past . . . that of the present to a certain

degree, and—if it is true that history often teaches us what to expect in the future—that of tomorrow as well, makes use of punishments involving physical pain . . . and capital punishment in various forms."[148] Pius made perhaps his most developed statement in 1952, in a discussion of the limits of public authority's coercive power:

> Even when there is a question of the execution of a condemned man, the state does not dispose of the individual's right to life. In this case it is reserved to the public power to deprive the condemned person of the *enjoyment* of life in expiation of his crime when, by his crime, he has already disposed himself of his *right* to live.[149]

Defense of the moral right to kill criminals remained part of mainstream Catholic belief well into the 1960s. London's *Catholic Truth Society* printed a tract on the death penalty in 1964 which stated that "the Catholic Church has always defended the view that the right, and therefore the power, of inflicting capital punishment on those who have been found guilty of more atrocious crimes, has been conceded by God to the lawful supreme civil authority for the common good." The author concludes: "A Catholic may not deny that the State has the right [to inflict capital punishment] and therefore he may not give his support to any movement for the abolition of the death penalty if such a movement is an expression of the denial that the State has the right to inflict it."[150]

The Logic of Catholic Resistance to Change

The trumpet call sounded in Western Europe in 1764 by the publication of Cesare Beccaria's highly influential *Dei delitti e della pene* ("On Crimes and Punishments")[151] was barely audible in Catholic ecclesiastical and theological circles.[152] And notwithstanding an unprecedented rise, over the next hundred years or so, in legislation abolishing the death penalty for many crimes, both in Europe and elsewhere,[153] Catholic thinkers were largely absent from the conversation.[154] Why is this? What kept the Church from receiving new ideas about the death penalty?

The early organized public efforts to eliminate (or limit, with a view to eliminating) capital punishment, at least for ordinary or "lesser" crimes, were almost exclusively secular phenomena.[155] Early spokesmen for the cause include Montesquieu, Voltaire, Robespierre, and Diderot in France, Hume and Bentham in Britain, and Fichte in Germany—all harsh critics of the Catholic Church and

its orthodox teaching, whose advocacy would inevitably provoke resistance from the Church. Moreover, concepts in British and Continental philosophy employed in defense of abolishing capital punishment, for example, ones drawn from social contract theory and utilitarianism, were rejected by the Church on their own terms as incompatible with sound anthropology and moral and political theory. Their use in the service of the new penal ideas made those ideas even more suspect. In addition, causes both intellectual and social in the eighteenth and nineteenth centuries hastened changes in attitudes toward religion, including attitudes toward death and judgment. As people placed increasing value on temporal life and less value on life after death, the finality of capital punishment loomed larger.[156] If by killing a person one thinks his existence ceases absolutely, one will probably view his killing differently than if his bodily death is a phase in a wider life before God. On this, Avery Dulles, S.J., comments: "When death came to be understood as the ultimate evil rather than as a stage on the way to eternal life, utilitarian philosophers such as Jeremy Bentham found it easy to dismiss capital punishment as 'useless annihilation.'"[157] Not surprisingly, religious terms like "purgation" and "retribution," valued in Christian tradition as goods related to punishment, lost their former meanings and became subject to ridicule.[158] Nor were Christians in general spared the bitter criticisms of secular authors, who laid at their feet responsibility for the massive bloodshed of the sixteenth- and seventeenth-century wars of religion.[159] At length, abolitionism—as a social movement to abolish capital punishment—became associated in the minds of many Catholic thinkers with opposition to orthodox belief and to the Church. Richard Evans, writing on the rise of abolitionism in nineteenth-century Germany, has observed that "the Christian Churches, Catholic and Protestant, and the political groupings most closely associated with them, were the most consistent supporters of capital punishment during this period, and the groups most hostile to them . . . were the most consistent advocates of abolition."[160] The same could be said for the debate in nineteenth-century France and Italy.

Catholic (and Protestant) resistance to abolitionist ideas and activism in the eighteenth and nineteenth centuries was in part a response to the moral and political ideas of Enlightenment philosophies, and in part a response to the patent anti-Christian attitudes characteristic of prominent leaders and members of movements for penal reform. One might argue that the Church's delay in accepting the new ideas was an expression of caution. It did not choose to side with the conclusions of secular philosophies before the errors of those philosophies had been sufficiently refuted.

The Church's Turn toward Opposition

Early Catholic Voices

Although the first signs of *official* opposition to the death penalty do not appear until the 1950s, arguments by modern Catholic authors against the death penalty go back to the eighteenth century. One of the earliest, by the Italian priest Cesare Malanima in 1786, is a straightforward theological argument based on the claim that the New Testament abrogates the Old Testament precepts prescribing death for crimes. If the precepts of the Old Law are valid under the New Law, he reasons, it follows that we should observe the Old Law; but in observing the Old Law we would be required to repudiate the New.[161] And this is obviously an error. By appealing to Scripture, Malanima's argument represents an early attempt by a Catholic writer to base opposition to the death penalty on a theological perspective.

In 1867 the French cleric Abbé Le Noir published a thoroughgoing utopian abolitionist philosophy in the second edition of Bergier's *Dictionnaire de théologie*. Le Noir conceives the history of humanity's involvement with the death penalty as analogous to Comte's three stages of the history of science. In the first age of humanity the death penalty is unknown—as a sign against it, God marks the forehead of Cain. In the second age, through human wickedness and the violation of natural right, the death penalty arrives on the scene. God tolerates a period of injustice and darkness in anticipation of the final age, ushered in by Christ, where the death penalty will vanish and Christians will reign in true justice. In the meantime, capital punishment should be opposed as illegitimate both in principle and as a goal of punishment.[162] Le Noir's argument is a mixture of historical utopianism, French positivism, and Christian eschatology, but is nonetheless interesting in the way it attempts to reconcile certain elements of Enlightenment philosophy with biblical theology.

In 1874 an Italian monsignor, G. C. Zanghy, published *Catholicism and the Death Penalty*, in which he argued that capital punishment is hostile to the spirit of the Catholic Church, a spirit which is gentle and opposed to all bloody punishment. This truth, he says, is attested to in Scripture, the Church Fathers and Doctors, the writings of the popes, and the history of the Church. The Old Testament precepts prescribing death were particularly meant for the Jews because of their "great propensity at that time toward disobedience." These precepts therefore cannot apply to Christians.[163] Zanghy's appeal to Scripture, the Fathers, papal tradition, and Church history is admittedly gratuitous, but his ar-

gument, like Le Noir's, is fascinating in the way it appeals to doctrinal sources traditionally used to defend capital punishment in order to argue *against* it.

Twentieth-Century Developments

The Catholic hierarchy in the first half of the twentieth century had little to say about the morality of capital punishment, as indicated above, and the few references by Popes Pius XI and Pius XII amount to little more than a guarded acceptance. It is not until the 1970s that the Catholic hierarchy began to openly and officially oppose the death penalty. But the tide was already turning in the two decades prior. At the time of the Rosenberg espionage case in the United States (1953), Catholic priests, bishops, and even Pope Pius XII made direct appeals to President Harry Truman to grant clemency.[164] When Carol Chessman was executed in California seven years later, the editor of *L'Osservatore Romano* wrote bluntly, "The execution of criminals is repugnant to the modern conscience."[165] In 1959 the auxiliary bishop of Chicago, Bernard J. Sheil, head of the Illinois Committee to Abolish Capital Punishment, said that "its members believe the death penalty is morally indefensible and that it brutalizes society by cheapening life."[166] In the same year Rev. Charles Sheedy, C.S.C., a dean at the University of Notre Dame, became a national board member of the American League to Abolish Capital Punishment,[167] and Donald Campion, S.J., published *America* magazine's cover story, "Should Men Hang?" in which he expressed the hope that soon "the gallows, the electric chair, the guillotine and the gas chamber . . . be relegated to our museums . . . [to] take their appointed places alongside the rack, the thumbscrew and other rightfully discarded instruments of earlier systems of justice."[168]

But these were the signs of change rather than its causes. Several factors seem to have contributed to the change. First, on the heels of the Second World War, a theoretical vocabulary, drawn in part from Enlightenment philosophy, in part from older sources in Western philosophical tradition, increasingly began to be used in public discourse to defend and promote the value and good of the human person. With the adoption and proclamation of the *Universal Declaration of Human Rights* by the General Assembly of the United Nations on 10 December 1948, that theoretical vocabulary, the subjective language of rights, e.g., "my rights," "her rights," human rights," took on a new prominence in ethical and political discourse. While the language itself tells us nothing new about the requirements of justice and the dignity of the human person—nothing new that is beyond what the Church has always taught[169]—it does so in a new way.

Rather than speaking about the duties we as agents owe to all persons by virtue of their having the natures they do, it refers to the claims we are entitled to make on others by virtue of the same truths. "Rights-language," properly understood, is the language of justice viewed from the perspective of the beneficiary of the just act rather than from the perspective of the duty-bound agent.

Despite ambiguities and errors associated with the rights theories that emerged from the Enlightenment—ambiguities causing the Church to delay ratifying the language of human rights[170]—the Catholic Church at length has judged that rights-language, properly conceived, is a medium of universal moral discourse on social issues that can be incorporated into its authoritative teaching. The first systematic declaration of the magisterium on human rights is John XXIII's encyclical *Pacem in Terris* (1963).[171] There the pope states:

> Any well-regulated and productive association of men in society demands the acceptance of one fundamental principle: that each individual man is truly a person. His is a nature, that is, endowed with intelligence and free will. As such he has rights and duties, which together flow as a direct consequence from his nature. These rights and duties are *universal* and *inviolable*, and therefore altogether *inalienable*.[172]

The U.N. General Assembly, in framing its Declaration as it did—including the statement in article five, "No one shall be subjected to torture or to cruel, inhuman or degrading treatment or punishment"—did not intend to say that capital punishment was illegitimate, at least in principle.[173] And presumably neither did John XXIII. The implications of the emerging public vocabulary for the question of capital punishment were less direct. Respect for human rights turned attention toward the subject, namely, the rights-bearer, and in so doing, invited sustained reflection on the basic implications for morality of our having the natures we do, with such rights and duties. This, I suggest, was and still is a factor influencing the Church's rethinking of questions of lawful killing.

Another factor that no doubt contributed to the rethinking of the death penalty by the Catholic hierarchy was the enormous disregard for human life during the wars and occupations of the twentieth century, exhibited by followers of ideological political systems such as Marxist-Leninism and Nazism, and many others. "The twentieth century," John Paul II writes, "will have been an era of massive attacks on life, an endless series of wars and a continual taking of

innocent human life" (*EV*, no. 17). This has led to a general erosion of confidence in the authority of the state to exercise the power of life and death over its citizens. People have become less willing to look on the state as a moral authority and to entrust to it the kind of powers that earlier generations tolerated and even defended. According to John Paul II,

> The State is no longer the "common home" where all can live together on the basis of principles of fundamental equality, but is transformed into a *tyrant State*, which arrogates to itself the right to dispose of the life of the weakest and most defenseless members. . . . When this happens, the process leading to the breakdown of a genuinely human co-existence and the disintegration of the State itself has already begun. (*EV*, no. 20)

Perhaps even more influential, however, was the unprecedented rise in liberal legislation in the twentieth century permitting the intentional killing of the innocent. At the turn of the century the legislative systems in Europe, Britain, and the United States agreed on issues such as abortion and euthanasia: abortion was criminal, and legalization of euthanasia was not even on the juridical map. In 1920 abortion was legalized under the new Soviet norms. In the 1950s permissive abortion laws were passed in the Soviet bloc countries of Bulgaria, Czechoslovakia, Hungary, Poland, and Romania. In 1967 the United Kingdom became the first Western democracy to legislatively approve abortion, an example that other Western countries were quick to follow: the Federal Republic of Germany, Denmark, and the United States (1973); Sweden (1974); France (1975); Italy, Luxembourg, and Greece (1978); the Netherlands (1981); Portugal (1984); Spain (1985); and Belgium (1990). Although the Netherlands to date is the only country to legalize euthanasia, organized efforts aimed at the same goal are active in most Western nations.[174] All this has drawn significant attention to issues of life and has mobilized the energies of the Catholic Church in defense of human life:

> This situation, with its lights and shadows, ought to make us all fully aware that we are facing an enormous and dramatic clash between good and evil, death and life, the "culture of death" and the "culture of life." We find ourselves not only "faced with" but necessarily "in the midst of" this conflict: we are all involved and we all share in it, with the inescapable responsibility of *choosing to be unconditionally pro-life.* (*EV*, no. 28)

Many (primarily Western) countries have also been passing legislation either abolishing the death penalty completely, or at least abolishing it for the more "ordinary" crimes: Ecuador (1906); Columbia (1910); Denmark (1930); Switzerland (1937); Italy, Finland, and the Federal Republic of Germany (1949); Austria (1950); Honduras (1956); New Zealand (1961); Dominican Republic (1966); the Vatican City State (1969); Sweden (1973); Portugal (1976); Spain (1978); Norway, Luxembourg, and Nicaragua (1979); France (1981); and the Netherlands (for ordinary crimes in 1870, completely in 1983).[175] The groundswell of popular and political support, together with national debates and associated literature leading up to the passage of such legislation, could not but have had influence on the thinking of the Catholic hierarchy.

Finally, philosophical changes in the West over the last three centuries emphasizing the individual over the community, and personal fulfillment over the common good, have altered contemporary views of the body. One implication is that not only the death penalty but bodily punishment in general is less palatable to the Western imagination.[176]

The year 1976 marks the date of the first official Vatican statement seriously raising the question of the death penalty. The Pontifical Commission for Justice and Peace, at the request of the American bishops, drafted a document intended to assist the United States Catholic Conference in reaching a consensus on the issue.[177] The first section addresses three questions: (1) whether the state has the right to inflict capital punishment; (2) whether capital punishment is contrary to or demanded by divine law; and (3) whether the magisterium has adopted an authoritative position. To the first, the document replies: "That the state has the right to enforce the death penalty has been ceded by the church for centuries." To the second, "The traditional doctrine is that the death penalty is not contrary to divine law nor demanded by divine law but depends on the circumstances, the gravity of the crime, etc." The document adds that neither the prescriptions of the Old Testament nor the teaching of the New Testament in themselves justify capital punishment "for today." The third question is treated at more length, concluding with four propositions summarizing the Catholic Church's position on the death penalty:

1. "The church has never directly addressed the question of the state's right to exercise the death penalty." Councils such as Lateran IV and Toledo (675) do not prescribe it, only express "an indirect acceptance of it."
2. "The church has never condemned its use by the state."

3. "The church has condemned the denial of that right" (referring to Innocent III's condemnation in the Waldensian oath).
4. "Recent popes have stressed the rights of the person and the medicinal role of punishment." (With regard to the medicinal role, the Pontifical Commission refers to discourses of Pius XII on crime and punishment; with regard to personal rights, it does not give names, but it is not hard to infer that Pope John XXIII is at the top of the list.)

Finally, addressing the principal concern of the U.S. bishops, the Pontifical Commission states: "Therefore, without reference to the American constitutional question, it can be concluded that capital punishment is outside the realm of practicable just punishments."[178]

Though the American bishops had gone on record as opposing the death penalty, once in 1974,[179] twice in 1977,[180] and again in 1978,[181] it was not until November 1980, four years after the reinstatement of the death penalty in the United States, that they issued their well-known *Statement on Capital Punishment*.[182] They outline ten reasons, religious and secular, why the death penalty should be abolished. Its abolition would (1) send "a message that we can break the cycle of violence . . . that we can envisage more humane and more hopeful and effective responses to the growth of violent crime"; (2) testify "to our conviction . . . that God is indeed the Lord of life"; (3) manifest "our belief in the unique worth and dignity of each person from the moment of conception, a creature made in the image and likeness of God"; and (4) be "most consonant with the example of Jesus, who both taught and practiced the forgiveness of injustice and who came 'to give his life as a ransom for many.'" On the other hand, inflicting the death penalty (5) eliminates the possibility of reformation; (6) can lead to the death of an innocent person; (7) brings "great and avoidable anguish" to the criminal; (8) can undermine popular trust in the legal process; (9) is often disproportionately inflicted on the poor and minorities; and (10) subjects criminals to "long and unavoidable delays."[183]

Since 1980 the U.S. Catholic bishops, either personally or in national or state conferences, have issued over 130 statements opposing the death penalty.[184] Other national Catholic conferences have also gone on record in the past twenty-five years in opposition to the death penalty, including the Canadian Catholic Conference (1976),[185] Irish Bishops' Conference (1976),[186] French Bishops' Conference (1978),[187] the Philippines Conference of Bishops (1992),[188] the Italian Bishops' Conference (1981),[189] and Roman Catholic Bishops of England and Wales (1983).[190]

■

If one juxtaposes the historic positions of the Catholic Church on capital pun-
ishment with the positions of many Catholic leaders in the final three decades
of the twentieth century, particularly the 1990s, the almost unavoidable ques-
tion is, What happened? I have proposed that the language of human rights
has provided a new perspective from which to reflect on the requirements of
human dignity; that the devaluing of human life in the twentieth century as a
result of wars and occupations has undermined public confidence in the state's
exercise of its coercive authority; that legislation permitting the intentional de-
struction of innocent human life has mobilized the Church in regard to all is-
sues of life; and that international trends to abolish the death penalty in the
twentieth century, at a time when the Church and secular society have greater
dialogue than ever before, have provided new incentives to reconsider questions
of lawful killing. The early resistance of the Church to the philosophies and ac-
tivism of movements favoring abolition of capital punishment has given way to
wholehearted acceptance of the cause; the situation has changed so thoroughly
that the Catholic Church is now perhaps the most outspoken opponent of capi-
tal punishment on the international scene.

But these factors alone fail to account fully for the dramatic transition. John
Paul II suggests that more is happening. In the midst of the "lights and shad-
ows" of our age, the new pro-life consciousness is one of the "positive signs" of
the victory of the blood of Christ, a sign of hope in societies and cultures other-
wise marked by the "culture of death" (*EV*, nos. 25–27). Amid the sociological
and intellectual influences I have mentioned, the pope suggests there are intan-
gible and non-calculable factors arising from the work of the Holy Spirit. Prayer,
time, and careful analysis will elucidate the degree to which this is the case.

PART III

■

RETHINKING THE CHURCH'S TRADITIONAL NOTION OF JUSTIFIABLE HOMICIDE

■

■

■

CHAPTER 7

■

Capital Punishment and the Development of Doctrine

■

The question prompting the historical survey in chapters 3 through 6 was this: is it possible for the Catholic Church, limited by the requirements of sound biblical exegesis and its own doctrinal tradition, to teach in an authoritative way that capital punishment is always morally wrong (the judgment to which the *Catechism of the Catholic Church* is pointing)? Before this question could be answered, it was necessary to set forth the Church's teachings on the morality of capital punishment and to examine their authoritative nature.

The cumulative consensus of patristic, medieval, and modern ecclesiastical teachings on the morality of capital punishment may be summarized as follows: (1) the death penalty is lawfully inflicted on the guilty by public authority alone; (2) the authority to inflict it derives from God and (3) is witnessed to in Scripture, the practice of the Church, and by natural reason; (4) its infliction serves to *protect* the community by removing a harmful influence, to *deter* other members of the community from serious crime by instilling a "salutary fear" of punishment, and to *redress* disorder caused by an offense by imposing on offenders proportionate and due punishment; (5) its lawful infliction requires an upright intention; (6) clerics are forbidden from participating in the sentencing and inflicting of capital punishments; and (7) not only the state but the Church possesses the authority to take life. I refer to this collection of propositions as the "traditional teaching." That it has been authoritative in some strong sense is indisputable. Does it meet the criteria for the strongest kind of authority—that

is, infallibility—which would rule out any reappraisal or substantive change in moral teaching?

With What Authority?

The charism of infallibility—a gift of the Holy Spirit—is the Catholic Church's "supreme degree of participation in the authority of Christ" (*CCC*, no. 2035) and is meant to ensure that the Christian faithful will be preserved "in the purity of the faith handed on by the apostles" (*CCC*, no. 889). Vatican II states that the magisterium of the Church, teaching on matters of faith or morals, participates in Jesus' infallible authority in three ways: (1) when the pope speaks *ex cathedra*, that is, when in his capacity as supreme shepherd and teacher of the universal Church he proclaims in a definitive act a doctrine of faith or morals; (2) when the bishops together with the pope (for instance, gathered at an ecumenical council) teach definitively a matter of faith or morals; and (3) when the bishops dispersed throughout the world, yet still united in a bond of communion among themselves and with the successor of Peter, agree on a judgment regarding a matter of faith or morals and teach that judgment as to be definitively held (*definitive tenenda*).[1] With respect to the first two modes, the task of determining whether infallibility has been invoked is rather straightforward. The question is either whether the pope intended to solemnly define a dogma, or whether the assembled bishops in a council intended to teach definitively a matter of faith or morals. The third mode, namely, the infallible exercise of the "ordinary and universal magisterium" (by the bishops "united in a bond of communion"), is not so straightforward, and merits separate discussion.

In chapter 4 I attempted to determine what the Fathers of the early Church held to be true about the morality of the death penalty and why they held it. Among those Patristic writers whose reflections permit us (directly or by inference) to know their views on the subject, we find unanimous agreement that civil authority, as guardian of the public good, has the right to inflict punishments on evildoers, including the punishment of death. As to why they held what they did, the reasons are at once theological, philosophical, and practical: theological insofar as Patristic writers ground their beliefs in the authority of Scripture, particularly in the writings of the Apostle Paul; philosophical insofar as they believed the same truths to be testified to by human reason; and practical insofar as their beliefs reflect the historical situations in which they lived and the conventional assumptions about the nature of authority and punishment

which they shared. However, none of the propositions in which the Fathers expressed what they held to be true satisfy the first two criteria of infallible proclamation outlined by Vatican II (proclamations intended to be definitive by the pope alone or by the pope in council with the world's bishops). The two councils considered in chapter 4 (the early-fourth-century Spanish Synod of Elvira and the late-fourth-century Council of Rome) were local rather than universal councils, and the relevant writings of Popes Gregory I and Innocent I were personal letters, not documents promulgated with the specific intent to solemnly define doctrine.

Has any proposition asserted by a medieval writer or council on the morality of capital punishment been proposed infallibly, in terms of the first two criteria of infallibility? The most important case is Pope Innocent III's statement in the Profession of Faith for the Waldensians that "secular power can without mortal sin impose a judgment of blood." However, given that this profession is directed to a particular group and not the universal Church, and that its promulgation is by means of pastoral and personal letter, not by means of a bull or otherwise universally authoritative document (e.g., the decree of an ecumenical council), not all the assertions in it should be taken as articles of faith, even though some of them *already* have been defined as articles of faith. If one of its propositions is not already a defined doctrine, the presence of that proposition in the oath to the Waldensians does not suffice to make it such. On this argument, Innocent's statement does not meet the criterion of an *ex cathedra* statement.[2] For similar reasons, the statements of Pope Nicholas I and Pope Alexander III also fail to satisfy this criterion. Nicholas' remark that the Church bears only a spiritual sword and Alexander's claim that clerics are not permitted to carry out a judgment of blood were made in the context of personal letters to fellow bishops. They were not the kind of universal promulgation required for a solemn definition.

What about constitution 18 of the Fourth Lateran Council (1215), which asserted the traditional clergy prohibition? Since the council was ecumenical, it is possible in principle that its promulgations include infallibly asserted propositions. But given the non-dogmatic nature of all but three of the Council's seventy constitutions (the exceptions are nos. 1–3), and the obviously historically conditioned nature of many propositions in nos. 14–22 (those dedicated particularly to the reform of clerical morals)—for example, clerics may not hunt or fowl or own dogs and birds for those purposes (no. 15), may not watch mimes and entertainers (no. 16), may not store personal furniture in their churches (no. 19), must have a suitable crown and tonsure (no. 16), and so

forth—it seems clear that the asserted propositions in this group of constitutions, including no. 18, are not intended *qua asserted* to constitute solemn definitions.

With respect to the papal statements examined in the first part of chapter 6 (on Catholic teachings between the Council of Trent and Vatican II), only one directly concerns the question of the morality of killing criminals, namely, the condemnation by Pope Leo X in *Exsurge Domine* of Luther's article that burning heretics is against the will of the Spirit. All the rest, including the statements of Leo XIII, Pius XI, and Pius XII, are allusions to or affirmations of the legitimacy of the death penalty in the context of statements asserting other propositions. For example, Leo XIII asserts that dueling is immoral, Pius XI asserts that it is always wrong for public authority to harm, tamper with, or destroy the life and bodies of its innocent subjects, and so forth. Does *Exsurge Domine* infallibly propose that Luther's error is false? No, it proposes only that the proposition is among a set of articles whose members are either heretical *or* scandalous *or* false *or* offensive to pious ears *or* seductive of simple minds, and are thus obstructive to Catholic truth.[3]

This leaves the third mode of infallibility. Has the traditional teaching or any of its propositions been infallibly taught by the Church's "ordinary and universal magisterium"? According to Vatican II, in *Lumen Gentium*, the third criterion of infallibility requires positive answers to the following four questions: (1) Have the bishops scattered throughout the world remained united in a bond of communion among themselves and with the successor of Peter in regard to the question of capital punishment? (2) Have they authoritatively taught on the morality of capital punishment? (3) Have they agreed on one judgment? (4) Have they proposed that judgment as "to be definitively held"? (*LG*, no. 25). To the first two questions the answers seem to be affirmative. As I have shown in the preceding chapters, bishops have taught or upheld the traditional teaching on the morality of capital punishment in their capacity as bishops, and there does not appear to have been any notable dissent nor divisions on this matter, either among themselves or between them and the pope.[4]

The third condition, that the bishops agree on one judgment, emphasizes the necessary "universality" of the infallible ordinary magisterium. The bishops in union with the pope enjoy infallibility when they teach *as a whole*. This, of course, requires not "mathematical" unity but "moral" unity. John Ford and Germain Grisez have broadly described the two kinds of evidence we might look for in discerning moral unity. The first is

that a certain point of teaching has been proposed by bishops repeatedly, in different times, in different places, in response to different challenges, that the bishops have articulated and defended this point of teaching in different intellectual frameworks, perhaps reinforcing it with varying disciplinary measures. Moreover, there must be no evidence that the point of teaching has ever been questioned or denied by any bishop or by anyone else authorized to participate in the Church's teaching mission without eliciting an admonition and a reaffirmation of what had been universally taught.[5]

Do we find this kind of evidence with respect to the traditional teaching? It seems so. Among the judgments considered (which included those of twenty-two bishops,[6] among whom were eleven popes,[7] of two ecumenical councils,[8] and of three synods of bishops[9]), there were no examples of principled dissent from a scripturally grounded teaching acknowledging the God-given right of civil authority to inflict the death penalty on behalf of the welfare of the community, assuming this right is exercised fairly and judiciously, and excluding clerical participation. Moreover, many judgments explicitly affirm one or more of the propositions of the traditional teaching, and even more indicate a tacit acceptance of one or more. In one instance, a denial of the traditional teaching elicited ecclesiastical censure and discipline, namely, Innocent III's Profession of Faith for the Waldensians. In another, a position contrary to one or more of the articles of the traditional teaching was authoritatively condemned, namely, Leo X's condemnation of Luther's view.[10] Moreover, Pius V promulgated (in accordance with a decree of Trent) a universal catechism, the first of its kind, which was widely used for several centuries and which taught several of the propositions of the traditional teaching. While these examples hardly prove that the traditional teaching was universally accepted and taught by Catholic bishops, the absence of any dissent remotely comparable to the contemporary dissent makes it reasonable to draw such a conclusion.

The second kind of evidence for moral unity, or universality, is the unanimous consent of the faithful to a given teaching. Based on the contributions of Catholic philosophers and theologians and the teachings of catechisms and moral manuals, it is reasonable to conclude that the conditions for universality have been met. The basis for this conclusion is, again, the absence of any noteworthy dissent and the broad spectrum of positive approval (from Fathers and Doctors of the Church to works of canon law, influential catechisms, and

many, if not most, of the approved manuals of moral theology from Trent to Vatican II).[11]

The final condition specified by Vatican II for an infallible exercise of the ordinary and universal magisterium is that the judgment upon which the bishops agree must be proposed "as one that has *to be definitively held*" (*definitive tenenda*) (*LG*, no. 25). Given that the bishops had agreed on one judgment regarding the lawfulness of capital punishment, the question is whether that judgment has been proposed as *definitive tenenda*. According to Ford and Grisez, this does not necessitate a unified and explicitly intended communal act of teaching on the part of the world's bishops, nor can it require solemn definitions from each individual bishop. It does, however, require that in proposing a teaching on the lawfulness of capital punishment, a bishop does so in a way that is "not at his option but as part of his duty to hand on the teaching he has received; not as doubtful or even as very probable but as certainly true; and not as one which the faithful are free to accept or to reject but as one which every Catholic must accept."[12]

But more is required than the simple fact that a teaching is proposed as authoritative. The terms used in *Lumen Gentium* for the fulfillment of this condition are critical. The Latin word *definitive* ("in a definitive way") here, unlike elsewhere in *Lumen Gentium* no. 25, relates not to the quality of the act of teaching, but to the manner in which the teaching, having been received, is held by the faithful.[13] This implies, and experience confirms, that certain things have been or are being proposed by bishops to explain, apply, and elaborate on Christian doctrine which are *not*, nor should they be taken to be, part of the "deposit of faith" and hence are not to be definitively held. Moreover, even truths pertaining to faith or morals are taught without being proposed as *definitive tenenda*, for example, teachings that experience no active opposition from critics, the surrounding culture, or the faithful in general. In discerning, therefore, whether or not a teaching has been proposed as *definitive tenenda*, it is essential, among other things, to attend to the relevant details of a bishop's reassertion of the teaching for any indication that those to whom the statement is addressed require a reassertion in this manner.

Among the authors I considered from the Patristic period, there is little evidence to suggest that the lawfulness of capital punishment was proposed as *to be definitively held* by more than a few of them. Of the three successors of Peter who raised the topic in any way—Innocent I, Leo the Great, and Gregory the Great—Leo says nothing directly about the morality of capital punishment except that the Church shuns bloody punishment; Gregory, in the context of a

personal letter, expresses a sentiment whose relation to the problem of capital punishment is inconclusive; and Innocent I, in a letter to a bishop concerning what to do about civil officers who carry out capital punishment after their baptism, says that "nothing definitive from the forefathers" has been taught. His letter then repeats the customary interpretation of Romans 13, calling it a teaching which we dare not deny without seeming to "go against the authority of the Lord." Pope Innocent, here instructing a fellow bishop, hands on a traditional teaching with the intention of dispelling doubts—the bishop is apparently inclined to resist or at least doubt the conclusion—as to whether the officers in question rightfully sentence offenders to death. This, it seems to me, is an example of a bishop teaching something as *to be definitively held*.

Among the two synodal texts considered in chapter 4—those of Elvira and Rome—canon 73 of the former deals with the death penalty only in relation to Christian participation, and the propositions of the latter are ambiguous. Among the writings of eight other bishops, only those of Ambrose and Augustine contain references explicitly treating the morality of the death penalty. But Ambrose's "fear to venture a response" and his comment that in light of the authority of the Apostle, "we dare not deny them [magistrates who inflict capital punishments] communion," uphold a particular position but do not formally assert that position. Most of the positive assertions of Augustine on the lawfulness of capital punishment are in the context of didactic or polemical theological treatises.[14] One exception is found in a pastoral letter to a Christian schismatic, Emeritus, who has said that Christians should never treat anyone with harshness (*Letter 87*). Augustine, urging Emeritus to return to right belief, asks, "Is it right to oppose the powers which are set up for that purpose? Or shall we erase the Apostle? Do your books contain what I quoted a while ago [Rom. 13:2–4]?"[15] Augustine is defending the coercive power of civil authority to someone inclined to reject it, and doing so by an appeal to Scripture, implying to that extent that this teaching pertains to Christian faith. This, too, seems to be an example of a bishop teaching the lawfulness of capital punishment as to be definitively held.

The sermons of Chrysostom contain no explicit assertions on the morality of the death penalty. Neither do the letters of Cyprian or the monograph of Irenaeus. With regard to the other Patristic writers I considered, Tertullian and Lactantius do not directly discuss capital punishment, and the teaching of Hippolytus relates not to the morality of the death penalty per se, but to professions unsuitable for Christians. Only the writings of Clement and Origin make direct assertions about the lawfulness of capital punishment, but since neither

were bishops, their statements, properly speaking, are not instances of authoritative episcopal teaching. That is, they are not instances of bishops teaching in union with the pope. One might argue that this is a distinction without a difference. Such an argument, however, would miss the point. The prerogative of infallibility, as Vatican II affirms, has been entrusted by Christ to Peter and to the apostles in union with Peter, so that through the apostolic teaching and preaching Christ might guide the Church in truth and guard it from serious error. The pope and bishops, therefore, as legitimate successors of Peter and the apostles, endowed by virtue of their succession with Christ's authority, are in the fullest sense "authentic teachers" of the Christian faith (*LG*, no. 25); they enjoy this endowment precisely *because* they are successors of the apostles. Hence, the bishops' teachings enjoy divine assistance when, in union with the pope, they teach *in their capacity* as successors of the apostles, not when they write or speak otherwise as citizens, theologians, scholars, administrators, and so forth. The extensive theological writings of theologians-turned-bishops—a progression common, for example, in Germany—do not constitute part of their pastoral teaching office, and the faithful are not bound in conscience to give them special heed. The same can be said for the theological writings of Karol Wojtyla, bishop of Krakow (for example, "The Acting Person," 1969), as well as for the non-authoritative writings of Pope John Paul II (for example, "Crossing the Threshold of Hope," 1994).

Among medieval authors other than Innocent III, the only proposition from the traditional teaching consistently and forcefully taught by bishops *qua* bishops is the clergy prohibition. Likewise, the two provincial councils of Toledo (AD 633 and 675), Lateran IV (1215) and the Decretals of Gregory IX (1234) assert a clergy prohibition, but none make explicit positive assertions about the morality of capital punishment.[16] This leaves the Profession of Faith for the Waldensians, in which Innocent III teaches the principles of proper authority, upright intent, and the fair and judicious carrying out of capital sentences. No one can deny that he proposed these principles to the reconciling members of the Waldensian sect as a moral norm to be definitively held.

The situation among post-Reformation prelates is more complicated. The traditional teaching on capital punishment during this period is set forth with great consistency by some of the most eminent Catholic thinkers, but we find few examples of an episcopal teaching deliberately intending to establish a judgment on the morality of capital punishment and to exclude its opposite as contrary to the faith and morals of the Church. Bishop Cajetan (in his commentary on q. 64, a. 2) , Bishop Bellarmine (in *De Controversiis*), and Bishop de

Liguori (in *Theologia Moralis*), for example, assert the lawfulness of capital punishment, the need for lawful authority, the divine origin of the state's coercive power, and so on. In each case, however, they do so in theological monographs, that is, acting in their capacities as theologians, not in episcopal writings. The writings of de Lugo, Lessius, and Billuart are those not of bishops but rather of theologians. Catholic encyclopedias and periodical literature of the period, while lucidly repeating the authoritative teaching, are not episcopal documents and hence possess no authority per se to teach what is to be definitively held.

Leo X's condemnation of Luther's proposition that burning heretics is contrary to the will of the Holy Spirit (*Exsurge Domine*) is certainly taught as to be definitively held. But the pope's censure asserts with certitude neither the moral legitimacy of the death penalty nor the falsity of Luther's proposition. As already noted, it merely states that the proposition in question is among a set of propositions whose members are either heretical or scandalous or false or offensive to pious ears or seductive of simple minds, and thus are obstructive to Catholic truth. This leaves us with the *Roman Catechism* and the statements of twentieth-century popes.

The *Roman Catechism* authoritatively reaffirms the legitimacy of the death penalty and asserts in particular the principle of lawful authority. Should its teaching on capital punishment be taken to have been proclaimed *definitive tenenda?* There are good reasons for answering both in the negative and in the affirmative. On the one hand, the document is catechetical. It contains neither canons nor condemnations.[17] Given the fact that both Catholics and Protestants in the sixteenth century were virtually unanimous in affirming the right of civil authority to inflict the death penalty, what reason could there have been for a bishop, a pope, a council, or a catechism to propose this same teaching not merely as true but also, for the sake of the faith, as to be definitively held? On the other hand, it is a document episcopally approved and promulgated by Pope Pius V that intends to teach Catholic doctrine (specifically, to instruct Catholic clergy to offer sound catechesis and sacramental instruction to those under their spiritual charge) and hence to dispel error. Given the conflicting reasons, the answer to whether its teaching meets the fourth condition for an infallible exercise of the ordinary and universal magisterium is inconclusive.

Leo XIII's allusion to killing "in a public cause" in his pastoral letter on dueling is no more than a passing reference to the lawfulness of capital punishment in a section otherwise dedicated to condemning the kind of intentional wounding and killing involved in dueling. Likewise, Pius XI in *Casti Connubii* alludes to the right of public authority to kill the guilty (and only the guilty), but

he does so in order to authoritatively refute the objection that abortion is not always wrong, not to teach in a definitive way that capital punishment is morally upright. The conclusion that these two references amount to proposing a teaching to be definitively held seems to me unwarranted.

Pius XII in a 1952 address stated: "In this case it is reserved to the public power to deprive the condemned person of the *enjoyment* of life in expiation of his crime when, by his crime, he has already disposed himself of his *right* to live."[18] This affirmation of the basic lawfulness of killing criminals was made in the context of a discussion intending to specify the limits of the coercive power of public authority. In this wider context it becomes clear that the proposition being asserted as to be definitively held, if any, is not that the death penalty is legitimate, but that the state has no *right* to dispose of the life of individuals.

As for the manuals of moral theology in the post-Reformation period, most were authorized by Catholic bishops for use in seminaries, hence for the training of future confessors and the formation of the consciences of the Catholic faithful. Although the manuals themselves lack episcopal authority, it is not unreasonable to conclude that their moral teachings were universally held and proposed by Catholic bishops. Is this a sufficient ground for concluding that their teachings were universally taught by Catholic bishops as to be definitively held? For a judgment to be established as an infallible teaching of the ordinary and universal magisterium, more, it seems to me, is needed than a statement in an approved textbook. It is not enough for a theologian, or many theologians, to say that the teaching on capital punishment is part of the constant and unchanging teaching of the Church, or that it is part of natural law, or that the Church has no authority to change the teaching, or that contrary assertions contradict Scripture, the perennial practice of the Church, and natural reason. Bishops themselves must explicitly and authoritatively teach the same. The fact is that in the post-Reformation period, all sorts of moral questions are addressed by Catholic bishops, including clandestine marriages in Belgium (*Denz.* 1452 ff.), usury (*Denz.* 1475 ff.), baptism of Jewish children (*Denz.* 1480 ff.), the misuse of magnetism (*Denz.* 1653 ff.), dueling (*Denz.* 1939 ff.), cremation (*Denz.* 1863 ff.), craniotomy (*Denz.* 1889 ff.), abortion (*Denz.* 2242), sterilization (*Denz.* 2283, 2245 ff.), sex education (*Denz.* 2251), eugenics (*Denz.* 2252), divorce (*Denz.* 2249 ff.), the natural law (*Denz.* 2279), and even the practice of demanding the name of an accomplice by confessors in the sacrament of reconciliation (*Denz.* 1474). However, *no* such document, not even a canon or a condemned proposition in such a document, addresses the question of capital punishment with the intention of authoritatively judging its morality and rejecting opposing views—none,

that is, before the second half of the twentieth century. In the absence of specific instances of moral teaching in the form of episcopal documents (ones by specific bishops, groups of bishops, or regional or general councils, or catalogues of condemnations, curial documents, and the like), the evidence that the lawfulness of capital punishment was *both* held to be a matter of faith by the bishops of the world *and* taught to the Christian faithful as a matter of faith *to be definitively held* is inconclusive.

In response to the question whether the traditional teaching on the morality of capital punishment has been infallibly proclaimed by the ordinary and universal magisterium, I offer the following provisional answer. With regard to the four criteria outlined by Vatican II, the evidence supports the conclusion that the first three criteria have been met. The writings of Catholic bishops and councils of bishops going back to early Christianity contain an explicit or implicit affirmation of one or more of the propositions summarizing the Church's traditional teaching. These affirmations have remained constant, and the bishops have remained united in them among themselves and with the successor of Peter. If chronological scope and the magnitude and firmness of consensus were all that were necessary for the bishops in their ordinary teaching to proclaim doctrine infallibly, there could be little doubt about the status of the Church's traditional affirmation of the lawfulness of the death penalty. But *Lumen Gentium* states that the bishops' judgment on an issue, even their united and firm judgment, is not enough to assure the protection of the Holy Spirit from error. As teachers of the Christian faith, the bishops must teach that judgment to the faithful not simply as a doctrine of Christianity, nor as a probable or very probable conclusion of Christian faith, but as a matter of faith, certainly true, to be definitively held by all. Their act of teaching and the faithful's act of receiving are complementary, and it is in this movement of teaching and receiving that the Holy Spirit secures and advances the right belief of the Church.

As I have argued, the evidence does not warrant the conclusion that this final criterion of the ordinary and universal magisterium has been met. Scattered episcopal statements assert all or part of the traditional teaching as to be definitively held, but the majority of episcopal statements are not proposed in this manner. More often than not, the lawfulness of capital punishment is directly or indirectly affirmed only in the context of discussions, condemnations, and affirmations of other points of human morality.

If the traditional teaching of the Church on the morality of capital punishment does not meet the necessary conditions outlined in *Lumen Gentium* for an

infallible exercise of the ordinary and universal magisterium, it follows that a rethinking of the traditional teaching is possible. The problem apparently posed by Genesis 9:6 (with its underlying affirmation that humans have a role in mediating divine justice by inflicting retributive punishment, specifically, the punishment of death) still stands and is not resolved here. Instead, I propose to consider the term "development of doctrine" and to ask in what sense the current magisterial teaching on capital punishment might be understood as a development.

The Idea of Development of Doctrine

The word "doctrine" comes from the Latin word *doctrina*, the Vulgate translation of the Greek terms διδασκλία and διδαχή, meaning simply instruction or teaching. *Doctrina* is used in the Bible to refer to both the teaching (1 Timothy 4:6, *enutritus verbis fidei et bonae doctrinae*) and preaching (Acts 2:42, *in doctrina apostolorum*) of the Apostles, who understood their task as that of faithfully handing on the teachings they had received from Christ. The term "Christian doctrine" was popularized by Augustine in his monograph by that name.[19] Session 5 of the *Council of Trent* mandated the widespread teaching and preaching of Christian doctrine, and the influential catechisms of the sixteenth century were among the first fruits.[20] Even today the word "doctrine" is often used with catechetical overtones to refer loosely to Church teaching in all its forms.[21] Its usage, however, is often imprecise or poorly defined. It may mean simply "that which one thinks true, an opinion," "a resolution or decree," "a philosophical tenet," or, in the Catholic tradition, "defined doctrine," "definitively taught doctrine," and so forth. It is therefore important to establish a working definition.

The reality that divine revelation makes known to human persons is God himself as a communion of persons and his invitation to all men and women to share in his divine life.[22] God's self-revelation is communicated through words and deeds, imperfectly at first in creation and the history of Israel, and finally, in its fullness and perfection, through the words and deeds of the public life of Jesus Christ.[23] The enduring reality of God's revelation received and existing in the world constitutes the faith of the Church, whose outward expressions are at once affective, cognitive, and volitional.[24] The objective correlate to the cognitive expression of faith is knowable truth that can be expressed propositionally in human language.[25] By the term *doctrine*, I refer to a proposition asserted in Scripture or by the magisterium about what is (or is not) the case or what is (or

is not) to be done. According to this definition, doctrines include both revealed and non-revealed propositions. This is consistent with the meaning of its Latin cognate, *Christiana doctrina,* which simply means "Christian teaching" or "instruction." I refer to a proposition asserted by the magisterium intending to identify a truth as revealed by God, or as logically or historically connected with revealed truth, and to exclude its contrary as incompatible with the faith of the Church, as a *definitive doctrine.*

What do we mean when we say doctrines develop? In what ways or by what modes do they develop? A distinction is necessary here. Doctrines, defined as propositions (theoretical or practical) asserted in Scripture or by the magisterium, may be divided into two kinds: those that are infallibly asserted and hence are irreformable, and those that are non-infallibly asserted and hence are *in principle* reformable. I will consider the concept of development in relation to each kind of doctrine.

With respect to irreformable doctrines, the problem of development can be formulated as the problem of reconciling the third statement with the first two:

1. There is no new public revelation after the death of the last apostle.[26]
2. The truths of revelation are trans-temporal and unchanging.
3. The creeds and other definitive Church teachings contain propositions that are not stated in Scripture or the apostolic deposit.

Perhaps the two most influential theological attempts to resolve the apparent inconsistency are by Vincent of Lérins (d. ca. AD 445) and John Henry Newman (1801–1890). Vincent's major contribution to the theology of development is his notion of continuity in the midst of progress, and Newman's, his seven characteristics or "notes" of a true development.

Early in his famous work, *Commonitorium,* Vincent states that he endeavors to provide for himself a trustworthy rule for distinguishing Catholic truth from heresy.[27] His rule is straightforward: in questions concerning Christian belief and practice, Scripture and tradition constitute the sure norm. Because Scripture is subject to conflicting interpretations, it must always be read in accordance with the authoritative interpretation of the Church; the standard of that interpretation is the conformity of a belief with the principles of *universality, antiquity,* and *consent.* Namely, the faithful are to believe what the Catholic Church *everywhere* confesses; to believe in accordance with interpretations *always* held to be true by the ancient fathers; and to believe such interpretations

as have been acknowledged by *all* who have been charged with the ministry of teaching. Hence, Vincent's famous dictum: *quod ubique, quod semper, quod ab omnibus creditum est.*[28]

Vincent outlines a rough practical method for applying his rule. In doctrinal disputes, resolution should first be sought in the judgments and decrees of general councils; if matters remain unsettled, the judgments and opinions of ancient masters should be explored;[29] and whatever one shall ascertain "to have been held, written, taught, not by one or two of these only, but by all, equally, with one consent, openly, frequently, persistently, that he must understand that he himself also is to believe without any doubt or hesitation."[30]

Vincent holds that this continuity, which is required for the preservation of orthodox belief, does not exclude progress, but he insists that any progress be what he calls "real progress," not an "alteration of the faith."[31] To illustrate real progress, Vincent appeals to biological imagery. He notes that the human body as it develops from infancy through adulthood changes in stature and outward form, though all the while preserving the person's essential identity; "nothing new is produced in them [persons] when [they are] old which was not already latent in them when [they were] children."[32] The same can be said for wheat; no discrepancy exists between what was sown and what is reaped. "There may supervene shape, form, variation in outward appearance, but the nature of each kind must remain the same."[33] So it is with Christian doctrine. What was once "believed in simplicity" is later "believed intelligently."[34] Yet amidst modifications in form, and growth and clarifications in meaning, real progress admits of no fundamental change of sense, no loss of character, and no enlargement beyond circumscribed limits.[35]

John Henry Newman, in his *Essay on the Development of Christian Doctrine* (1845), observes that not all doctrinal developments can be called "true" developments. As a disease can be called a development of the body but yet is untrue to the body's proper functioning, so certain doctrinal developments are not true to their origins and hence end up as "corruptions." A corruption is a "false or unfaithful development," a "perversion of the truth."[36] To discriminate between healthy developments and corruptions, Newman identifies seven characteristics or "notes" of genuine developments.[37] If a doctrine preserves its type (i.e., develops in "due proportions, and yet remains identically what it was");[38] if it maintains continuity with its basic principles;[39] if it has a power of assimilation (the power to incorporate external ideas without dissolving into them);[40] if it demonstrates logical sequence (i.e., has developed according to—or at least not in contradiction to—the laws of logic);[41] if it anticipates its future shape in

its early stages,[42] yet is conservative upon its past (i.e., invites investigation to see if its later form has conserved "the course of antecedent developments, being really those antecedents and something besides");[43] and if it expresses chronic vigour (i.e., both "tenacity" and "continuity," neither the one nor the other by itself, since alone each is a sign of corruption);[44] then it is reasonable to conclude that a particular doctrinal development is a true development.

Both Vatican I and Vatican II, as well as Popes Pius XI and Pius XII, have endorsed in varying degrees the notion of doctrinal development. Vatican I teaches that doctrines of the faith are to be understood according to the meaning given them by the Church, and this meaning must not be abandoned under pretense of a more profound understanding: "May understanding, knowledge and wisdom increase as ages and centuries roll along, and greatly and vigorously flourish, in each and all, in the individual and the whole church: but this only in its own proper kind, that is to say, in the same doctrine, the same sense, and the same judgement."[45] Pius XI, in defense of the tradition of faith, writes, "to be sure, nothing factitious is introduced, neither is anything new added to the highest truth of those things which are at least *implicitly* contained in the deposit of revelation entrusted to the Church."[46] His successor twenty-two years later, reflecting on the duties of the magisterium in relation to theologians, writes: "it is their [the theologians'] duty to indicate how what is taught by the living *magisterium* is found, either explicitly or implicitly, in Sacred Scripture and in divine 'tradition'. . . . God has given a living *magisterium* to His Church, to illumine and clarify what is contained in the deposits of faith obscurely and implicitly."[47] Vatican II takes a further step by asserting that the apostolic tradition "progresses [*proficit*] in the church under the assistance of the Holy Spirit. There is growth [*crescit*] in understanding of what is handed on, both the words and the realities they signify."[48] In each case, legitimate development is joined to the Vincentian idea of continuity in the midst of progress. While it is true that the Church's understanding of revelation develops and matures with time, nevertheless, the fundamental affirmations put forward in the apostolic deposit are unchanging.[49] To admit this, however, is no more than to admit that revelation itself is unchanging.

As indicated above, divine revelation includes an intelligible (i.e., propositionally expressed) invitation to participate in a more-than-intelligible relationship with God. The invitation is actualized through the exercise of faith. Therefore, faith enables the believer to attain in and through propositional knowledge the divine mystery which is faith's object; in a real sense, revealed propositions are an introduction to the fuller mystery of the life of God.

Although adequate for their purpose, they are still partial insofar as the reality of the mystery they express is not exhausted by their content.

This, then, is the starting point for development in relation to revealed doctrines: the partial and imperfect understanding of revealed truth by those living by faith in the Church Militant under the guidance of the Holy Spirit. Because of the definitive and fully determined character of revelation, whatever is not at first explicit (or, rather, understood explicitly) is nevertheless already indicated in the explicit. In a process prompted by the contingencies of history and culture and the impulses of a living faith, implicit aspects of revealed truths, under the guidance of the Holy Spirit, may emerge from the deposit of revelation into the consciousness of the Church, making way for a fuller and more perfect understanding, and hence verbal expression, of the divine mystery, while all the time maintaining continuity with antecedent principles and types. This definition applies both to doctrines of faith and doctrines of morality.[50]

Moral Doctrines and the Infallible Magisterium

According to the consistent teaching of the Catholic Church, the competency of the magisterium to teach authoritatively, including its competency to teach infallibly, extends to truths of the natural law.[51] Two types of moral doctrines are possible objects of infallible teaching.[52] The first are moral doctrines that do not constitute part of divine revelation, sometimes called "secondary objects of infallibility"—secondary because, while not themselves revealed, they are necessarily connected with divine revelation insofar as they are required for its preservation and faithful exposition.[53] The second are doctrines which do constitute part of divine revelation. Although they are naturally accessible to unaided human reason, God, we might say, judged it necessary to include them in divine revelation. The Congregation for the Doctrine of the Faith teaches that it "is a *doctrine of faith* that these moral norms can be infallibly taught by the Magisterium."[54] The precepts of the Decalogue are an example of moral norms that are part of divine revelation *and* can be infallibly taught.

What is the possibility of error in magisterial teaching? In one sense, none. By definition the Church, exercising its prerogative of judging infallibly, is preserved from the possibility of definitively asserting an erroneous proposition. Of course, it goes without saying that the unaided human mind not infrequently errs in judgment. And while it is true that divine assistance ac-

companies the Church even in its non-infallible teaching capacity, it is also true that the verity of such acts of teaching is not guaranteed. It is therefore possible that particular pastors (including bishops, among them the bishop of Rome), because of cultural limitations, incorrect philosophical or theological assumptions, emotional biases, and the like, have judged wrongly and have ended by asserting a false proposition, despite the fact that the assertion presupposed judgments which may have been true.[55] It follows that it is necessary to determine whether a moral doctrine is a possible object of infallibility before determining the precise nature of a development associated with it.[56] If it is, its meaning and the pattern of its development must be strictly governed by its antecedents. If it is not, then other patterns of development are *possible*.

The danger in speaking about the reformability of magisterial teaching, of course, is that this can lead to a sort of theological positivism, which treats non-infallible moral doctrines as if they were not obligatory. Such, however, would be in clear contradiction to Church teaching, which states that the faithful are bound in conscience to form their beliefs and actions not only in accord with the infallible teachings of the magisterium, but also in accord with its ordinary, non-infallible teachings.[57]

One might argue, given my concern with the question of infallibility, that my method is itself infected with a false dichotomy: either infallible or non-authoritative. This complaint, however, misses the point. What is at stake is whether the traditional teaching on the morality of capital punishment is part of Christ's fixed will for human morality and hence human flourishing. If the traditional teaching has been proposed infallibly, the question is answered. If it has not, the question *in principle* remains open. One might argue that even if the traditional teaching turns out to be non-infallible, its status in the tradition is such that a subsequent revision, even by an authoritative magisterial source, would have to provide a satisfactory demonstration of the insufficiency of the traditional view. I agree. But this is beyond the scope of the present work. The evidence suggests that a fundamental revision is on the horizon, evidence stemming not from the secular media, nor from public opinion, nor even from the community of Catholic theologians, though many of these sources concur. The evidence derives from the papacy of John Paul II. To read into John Paul's teaching the content of the traditional teaching is, in my judgment, a failure to take his teaching seriously; and to disregard what he *is* teaching, as many have done and continue to do, is irresponsible. My purpose in this and the preceding chapters has been to ask whether such a revision is possible. If the Church were to

take the next step, a more thorough authoritative *apologia* for the revision—more thorough than that which we find in the *Catholic Catechism* and *Evangelium Vitae*—may well be expected.

Development of Non-Irreformable Doctrines

I suggest that there are two possible patterns of development for *non-irreformable* moral doctrines. The first I will call *development as filtering and reformulating*, and the second, *development as specification*.

Development as Filtering and Reformulating

The document *Instruction on the Ecclesial Vocation of the Theologian*, discussing the possibility of "deficiencies" in non-infallible magisterial teaching, observes that theologians who are competent in history will no doubt be aware of "the filtering which occurs with the passage of time." Further,

> The theologian knows that some judgements of the Magisterium could be justified at the time in which they were made, because while the pronouncements contained true assertions and others which were not sure, both types were inextricably connected. Only time has permitted discernment and, after deeper study, the attainment of true doctrinal progress.[58]

The text does not elaborate upon its reference to assertions in ecclesiastical pronouncements that "were not sure." But since the reference is juxtaposed to a reference to "true assertions," it is reasonable to conclude that its scope includes magisterial assertions that were false. Now, truth and falsity are predicated of propositions as asserted (assertions), and of judgments, or acts of affirming or denying propositions. Assertions can be simple or complex. A true assertion can follow immediately from an empirical observation with little or no deliberation. For example, Emily rings the doorbell; I see her and say, "Emily's here." Other assertions, however, presuppose a process (sometimes complex) of deliberation and judgment on the truth or falsity of prior propositions.

Taking the above passage and these reflections as a point of departure, I propose a process whereby false propositions presupposed by complex assertions are filtered out and, in consequence, new assertions on the matter in ques-

tion are formulated. The process looks something like this: we begin with ethical question X; the longstanding answer to X, namely, complex assertion A, is suspected of being false; a process of examination brings to light the fact that A presupposes false proposition Z. Why, then, we ask, was A taken to be true in the first place? We determine that (among other reasons) it was because complex assertion A not only presupposes false proposition Z, but also true proposition(s) Y (and K, L, M, \ldots). By way of correction, Z is filtered out and new assertion B is adduced in answer to question X.

Doctrinal development in this respect is a process of filtering out false propositions from complex assertions and formulating new complex assertions. The process may be deductive or inductive. We may first recognize an erroneous presupposition within a complex assertion and only then formulate a new assertion. Or, we may first suspect that the general complex assertion is false, scrutinize its presupppositions, identify and separate out the erroneous one(s), and finally, formulate a new assertion.

By way of example, suppose we consider the ethical question, "What is the correct behavior of Christians toward others in light of the problem of human sinfulness?" A partial longstanding answer, "All people who do evil ought, as far as possible, to be avoided," is one that we now suspect is false. On examination we find that it presupposes a false proposition based on a misguided interpretation of 2 Corinthians 6:14 ("Do not be mismated with unbelievers"); the false proposition runs, "Only members of our enlightened group are free from evil while all outsiders are not." Why was the false answer taken to be true in the first place? We discern that it is because our longstanding answer (complex assertion A) also presupposes the true proposition, "Good is to be done and evil avoided." We filter out the erroneous presupposition and formulate the new, more satisfactory assertion B: "All occasions that incline us to do evil ought, as far as reasonably possible, to be avoided."

True and even infallibly proposed assertions may also have false presuppositions. These, however, would be merely contingent elements of the assertion. Development in this case would be a process, over time, of distinguishing between what is necessary to the true assertion and what is merely contingent. So, for example, while it is possible that the definitive Catholic teaching on the all-male priesthood historically presupposed false propositions regarding the inferiority of women, the substance of the teaching was and is founded on true propositions. As we see in recent magisterial reflections on the dignity of women, such judgments no longer inform the understanding of women in the Catholic Church or the enduring teaching on the sacerdotal priesthood.

Development as Specification

The second mode of development concerns the precision with which doctrines are specified. Propositions as asserted are intended to relay meaning. But the successful communication of that meaning depends (in part) on the degree to which the terms chosen to relay that meaning are understood. Poorly chosen language or imprecise concepts can obfuscate the meaning of a statement. For example, a student of late-twentieth-century youth culture might make the statement: "Members of 'Generation X' dangerously yearn for transcendence." Unless we know precisely what is meant by the terms "Generation X" and "transcendence," the statement is ambiguous. "Yearn for transcendence" might mean "have a propensity to contemplate suicide," or "is attracted to the bizarre and the lurid," or "is in search of a deeper meaning in things than has been proposed by science," or any of a number of other things. Again, one might readily affirm the proposition, "There exists a non-universalizable ought." But should it be affirmed? Is it true? That depends on how the concept "ought" is being used. Taken conventionally, that is, in a non-morally specified way, it might indeed be true. We often say things like "The rain has finally stopped, I really *ought* to get out and garden a bit," or "I *ought* to get up an hour early and exercise today," referring to actions which in most circumstances are not morally required. But if "ought" is specified in its strict "Golden Rule" sense, then such a ready affirmation is not so certain. Strictly construed, even "oughts" associated with a person's peculiar vocation could be said to be universalizable insofar as these are shaped by the prior normative proposition that "each person is bound by the duties of his or her peculiar vocation." Many assertions, because of unspecified terms, leave themselves at once open to affirmation and denial: "The weather is *fine*," "The monarchy is *healthy*," "The guillotine is *cruel* and *unusual*." In the absence of specification one is left to interpret the statement as best one can.

The meaning of moral doctrines is subject to similar ambiguities, particularly regarding the way behavior is defined. Morally specified terms, such as "murder" and "adultery," can be taken to refer to kinds of behavior which are defined purely conventionally or behaviorally; or, as should be the case, they can be taken to refer to actions specified in terms of precise intention and choices. For example, if "murder" is taken to mean any deliberate act that foreseeably results in the death of another, then many more acts are characterized as murder than if "murder" is rightly defined as killing the innocent with intent. Development in this instance would mean specifying with increasing precision

the nature of the moral acts under consideration, or the language with which the acts have hitherto been described, with the possible result that the sense in which a moral doctrine has been interpreted stands in need of revision.

Capital Punishment and Development: What Mode?

If my conclusion regarding the authoritative nature of the traditional teaching is correct, then it is *possible* that a definitive teaching contradicting one or more of the propositions of the traditional teaching could be proposed by the magisterium. I shall attempt, therefore, to outline the shape that a development of doctrine could take if the Catholic Church one day were to teach that the act of intentional killing normally referred to as capital punishment is intrinsically evil.

A process whereby erroneous presuppositions are filtered from complex assertions and new assertions are formulated is one way that moral doctrines can be said to develop. Let us relate this to the problem of capital punishment. The analysis is slightly more complicated than it was in the example sketched above (on Christian behavior toward non-Christians), but follows the same basic logic. We start with ethical question X: "What forms of punishment best correspond to the concrete conditions of the common good and are most in conformity to the dignity of the human person?"

Until recent times the magisterium may very well have given the following answer (complex assertion A): *for human dignity and the common good of society to be honored and preserved, the deliberate crimes—especially grave crimes—of social offenders should be punished, if need be with death. Therefore capital punishment is legitimate and should be defended in the face of those who publically deny it and/or seek to have it abolished.*

This answer presupposed the following propositions: (Y) deliberate crime brings into existence a disorder in civil society, and grave crime, grave disorder; (K) to preserve the conditions for the common good this disorder must be redressed; (L) proportionate punishment can redress this disorder; (M) it is legitimate to impose proportionate punishment upon offenders, including grave punishments on grave offenders; and (Z) the act of killing entailed in lawfully executed capital punishment is legitimate and should not be subsumed under the norm forbidding homicide.

These presuppositions presuppose at least two more propositions: (N) that civil magistrates derive their lawful authority to kill criminals from the authority of God, and that this is a truth attested to in Scripture; and (P) that

when public authority kills the guilty with intent, the act is fundamentally different from an act of killing the innocent with intent; for a systematic account as to why, most Catholic authors would have appealed to the reasoning of Aquinas, who says that grave sinners descend from the order of human reason to the order of beasts and may be treated accordingly (*ST*, II-II, q. 64, a. 2, ad 3).

What if, based on sound scholarship now or at some time in the future, we concluded that the arguments from Scripture are inconclusive and those of Aquinas are mistaken? And what if we further concluded that not only is killing the innocent with intent wrong, but killing anyone with intent is wrong, no matter the circumstances? This would mean that Z (and hence N and P) is false. Complex assertion A was taken to be true for two reasons. First, because it presupposes true proppositions Y, K, L, and M. And second, because to deny complex assertion A would have been taken as an implicit denial of the retributive principle outlined in Y, K, L, and M. It would have been taken as implying that (R) the death penalty is excessive or beyond the measure, and in *that* sense unjust or unfair, no matter how grave the offense; but R is false.

On this conjecture, we must filter out proposition Z from A and formulate a new assertion B, taking care that it does not imply that R is true. The new complex assertion B might look something like this:

> The nature of certain offenses is such that an offender could not complain of distributive injustice (i.e., unfairness) if, as punishment, he were deprived of life; yet capital punishment is still wrong, not because it is unfair (in the distributive sense just stated), but because as an act precisely intended to destroy human life it is a violation of inalienable human dignity and hence a violation of the norm singling out and forbidding all such acts. Therefore, although punishing deliberate crime is good and necessary for the maintenance of the common good, non-lethal punishments should always be chosen.[59]

This is essentially the conclusion that, as I have argued in chapter 1, lies inchoate in the teaching of the *Catechism of the Catholic Church*.

But *filtering and reformulating* would not be all that was required. Because the new assertion B has implications for other forms of so-called justifiable homicide, for example, killing in a just war and in the course of police duty, its terms would need careful *specification* in order to make clear what kinds of acts are and are not singled out by it as contrary to human good. This is addressed in the next and final chapter.

▪

By proposing in this chapter a sketch of a reasoning process from *A* to *B* (that is, from pro to con vis-à-vis the morality of capital punishment), I have tried to highlight the *continuity* in a developmental reasoning process which can otherwise look terribly discontinuous. The Church historically conceived the question of the legitimacy of the death penalty in terms of retribution and community safety. A series of social and intellectual conditions has led to a process whereby the Church began to analyze the question in terms of the morality of the act itself in relation to the intrinsic good of the person being punished. Careful to avoid the conclusion that punishment does not serve a necessary end by restoring a disrupted social order, or does not provide a necessary line of defense for the community, the Church has begun to teach that capital punishment is an unacceptable means for serving these necessary social ends. It is worth recalling the observation of Gino Concetti in his 1993 monograph, *Pena di morte:* "Nobody has ever posed the question whether such a practice might be opposed to the moral order and to the dignity of the human person."[60] As I suggested at the end of chapter 1, this is the ground upon which the development of Catholic doctrine is being built. Because the value of every human life, intrinsic and inalienable, renders wrongful every deliberate attack against it—because it yields a right which may never be deliberately violated—capital punishment and every other kind of intentional killing are wrong.

■

Toward an Ethical Judgment that Capital Punishment Is Intrinsically Wrong

■

Thus far I have set forth only the conclusions of what I have called the *new position* of the Catholic Church on the morality of capital punishment, and have merely hinted at what a wider theory yielding such conclusions might look like. My purpose in this final chapter is to develop the suggestions of previous chapters into a systematic and philosophically consistent account of the new position. This account is not intended to be a free-standing moral theory, but rather stays as much as possible within the tradition of practical reasoning to which the Church is committed, and supplements that tradition only where it remains silent. John Paul II's pontificate, which has done the groundwork on capital punishment, has also provided a succinct account of the rational foundations of human morality in the 1993 encyclical *Veritatis Splendor*. I have already summarized this account in chapter 1, and the present chapter relies upon that summary.

Veritatis Splendor does not address all the relevant points. In particular, it remains silent on the notion in Catholic moral tradition of "exceptions" to the norm against killing. On the question of exceptions I turn to Aquinas, who has provided the most systematic and influential account in the Christian tradition of the foundations for justifiable homicide. I argue, however, that his attempts to give a rational account of certain forms of justifiable intentional killing fail, and indeed that his account is not even consistent with his own general moral theory.

The final part of this chapter undertakes the specification of terms that is necessary to clarify the implications of the new position for other teachings in the Catholic tradition of "justifiable homicide," specifically, killing in self-defense, the lethal activities of law enforcement officials, and killing in a just war, as well as the implications for the right of the state to punish in general. Again, it is necessary to go beyond *Veritatis Splendor*, whose account of the foundations of morality leaves undeveloped the notion of basic human goods and their relationship to concrete moral norms. Here, too, I appeal to the moral reasoning of Aquinas, as well as the development of Aquinas' moral theory by Germain Grisez and John Finnis.

The New Position of the *Catechism* Developed

The Catholic Church has never taught that all intentional killing is wrong. The apparent inconsistency between elements of fundamental moral reasoning on the value of human life and the scope of the negative norm protecting human life has traditionally been overcome by limiting the norm to the killing of an innocent person. This is, for example, the model used by Aquinas[1] and by *Evangelium Vitae* in the formulations of its three most authoritative negative norms.[2]

Is this to say that a guilty person is not absolutely immune, morally speaking, from intentional killing? Although Catholic natural law theory has assumed that respect for human life is a basic moral requirement, the Catholic tradition has answered in the affirmative. Two exceptions have traditionally qualified the norm, namely, the killing of malefactors and killing in a just war. When Catholic scholars have asked how these two types of intentional killing can be lawful while killing the innocent with intent is always wrong, the most influential response in the tradition has been that of Aquinas. The cliché that all philosophy is a footnote to Aristotle is aptly applied to Aquinas in this regard: all post-Aquinas arguments for the lawfulness of capital punishment are footnotes to the *Summa Theologiae*, II-II, q. 64.[3] It is no exaggeration to say that the *rational* plausibility of the traditional philosophical position depends in large measure on the viability of Aquinas' reasoning.

The Norm against Killing in Aquinas

According to Aquinas, the norm against killing, applied to private individuals, admits of no exceptions: a private person may *never* choose as an end or a

means to kill (or even to harm) a human being for any reason.[4] Why is this? Although Aquinas does not answer directly, we can infer his answer from what he says in other passages, in particular, what he says about suicide.

Aquinas proposes an imaginary interlocutor who argues for the lawfulness of suicide as follows: the wrongness of wrongful killing (*homicidium*) is that it is contrary to justice; but no man can do an injustice to himself; therefore killing oneself is lawful. Aquinas replies: "*Homicidium* is a sin, not only because it is contrary to justice, but also because it is contrary to the *charity* which one ought to have toward oneself."[5] His distinction between justice and charity is not significant in itself because injustice, too, is a sin against charity, the charity we owe our neighbor. What is significant, rather, is his reference to charity. He speaks about the ground for charity as follows:

> To kill oneself is always illicit since everything naturally loves itself; and to this belongs the fact that everything naturally preserves itself in being, and resists corruptions as much as it can. Wherefore, killing oneself is contrary to the inclination of nature, and contrary to charity [*caritatem*] by which every man ought to love himself. Therefore, killing oneself is always a mortal sin, insofar as it is contrary to the natural law and contrary to charity.[6]

It would seem Aquinas is arguing that the wrongfulness of suicide lies in its contrariety to the natural inclination to preserve oneself in being. A close reading, however, reveals a different line of reasoning. Yes, killing oneself is contrary to the natural inclination to preserve oneself. And yes, charity is natural to all and in that sense can be said to be proper to human nature. It does not follow, however, that killing oneself is contrary to charity *because* it is contrary to the inclination to preserve oneself. If that were so, charity would derive from the inclination to self-preservation. Rather, the charity that is morally relevant to the act of self-killing is grounded not in inclinations, but in the rational recognition of the fundamental goodness of human life.

Aquinas speaks in the *Summa Theologiae*, in his famous question on natural law, of the human inclination to preserve oneself in being.[7] He argues that the order of inclinations corresponds to the order of the first principles of the natural law. But the first principles of the natural law, or practical reason (*ratio practica*), are not derived—in the sense of inferred—from inclinations, or from a prior account of human nature, or, for that matter, from anything else. That is precisely why they are called *first* principles: they are first in the sense of primary or basic, not derived from any more basic principle(s).

For Aquinas, first principles are "self-evident" (*per se nota*, i.e., underived and known in themselves) and universal.[8] He is not thereby claiming that these principles exist in us in the form of innate ideas or in the form of nonrational intuitions. These principles are neither understood nor assented to until their relevant terms are understood. And such understanding can only come about through what Aquinas calls "induction," that is, through association with things first experienced through the senses.[9] So, for example, if I do not understand what human life is, I cannot come to the non-inferential judgment that human life is good and action on its behalf to be pursued.[10] And I cannot come to understand what human life is unless I come into sensory contact with it, unless I see, touch, smell, or hear myself and others. But the claim that knowledge of first principles depends upon prior knowledge gained through sense experience does not imply that such knowledge is attained through a process of deductive reasoning. Rather, when we come to understand the terms of the first principles we recognize without appealing to a middle term that those principles are true, and that the goods toward which they direct us are choiceworthy. This intellectual grasping, Aquinas holds, is analogous to the way we grasp, without inferential reasoning, the verity of the principle of noncontradiction (i.e., "a thing cannot be simultaneously affirmed and denied").

As first principles of practical reason, these principles are the differentiated propositional content of that which first falls under the practical intellect's understanding, namely, human good or simply "the good" (*bonum*):[11] our first intellectual movement when contemplating action is toward human good. And the most basic undifferentiated first principle (*primum praeceptum*) is that "good is to be done and pursued, and evil avoided."[12] On this, Aquinas says, "[is] founded all the other principles of the natural law; so that all those things-to-be-done (or to-be-avoided), which practical reason naturally understands to be human goods [or their contraries], pertain to the principles of the natural law."[13] Human goods, "naturally" understood as such, act as first practical principles. As the first principles are said to be primary or basic, similarly, the goods toward which they direct us can be called "basic": they are not means to any more basic goods but rather goods sought for their own sakes.[14] The first practical principles, therefore, are rationally intelligible starting points (and in that sense sources) of human action. They direct the acts of intelligent agents toward basic human goods; their directiveness is a principle of action. The goods they specify are recognized as desirable, as choiceworthy, and as ends to be pursued, and those things which are opposed to them are recognized as bad and to be avoided. Motive to act is not a product of dumb emotions (*pace* David

Hume), eternal fitnesses (*pace* Samuel Clarke) or a superior's will (*pace* William of Ockham). It is a result of the attractive force of human good.[15]

How do the inclinations fit into this account? In Aquinas' words, "good has the nature of an end, and evil, the nature of a contrary, hence it is that all those things to which humans have a natural inclination, are naturally understood by reason as good, and consequently as objects to be pursued, and their contraries as evil and to be avoided."[16] As something to be pursued through action, human goods are practical ends. By the term "end," Aquinas makes clear that the inclinations to which he is referring are rational inclinations. Basic human goods are basic objects of human rational inclination, or equivalently, objects of innate rational interest. The intellectual movement that begins a practical endeavor must have an intelligible starting point or points, lest action never occur at all. And those starting points are things perceived in themselves as desirable to pursue and to attain, namely, basic human goods.

Aquinas correlates the various levels of human inclination with ascending levels of created things, from the subhuman to the human. Why? Aquinas was first and always a theologian. As a result he is concerned with locating the subject matter at hand in the context of his general theory of reality. When discussing practical science (the order of action of free and intelligent agents in accord with the way things ought to be), he always keeps in mind his speculative views concerning the way things are. His speculative ideas on cosmology, influenced by recently translated works of Aristotle, particularly the *Metaphysics*, as well as by the Neoplatonism of the Dionysian corpus,[17] probably led him to treat the inclinations as a way of situating the human person within the great metaphysical hierarchy of created being. To this end, he identifies those things that humans share in common with all substances, namely, the inclination to preserve themselves in being; that they share in common with other animals, namely, inclinations to procreation and nurture; and that they possess *qua* humans (i.e., as having a rational nature), namely, inclinations to know truth, especially about God, and to live in community.

Thus, charity is grounded not in inclinations but in the intelligent recognition of human goods. Desire in humans is motivated by the practical recognition of possible human goods as opportunities for action and as worthwhile objects to be pursued.[18] It follows, for Aquinas, that in the proper order of things the desire "to be" (i.e., to be alive rather than dead, to remain living and to sustain the integrity of body and soul) is preceded in rational creatures by the intelligent recognition of the goodness of life. Practical reason recognizes that life is a good to be pursued and that what is contrary to life is to be avoided.

This, then, is the rational ground for love. We love in ourselves and in others the basic good of human life; we love, if you will, the good nature God has created: "In every man, even in a sinner, we ought to love the nature that God has made."[19]

How do we get from the basic practical judgment that human life is good to the normative judgment that the intentional destruction of human life—one's own or another's—by private individuals is always wrong? The reply, for Aquinas, is that the reasonableness of love of self and neighbor (i.e., of loving the good natures we recognize in ourselves and in our neighbors) gives rise to a negative norm that bears upon actions intending to harm or destroy human life. In other words, it gives rise to a norm that excludes intentional killing.

Is all intentional killing excluded? Not according to Aquinas. The norm binds without exception only in relation to private individuals. But is it not reasonable to conclude from Aquinas' own account that the negative norm should be construed as forbidding *all* actions contrary to life, with "contrary" specified primarily in terms of the intentional? The logic, after all, seems plain. The premises are as follows: whatever human reason naturally understands as good or evil belongs to the first principles of the natural law as something to be done or avoided;[20] human reason naturally apprehends the preservation of human life as good and worthy of pursuit, and that which is contrary to human life as bad and worthy of avoidance;[21] and what is primary (though not sufficient) for purposes of morally assessing the goodness or badness of any given instance of human behavior is the intentional.[22] It seems to follow that the various precepts of the moral law should include the assertion that the intentional harming or destroying of human life is contrary to human good and therefore understood and judged by practical reason to be bad and to be avoided.[23] Yet that is not Aquinas' position.[24] Instead, he holds that the norm against intentional killing does not bind without exception in relation to public authority.

Killing the Guilty: Aquinas' Part-to-Whole and Gangrenous Limb Analogies

If we are to love the nature with which God has endowed all people, even sinners, how can it ever be permissible to choose to kill another person? As discussed earlier, Aquinas answers in the first place by appealing to an Aristotelian model of the relationship of a part to its whole.[25] It is justified to remove a part that is endangering the whole, such as a gangrenous limb of the human body; similarly, "if any man is dangerous and corrupting to the community on account

of some sin, it is praiseworthy and salubrious that he be killed, in order to pre-serve the common good."[26]

The analogy breaks down in several places. First, it operates on the as-sumption that the unity of the "whole community" (*tota communitas*) is like that of a human body. But a foot or a finger exists for the body in ways both like and unlike a person for the community. Granted that the good order of a com-munity depends on the cooperation of its members, yet the existence of a mem-ber makes sense apart from the community in a way that the existence of a limb, or an organ or even a system of organs does not apart from the body. With respect to the body, the only "life" that can meaningfully be spoken of is the life of the body; other than as a metaphor, it makes no sense to speak of the "life" of a finger. But the members of a community are distinct lives in their own right apart from the life of the community. In one way we can say the members of a community, like those of a body, rise and fall together; in an-other, we must acknowledge that members, with their contingencies, opportu-nities, distinct vocations, and free wills, rise and fall alone. Eyes and hands will necessarily go to Gehenna with the heads of the bodies of which they are parts; the same cannot be said of citizens and heads of state.

Aquinas himself acknowledges the distinction between the two types of "wholes" in his commentary on Aristotle's *Nicomachean Ethics*, when he identi-fies the relevant senses of "unity" in the two cases. For the political community, the unity of the whole is only a unity of *order*. For an object like a human body there is also a unity "of composition, or of conjunction, or even of continuity, and according to this unity a thing is one absolutely."[27] Aquinas is clear that a part in the first sense of unity can have operations which are not the operations of the whole. In the second sense of unity, the operations of the part are also the operations of the whole. Having said this, however, Aquinas still draws a strict analogy between humans and parts of the body. But it is not difficult to see that the amputation of a putrid limb is different in a fundamental way from the killing of a harmful member of the community. In the former, no integrated and distinct living being is destroyed.

Removing a diseased limb is more properly compared to a separation pro-cedure than to a killing. The analogy best fits an argument for the separation of dangerous members from the communities of which they are a part, rather than an argument for their deaths.[28] Suppose that a gangrenous appendage were not a limb but rather another person, as in the case of a pair of Siamese twins, one of whom is dangerously diseased. Morality requires intervention aimed at separating the diseased twin from the healthy twin, while attempting

to preserve the lives of both. Common morality would hardly justify intention-
ally killing the diseased twin for the sake of the other.

Aquinas' reasoning breaks down further. In slightly different language
from that quoted above on the relation of part to whole, Aquinas writes: "every
part, as such, belongs to the whole [*est totius*]; now every man is part of the
community, hence, what he is belongs to the community [*est communitatis*]."[29]
Here again, Aquinas tends to absolutize the whole with respect to its parts. A
person's communal existence, however, is not limited to the state. A person
exists in a number of different communities, ranging from the family, to neigh-
borhoods, to church, to other communities of common interest, each con-
tributing to the person's good in unique and incommensurable ways and no
single one constituting the person's total communal life. If the state did consti-
tute one's total communal existence, one might be justified in speaking of the
individual as naturally existing "for the sake of the whole" (*propter totum*) and
perhaps even, by extension, being killed for the sake of the whole. But the state
is not absolute relative to the individual, nor do individuals live exclusively for
its sake. Nor can the levels of a person's communal existence even be said to
coalesce at the level of the state, since interdependence and cooperation be-
tween present-day states in our day are constitutive of a state's communal exis-
tence (as they were in Aquinas' day, although to a lesser degree). More strongly,
much of what is proper to the life of intermediate communities is simply out-
side the purview of the state. For example, central to one's membership in the
Christian community is the *communio* of the people with God in Christ, and
with one another as members of Christ. While the state must protect freedom
of religion and even should favor—without coercion—religion in general, it is
quite incompetent to preach religious teachings, conduct religious services, or
organize and guide believers. With this in mind, Vatican II defined the "com-
mon good" as instrumental to the goods of persons.[30] Finally, the communal re-
lations and dependencies of Christian and other religious believers often
transcend the earthly community altogether, including for Christians, particu-
larly for Catholics, the community of saints in purgatory and heaven.

The role of the individual relative to civil society is one of citizen, taxpayer,
voter, and so on, while the role of civil society relative to the individual is lim-
ited to providing services that cannot reasonably be provided by smaller com-
munities. Most significant among these are the establishment and enforcement
of laws aimed at the peaceful ordering of all society's members as they live to-
gether in the civil community and in their smaller communities, as well as com-
mon defense against external threats to the life and weal of the state.

The difficulties associated with assigning persons to the category of "parts" are not unknown to Aquinas. He was familiar with the problems raised by the famous *usus/fruitio* distinction of Augustine in *De Doctrina Christiana*.[31] Augustine divides all of reality into two categories: things to be enjoyed (i.e., loved for their own sakes) and things to be used (i.e., loved for the sake of something else). God alone occupies the former category, and all other things, including persons, the latter.[32] Augustine avoids a crass instrumentalization of persons by arguing that God is to be loved for his own sake and all others are to be loved *for the sake* of God, and that in heaven we will enjoy both God and neighbor, God for himself and our neighbor in God.[33] Nevertheless, he does not escape the criticism that according to his theory, men and women are loved as means and not as ends in themselves.[34]

Not content to put individuals in the category of *usus* alone, Aquinas tries to carve out another position. He knows that something which exists only for the sake of the good of something or someone else has the character of an instrument and hence is subject to slavery, a status he assigns to all nonrational creatures.[35] But he deliberately does not put rational creatures in this category. Rather than categorizing humans as a class of objects, he adopts the concept of, as it were, a class of subjects.

In book III of the *Summa Contra Gentiles*, where Aquinas treats this topic, he states emphatically that rational creatures are subject to divine providence differently from all other creatures. All other creatures are moved to their respective ends by being acted upon. Intelligent creatures alone move themselves by their free acts. Humans, therefore, are in a class of their own.[36] Among all creatures, the human person alone is governed by God for his own sake (*propter seipsas*).[37] He alone is prized by God, not merely as a member of a species, as are nonrational creatures, but also as an individual (*individuo*).[38] He exists, therefore, both for himself and for the sake of the species. He is both a member of a species and a whole in himself.[39]

Aquinas even overcomes the limitations of his own part-to-whole analogy. In words almost identical to those he will use later in the *Summa Theologiae*, he states that "all parts are ordered to the perfection of the whole, since a whole does not exist for the sake of its parts [*partes*], but, rather, the parts are for the whole."[40] He then makes a fascinating move. He proposes that men and women are not to be understood as parts in the same way all other substances are parts, i.e., sharing in the whole only as far as they have being. Men and women have a closer relationship to the whole insofar as they are able to comprehend in their intellects the entirety of being (*totius entis*): "each intellectual substance is, in a

way, all things."[41] We might say the human person has the universal in himself. It follows that humans should be cared for not only for the sake of something else, but also according to what befits them as individuals.[42] Aquinas holds, in effect, that the good of an individual is analogous to the good of a whole. Yet when he comes to the question of the death penalty, he still maintains that the human person—a part relative to the whole, a whole relative to itself—can be sacrificed for the sake of the whole.

Killing the Guilty: Grave Sinners as Beasts

Suppose we grant for the sake of argument the plausibility of Aquinas' part-to-whole analogy and hence the conclusion that the community has a claim on individuals such that one who threatens the common good may be intentionally killed. The objection still holds that such an act, apart from any beneficial states of affairs it promises, is in itself wrong, because, as the intentional destruction of a person's life, it is contrary to the charity we are bound to have for all. Aquinas states this objection in the following terms: a good end can never justify doing what is evil; but killing a person is evil since we are bound to have charity for all, which includes willing our friends to live and exist; therefore killing sinners is in itself evil. As discussed earlier, Aquinas replies:

> By sinning man departs from the order of reason, and therefore falls away from *human dignity*, insofar as man is naturally free and exists for his own sake, and falls somehow into the slavery of the beasts, so that he may be disposed of according to what is useful to others. . . . Therefore, although it be evil in itself to kill a man who preserves his *human dignity*, nevertheless to kill a man who is a sinner can be good, just as it can be good to kill a beast. . . ."[43]

Aquinas has already argued that killing the innocent with intent is always wrong. Here he says that killing one who preserves human dignity is evil in itself. But he then introduces a problematic idea: by sinning, a person "departs from the order of reason, and therefore falls away from human dignity." While it is always wrong to kill one who preserves human dignity, it is not only permitted but even can be good to intend to kill one who because of some sin has fallen from human dignity; such a person may be treated like one would treat dumb animals, namely, "according to what is useful to others." "Human dignity" in this passage is the morally relevant element Aquinas puts forward as

the key to whether or not someone is legitimately subject to intentional killing. If a person preserves human dignity, he may never be intentionally killed; but if he loses human dignity, he may. What is the nature of the human dignity Aquinas appeals to here, which is relative to one's moral state and which, when preserved, stands as a moral barrier between a person and every intentional homicidal attack?

This is a difficult question to answer because Aquinas himself is not clear. Typically, for Aquinas, to refer to the dignity of a thing is to refer to its intrinsic goodness: "dignity signifies the goodness of something according to itself" (i.e., for its own sake).[44] *Human* dignity, therefore, refers to the intrinsic goodness of human persons *qua* human persons. A human person, according to Aquinas (and *Veritatis Splendor*), is a unified and active subject constituted by a material body and a rational (immaterial) soul. (The rational soul is the substantial form of a person and, as such, is necessarily corporeal.)[45] Human nature, therefore, is a rational nature. It follows that the intrinsic goodness of human rational nature is the subject of human dignity.[46] And since one's rational nature cannot be lost, neither can one's dignity.[47] Human dignity in this sense is predicated of human nature and therefore is not relative to one's moral state; one cannot "fall away" from human dignity so conceived.

Is there another plausible understanding of human dignity that Aquinas might be using in this passage? We might look to his treatment of the human person as *imago Dei*. Asking how God's image is found in every human person, Aquinas replies that it is found "by reason of human intellectual nature"; that nature is most perfectly like God when it imitates God's act of understanding and loving himself; hence, Aquinas concludes, "we see that the image of God is in man in three ways." The first way corresponds to what every human being possesses inasmuch as every human being, like God, has a natural aptitude for understanding and loving; the second corresponds to those who are just, inasmuch as the just know and love God, albeit imperfectly; and the third corresponds to the blessed, inasmuch as the blessed know and love God perfectly.[48] Each way, we might say, is a source of human dignity insofar as each corresponds to a different level of relatedness to God, the first and third being inalienable, and the second being alienable. Is it possible that the second level of dignity is the dignity from which Aquinas says sinners fall and, having fallen from, makes the sinner a legitimate object of intentional killing? It is unlikely.

Aquinas is clear that there is only one principal sense in which the image of God subsists in the human person, and that is by reason of human rational nature.[49] The "three ways" he refers to are not three different properties of human

nature—not three distinct *imagines Dei*—but rather three ways the one ratio-
nal nature imitates God's intellectual nature.[50] They are not God's image per se
but rather proper functions of that image.[51] And it hardly need be said that the
divine image in the human person in the form of rationality cannot be lost
through sin.

Let us return to our question on human dignity. Aquinas has maintained
that it is intrinsically evil to kill one who preserves human dignity, but that by
sinning a person falls away from human dignity and therefore it can be legiti-
mate to kill him. What precisely is the nature of the *human dignity* that sinners
fall from but that when preserved makes it always wrong to kill them? What is it
that is preserved in innocence and lost through sinning? We might look to an-
other passage in Aquinas dedicated to the question of killing the innocent:

> a person can be considered in two ways: first, in himself, second, in relation
> to something else; considering one in himself, it is never licit to kill him be-
> cause in everyone, even in a sinner, we ought to love the nature which God
> has made, which through killing is destroyed. Nevertheless . . . the slaying
> of a sinner becomes lawful in relation to the common good, which is cor-
> rupted by sin.[52]

Intentionally killing a person, considered in himself (i.e., in relation to himself
as having a rational human nature), is wrong. Why? Because, as stated above,
we are bound to love in ourselves and others the good nature God has created
and that killing destroys. But intentionally killing a person, considered in rela-
tion to the whole of which the sinner is a part, can *become* legitimate. But why?
Is a sinner in relation to his community any less human or any less due charity?
Aquinas is quite clear that sin does not diminish the good of human rational
nature and hence that charity is due sinners, too.[53] Why, then, when we move
from considering the part in itself to the part in relation to the whole does the
logic regarding the love we owe to all on account of their God-given natures no
longer hold? If we *ought* to love all people, even sinners, on account of a dignity
arising from rational human nature, and if killing someone is destroying his
God-given nature, then why is it ever permissible to intend to kill a sinner?
Moreover, if all acts of suicide (i.e., intentional self-killing), even the suicide of
grave sinners, are wrong because they are contrary to the charity we owe to our-
selves,[54] why is the killing of another person, even a grave sinner, not contrary
to the charity we owe to our neighbor and hence wrong? Aquinas says that a
judge condemns to death "not out of hatred for the sinners, but out of the love

of charity, by reason of which he *prefers* the public good to the life of the individual."[55] So the judge loves the sinner *and* the community but is bound by duty to prefer the interests of the community. This still does not answer the question why preferring the community *in this sort of way*, by intentionally killing the sinner, is not doing evil so that good may come; surely not all means that civil authority could adopt would be morally legitimate. However "falling away from human dignity" is conceived, the effect is that whereas the person was to be treated "for his own sake," now he can be treated as "useful to others."

Why are grave sinners rightly killed and public magistrates authorized to do the killing? It seems that Aquinas' answer is found not in his treatment of human dignity and its loss through sin, but rather in his treatment of the relationship of a part to its whole: because the good of a part is subordinate in a radical sense to the good of the whole, sinners may be intentionally killed for the sake of the welfare of the community. This reasoning, however—as I have shown—is both flawed and question-begging. It is flawed insofar as it is based on a false (and dangerous) conception of the relationship of the individual to the state, and question-begging in that it fails to answer the objection that intentionally killing malefactors is doing evil that good may come.

A further criticism concerns Aquinas' use of the concepts "sin" and "sinners."[56] If we grant the doubtful premise that through sin one loses one's human dignity, we find the argument proves too much. If the kind of sin to which Aquinas refers is mortal sin, everyone who commits mortal sin may rightly be killed as a beast. But Aquinas imposes two conditions. He maintains, first, that not every mortal sin is rightly punished by death, but only such as inflict "irreparable harm" or as contain some "horrible deformity";[57] and second, that the sinner to be put to death must be more likely to harm others in the future than to mend his ways.[58]

While the two conditions limit the number of potential candidates for capital punishment, they also limit the plausibility of Aquinas' argument. If the criterion for losing dignity is intrinsic to the relation of the sinful act to the order of reason, then the added conditions are arbitrary. If the criterion for losing dignity depends on the opinion of a judge or jury that the relative gravity of the crime in question warrants death, then human dignity can be dispensed with by a juridical judgment. As regards the first condition, Aquinas' logic implies, in effect, that there are many more rightly "kill-able" people (by virtue of their sinful beastly status) than may rightly (juridically speaking) be killed. Regarding both conditions, the difficulties include expecting judges or juries to determine not simply who is an intentional lawbreaker, but who is an irreformable sinner, and

to draw accurate lines between mortal sins as containing mild, serious, or horrible deformities (implying grades of viciousness in the wills of sinners, thus implying the ability to judge not only the degree of the evil of external acts, but also degrees of engagement of a sinners' freedom). These difficulties are effectively insurmountable.

The Role of Public Authority and the Responsibilities of Subordinates

If, as I have argued, Aquinas' part-to-whole and sinners-as-beasts analogies are unsound, then his argument in favor of capital punishment is still open to the criticism that killing criminals is doing evil that good may come. Is there any other means by which Aquinas could overcome this criticism? Here it may be relevant to explore Aquinas' conception of the relationship between authority and subordinates.

Aquinas limits the lawful exercise of capital punishment to persons holding public authority. Because the care for the community is entrusted to public authority and not to any individual, the prerogative to make and enforce laws, including the right to punish, belongs to public authority alone. How does this exonerate legislators and law enforcement officials from the charge that their act, because of its object, is wrong per se? Following Augustine, Aquinas holds that one who carries out the command of a higher legitimate authority is not responsible for the act, but merely an instrument, as a sword is an instrument in the hand of the one who wields it.[59] The act is, strictly speaking, *done* by the one from whom the command was issued. It is therefore the judge rather than the executioner who slays the criminal.[60] Now the authority to punish can be said to derive ultimately from God, whose providence requires that good be rewarded and evil be punished and whose authority extends to all things necessary to preserve the common good.[61] Public authority, therefore, acting on behalf of a system of order whose authority derives ultimately from God, may rightfully kill criminals. Those acting in such a capacity "do no wrong when they reward the good and punish the evil."[62] It seems to follow that responsibility for the killing of criminals is borne not by the human instrument but by God, from whom the authority to punish derives; this makes secondary the question whether or not dignity is lost through sin, since the action in question, even if forbidden to a human person, is not forbidden to God, who rightfully puts to death both the innocent and the guilty.[63] Would Aquinas go this far?

It is unclear how far Aquinas would be willing to take his principle of the attribution of responsibility. However, it is fair to conclude for two reasons that

he would not take this principle *alone* to be a sufficient warrant for the death penalty. First, Aquinas never, to my knowledge, grounds the right of public authority to kill in the authority of God.[64] Although he says that the executioner slays by the authority of the judge,[65] he never says that the judge slays by the authority of God. The only kind of killing to which he applies his principle of attribution is killing ordered by a *direct command* of God. Those, therefore, "who slew their neighbors and friends by the mandate of the Lord [see Exodus 32:27], would seem not to have done this themselves, but it was done rather by him by whose authority they did it";[66] and again, "he who by a command of God kills the innocent, such a man does not sin, just as God does not sin, Whose executor the man is."[67] And again,

> Abraham, when he consented to slay his son, did not consent to murder, because his son was due to be killed by the command of God, who is Lord of life and death: for he it is who inflicts the punishment of death on all men, just and unjust . . . and if a man be the executor of that sentence by divine authority, he will be no more a murderer than God would be.[68]

Whenever Aquinas moves to a justification of state killing, however, he always appeals to the order that exists between a part and its whole, an order which, to be sure, he takes to be established by God, but whose moral consequences are not governed by special divine command, but rather by the rule of law in accord with the rule of right reason. In the absence of another suitable foundation, there is little to suggest that Aquinas would have been willing to ground the authority of the state to intentionally kill solely in his principle of attribution.

Second, what Aquinas says elsewhere about moral reason in general and the nature of law in particular contradicts the conclusion that the state is above common morality. In a discussion about whether the moral precepts of the Old Testament can be considered part of the natural law, he states that "every judgment of practical reason proceeds from certain naturally known principles."[69] The principles to which he refers are, of course, the first principles of practical reason.[70] To act in accord with these principles is to act in accord with reason. Since only acts in accord with reason are good moral acts,[71] *every* upright judgment of human reason must of necessity be in accord with natural reason.[72] Now human laws are none other than the judgments of human reason ordered to the common good. Consequently, for a law to be an upright law it must be congruent with the law of reason. Insofar as it is contrary to reason, "it will not be law but a corruption of law."[73] Therefore, the judgments of legislators and

judges no less than private individuals are required to conform to reason. If an action is judged to be contrary to reason, it is neither upright for individuals nor those invested with public authority to carry it out. Even executioners and other ministers of the state who are ordinarily required to act in accord with the judgments of authorized judges, Aquinas argues, should refuse to obey if a judge's sentence is manifestly unjust.[74] If Aquinas' organic conception of society and his notion of falling from dignity were sound, then killing serious criminals would not be unjust because, all things considered, it would be what is due (*debitum*) them.[75] It would be fully reasonable. But if the conceptions are unsound, then capital punishment, as involving a will precisely against the good of life, would be undue (*indebitum*) and therefore contrary to reason.

In summary, though a person who commits wrongdoing degrades himself and can be said to fall from the dignity of upright moral agency, or the dignity of being esteemed by others and himself, his wrongdoing does not alter his basic human nature and therefore does not subtract from his intrinsic dignity. Neither appeals to guilt nor appeals to the prerogatives of authority render the otherwise inviolable good of life violable. Aquinas' account fails to respond to the charge that capital punishment, because it is the willful destruction of an intrinsic human good, is wrong per se.[76] In the absence of Aquinas' arguments for the lawfulness of capital punishment, Catholic tradition (and, for that matter, Western philosophical tradition) has no other philosophical ground from which to argue that the object chosen in a deliberate act of killing the guilty—by the state or any other person—is, morally speaking, fundamentally different from the object chosen in an act of killing the innocent.[77]

A Reformulated Catholic Teaching on Killing

If the Catholic Church were to teach that capital punishment, as an act of intentional killing, is wrong, what would be the implications for its teachings on the coercive prerogatives of the state in forms other than lethal punishment, namely, on (1) punishment in general, (2) protection from internal threats, i.e., law enforcement activity, and (3) protection from external threats, i.e., engaging in war? Would the logical implication be a teaching that rejects *all* lethal and coercive measures? In this final section I examine the implications of a categorical rejection of the death penalty on the three areas just mentioned. Although certain measures traditionally not morally excluded would now be excluded, I hope to show not only that the new position does not imply pacifism, but that it

does not unreasonably limit the state in its efforts to defend the peace. The discussion centers around Aquinas' analysis of killing in self-defense. The aim is to construct a general account of justifiable violence which may be extended to particular forms of state (or individual) violence.

Punishment in General

If capital punishment is morally unacceptable because it is a willful destruction of human good, is not all punishment unacceptable to the extent that all punishment involves some harm to human good? To answer this we must return to the topic of first principles, the basic human goods they specify, and the moral norms that prescribe concretely how these goods ought to be chosen. Germain Grisez and John Finnis have offered a convincing and lucid development of Aquinas' account in regard to these ideas, and I appeal to them when it is necessary to go beyond Aquinas.

When we speak in practical terms about human good as a "reason for action," we are referring to that element of a plan or purpose which interests us in acting for it.[78] Such reasons can be either instrumental, insofar as they need further reasons to explain the interest people take in them, or basic, insofar as they are reasons for acting which need no further reasons to explain the interest people take in them. Basic reasons, then, or basic goods, are ends sought for their own sakes, and it is toward basic goods, as the intelligible starting points of human action, that the first practical principles direct us. It is around their realization that purposes, limited plans of action, and larger life plans are formulated, and it is on their behalf that moral norms prescribe what they do.

Since moral norms derive from first practical principles, and since first principles are self-evident (i.e., not derivative), the epistemological "pathway," as it were, from first principles to moral norms is one that is thoroughly practical. We come to recognize basic goods by reasoning practically, that is, by considering in the concrete what would be good to do, to have, or to become.[79] And we come to understand the derivative moral norms by reflecting on the requisites of practical reasonableness in relation to the range of practical alternatives which lie open to us as a result of the basic goods.[80]

Some critics have objected that persons, not rational goods, are the subject matter of ethical norms.[81] The basic goods that move practical reason to action and from which moral norms derive, however, are nothing more than aspects of the full being and well-being of human persons. Basic goods are what they are because human persons are what they are. Their goodness lies precisely in their

capacity to fulfill human persons. Those things which correspond to the fulfilling of the intrinsic capacities of human nature *are that nature's goods*;[82] they are intrinsic realities to it, not extrinsic.[83] As sweets taste sweet because tastebuds are fitted for sweet things, basic goods are rationally desirable and attractive because the human person is fitted by nature for their realization. When basic goods are respected through action, human persons are respected, and when they are attacked, human persons are attacked. Moreover, a summary catalogue of basic human goods is a summary of the various kinds of fulfillment of which human nature is capable.

Aquinas names a few basic goods: life, the procreation and education of children, knowledge of truth, especially about God, and sociability or friendship.[84] In reflecting on the grounds for Aquinas' list, one might propose the following additional basic human goods: aesthetic experience, skillful performance in work and play, inner peace (which comes about when our feelings are in harmony with one another and with our judgments and choices), and authenticity (which comes about when our choices are in harmony with our judgments and our external self-expression with our true inner self).[85] As I have indicated, a summary of the basic goods is a summary of the different ways human persons can be fulfilled. For example, the basic goods of knowledge of truth and aesthetic experience correspond to human rationality; life, health, and bodily integrity correspond to the fact that human persons are animate and bodily; friendship corresponds to human sociability; knowledge of and harmony with God correspond to the fact that human persons are derived from a source of meaning and existence greater than themselves (that is, they do not have within themselves the sufficient source of their own meaning and existence and hence must look beyond themselves for this source); skillful performance corresponds to the fact that human beings, as simultaneously rational and bodily, are able to envisage creative goals and projects and endeavor to bring them about through a resourceful employment of mind and body; and so on. The possibility of realizing each and all these capacities, of acting on behalf of their fulfillment, is grasped as desirable and hence is a principle motivating human action.

But the moral problem is not whether to act on behalf of basic goods: that is a given. The problem rests in choosing in respect to them in a way that remains at all times consistent with the real good of individuals and communities, and that avoids the kinds of pursuit which, while perhaps realizing certain goods, are destructive or damaging of other goods and hence of human fulfillment. Although the rational pursuit of any basic good gives meaning to human

action (since action on behalf of a basic good is not pointless), morality requires more than avoiding pointlessness. It requires that one be fully reasonable in acting; it requires that "in voluntarily acting for human goods and avoiding what is opposed to them, one ought to choose and otherwise will those and only those possibilities whose willing is compatible with a will toward integral human fulfillment."[86] Integral human fulfillment envisages as a practical ideal the full realization of all the capacities of human nature in every member of the human community, as a result of each member's participation in every basic human good in every way possible compatible with every other good.[87] While no individual or community can attain integral human fulfillment, nevertheless, as a practical ideal it stands as a measure for the choices of individuals and communities: it requires that I respect in every concrete choice every instance of a basic human good, which, among other things, requires that I do nothing deliberate to damage, diminish, or destroy the good of any other person.[88] Simply stated, a good person is never willing to will against his neighbor's or his own good. This kind of openhearted respect is in fact an important part of what the first practical principles, taken together, require of human action.[89]

Punishment inflicts deliberate harm, but it need not involve choosing to destroy, damage, or impede any instance of a basic human good. The disorder that crime entails resides, precisely speaking, in the waywardness of a criminal's will. While other members of the community have chosen to restrain themselves in relation to (let us presume) just laws guiding community behavior, the criminal exceeds his due measure, gaining an unfair advantage over the law-abiding. To overcome this disorder an act is required by which the criminal is said to suffer something contrary to his will (namely, conditions and limitations against his interests).[90] The chosen means of punishment can be bad or good, bad to the extent they are disproportionate to the gravity of the offense or are wrong in themselves, good to the extent they are proportionate to the gravity of the offense and respect all the criminal's basic human goods. Although the exercise of the will is a functional requisite for the pursuit of any good, it is not itself a basic reason for acting; people are not moved to act by grasping the goodness of the will. Punishment, therefore, can deliberately inflict harm without deliberately harming basic goods. One can intend the good end of restoring the order of justice and adopt means such as censure, fines, imprisonment, or exile, and yet never will as an end or means the destruction of or harming of a person's life, pursuit of knowledge, relationships of friendship, and so forth. Basic goods such as these are apt to suffer because of the punishment, but their diminution or destruction can remain outside the scope of what is intended;

what is willed is the proportionate suppression of the offender's will. The damage to basic goods is not sought for itself, nor for what it can bring about. There could be cases where prisoners, by subjecting themselves to strict exercise or academic regimens, end their prison terms physically or intellectually better off than when they entered prison; or cases where the separation from a loved one causes the reciprocal commitment and feelings of love to intensify. In these cases the punishment is no less effective than in cases where inmates leave prison friendless or less physically or intellectually healthy. Whether basic goods flourish or diminish is incidental to the morally relevant ends and means of the act of punishment. It is very important to keep in mind, however, that unintended effects *may well be relevant to the morality of punishment.* Some effects, for example, threats or harm resulting from prison terms in facilities with negligent prison management or unsafe conditions, though unintended, are immoral because it is wrong to subject anyone to them. (I take up the notion of "proportionality" below.)

One might object that anything directed against the freedom of the will has the nature of pain, and pain insofar as it is a loss (and hence a privation) is an evil;[91] hence all punishment insofar as it involves pain deliberately inflicted is morally illicit. This objection, however, involves an equivocation in the use of the term "evil." When Aquinas calls punishment a species of evil he is not referring to evil in the moral order. He identifies four orders of things: an order that reason does not establish but only beholds, i.e., the order of nature; an order that persons establish in their own thinking, i.e., the order of logic, or rational philosophy; an order that persons bring into the operations of their wills pertaining to voluntary action, i.e., the moral order; and an order that reason brings into the planning and establishing of external things, i.e., the order of practical skill and technique.[92] To the extent that evil is defined as a privation of good, each of the four orders can be said to have evils associated with it: in the order of nature, for example, the evil of congenital deformity; in the order of logic, an unsound argument; in the moral order, a morally bad action; and in the practical order, a structurally unsound house. The evil that the will experiences in being suppressed is proper to the natural order and not to the moral order.

Responsibilities of Law Enforcement Officials

Would a rejection of intentional killing limit the ability of police and other law enforcement officials to carry out their responsibilities? Only if plans expressly intending to kill are considered necessary to meeting their responsibilities. For

example, if in an attempt to crack down on domestic terrorism, police or military officers plan and carry out the assassination of a suspected or known terrorist, such a plan of action under the view I am defending would be excluded as morally wrong, as would all "shoot to kill" policies. Likewise excluded as morally wrong would be all death threats in police or military interrogations or hostage negotiations, to the extent such threats involve a real, albeit conditional, intent to kill.[93] But if force is selected and limited according to what is necessary for apprehending aggressors and rendering them harmless, then law enforcement officials may rightly use force, even when they foresee that the use of such force may result in the aggressor's death. They may rightly undertake whatever is necessary to anticipate and suppress potential criminal activity, to stop criminal activity in progress, to assure that criminals who have been stopped are adequately restrained from resuming their harmful activity, and finally—as part of the criminal justice system—to assist where necessary in trials, sentencing, and punishment. At each level, including the level of punishment, the concrete measures are selected according to prudential judgment and existing law and are not predetermined by the law of reason.[94] So the choice of using a gun, a billy club, or tear gas in a particular situation is up to the discretion of the well-trained officer or possibly the judgment of the law enforcement community, which reflects in advance on the efficacy of certain means to certain ends in common types of situations, on the risks of alternatives, and on the fairness of permitting foreseeable bad side effects, even lethal ones, to befall the "innocent bystander."

The above analysis is drawn from Aquinas' account of killing in self-defense.[95] In answer to the question whether it is lawful to kill a man in self-defense, Aquinas replies that individual acts can have more than one effect, one which is intended, the other(s) lying outside the agent's intention. Because "moral acts take their species according to what is intended, not from what is beyond the intention, since this is a secondary quality,"[96] an act of self-defense that results in the death of the aggressor is not necessarily forbidden, because such an act need not entail an intent precisely to kill.[97] In such a case the killing per se falls outside the agent's intention.

What is the morally relevant basis for distinguishing between what one intends and what one merely foresees? Why does Aquinas say that in a moral act the latter is *per accidens?* Intention is an act of the will whereby some good or apparent good is chosen in response to reason moving it to act.[98] Since the will is a rational appetite,[99] what one intends is what one desires, or what one endeavors to have, be, or bring about; we might say it is what one sets one's heart upon,

what one seeks to possess, or rest in.[100] A foreseen effect that lies outside one's intention is not absent from one's deliberations, but is not what one directly commits oneself to when acting; it is not for that effect's sake that one chooses to act. The two effects stand in a different relationship to the will of the actor. To be sure, in foreseeing such a state of affairs resulting from one's freely chosen action, one is willing to do an act which brings about those states of affairs. In intending action x with consequence y, I consent to bring about y (i.e., I choose a y-bringing-about action). But I have no commitment to y, no morally relevant interest in bringing about y, and no morally relevant desire to see y happen.[101]

The fact that the effect y is unintended, however, does not by itself guarantee a morally good act. Aquinas, offering a further insight into the morality of acts, points out that one's acceptance of side effects is subject to another moral principle, namely, the principle of proportionality: an unintended lethal act of self-defense is still wrong "if it is not proportionate to its end" (i.e., if more violence than necessary is used to bring about the good end of rendering the aggressor incapable of committing harm).[102] This moral requirement, which Aquinas calls maintaining "due and solicitous carefulness"[103] in our dealings, fills out his account of the norm against killing. According to John Finnis,

> Within the one, verbally undifferentiated norm against 'homicide', Aquinas distinguishes between the exclusion of all private killing with intent (i.e. all choices *to* kill) and the requirement of due diligence . . . i.e. the duty to take all due care—all the care that the Golden Rule requires in the circumstances—to avoid causing death as a side-effect of some otherwise reasonable choice.[104]

Thus, the conclusion that capital punishment is wrong because killing with intent is wrong implies that the activity of police and others in law enforcement should be limited by the requirement that they act with right intention: to pursue, to apprehend (and if need be incapacitate), and to incarcerate criminals and suspected criminals, but not to kill them. This, coupled with the general requirement that violent measures should be limited to what is necessary to successfully repel an (underway or foreseen) attack, defines the scope of restraint on police activity.

Killing in War

The norms applied to police and law enforcement activity also apply to killing in war. In fact, traditional Catholic just war theory, which deals with the question

of what acts are and are not excluded as morally wrong in war (*jus in bello*), has taught the same two principles: the necessity of right intention, and proportionality in choosing means to ends. There is one major difference, namely, that the former principle, sometimes called the *principle of discrimination*, does not forbid all military attacks intended to take human life, but merely forbids attacks which include the intentional killing of noncombatants. Our reformulated position would exclude both.

One might argue that to exclude intentional killing from the bloody business of war is to effectively take a pacifist line.[105] Such a conclusion, however, need not follow. Take an example: a regional military commander intends to take the enemy's capital city. His purpose (end) is itself a means with respect to the prior purpose of his commanding general (i.e., to take control of the heart of the nation's territory), whose purpose is in turn a means with respect to the prior purposes of the Joint Chiefs, whose purposes are means with respect to the purpose of the commander-in-chief, whose intended purpose is to *win the war*.

If the regional commander wishes to realize his purpose he must deliberate over possible suitable means, and, unless his choice is to abandon or revise his purpose, he must settle upon, i.e., choose, one or a suitable combination of means as his preferred plan of action. Suppose he deliberates and proposes the following plan: a helicopter will drop a small team of army special forces behind enemy lines with the reconnaissance aim of locating strategic attack sites, then directing air strikes against them. The commander chooses (i.e., intends as means) this limited plan among alternatives and it becomes for him, as for those under him, a concrete plan of action aimed at winning the city (the country, the war). However, since each limited plan of action constitutes a moral act directive of the actions of one or more persons, it cannot be legitimate unless the ends and means involved are legitimate. More remote plans are often of graver moral significance because they determine a greater number of subsequent actions. A plan that includes a bad object early on (such as the destruction of as many people as possible in a civilian center) will involve everyone participating in that plan in its moral evil, either in a formal or material way. For obvious reasons, the deliberations from which these plans derive require great care to ensure that bad objects are excluded from their scopes.

So how can intentional killing be excluded without excluding the possibility of war? Adapting Aquinas' paradigm of self-defense as a model for violence in war, we can say that in the deliberation and choosing of suitable means for realizing particular limited purposes in war, measures of violence must be selected that are proportionate to (i.e., not in excess of what is necessary for)

realizing the limited military objectives, such as destroying munitions factories; and proposals arising from deliberation must not include *at any level* the deaths per se of the enemy. It falls to each active participant in the plan, especially those closest to the planning and executing of the violence, to keep in mind the chosen, limited plan of action and not to be coaxed by feelings of disgust, hatred, vainglory, or triumphalism into doing things intrinsically wrong or disproportionate to the plan's purpose. Chosen proposals may include measures which one foresees are likely or even certain to cause death, but such deaths are not what the measures are designed to bring about, whether to satisfy feelings or to achieve military objectives. They will be the unintended results of otherwise intended acts of collective defense. In other words, if success could be achieved without causing deaths, all the better. The object is an enemy rendered unable to fulfill his hostile designs, not a dead enemy. Justifiable measures could go beyond simply halting an immediate attack by an aggressor; they might include measures which, in anticipation of future aggression, prevent ready access to future means of aggression. Hence, it could be morally justifiable to select strategic arms production or storage sites for destruction; to plan and execute surprise assaults, presuming they are free of treachery; to conduct bombing campaigns on advancing troops; to destroy submarines, ships, planes, armed personnel carriers, and any other target that constitutes a part of an enemy's deliberate advance; and so on. Yet whatever goes beyond the limited goal is unjustifiable, for example, killing or disfiguring prisoners, insisting on terms of absolute surrender as a way of "punishing" the enemy, or lethally bombing military units when it is clear that the enemy is about to surrender.[106]

The same two moral principles governing the activity of nations, or federations of nations, engaged in hostile combat against foreign aggression also govern the deliberations and choices of nations or federations that adopt other forms of international violence against other forms of aggression. An example is that of imposing sanctions to facilitate the fall of nationally or internationally harmful political regimes. The intended ends and concrete plans of action adopted as means must be free of wrongful objects and must be checked and continually revised to ensure that the harm suffered, especially to noncombatants, is proportionate to the ends being sought.[107]

■

In reformulating the Catholic position on justifiable violence to exclude intentional harm to basic goods, I have tried to develop a systematic and

philosophically consistent account of the morally relevant elements of the *new position* that (I have argued) lies implicit in the teaching of the *Catechism of the Catholic Church* on capital punishment. If my account is sound, then it is correct to say that refraining from deliberately killing serious offenders is an expression of commitment to the fundamental dignity of the human person, an expression which in a significant sense is *required* by reason. Justifications for the death penalty that fail to take into account the moral requirements deriving from intrinsic human dignity are inadequate, and those that take into account these requirements but appeal, implicitly or explicitly, to notions of forfeiture of human dignity are unsound, or at least unworkable. If the forfeiture of human dignity were possible, civil authority would be morally justified in killing those and only those criminals who have forfeited their human dignity and are, in that sense, no longer human. The problem of theoretically defining where to draw the line between having and losing human dignity is difficult enough— just how guilty does one have to be before one is literally too guilty for one's own good? But in light of complex human subjectivity, the task of judging who has and has not exceeded the fateful line, if such a judgment were even possible, would swallow so much time and resources as to render the whole project effectively unworkable.

It may seem unreasonable to claim that replacing the death penalty with lengthy prison terms for society's most serious offenders is an expression of commitment to human dignity. Locking a nineteen-year-old away in an island of iron for the better part of his earthly life might seem as bad as, or worse than, killing him. In prisons where conditions are negligently inhumane, such, morally speaking, might indeed be the case; such situations of imprisonment might express greater disrespect for human dignity than that expressed in a more humane prison system where the objective disrespect of capital punishment is also practiced. However, the arguments against abolishing the death penalty in either case (i.e., regardless of whether humane and inhumane prison conditions prevail) are unconvincing. The inhumanity of inhumane prison systems argues convincingly neither for nor against capital punishment. It argues rather for a correction of the inhumane conditions.[108]

Where prison systems provide safe and humane conditions, inmates can have available to them, albeit in a limited way, authentic means of human flourishing and hence can lead lives which are meaningful. In either case, the argument in favor of abolishing capital punishment sets forth the persuasive and uncontroversial claim that to live is good and not to live is in itself bad. As for the claim that abolishing capital punishment is a "commitment to human dig-

nity," it is actually rather modest. It says no more than that morality—because of intrinsic human dignity—forbids such and such kind of act and therefore we will not do it. As regards other moral implications for prison systems, for example, regarding standards of prison management, the bodily, moral, and spiritual care of inmates, facility upkeep, reasonable access to juridical appeal, and the like, these too should be respected. Deficiency with respect to one of *these* moral requirements is not a reasonable ground for concluding that it is legitimate to set aside morality's *other* requirement, namely, to maintain at all times a right intention relative to the lives of inmates.

Finally, to deny the state its singular prerogative of intentional killing does not undermine the valid conception that punishment, justly inflicted by public authority, involves a vindication of the order of justice, nor does it threaten the Christian teaching that all authority comes from God (Rom. 13:1), nor the view that the divine creator has willed for the sake of human good the authority of the state and therefore willed all means necessary for its maintenance and flourishing, in particular, law making and coercive punishment. It simply excludes lethal punishment as a legitimate expression of that authority; it affirms the proposition that all authority comes from God, but rejects the conclusion that this extends to the authority to intentionally kill; it asserts the rightful and necessary place of the coercive power of the state in vindicating justice and maintaining the common good, but denies that the state has power over the life and death of its citizens. Moreover, even if we conceded the questionable hypothesis that God grants to some to do what is otherwise forbidden by the natural law, still, it is far from clear that intentional killing is ever necessary to the project of maintaining the common good.

Notes

Notes to Introduction

1. George Bernard Shaw, "Capital Punishment," *The Atlantic Monthly* (June 1948); available at http://www. theatlantic.com/atlantic/atlweb/flashbks/death/dpenshaw .htm.

2. As of January 1, 2003, 112 countries had abolished the death penalty in law or practice, and 83 countries retained it. The term "abolitionist" is assigned not only to countries that have legally abolished the death penalty, but also to countries that retain it for ordinary crimes but have not inflicted it for at least ten years, or that have an international commitment not to inflict it; see Amnesty International, *The Death Penalty: List of Abolitionist and Retentionist Countries* (Report, 1 January 2003).

3. Roger Hood, *The Death Penalty: A World-wide Perspective* (Oxford: Clarendon Press, 1996), 7–11, 241–45.

4. I capitalize "Church" throughout this monograph when referring to the Roman Catholic Church.

5. For example, in his Christmas "*Urbi et Orbi*" address in December 1998, Pope John Paul II said: "May Christmas help to strengthen and renew, throughout the world, the consensus concerning the need for urgent and adequate measures . . . to end the death penalty." *Origins* 28, no. 29 (7 January 1999): 506. In January 1999, during a trip to St. Louis, he appealed to Governor Mel Carnahan of Missouri to commute the death sentence of Darrell Mease to life without parole; on January 28 the governor announced he had done what the pope had asked; in the pope's homily at the St. Louis Trans World Dome several days later he said: "I renew the appeal I made most recently at Christmas

for a consensus to end the death penalty which is both cruel and unnecessary." *Origins* 28, no. 34 (11 February 1999): 601. At an international congress on the death penalty in June 2001, the Holy See stated that it "has consistently sought the abolition of the death penalty and his Holiness Pope John Paul II has personally and indiscriminately appealed on numerous occasions in order that such sentences should be commuted to a lesser punishment." It added, "It is surely more necessary than ever that the inalienable dignity of human life be universally respected and recognized for its immeasurable value." Zenit, *Weekly News Analysis,* 19 January 2002.

6. Since 1980 the U.S. bishops alone have issued—personally or collectively— over 214; most are listed in the *Bibliography of Statements by U.S. Catholic Bishops on the Death Penalty: 1972–1999,* compiled by Catholics Against Capital Punishment (Arlington, Va.); available at http://www.igc.org/cacp/biblio.html.

7. Sections 2263–2267, *Catechismus Catholicae Ecclesiae (editio typica Latina) (Catechism of the Catholic Church* [hereafter *Catechism*]) (Rome: Liberia Editrice Vaticana, 1997). The original edition—in French—was released in 1992 and the English translation of the French in 1994. In September 1997, with the revisions of the first edition complete, the definitive Latin text was promulgated by Pope John Paul II. English references unless otherwise indicated are from the English translation of the *editio typica,* i.e., the 1994 Vatican-approved English translation of the 1992 French edition with the inclusion of the additions and changes required by the 1997 *Corrigenda* (Amendments to the 1992 Edition, Vatican English translation).

Notes to Chapter 1

1. The following facts are drawn from an essay by Christoph Cardinal Schönborn, secretary of the commission that produced the *Catechism* (and subsequently named archbishop of Vienna and made a cardinal): "Brief Note on the Revision of the Passages in the *Catechism of the Catholic Church* Having to Do with the Death Penalty," *Catholic Dossier* 4, no. 5 (September–October 1998): 9–11, translated from the French by Ralph McInerny.

2. John Paul II, *De vitae humanae inviolabili bono (Evangelium Vitae)* (25 March 1995).

3. Capital punishment is also briefly mentioned in nos. 27 and 40.

4. Cardinal Schönborn, "Brief Note," 9.

5. *Origins* 27, no. 6 (June 1997): 84, gloss; the *Origins* editor adds after the words "real development" the words "of Catholic teaching."

6. Ratzinger, quoted in Richard J. Neuhaus, "The Public Square," *First Things,* no. 56 (October 1995): 83.

7. See the summary of the Church's traditional teaching in chapter 7.

8. Pope Pius V, *Catechism of the Council of Trent for Parish Priests,* part III, cap. VI, par. 4, trans. John A. McHugh, O.P., and Charles J. Callan, O.P. (New York: Joseph F. Wagner, 1923), 421. Viewing the death penalty as an "exception" to the norm against

murder goes back to the Church Fathers; for example, Augustine writes, "The same divine law which forbids the killing of a human being allows certain exceptions, as when God authorizes killing by a general law. . . . [I]t is in no way contrary to the commandment, 'Thou shalt not kill,' to wage war at God's bidding, or for the representatives of the State's authority to put criminals to death, according to law or the rule of rational justice." *De Civitate Dei*, lib. I, cap. XXI (*FOC*, vol. 8, p. 53).

9. "*Utrum sit licitum occidere homines peccatores*," Aquinas, *ST*, II-II, q. 64, a. 2; other examples include Thomas Cardinal Cajetan, Commentary on q. 64, a. 2, from *Commentaries of Thomas Cajetan*, in Aquinas, *Opera Omnia*, vol. 9, Leonine ed. (1897), p. 69; Juan Cardinal De Lugo, *De Justitia et Jure*, in *Disputationes Scholasticae et Morales* (Paris, 1893), disp. 10, sec. 2, par. 56, p. 69; Robert Cardinal Bellarmine, *De Laicis sive Saecularibus (De Laicis)*, trans. Kathleen E. Murphy (Westport, Conn.: Hyperion Press, 1928), ch. 13, p. 54.

10. *ST*, II-II, q. 64, a. 7c, emphasis added. Unless otherwise indicated, all translations from the *Summa Theologiae* are my own.

11. Ibid.

12. E.g., Alphonsus Marie de Liguori, *Theologia Moralis*, tom. 1, lib. 3, tract. 4, cap. 1, dub. 3, par. 380 (Rome: Ex Typographia Vaticana, 1905); M. Zalba, S.J., *Theologiae Moralis Compendium*, vol. 1 (Madrid: Biblioteca De Autores Cristianos, 1958), no. 1591, p. 871; I. Aertnys, C.SS.R., and C. Damen, C.SS.R., *Theologia Moralis* (Rome: Marietti, 1956), tom. I, lib. III, tract. V, cap. III, no. 571, p. 541.

13. In the tradition, "self-defense" includes defense of others by a private person; see *ST*, II-II, q. 60, a. 6, ad 2, where Moses kills someone who was killing an Egyptian, and does so "*Aegyptiam defendendo . . . cum moderamine inculpatae tutelae.*"

14. *Codex Iuris Canonici* (1917), canon 2205, § 4.

15. In a treatment on clerical irregularity resulting from acts of homicide, Trent teaches: "If, however, it is reported that he has killed someone not intentionally [*non ex proposito*] but by accident [*sed casu*], or in repelling force by force as when one protects oneself from death . . . then let the matter be committed to the local ordinary. . . ." Council of Trent, Session 14, canon 7 (*DEC-II*, 717).

16. John Finnis, *Aquinas: Moral, Political, and Legal Theory*, Founders of Modern Political and Social Thought (Oxford: Oxford University Press, 1998), 27.

17. My translation. The Vatican English translation of the first sentence is a serious—indeed nonsensical—mistranslation of the French and Latin and reads: "The legitimate defense of persons and societies is not an exception to the prohibition against the murder of the innocent that constitutes intentional killing."

18. See Aquinas, *ST*, II-II, q. 64, a. 7c; although Aquinas only refers to aggressors, not *unjust* aggressors, it is not uncommon for authors to refer to the status of the aggressor's aggression as *unjust*, if not formally, at least materially; e.g., Henry Davis writes: "Everyone has a natural right to defend himself against unjust aggression even to the death of the assailant. . . . But the assailant's death is a secondary result of my

act, the primary result being my own defence. The doctrine is justified on the universally valid principle of the double effect"; Henry Davis, S.J., *Moral and Pastoral Theology*, 5th ed. (London: Sheed and Ward, 1946), 152–53. See also Dominic Prümmer, O.P., *Handbook of Moral Theology* (Cork: Mercier Press, 1956), 127.

19. The *Catechism* even says elsewhere that the *common good* "is the basis of the right to legitimate personal and collective defense" (no. 1909).

20. Steven Long, treating the parallel argumentation to section 2267 in *Evangelium Vitae*, no. 56, writes: "If one incorporates within 'protection of society' not only physical protection, but also the manifestation of transcendent justice in society as constituting a good in its own right . . . then there is no particular *doctrinal* reason why justified uses of the death penalty should be absolutely 'very rare, if not practically non-existent' (*EV* 56)." Steven A. Long, "*Evangelium Vitae*, St. Thomas Aquinas, and the Death Penalty," *The Thomist* 63, no. 4 (October 1999): 539.

21. See Aquinas, *ST*, II-II, q. 64, a. 7c.

22. *ST*, II-II, q. 64, a. 7, ad 4.

23. Alphonsus de Liguori, *Theologia Moralis*, tom. 1, lib. 3, tract. 4, cap. 1, dub. 3, par. 380, p. 631.

24. Ibid.

25. Zalba adds that there are some (he gives no references) who think it is legitimate in cases of necessary defense to intend to wound or kill the aggressor. Zalba, S.J., *Theologiae Moralis Compendium*, vol. 1, no. 1591, p. 869.

26. McHugh and Callan state that killing an assailant is lawful provided one's life is in danger, the attack is unjust, the resistance is truly self-defense, and the resistance is moderate, "*i.e.*, the person attacked must not use more force than necessary and he must not intend to kill the assailant." John A. McHugh, O.P., and Charles J. Callan, O.P., *Moral Theology: A Complete Course*, vol. 2 (New York: Joseph F. Wagner, 1930), no. 1828, p. 105.

27. Aertnys and Damen, *Theologia Moralis*, tom. I, lib. III, tract. V, cap. III, no. 571, p. 541, emphasis in text.

28. Further examples where necessary defense is construed as private [self] defense include A. J. J. F. Haine, *Theologiae Moralis* (Rome: Desclée, 1900), 4th ed., tom. I, pars II, cap. III, no. 1, q. 130, p. 453; Prümmer, *Handbook of Moral Theology*, 127; "Edward Genicot, S.J., *Institutiones Theologiae Moralis* (Brussels: Alb. Dewit, 1927), vol. I, tract. VI, sect. V, cap. II, no. 366, p. 296; note the ambiguity in Scavini's use of the term "*solam necessitatem*," in Petro Scavini, *Theologia Moralis Universa* (Paris: Jacob Lecoffre, 1863), tom. III, tract. VII, disp. II, cap. I, art. I, no. 75, q. 7, p. 74.

29. This implies that a legitimate war is a defensive war, something Pius XII taught and Vatican II implied; see Pius XII, "Christmas Message" (24 December 1944), *AAS* 37 (1945): 18, and "Christmas Message" (24 December 1948), *AAS* 41 (1949): 12–13; Vatican II, *Gaudium et Spes*, nos. 79–80; see also the pastoral letter of the United States Catholic Conference, "The Challenge of Peace: God's Promise and Our Response" (3 May 1983), part I, sect. C-2, *Origins* 13, no. 1 (19 May 1983): 8–9.

30. It should be noted that this claim is a matter of sociological and technological fact, not a matter of faith and morals. Since the teaching authority of the Church extends only to matters of faith and morals (cf. *LG*, no. 25), it cannot be said to form part of the Church's authoritative teaching on capital punishment, but must be held to be incidental to it.

31. Again, both deal with acts of *private self-defense* and both say the aggressor's death must be *unintended;* Aquinas, *ST*, II-II, q. 64, a. 7; Alphonsus de Liguori, *Theologia Moralis*, tom. 1, lib. 3, tract. 4, cap. 1, dub 3.

32. Pope Pius XII says as much in an address to the Sixth International Congress of Penal Law in 1953. He writes: "Most modern theories of penal law explain punishment and justify it in the last resort as a protective measure, that is, a defence of the community against crimes being attempted, and at the same time, as an effort to lead the culprit back to observance of the law. . . . but they fail to consider expiation of [retribution for] the crime committed . . . as the most important function of the punishment. . . . The protection of the community against crimes and criminals must be ensured, but the final purpose of punishment must be sought on a higher plane." Pope Pius XII, "Nous croyons que très," *AAS* 45 (1953); English translation, "Address to the Sixth International Congress of Penal Law," *Catholic Mind* 52 (1954): 117.

33. The encyclical uses the terms twenty or so times, including in the cover page title of the encyclical itself: "On the value and inviolability of human life" (*De vitae humanae inviolabili bono*).

34. Emphasis added.

35. *ST*, II-II, q. 64, a. 2, ad 3.

36. Pius XII, "Lis qui interfuerunt Conventui primo internationali de Histopathologia Systematis nervorum," *AAS* 44 (1952): 787; English translation, "Address to the First International Congress on the Histopathology of the Nervous System," *Catholic Mind* 51 (1953): 311.

37. The three formulations of *Evangelium Vitae* read: "Therefore, by the authority which Christ conferred upon Peter and his Successors, and in communion with the Bishops of the Catholic Church, *I confirm that the direct and voluntary killing of an innocent human being is always gravely immoral*" (no. 57); "Therefore, by the authority which Christ conferred upon Peter and his Successors, in communion with the Bishops . . . *I declare that direct abortion, that is, abortion willed as an end or as a means, always constitutes a grave moral disorder*, since it is the deliberate killing of an innocent human being" (no. 62); "[I]n harmony with the Magisterium of my Predecessors and in communion with the Bishops of the Catholic Church, *I confirm that euthanasia is a grave violation of the law of God*, since it is the deliberate and morally unacceptable killing of a human person" (no. 65). The third does not use the term "innocent," but from the context we conclude that such is implied. Because the encyclical was motivated in large measure by the issues of abortion and euthanasia, the notion of innocence plays a prominent role in the specification of its moral norms.

38. One might be tempted to read section 55 as implying as much; we read there, "to kill a human being, in whom the image of God is present, is a particularly serious sin. *Only God is the master of life!* Yet from the beginning, faced with the many and often tragic cases which occur in the life of individuals and society, Christian reflection has sought a fuller and deeper understanding of what God's commandment prohibits and prescribes. There are in fact situations in which values proposed by God's Law seem to involve a genuine paradox." If the encyclical were going to state or imply that there are morally legitimate forms of intentional killing, here is where we would expect it to be. Yet this is not what we find. Section 55 continues: "This happens for example in the case of *legitimate defense*, in which the right to protect one's own life and the duty not to harm someone else's life are difficult to reconcile in practice. Certainly, the intrinsic value of life and the duty to love oneself no less than others are the basis of *a true right to self-defense*." Extending the right of legitimate defense from the individual to the state, we see that the encyclical intends to distance itself from any such conclusion; section 55 concludes: "Unfortunately it happens that the need to render the aggressor incapable of causing harm sometimes involves taking his life. In this case, the fatal outcome is attributable to the aggressor whose action brought it about, even though he may not be morally responsible because of a lack of the use of reason."

39. The official title of the encyclical is "On Certain Fundamental Questions of the Church's Moral Teaching" (6 August 1993). It was written with the limited aim of defending the Church's moral teaching against certain errors, particularly ones which would rule out in advance the traditional exceptionless norm against killing the innocent. While it is not proposed as a *treatise* on the foundations of morality, its treatment is sufficiently developed to serve the ends to which I put it. (I quote the Vatican English translation unless otherwise indicated.)

40. "It is in the light of the dignity of the human person—a dignity which must be affirmed for its own sake—that reason grasps the specific value of certain goods toward which the person is naturally inclined" (*VS*, no. 48); the encyclical does not discriminate between the terms "good" and "goods," therefore I use them interchangeably.

41. "It is precisely through his acts that man attains perfection as man. . . . Human acts are moral acts because they express and determine the goodness or evil of the individual who performs them" (*VS*, no. 71).

42. *VS*, no. 74.

43. *VS*, no. 74, nos. 76–78.

44. "Human life, even though it is a fundamental good of man, thus acquires a moral significance in reference to the good of the person, who must always be affirmed for his own sake" (*VS*, no. 50).

45. "Man's proper and primordial nature, the 'nature of the human person,' . . . is the person himself in the unity of soul and body" (*VS*, no. 50).

46. A quotation of the opening words of *Gaudium et Spes*, no. 14.

47. *VS*, no. 50; emphasis added.

48. *VS*, no. 13; cf. no. 72.

49. *VS*, no. 50; this is short for "to choose to kill. . . ."

50. F. X. Linsenmann, *Lehrbuch der Moraltheologie* (Freiburg im Breisgau: Herder, 1878), 472.

51. Ibid., 473; at the same time he says that if the legislative process has judged it necessary and public opinion concurs it has to be applied in the legislated cases, in order to uphold the authority of law (473–74).

52. Ibid., 474.

53. Ibid., 473, emphasis added.

54. Ibid., 480.

55. Jacques Leclercq, *Les Droits et devoirs individuels*, vol. 4 of *Leçons de droit naturel* (Louvain: Société d'études Morales, 1946, original edition, 1937), 89.

56. Ibid., 98.

57. Ibid., 89.

58. Ibid.

59. Ibid., 89–90.

60. Ibid., 90.

61. E.g., "the theologians' acceptance of the State's right to inflict capital punishment does not rule out a divergence of opinion on the appropriateness of exercising that power in given conditions. It seems that a growing number of moralists would like to see the power of the sword in abeyance, a power to be exercised should the need arise but otherwise resolutely kept in the background," M. B. Crowe, "Theology and Capital Punishment," *The Irish Theological Quarterly* 31, no. 1 (January 1964): 102; "There will always be criminals, but modern society has other means of protecting itself from them than this," Jean Imbert, *La Peine de mort: Histoire-actualité* (Paris: Armand Colin: 1967), English quote in James J. Megivern, *The Death Penalty: An Historical and Theological Survey* (New York: Paulist Press, 1997), 297; "the death penalty for murder in this country [i.e., England] at present is unnecessary and therefore unjust," Mannes Tidmarsh, O.P., et al., *Capital Punishment: A Case for Abolition* (London: Sheed and Ward, 1963), foreword. See also "Statement of Rhode Island's Religious Leaders," *Origins* 5, no. 40 (25 March 1976): 629, 631; *Declaration of the Administrative Board of the Canadian Catholic Conference*, 1976, in Thomas G. Daily, "The Church's Position on the Death Penalty in Canada and the United States," *Concilium* 120 (1978): 122; for statements before the twentieth century, see Cesare Beccaria, "On Crimes and Punishments," in *On Crimes and Punishments and Other Writings*, ed. Richard Bellamy, Cambridge Texts in the History of Political Thought (Cambridge: Cambridge University Press, 1995), ch. 28, par. 3.

62. Gino Concetti, *Pena di morte* (Casale Monferrato: Edizioni Piemme, 1993), 7.

63. Finnis, following Aquinas, holds that "the essential point of punishment is to restore the disrupted order of fairness by depriving the criminal of his ill-gotten advantage"; this advantage was gained at the moment the criminal chose to freely and

consciously indulge his or her will for self-preference in opposition to the social order established by natural and positive law. See John Finnis, *Fundamentals of Ethics* (Washington, D.C.: Georgetown University Press, 1980), 128.

64. See Finnis, *Aquinas*, 279; see also his *Fundamentals of Ethics*, 129–30; *Moral Absolutes: Tradition, Revision, and Truth* (Washington, D.C.: The Catholic University of America Press, 1991), 56; and "Comment," in *Issues in Contemporary Legal Philosophy*, ed. Ruth Gavison (Oxford: Clarendon Press, 1987), 317. Finnis has moved away from this position: "Aquinas rejects, and it seems rightly, the defense of capital punishment that formerly seemed to me to be available consistently with the principles of a sound ethics, namely that it need not involve the intent precisely to kill as a means or as an end" (*Aquinas*, p. 293, note c).

Gerard V. Bradley, interpreting the papal teaching on the death penalty, develops an argument along the lines of the former view of Finnis. He envisages a scenario, which he says is practically nonexistent in the modern world but perhaps possible in premodern societies, where the death penalty imposed as retribution could be imposed without death being intended. In such a case, death, he says, would be "the existential *condition* for imposing a deprivation (of opportunities, freedom) which was the *only* adequate punishment available. If so, public authority might well have been morally obliged to punish by death (if the alternatives available were, say, uncertain detention in the sheriff's barn or payment of a fine). One could then impose death without choosing it, choosing instead to restore the order of justice by the deprivation effected in and by the execution. One's choice would be just that deprivation which death makes possible, and which the restoration of justice demands." Bradley is careful to say that it must not be death per se that is judged necessary, but rather the proportionate suppression of will of which death is the existential condition. It seems to me, however, that if a judgment is made that nothing less than lethal suppression is proportionate for redressing a particular crime, then to will such a punishment is to do so under the specification of *lethal punishment.* Once again, it does not seem that, other than perhaps for analytic purposes, we can abstract the killing from what the agent intends and is trying to bring about. See Gerard V. Bradley, "No Intentional Killing Whatsoever: The Case of Capital Punishment," in *Natural Law and Moral Inquiry: Ethics, Metaphysics, and Politics in the Work of Germain Grisez*, ed. Robert P. George (Washington, D.C.: Georgetown University Press, 1998), 155–73, quote from 168.

Notes to Chapter 2

1. See Vatican II, *Gaudium et Spes*, no. 26, par. 1; *CCC*, no. 1906.
2. *CCC*, no. 1907.
3. *CCC*, no. 1908.
4. *CCC*, no. 1909.
5. See Aquinas, *Summa Contra Gentiles (SCG)*, III, c. 141, n. 7.

6. *CCC*, no. 2266, emphasis added; Pope Pius XII in an address in 1953 on penal law says something similar: the "expiation of the crime committed, which itself is a sanction on the violation of the law, [is] the most important function of the punishment." Pope Pius XII, "Address to the Sixth International Congress of Penal Law," 117.

7. Finnis, *Fundamentals of Ethics*, 128; Finnis has claimed since 1971 that his account is substantially that of Aquinas. See Finnis, "The Restoration of Retribution," *Analysis* 32 (1971–72): 134; see also Finnis, *Aquinas*, 210–15; he gives a helpful thumbnail sketch of his account in "Meaning and Ambiguity in Punishment (and Penology)," *Osgoode Hall Law Journal* 10, no. 1 (August 1972): 265. Herbert Morris argues for something similar but specifies the "advantage" simply as the offender's renunciation of something others have assumed, that is, "the burdens of self-restraint" (69); if he had specified it further as the deliberate and immoderate *exercise of free choice*, his account might have avoided unnecessary confusions like the one that leads Richard W. Burgh— in his unsuccessful refutation of Morris—to construe the nature of the criminal's unfair benefit as "a particular sphere of noninterference defined by the law." See Herbert Morris, "Persons and Punishment," *Philosophy of Punishment*, ed. Robert M. Baird and Stuart E. Rosenbaum (New York: Prometheus Books, 1988), 67–82 (esp. 69–71), and Richard W. Burgh, "Do the Guilty Deserve Punishment," *The Journal of Philosophy* 79 (1982): 193–210 (quote from 205). For a helpful summary of the retributive accounts of several prominent theorists, including Rawls, Hart, Finnis, Nozick, and Jeffrie Murphy, see C. L. Ten, *Crime, Guilt, and Punishment* (Oxford: Clarendon Press, 1987), 38–65.

8. John Finnis, *Natural Law and Natural Rights* (Oxford: Clarendon Press, 1980), 262–63.

9. Finnis, *Fundamentals of Ethics*, 128; see also *Natural Law and Natural Rights*, 263.

10. Finnis, *Natural Law and Natural Rights*, 263.

11. "The wrongfulness of gaining this advantage is the specifically relevant moral turpitude adverted to in the retributivist's talk of criminal 'guilt';" Finnis, "The Restoration of Retribution," 132.

12. Finnis, *Natural Law and Natural Rights*, 263.

13. "Punishment . . . seeks to restore the distributively just balance of advantages between the criminal and the law-abiding"; ibid.

14. Finnis, "The Restoration of Retribution," 132–33.

15. *Natural Law and Natural Rights*, 263–64.

16. Finnis, *Moral Absolutes*, 80; in this way punishment is to be understood not so much as the infliction of evil but as the suppression of will: see "The Restoration of Retribution," 133.

A question arises as to whether punishment, which is by nature against the will, is punishment at all if "willingly accepted" (*CCC*, no. 2266). The answer is affirmative. The will is complex and multilevel in its participations but unified and simple in its essence, just as the soul is simple and whole in each of its different powers. A punishment which

is freely accepted, therefore, is still against its beneficiary's will (i.e., still against its interests, still a deprivation) insofar as the scope of that will's operations is objectively limited. In this way, because of its unity, the whole will is being acted against. But insofar as the criminal freely accepts his punishment, his whole will freely accepts it. (On the simplicity and unity of the soul, see Aquinas, *In Lib. III Sent.*, d. 26, q. 1, a. 4c; see also Finnis, *Aquinas*, 179, n. 217.)

17. Finnis, *Aquinas*, 213 and n. 151.

18. Finnis, *Natural Law and Natural Rights*, 263; "The Restoration of Retribution," 134.

19. *Hegel's Philosophy of Right*, trans. T. M. Knox (Oxford: Oxford University Press, 1967), 64, 69.

20. Ibid., 69–70.

21. Ibid., 71.

22. Ibid., 69.

23. Ibid., 70.

24. Ibid.

25. Ibid., 72, 73.

26. Ibid., 72.

27. Ibid., 71.

28. Ibid.

29. Ibid., 72.

30. Ibid.

31. Ibid., 72–73.

32. Ibid., "Additions," 247.

33. Pope Pius XII, "Address to the Italian Association of Catholic Jurists" (5 December 1954), *AAS* 47 (1955); translated in *Catholic Mind* 53 (1955): 366.

34. Pope Pius XII, "Address to the Sixth International Congress of Penal Law," 117.

35. Ibid.

36. Pius XII writes, "It should be an unassailable principle of penal law that the 'penalty' in the juridical sense always presupposes a 'fault.'" "Address to the Sixth International Congress of Penal Law," 113.

37. Pope Pius XII, "Address to the Italian Association of Catholic Jurists," 370.

38. Ibid., 378–79.

39. Finnis, *Natural Law and Natural Rights*, 262.

40. Immanuel Kant, *The Metaphysics of Morals*, trans. Mary Gregor (Cambridge: Cambridge University Press, 1991), 140 [p. 331 in the Prussian Academy edition].

41. Ibid., 141 [332].

42. Ibid.

43. Ibid.

44. Ibid., 141 [331–32].

45. This would be rejected by Aquinas, who says that punishments share in the virtue of justice to the degree that they check sin. If the infliction of a particular punishment promises an increase in the commission of like or more grievous sins, then it may, in fact ought to be forgone: *ST*, II-II, q. 43, a. 7, ad 1.

46. Kant, *Metaphysics of Morals*, 143 [334].

47. Ibid., 142 [333].

48. Ibid.

49. Ibid., 141 [332].

50. The life-imprisonment solution has a problem, namely, how to sustain the will of the people (or judiciary) in relation to a particular punishment from one generation to the next. In this light, the question needs to be soberly considered: will future generations be willing to perpetuate sentences justly handed down by former generations or is it more likely they will overturn "embarrassing" sentences (because "so long ago")? Unless they remain firm, life imprisonment for society's most heinous is effectively not an alternative.

51. John P. Conrad, "The Retributivist's Case against Capital Punishment," in *The Death Penalty: A Debate*, ed. Ernest van den Haag (New York: Plenum Press, 1983), 19.

52. Ibid.

53. Ibid., 26–27.

54. Ibid., 27.

55. Ibid.

56. Ibid.

57. Conrad is not the only retributivist to argue against the death penalty but, as far as I know, he is the only one to argue from a retributive premise. Hugo Adam Bedau argues that the state has the right to take life but that it is almost never justified in exercising that right; Jeffrey Reiman argues that the death penalty is just in itself for murder but ought to be abolished as part of the "civilizing mission of modern states"; Grisez rejects capital punishment because it violates the norm against killing, *not* because it is otherwise retributively unjust. For references see the following texts, respectively: Hugo A. Bedau, *Death is Different: Studies in the Morality, Law, and Politics of Capital Punishment* (Boston: Northeastern University Press, 1987), 46–63; Jeffrey Reiman, "Justice, Civilization and the Death Penalty: Answering van den Haag," *Philosophy and Public Affairs* 14 (Spring 1985): 119–34, esp. 115; Germain Grisez, *Christian Moral Principles*, vol. 1 of *The Way of the Lord Jesus* (Chicago: Franciscan Herald Press, 1983), ch. 8, q. H.

58. Beccaria, "On Crimes and Punishments," ch. 12.

59. H. L. A. Hart, *Punishment and Responsibility: Essays in the Philosophy of Law* (Oxford: Clarendon Press, 1995), 185.

60. Bentham, *An Introduction to the Principles of Morals and Legislation* (hereafter *Principles*), ed. J. H. Burns and H. L. A. Hart (London: Methuen and Co., 1982), ch. I, pars. 1–2, including footnotes a and b.

61. *Principles*, ch. XIII, par. 1, p. 158.
62. *Principles*, ch. V, par. 33, p. 49.
63. *Principles*, preface, 4.
64. *Principles*, ch. XIV, par. 8, p. 166.
65. *Principles*, ch. XIII, note a, p. 158.
66. *Principles*, ch. XIV, note o, p. 171.
67. *Principles*, ch. XIII, note a, pp. 158–59.
68. *Principles*, ch. V, par. 33, p. 49.
69. *Principles*, ch. XIII, par. 2, p. 158.
70. *Principles*, ch. XIII, par. 3, p. 159.
71. *Principles*, ch. XIV, pars. 1–6, 8, 11–13, pp. 165–69.
72. *Principles*, ch. XV, par. 11, p. 179.
73. *Principles*, ch. XV, par. 18, p. 181, par. 25, pp. 184–85.
74. *Principles*, ch. XV, par. 19, p. 181, par. 25, p. 184.
75. John Rawls, "Two Concepts of Rules," *The Philosophical Review* 64 (1955): 3–13.
76. Ibid., 3.
77. In *A Theory of Justice* (1972) Rawls continues to argue that "punishment is [not] primarily retributive or denunciatory." Going beyond what he said in 1955, he argues that "the principles justifying . . . [coercive] sanctions can be derived from the principle of liberty. . . . It [i.e., punishment] is acknowledged for the sake of liberty itself." John Rawls, *A Theory of Justice* (Oxford: Oxford University Press, 1972), 241. The justification of punishment is not addressed in his *Political Liberalism* (1993).
78. Rawls, "Two Concepts of Rules," 4.
79. Hart, *Punishment and Responsibility*, 5.
80. Ibid., 9. Hart defines "retributivism" as a theory whose "main justification of the practice [of punishment] lies in the fact that when breach of the law involves moral guilt the application to the offender of the pain of punishment is itself a thing of value" (8).
81. Ibid., 9.
82. Ibid.
83. Ibid., 22.
84. Ibid., 77.
85. Ibid., 81.
86. Finnis asks a similar question of Hart's account in "The Restoration of Retribution," 35.
87. For an example of the more moderate claim, see Barbara Wootton, "Diminished Responsibility: A Layman's View," *Law Quarterly Review* 76 (1960): 224. For a critique of theories that propose the more radical claim, see Richard Wasserstrom, "Punishment v. Rehabilitation," in *Philosophy of Punishment*, ed. Robert M. Baird and S. E. Rosenbaum (New York: Prometheus Books, 1988), 57–66.

Rehabilitation accounts need not go to the extreme of denying responsibility. One can hold without contradiction both that persons should be held responsible for their actions and that punishment is to be curative. Such was the view of Plato and most Christian theorists up to the Reformation. It necessitates, of course, a definition of rehabilitation that does not define away criminality as a purely psychological and/or organic pathology.

88. Giles Playfair, "Is the Death Penalty Necessary?" *The Atlantic Monthly* (September 1957), available at http://www.theatlantic.com/unbound/flashbks/death/playnecc.htm.

89. Aquinas writes: "the act of sin makes one deserving of punishment"; *ST*, I-II, q. 87, a. 6c.

90. "Primitive man believed that a crime created an imbalance which could be rectified only by punishing the wrongdoer. Thus, sentencing was initially vengeance-oriented. Gradually, emphasis began to be placed on the deterrent value of a sentence upon future wrongdoing." Irving R. Kaufman, "Sentencing: The Judge's Problem," *The Atlantic Monthly* (January 1960), available at http://www.theatlantic.com/unbound/flashbks/death/kaufman.htm.

91. Another alternative is proposed by utilitarian George Bernard Shaw: "But the ungovernables, the ferocious, the conscienceless, the idiots, the self-centered myops and morons, what of them? Do not punish them. Kill, kill, kill, kill, kill them.... The percentage of incorrigibles is not affected by the cruelty or kindness of the law. It would remain the same whether we boiled murderers in oil or gave them gold medals. Capital punishment or no capital punishment, there they are with their problem of what is to be done with them. They are not all murderers. Most of them are quite incapable of committing a murder, but are equally incapable of discharging their social duties and paying their way.... The sole justification for kindly but ruthless judicial liquidation is that the delinquent is a loss and a danger to the community; and on this principle we shall liquidate many more human nuisances than at present if we are to weed the garden thoroughly." Shaw, "Capital Punishment."

92. Ernest van den Haag, "The Retributivist's Case against Capital Punishment" (Van den Haag Replies), in *The Death Penalty: A Debate*, ed. Ernest van den Haag (New York: Plenum Press, 1983), 30.

93. Ernest van den Haag, *Punishing Criminals: Concerning a Very Old and Painful Question* (New York: Basic Books, 1975), 21.

94. Van den Haag, "The Retributivist's Case," 28–29.

95. *Gregg v. Georgia*, 428 U.S. 153 (1976), plurality opinion of Justice Potter Stewart, reprinted in Hugo A. Bedau, ed., *The Death Penalty in America: Current Controversies* (Oxford: Oxford University Press, 1997), 196–205, quote on 200.

96. Ibid.

97. Ibid.

98. Ibid.; see *Furman v. Georgia* (Justice Potter Stewart, concurring), partially reprinted in Bedau, *The Death Penalty in America*, 189–95.

99. Lord Justice Denning, Master of the Rolls of the Court of Appeal in England, before the Royal Commission on Capital Punishment, Minutes of Evidence, 1 December 1949, p. 207 (1950), cited in *Gregg*, n. 4, in Bedau, *The Death Penalty in America*, 204.

100. The distinction between the two is in essence a distinction between the rational and the passionate (we might also say between the objective/public and the emotional/private). Retribution rightly construed is essentially a recognition of the rationality of punishment. For this reason the act of punishing is rightly reserved to the public sphere. If it were left to the injured party, rationality would not prevail.

Notes to Chapter 3

1. The legal prescriptions of the Pentateuch do not constitute a unified, systematically arranged corpus of law deriving from the time of Moses, as scholars of the Old Testament canon once believed. The consensus rather is that they are a collection of smaller codes and ordinances dispersed throughout a long narrative on the origins and development of the Hebrew people. The more important codes are divided as follows: (1) the Decalogue (Ex. 20:2–17, Deut. 5:6–21), believed to derive from the Mosaic age; (2) the legislative part of the book of Deuteronomy (chapters 12–26), generally dated around the seventh century BC; (3) the "Covenant Code" (Ex. 20:22–23:33), perhaps as old as the Decalogue; and (4) the "Priestly Code," dated around the sixth century BC and divided into laws on sacrifice (Lev. 1–7), rituals for the installation of priests (Lev. 8–10), laws on purity (Lev. 11–16), and what is sometimes referred to as the "Holiness Code" (Lev. 17–26). See R. de Vaux, O.P., *Ancient Israel: Its Life and Institutions* (London: Darton, Longman and Todd, 1961), 143–46; Albrecht Alt, "The Origins of Israelite Law," in *Essays on Old Testament History and Religion* (Oxford: Basil Blackwell, 1966), 81–132.

2. In the country the woman's cries would have little chance of being heard, hence the man alone was to be put to death; in the city, on the other hand, the act was presumed to be consensual and both man and woman were to be killed (Deut. 22:23–24).

3. Intentional homicide is clearly distinguished from death resulting from negligence or accidental injury; see the discussion of "cities of refuge" in Num. 35:11–15, Deut. 4:41–42, Deut. 19:1–13, Ex. 21:13–14, and Josh. 20:1–9.

4. See P. J. Harland, *The Value of Human Life: A Study of the Story of the Flood (Gen. 6–9)* (New York: E. J. Brill, 1996), 204–8.

5. Josef Scharbert, "Blood," *Encyclopedia of Biblical Theology*, vol. 1, ed. J. Bauer (London: Sheed and Ward, 1970), 75–76.

6. Numbers 35 repeats six times the phrase "the murderer shall be put to death"; see also 2 Sam. 4:11.

7. Nearly every prescription of the death penalty in Deuteronomy ends with the words, "So shall you purge the evil from the midst of you"; see Deut. 13:5; 17:2–7, 12; 19:11–13, 16–19; 21:18–21; 22:20–24; see also Judg. 20:13.

8. Bernard Schöpf, *Das Tötungsrecht bei den frühchristlichen Schriftstellern* (Regensburg: Friedrich Pustet, 1958), 149.

9. Scharbert, "Blood," 76–77; Schöpf, *Das Tötungsrecht*, 148.

10. Grisez, *Christian Moral Principles*, 219.

11. J. Greenberg, "Crimes and Punishments," *Interpreter's Dictionary of the Bible*, vol. 1 (New York: Abingdon Press, 1962), 734.

12. Many twentieth-century scholars of the Bible hold that the war-ban command against the populations of Canaan (Deuteronomy 7) was in fact never carried out; see G. E. Wright, *The Interpreter's Bible*, vol. 2 (New York: Abingdon Press, 1953), 378–79; A. R. S. Kennedy, "Ban," *Dictionary of the Bible*, ed. J. Hastings (1909; reprint, New York: Charles Scribner and Son, 1963), 86; Moshe Weinfeld, "Book of Deuteronomy," *The Anchor Bible Dictionary*, vol. 2 (New York: Doubleday, 1992), 179. It is generally admitted, however, that a ban of some sort was carried out earlier in Israel in connection with the destruction of Jericho, the defeat of Amalek, and in relation to apostate or traitorous cities within Israel (Deut. 13:16, Josh. 6:17, 1 Sam. 15:2–8).

13. A controversial Talmudic passage states that "forty years before the destruction of the Temple, the Sanhedrin was exiled and adjudication of capital cases stopped" (Sabbath 16a, quoted in Erez [see below], p. 31). Passages in the New Testament both support (John 18:31) and contradict (Acts 5:27–40, 26:10) this view. Either way, there is little dispute among scholars that in the first centuries AD there was diffidence toward applying the death penalty; see Edna Erez, "Thou Shalt Not Execute: Hebrew Law Perspective on Capital Punishment," *Criminology* 19, no. 1 (May 1981): 31–33, and Gerald J. Blidstein, "Capital Punishment—The Classic Jewish Discussion," *Judaism* 14 (1965): 163–66.

14. Erez calls it "the most important passage in Rabbinical literature on the topic of capital punishment," in "Thou Shalt Not Execute," 37.

15. Quoted in ibid.; cf. Blidstein, "Capital Punishment," 163. Notwithstanding the testimony of this passage, we would do well not to overstate the significance of Jewish leniency toward punishment in and around the first century AD. Since Jewish authorities had no jurisdiction over capital cases after AD 70 (at the latest), the leniency, juridically speaking, was forced.

16. Schöpf, *Das Tötungsrecht*, 149.

17. "We should hold that whatever the inspired authors or 'sacred writers' assert is asserted by the Holy Spirit"; "if the interpreter of holy scripture is to understand what God has willed to communicate to us, he must carefully investigate what the biblical writers actually intended to make known; that will also be what God chose to manifest through their words. . . . To understand correctly what a biblical writer intended to assert, due attention is needed. . . ."; *Dei Verbum*, nos. 11, 12, my translation.

18. Much of what I say here is drawn from Grisez's discussion of propositions and assertions in *Christian Moral Principles*, 35-B, and *Living a Christian Life*, vol. 2 of *The Way of the Lord Jesus* (Quincy, Ill.: Franciscan Press, 1993), 1-A, H.

19. Nor is a verbal statement necessary to express a proposition. Nonlinguistic forms of communication often effectively express propositions. A look from a spouse, for example, can at times express a proposition as effectively (or better) than words.

20. Grisez, *Living a Christian Life*, 38.

21. Most modern commentaries make this textual distinction. See Paul Achtemeier, *Romans* (Atlanta: John Knox Press, 1985), 193–214; C. E. B. Cranfield, *A Critical and Exegetical Commentary on The Epistle to the Romans*, vol. 2 (Edinburgh: T&T Clark, 1979), 592–748; Brendan Byrne, S.J., *Romans*, ed. Daniel J. Harrington, S.J., series *Sacra Pagina* (Collegeville, Minn.: Liturgical Press, 1996), 361–433. Many divide the section into two parts, the first, 12:1 to 13:14, dealing with general admonitions for Christians in daily life, and the second, 14:1 to 15:13, treating specific duties of charity within the Christian community by the strong for the weak. See Ernst Käsemann, *Commentary on Romans* (Grand Rapids: Eerdmans, 1980), ch. 4; Joseph A. Fitzmyer, S.J., *Romans*, series Anchor Bible (New York: Doubleday, 1993), 637–708; Achtemeier, *Romans*, 193–214.

22. Byrne, *Romans*, 386. Some commentators, noting a lack of strict logical connection between 12:21 and 13:1, conclude that the proper sequel to the former is 13:8, arguing that 13:1–7 is an addition to the original text of Romans; see Käsemann, *Commentary on Romans*, 337. Cranfield, however, argues for continuity along the lines I have; see *A Critical and Exegetical Commentary*, 652; for the same conclusion see Fitzmyer, *Romans*, 637–708.

23. T. W. Manson, "St. Paul's Letter to the Romans—and Others," in *The Romans Debate*, rev. ed., ed. Karl P. Donfried (Peabody, Mass.: Hendrickson, 1991), 4.

24. Roman occupation of Palestine dates back to 63 BC, when first Jerusalem and then all of Palestine yielded to Rome's military might under the generalship of Pompey. In 47 BC, under the Emperor Augustus, the Jews were granted limited independence, although life for Palestinian Jews still remained a struggle due to the expropriation of property and onerous tax regimen imposed by Rome's "puppet-king," Herod. Rome officially annexed Judea as a Roman province in 6 BC, which seems to be the proximate cause of the organizing—albeit gradual—of the Zealot party. For a helpful introduction to the historical-social context for Romans 13:1–7, see Victor Paul Furnish, *The Moral Teaching of Paul* (Nashville: Abingdon Press, 1979), 118–23.

25. "Judaism was on the brink of catastrophe as a result of its longstanding resistance to Roman imperialism. An emerging Christianity, founded by a Jew whom the Romans had crucified—regarded still by Rome as a Jewish sect, and inextricably implicated, by history and culture, by ideology and associational patterns, in the Jewish world—was inevitably caught up in the crisis of Jewish-Roman relations." M. Borg, "A New Context for Romans xiii," *New Testament Studies* 19 (1972–73): 214–18, quoted in Fitzmyer, *Romans*, 664.

26. A majority of biblical scholars date the edict of Claudius in AD 49, but Jerome Murphy-O'Connor, O.P., argues it should be dated AD 41; for his discussion on problems dating the edict, see Murphy-O'Connor, *St. Paul's Corinth: Texts and Archaeology* (Wilmington, Del.: Michael Glazier, 1983), 130–39.

27. See F. F. Bruce's historical considerations in "The Romans Debate—Continued," in *The Romans Debate*, 180–81.

28. Ibid., 185.

29. Ibid.

30. Byrne, *Romans*, 386.

31. Käsemann notes that there is no indication that there were Zealot tendencies in the Christian community in Rome; *Commentary on Romans*, 350; on this see also Günther Bornkamm, "The Letter to the Romans as Paul's Last Will and Testament," in *The Romans Debate*, 23.

32. Byrne, *Romans*, 386.

33. Cf. Matt. 22:21, Luke 20:25; on this see Byrne, *Romans*, 392, n. 7; Furnish, *The Moral Teaching of Paul*, 131. For the opposing view, see Käsemann, *Commentary on Romans*, 352.

34. *The Jewish War*, II, §140; quoted in Furnish, *The Moral Teaching*, 121.

35. *Letter of Aristeas*, 224; quoted in Furnish, *The Moral Teaching*, 121.

36. Verse 6 also introduces the idea, secondary to our discussion, of "for the sake of conscience." For considerations of Paul's term "conscience," see Byrne, *Romans*, 388; Käsemann, *Commentary on Romans*, 358.

37. This interpretation is favored by Byrne in *Romans*, 388–89, and Furnish in *The Moral Teaching*, 126–27; Bruce suggests something similar in "The Romans Debate—Continued," 184.

38. Bruce writes: "The paragraph about the Christian's relation to the secular authorities (Rom. 13:1–7) is best understood in the light of the Roman destination of the letter. This is not a universal statement of political principle." "The Romans Debate—Continued," 184.

39. Furnish makes this point: "The topic in 13:1–7 is *not* 'the state' and the main appeal of these verses is *not* to 'be subject' to it. The admonition to 'be subject' does open the paragraph (verse 1), and it is repeated in verse 5. But these verses are preliminary to the main appeal, which is to pay whatever kinds of taxes one owes (verses 6–7)" (*The Moral Teaching*, 126). Käsemann says something similar: "At root Paul's exhortation is not theoretically derived. In Romans 13 it is not the result of a solid systematic doctrine of the order of creation" (*Commentary on Romans*, 357); and again, "To assume so cavalierly that Paul's main purpose here is to speak of the State is to reduce what he is trying to say to an abstraction. . . . he has his eye on the circumstances of his own time when he takes as his starting-point the plurality of powers. . . . It is therefore not necessary for him to theorize as he would have to do if he were propounding a doctrine of the State." Ernst Käsemann, "Principles of Interpretation of

Romans 13," in *New Testament Questions of Today* (Philadelphia: Fortress Press, 1969), 201, see also 214.

40. "[Paul's] mention in 13:4 of the one who 'does not bear the sword in vain' might be a reference to special military police who were responsible for enforcing the collections of tax officials; the phrase Paul has employed matches the description of such police found in other ancient sources." Furnish, *The Moral Teaching*, 134.

41. "At first sight the context ([ch. 13] vv. 3–4) seems to support the assumption that the reference must be to the power of capital punishment. But a reminder that the government is possessed of military power and so is in a position to quell resistance would surely be equally appropriate. Perhaps the fact that Paul uses *forein* . . . rather suggests that the expression *thn macairan forei* should be understood either as a quite general statement concerning the authority's possession of military power ('wears the sword', i.e. is armed, is able to employ force), or else—less probably—as a particular reference to the dagger worn by the Emperor as *Imperator*." Cranfield, *A Critical and Exegetical Commentary*, 667.

42. For examples of the majority interpretation, see J. Fitzmyer, *The New Jerome Biblical Commentary* (1989), 864, no. 119; in *The Anchor Bible: Romans* (1993), Fitzmyer says the sword could be a symbol for capital punishment but remains tentative on the point; F. Davidson and R. Martin, *The New Bible Commentary Revised* (1970), 1041; T. W. Manson, *Peake's Commentary on the Bible* (1962), 950 [para. 825f.]; G. R. Cragg and J. Knox, *The Interpreter's Bible*, vol. 9 (1954), 598–604. Exceptions include C. K. Barrett, who interprets Paul's reference to the sword in light of the contemporary technical term *ius gladii*, "by which was meant the authority (possessed by all higher magistrates) of inflicting sentence of death" (see *The Epistle to the Romans*, rev. ed., Black's New Testament Commentary [London: Hendrickson, 1991], 277); and E. Best, who interprets the authority spoken of in verse 4 as including "the right to enforce their punishments even to the extent of putting men to death" ("The Letter of Paul to the Romans," *The Cambridge Bible Commentary* [1967], 148).

43. Pope Pius XII, "Address to the Italian Association of Catholic Jurists," 381, emphasis added.

44. *ST*, I-II, q. 100, a. 1c.

45. Ibid., a. 3c.

46. Ibid., a. 8, ad 3.

47. For a helpful essay on the New Testament understanding of blood, see Josef Schmid, "Blood of Christ," in *Encyclopedia of Biblical Theology*, vol. 1, ed. J. Bauer (London: Sheed and Ward, 1970), 79–81.

Notes to Chapter 4

1. *Protagoras* 322d, trans. W. K. C. Guthrie, in *The Collected Dialogues of Plato*, ed. E. Hamilton and H. Cairns (Princeton: Princeton University Press, 1989), 320.

2. *Laws* 862d–863a, trans. A. E. Taylor, *Collected Dialogues*, 1423.

3. Seneca, *De Ira*, bk. 1, ch. 6, in *Moral Essays*, vol. 1, trans. John Basore, Loeb Classical Library (Cambridge: Harvard University Press, 1928).

4. Justin Martyr, *The First Apology*, ch. 2, trans. Thomas Falls (*FOC*, vol. 6, p. 34).

5. *First Apology*, ch. 68 (*FOC*, vol. 6, p. 107).

6. *First Apology*, ch. 3 (*FOC*, vol. 6, pp. 34–35); later he writes: "we ask that the actions of all those denounced to you be judged, so that whoever is convicted may be punished as an offender, not as a Christian." *First Apology*, ch. 7 (*FOC*, vol. 6, p. 40).

7. *First Apology*, ch. 11 (*FOC*, vol. 6, p. 43).

8. According to Irenaeus, God established political power in the first place to deal with the problem of human sinfulness. He "imposed upon mankind the fear of man, . . . in order that, being subjected to the authority of men, and kept under restraint by their laws, they might attain to some degree of justice, and exercise mutual forbearance through dread of the sword suspended full in their view, as the apostle says: 'for he beareth not the sword in vain.'" Irenaeus of Lyons, *Against Heresies*, bk. 5, ch. 24, par. 2 (*ANF*, vol. 1, p. 552). We may infer from what he says earlier that "the sword" includes the death penalty. In a polemic against the Valentinians, Irenaeus, insisting that the Father of Jesus Christ is the one and same who both calls to salvation and judges the wicked, writes, "He [God] bestows freely upon those who should [receive]; but the most righteous retributor distributes [punishment] according to merit, most deservedly to the ungrateful and to those who are insensible of his kindness; and therefore He says, 'He sent His armies, and destroyed those murderers. . . .' He says here, 'His armies,' because all men are the property of God. For 'the earth is the Lord's, and the fulness thereof; the world, and all that dwell therein.' Wherefore also the Apostle Paul says in the Epistle to the Romans, 'For there is no power but from God; the powers that be are ordained of God. . . .' [quote continues through verse 7]." *Against Heresies*, bk. 4, ch. 36, par. 6 (*ANF*, vol. 1, p. 517). By quoting Matthew's parable of the marriage feast and following it with the quote from Romans 13, Irenaeus tells us that he understands the temporal punishments of God—including, the quotes make clear, lethal punishments—to be inflicted *inter alia* through the agency of civil authority.

9. Athenagoras, *A Plea for the Christians*, ch. 1 (*ANF*, vol. 2, p. 129).

10. *A Plea for the Christians*, ch. 2 (*ANF*, vol. 2, p. 130).

11. *A Plea for the Christians*, ch. 3 (*ANF*, vol. 2, p. 130).

12. *A Plea for the Christians*, ch. 35 (*ANF*, vol. 2, p. 147), emphasis added.

13. Minucius Felix, *Octavius*, ch. 30 (*FOC*, vol. 10, p. 387).

14. Tertullian, *De Idolatria*, ch. 17 (*ANF*, vol. 3, p. 72).

15. *De Idolatria*, ch. 19 (*ANF*, vol. 3, p. 73).

16. *De Corona*, ch. 11.4–5 (*FOC*, vol. 40, p. 257).

17. *De Corona*, ch. 11.2 (*FOC*, vol. 40, p. 256).

18. *De Spectaculis*, ch. 19 (*FOC*, vol. 40, p. 90).

19. *Scorpiace*, ch. 14 (*ANF*, vol. 3, p. 647).

20. Ibid.

21. *De Anima*, ch. 56 (*FOC*, vol. 10, p. 302), emphasis added. Tertullian implicitly recognizes the fittingness of capital punishment for serious crimes in *De Spectaculis*; treating the morality of attending for entertainment the sanguinary punishments carried out in the amphitheatre, he writes: "it is not becoming for the guiltless to take pleasure in the punishment of another; rather, it befits the guiltless to grieve that a man, like himself, has become so guilty that he is treated with such cruelty." *De Spectaculis*, ch. 19 (*FOC*, vol. 40, p. 90).

Interestingly, one of his arguments against viewing bloody spectacles is to keep oneself from witnessing the death of one wrongly condemned: "And who is my voucher that it is the guilty always who are condemned to the beasts, or whatever punishment, and that it is never inflicted on innocence, too, through the vindictiveness of the judge or the weakness of the defense . . . ?"—a perennially valid defense for the abolition of the death penalty. *De Spectaculis*, ch. 19 (*FOC*, vol. 40, p. 91).

22. *Treatise on the Resurrection* 16, in *Tertullian, Treatise on the Resurrection*, ed. Ernest Evans (London: S.P.C.K., 1960), 42.

23. Tertullian, *Apology*, ch. 4.9 (*FOC*, vol. 10, p. 19).

24. "*a speculatoribus condemnationis*," *Didascalia et Constitutiones Apostolorum*, lib. IV, cap. 6, no. 4, ed. F. X. Funk, vol. 1 (Paderborn, 1905), 224.

25. *The Apostolic Tradition of St. Hippolytus of Rome*, part II, ch. 16, articles 17–19, ed. Gregory Dix, reissued by Henry Chadwick (London: S.P.C.K., 1968), 26–27.

26. "*Delator si quis exstiterit fidelis, et per delationem ejus aliquis fuerit proscriptus vel interfectus, placuit eum nec in finem accipere communionem*," *PL*, vol. 84, 309c.

27. Clement of Alexandria, *Stromateis*, bk. 1, ch. 27, par. 173 (*FOC*, vol. 85, pp. 149–50).

28. Clement of Alexandria, *Paidagogos*, bk. 1, ch. 8 (*FOC*, vol. 23, pp. 58, 63); he quotes Plato's *Gorgias* (477a): "Now all who are punished, in reality suffer what is good. For they are benefited by those who punish justly, in that their soul is improved" (p. 60).

29. *Paidagogos*, bk. 1, ch. 8 (*FOC*, vol. 23, p. 58).

30. *Stromateis*, bk. 1, ch. 27, par. 171 (*FOC*, vol. 85, p. 149).

31. Ibid.

32. *Stromateis*, bk. 1, ch. 27, par. 172 (*FOC*, vol. 85, p. 149); cf. *Paidagogos*, bk. 1, ch. 8, and bk. 3, ch. 8.

33. *Stromateis*, bk. 1, ch. 27, par. 173 (*FOC*, vol. 85, p. 150).

34. Ibid.

35. *Paidagogos*, bk. 1, ch. 8 (*FOC*, vol. 23, p. 62).

36. Ibid.

37. Ibid.

38. *Stromateis*, bk. 4, ch. 24 (*ANF*, vol. 2, p. 438) (*FOC* covers only bks. 1–3).

39. Origen, *In Jeremiam Homilia XII* (*PG*, vol. 13, col. 386b; for the wider discussion, see 383d–386d). I have been aided in my search for relevant passages in Origen by Schöpf's *Das Tötungsrecht*, 158–63.

40. Origen, *In Leviticum Homilia XI* (*PG*, vol. 12, col. 533a).

41. *In Leviticum Homilia XIV* (*PG*, vol. 12, col. 557a–b).

42. *"purgaretur ex peccatis populus magis, quam condemnaretur." In Leviticum Homilia XI* (*PG*, vol. 12, col. 533a–b). The heretics to whom Origen refers are, of course, the Marcionites, who rejected the authority of the Old Testament. Origen, like many Church Fathers from Tertullian on who were faced with the threat of Marcionism, was anxious to reconcile Old Testament passages with the New Testament revelation of the God of Jesus Christ.

43. *Contra Celsum*, bk. 8, ch. 65, in *Origen: Contra Celsum*, trans. Henry Chadwick (Cambridge: Cambridge University Press, 1953), 501, emphasis in text.

44. Origen, *Comment. In Matthaeum Tomus X*, 21 (*PG*, vol. 13, col. 890b).

45. Origen, *Comment. In Epist. ad Rom. Lib. VI*, 7 (*PG*, vol. 14, col. 1073a).

46. Origen, *In Leviticum Homilia XI* (*PG*, vol. 12, col. 532c); in his commentary on Romans he writes: "For all crimes God wills to be punished he wills to be punished, not through the bishops and leaders of churches [*non per antistites et principes Ecclesiarum*], but through a secular judge; and knowing this, Paul rightly calls him the minister of God and avenger upon him who does what is evil." *Comment. In Epist. ad Rom. Lib. IX* (*PG*, vol. 14, col. 1228b).

47. *Contra Celsum*, bk. 7, ch. 26 (trans. Chadwick, p. 415).

48. *Contra Celsum*, bk 8, ch. 73 (trans. Chadwick, p. 509).

49. Cyprian, *Epistle 60*, to Cornelius, par. 2 (*FOC*, vol. 51, p. 194).

50. Cyprian, *Ad Demetrianum*, ch. 13 (*FOC*, vol. 36, p. 179).

51. Ibid.

52. Cyprian, *Ad Donatum*, ch. 7 (*FOC*, vol. 36, p. 13), emphasis added.

53. Lactantius, *Divinae Institutiones*, lib. VI, cap. 20 (*CSEL*, vol. 19 [1890], p. 558, nos. 15–18); English translation with minor corrections from *ANF*, vol. 7, p. 187. Cf. *Epitome Divinarum Institutionum* 59 (64) (*CSEL*, vol. 19, p. 744, nos. 5 [14]–6 [15]; *ANF*, vol. 7, no. 64, par. 2, p. 249).

54. Lactantius, *De Ira*, lib. 17 (*CSEL*, vol. 27 [1893–1897], pp. 110–11, nos. 6–8; *ANF*, vol. 7, p. 273).

55. For a convenient description of the Antioch affair, see Gibbon, *The Decline and Fall of the Roman Empire*, ch. 27.

56. Chrysostom, *Homilies on the Statues (Sermons on the Monuments)*, *NPNF-I*, vol. 9, pp. 331–489. These were not systematic moral treatises but pastoral homilies addressed to a congregation burdened by fear and anxiety, in a political situation in which every word of the preacher might be politically construed. With this in mind, it is understandable that Chrysostom would employ rhetoric which, on the one hand, places an

inordinately strong emphasis on the responsibility of the people and, on the other hand, expresses an inordinately sanguine attitude toward the person and actions of the emperor. Having said that, the *Sermons* still, I think, tell us something of Chrysostom's own ideas about bloody punishment.

57. *Homily VI*, par. 2 (*NPNF-I*, vol. 9, p. 382).

58. *Homily V*, par. 10 (p. 374).

59. *Homily VI*, par. 6 (p. 383).

60. *Homily XXI*, par. 8 (p. 484).

61. *Homily VI*, par. 1 (p. 381).

62. *Homily XVII*, par. 3 (p. 453).

63. Ibid.

64. Ibid.

65. Eusebius, *Vita Constantini*, lib. III, ch. 1 (*NPNF-II*, vol. 1, p. 519).

66. *Vita Constantini*, lib. II, ch. 18 (*NPNF-II*, vol. 1, p. 504); cf. *Church History*, bk. X, ch. 9.3 (*NPNF-II*, vol. 1, p. 386). The influential church historian is so taken up in the drama of the Constantine "event" that he writes as if he were unaware that his lively acceptance and narration of the bloody exploits of Constantine breaks with a deeply rooted Christian tradition.

67. Gregory of Nazianzus, *Oratio XVII*, par. 9 (*PG*, vol. 35, col. 975b).

68. Ibid. (*PG*, vol. 35, col. 975c).

69. Gregory of Nazianzus, *Epistola LXXVIII* (*PG*, vol. 37, col. 147b–c).

70. Gregory of Nazianzus, *Oratio XVII*, par. 6 (*PG*, vol. 35, col. 974b), emphasis added.

71. Ambrose, *Epistola L (XXV)*, to Studius (*CSEL*, vol. 82 [1990], part 10, tom. II, pp. 56–59); the *PL* version (vol. 16, cols. 1039–1042) is corrupt in places, hence *CSEL* is to be preferred.

72. "*his communionem non audeamus negare,*" ibid. (*CSEL*, vol. 82, part 10, tom. II, p. 56).

73. Ibid. (*CSEL*, vol. 82, part 10, tom. II, pp. 56–57); excerpt translated in *From Irenaeus to Grotius: A Sourcebook in Christian Political Thought*, ed. Oliver O'Donovan and Joan Lockwood O'Donovan (Grand Rapids: Eerdmans, 1999), 83.

74. Ibid. (*CSEL*, vol. 82, part 10, tom. II, p. 57); cf. Augustine, *Tractate 33 on the Gospel of John*, par. 5 (*NPNF-I*, vol. 7, pp. 198–99).

75. Ibid. (*CSEL*, vol. 82, part 10, tom. II, p. 57).

76. Ambrose, *On Cain and Abel*, bk. 2, par. 34 (*FOC*, vol. 42, p. 433).

77. *On Cain and Abel*, bk. 2, par. 38 (*FOC*, vol. 42, p. 436).

78. Ibid. (p. 437).

79. Ibid.

80. Ibid., bk. 2, par. 15 (*FOC*, vol. 42, p. 416).

81. Ibid.

82. "*Eos praeterea, qui saecularem adepti potestatem, jus saeculi exercuerunt, immunes a peccato esse non posse manifestum est. Dum enim et gladius exseritur, aut judicium confertur injustum, aut tormenta exercentur pro necessitate causarum, aut parandis exhibent voluptatibus curam, aut praeparatis intersunt, in his se, quibus renuntiaverunt, denuo sociantes, disciplinam observationis traditam mutaverunt.*" Council of Rome, *Epistola X, seu Canones Synodi Romanorum ad Gallos Episcopos*, cap. V, can. 13 (*PL*, vol. 13, col. 1190a).

83. Francesco Compagnoni interprets the first part of this passage as asserting that officials who have administered *capital punishment* cannot be regarded as free from sin; this, it seems to me, reads into the Latin more than is present. See Francesco Compagnoni, O.P., "Capital Punishment and Torture in the Tradition of the Roman Catholic Church," *Concilium* 120 (1978): 41; cf. Megivern, *The Death Penalty*, 33.

84. Pope Innocent I, *Epistle VI*, to Exsuperium, cap. III.8 (*PL*, vol. 20, col. 499a–b).

85. Augustine's views on the morality of coercing heretics to orthodox belief developed, even changed, during his long and painful engagement with the Donatists; compare *Letter 34* (AD 396) with *Letter 93* (AD 408). His ideas about capital punishment seem to have remained constant throughout his Christian life.

86. Augustine, *On Free Choice of the Will*, lib. I, cap. IV (*FOC*, vol. 59, p. 79); in another early work, *De Ordine* (386), written in the year of his conversion, he states that the hangman (*carnifex*), who harms those who harm the social order, holds a necessary place in the plan of God for the ordering of the *civitas*. Lib. I, ch. 2, quoted in Crowe, "Theology and Capital Punishment," 36.

87. Saint Augustine, *Commentary on the Lord's Sermon on the Mount*, ch. 20, par. 64 (*FOC*, vol. 11, p. 90). St. Jerome (d. 420), writing around the same time, is likewise on guard against these two heresies; commenting on a verse from Jeremiah, "do not shed innocent blood in this place," he writes: "To punish murderers, the sacrilegious, and poisoners is not the shedding of blood, but the duty of the laws." *Commentariorum in Jeremiam*, lib. IV, cap. 22 (*PL*, vol. 24, col. 811d).

88. "This authority [to put to death] was not exercised rashly by those to whom God had committed it." Augustine, *Commentary on the Lord's Sermon on the Mount*, ch. 20, par. 64 (*FOC*, vol. 11, p. 90).

89. Augustine also cites a similar event recorded in an apocryphal work which, he alleges, the Manichaeans consider authoritative, i.e., *The Acts of St. Thomas;* ibid., par. 64, 65 (*FOC*, vol. 11, pp. 91–92); a similar line of reasoning is followed in bk. 22, par. 79 of *Reply to Faustus the Manichaean* (AD 400) (*NPNF-I*, vol. 4, pp. 303–4).

90. *Commentary on the Lord's Sermon on the Mount*, ch. 20, par. 64 (*FOC*, vol. 11, p. 91).

91. *Letter LXXXVII* (ca. AD 405), to Emeritus (*FOC*, vol. 18, p. 19).

92. *Letter CLIII* (AD 414), to Macedonius (*FOC*, vol. 20, p. 293).

93. *Letter XLVII* (AD 398), to Publicola, par. 5 (*FOC*, vol. 12, p. 230).

94. *Reply to Faustus the Manichaean* (AD 400), par. 70 (*NPNF-I*, vol. 4, p. 299).

95. *Reply to Faustus,* par. 70 (*NPNF-I*, vol. 4, p. 299); later Augustine defends Abraham's sacrifice of Isaac by arguing that because the act was commanded by God and did not proceed from private authority, it was therefore legitimate: "while Abraham's killing his son of his own accord would have been unnatural, his doing it at the command of God shows not only guiltless but praiseworthy compliance." Ibid., par. 73 (*NPNF-I*, vol. 4, p. 300).

96. *De Civitate Dei,* lib. I, cap. XXI (*FOC*, vol. 8, p. 53).

97. *Letter XC* (AD 408), Nectarius to Augustine (*FOC*, vol. 18, p. 41).

98. Augustine's lengthy *Letter CLIII* (AD 414) is an extended discussion of the priestly ministry of reconciliation; (*FOC*, vol. 20, pp. 281–303, quotes from 281–82).

99. *Letter LXXXVI* (AD 405), to Caecilianus (*FOC*, vol. 18, p. 12).

100. *Letter C* (ca. AD 409), to Donatus (*FOC*, vol. 18, p. 142).

101. Ibid.

102. Ibid.

103. *Letter CIV* (AD 409), to Nectarius (*FOC*, vol. 18, p. 184); see also *Letter CIII* (pp. 179–80).

104. *Letter CIV,* to Nectarius (*FOC*, vol. 18, p. 194).

105. *Letter CXXXIX* (AD 412), to Marcellinus (*FOC*, vol. 20, p. 54).

106. To those who say that enacting laws against heretics is contrary to the Apostolic witness and hence forbidden, Augustine replies: such critics "fail to notice that times were different then, and that all things have to be done at their own times. At that time there was no emperor who believed in Christ, or who would have served Him by enacting laws in favor of religion and against irreligion." *Letter CLXXXV* (AD 417), to Boniface, ch. 19 (*FOC*, vol. 12, p. 159).

107. Chrysostom states this more strongly: "For it is not right to put a heretic to death, since an implacable war would be brought into the world." John Chrysostom, *Gospel According to St. Matthew, Homily 46* (*NPNF-I*, vol. 10, p. 228). See the entire homily, particularly pp. 288–99, for Chrysostom's interpretation of Matthew 13:24–30 on the parable of wheat (symbol for faithful Christians) and weeds (symbol for heretics).

108. *Letter CXXXIII* (AD 412), to Marcellinus (*FOC*, vol. 20, p. 6).

109. "What I fear is that either they or the others who have been convicted of murder may be sentenced according to the *full weight of your authority.*" In its context this is clearly a reference to the death penalty. *Letter CXXXIV* (AD 412), to Apringius (*FOC*, vol. 20, p. 10), emphasis added.

110. Ibid.

111. Ibid. (p. 12).

112. Ibid. (p. 11).

113. *Letter X** (AD 422), to Alypius (*FOC*, vol. 81, pp. 76–77).

114. Ibid., par. 4 (*FOC*, vol. 81, p. 78).

115. Leo the Great (d. 461), *Epistola XV* (*PL*, vol. 54, col. 680a).

116. Gregory the Great, *Epistle XLVII,* to Sabinianus (*NPNF-II*, vol. 12, p. 161).

117. Crowe, "Theology and Capital Punishment," 31.

118. Compagnoni, "Capital Punishment and Torture," 41; cf. Megivern, *The Death Penalty*, 33.

Notes to Chapter 5

1. Fourth (national) Council of Toledo (AD 633), c. 30; in *Decretum Gratiani*, Causa 23, q. 8, c. 29, *Corpus Iuris Canonici*, vol. 1 (*CIC-1*), "Decretum Magistri Gratiani" (Lipsiae: Ex Officina Bernhardi Tauchnitz, 1879), col. 964.

2. Eleventh (provincial) Council of Toledo (AD 675), c. 6; in *Decretum Gratiani*, Causa 23, q. 8, c. 30; (*CIC-1*, col. 964).

3. Attonis Vercellensis Episcopi (Atto of Vercelli) (924–961), *De Pressuris Ecclesiasticis*, pars I, 36–37 (*PL*, vol. 134, col. 61a–b).

4. Pope Alexander III (r. 1159–1181), "To Archbishop of Canterbury," in *Decretal. Gregor. IX*, lib. III, tit. L, cap. V, in *Corpus Iuris Canonici*, vol. 2 (*CIC-2*), "Decretalium Collectiones" (Lipsiae: Ex Officina Bernhardi, 1881), cols. 658–659.

5. Fourth Lateran Council (1215), Constitution 18, trans. Norman P. Tanner, S.J., and G. Alberigo (*DEC-I*, p. 244); this statement appears later in *Decretal. Gregor. IX*, lib. III, tit. L, cap. IX (*CIC-2*, cols. 659–660).

6. "*Ecclesia gladio non vindicet*," Theodore the Studite, *Epistolarum*, lib. II, *Epistola CLV*, to Theophilus of Ephesus (*PG*, vol. 99, col. 1486c, Migne's Latin). Theodore's use of the term "church" is bound to imply sentiments peculiar to Eastern Christianity, for example, the divine tradition of Christian liturgy and doctrine; nevertheless, his numerous appeals to Roman pontiffs during the images controversy and his clearly articulated conviction that the see of Rome had been "from the beginning until now, by the very providence of God, the one and only help in recurrent crises . . . the pure and genuine source of orthodoxy . . . the distinct calm harbor for the whole church from every heretical storm," make it clear that he understands the Church to be the apostolic and universal Church under Peter's headship; *PG*, vol. 99, col. 1153, also col. 1117, quoted in Jaroslav Pelikan, *The Spirit of Eastern Christendom (600–1700)*, vol. 2 of *The Christian Tradition: A History of the Development of Doctrine* (Chicago: University of Chicago Press, 1974), 154–55.

7. Theodore, *Epistola CLV* (*PG*, vol. 99, col. 1486c).

8. Pope Nicholas I (d. 867), Letter to Archbishop Albino, in *Decretum Gratiani*, Causa 33, q. 2, c. 6 (*CIC-1*, col. 1152). Nicholas' strong sense of the implications of Christian discipleship on killing is evident in his letter to the newly converted Bulgars: "You must act like the apostle Paul who, having been a persecutor, was converted and not only desisted from any application of the death penalty but gave himself up totally to the salvation of souls. Thus you must give up your former habits and not merely avoid every occasion of taking life, but also, without hesitation and in every possible circumstance,

save the life, both of body and of soul, of each individual. You should save from death not only the innocent but also criminals, because Christ has saved you from the death of the soul"; *Epistle 97,* Letter to the Bulgars, ch. 15; quoted in Compagnoni, "Capital Punishment and Torture," 47–48.

9. That doctrine is summed up in the metaphor of the two swords, which gained popularity during the Hildebrandine reforms; the doctrine states that the Church possesses two swords, one for purposes of spiritual correction, the other for exacting temporal punishments; the spiritual sword is wielded by the Church while the material sword is delegated to temporal authority to be wielded on the Church's behalf. John of Salisbury (twelfth century) writes, "This [material] sword is therefore accepted by the prince from the hand of the Church. . . . The prince is therefore a sort of minister of the priests and one who exercises those features of the sacred duties that seem an indignity in the hands of priests." *Policraticus: Of the Frivolities of Courtiers and the Footprints of Philosophers,* trans. Cary J. Nederman, Cambridge Texts in the History of Political Thought (Cambridge: Cambridge University Press, 1990), 32. The crucial point of the doctrine is that *both* swords belong to the Church

10. This genre of tracts, sometimes called the "mirror for princes," originated in Ireland in the seventh century but was not popularized until the ninth. Generally written by learned men—churchmen, philosophers, poets—these so-called mirrors held up before princes the qualities of just and unjust rulers and admonished them to conform their lives and rules to principles of justice. Perhaps best known is *De Rectoribus Christianis* (On Christian Rulers) by Sedulius Scottus in the mid-ninth century, but this was just one of many, including *De Institutione Regia* by Jonas of Orleans, *Via Regia* by Smaragdus, the influential *De Regis Persona* by Hincmar of Rheims, and John of Salisbury's *Policraticus.*

11. Philip Hughes, *A History of the Church,* vol. 2 (New York: Sheed and Ward, 1949), 153.

12. John of Salisbury, *Policraticus,* bk. 4, ch. 2 (trans. Nederman, p. 30), emphasis added.

13. *Policraticus,* bk. 4, ch. 1 (pp. 28–29).

14. *Policraticus,* bk. 4, ch. 2 (p. 30).

15. Ibid.

16. Ibid. (p. 31).

17. Ibid.

18. Ibid.

19. Hincmar (806–882) was a counselor to Louis the Pius and Charles the Bald, and was for four decades (according to the *Catholic Encyclopaedia*) "at the very centre of government, both ecclesiastical and political, in the West-Frankish Empire"; *Catholic Encyclopaedia,* s.v. "Hincmar, Archbishop of Reims," vol. 7, p. 356.

20. Hincmar Rhem. Archiep. (Hincmar of Reims), *De Regis Persona et Regio Ministerio,* cap. 24 (*PL*, vol. 125, col. 850b).

21. Quoted in Walter L. Wakefield and Austin P. Evans, eds., *Heresies of the High Middle Ages: Selected Sources Translated and Annotated* (New York: Columbia University Press, 1969), 228. Cited hereafter as *HHM*.

22. *Decretum Gratiani*, C. 23, q. 5, (dict. post) c. 7 (*CIC-1*, col. 932); C. 23, q. 8, (rubric) c. 33 (*CIC-1*, col. 965).

23. *Decretum Gratiani*, C. 23, q. 5, c. 14 (*CIC-1*, col. 935); see also c. 13 (col. 935) and c. 31 (col. 939).

24. The *Decretum Gratiani* (its proper name was *Concordantia discordantium canonum*), published around 1139, was larger and far better systematized than its early medieval predecessors. For a fine introduction to the *Decretum,* see Stanley Chodorow, *Christian Political Theory and Church Politics in the Mid-Twelfth Century: The Ecclesiology of Gratian's Decretum* (Berkeley: University of California Press, 1972), 1–16.

25. *Decretum Gratiani*, C. 23, q. 5, pars. 1 (*CIC-1*, col. 928).

26. C. 23, q. 5, (dict. post) c. 48 (*CIC-1*, col. 945).

27. "*Ex offitio non est peccatum hominem occidere,*" C. 23, q. 5, (rubric) c. 8 (*CIC-1*, col. 932); "*Prohibetur ergo illo precepto quisque sua auctoritate in necem alicuius armari, non legis inperio reos morti traere,*" C. 23, q. 5, (dict. post) c. 7 (*CIC-1*, col. 932); "*Non peccat qui ex offitio nocentem interficit,*" C. 23, q. 5, (rubric) c. 41 (*CIC-1*, col. 941); "*Homicidas, et sacrilegos, et uenenarios punire non est effusio sanguinis, sed legum ministerium,*" C. 23, q. 5, c. 31 (quoting St. Jerome) (*CIC-1*, col. 939). Having said this, Gratian makes clear that the authority of the law does not permit one to kill oneself: "*Se ipsum autem perimere nulla legis auctoritate alicui permittitur.*" C. 23, q. 5, (dict. post) c. 8 (*CIC-1*, col. 933).

28. In Causa 33 Gratian says, "the discipline of the Church [*ecclesiastica disciplina*] prescribes that criminals be struck not with the material sword but with a spiritual sword like the one with which Peter was commanded to kill and eat or about which the Lord spoke in the Gospel when he said, 'I have come not to bring peace on earth but the sword.'" C. 33, q. 2, (dict. post) c. 5 (*CIC-1*, col. 1152); in C. 33, q. 2, c. 6, he quotes Pope Nicholas' words: "*gladium non habet, nisi spiritualem; non occidit, sed uiuificat.*"

29. C. 23, q. 8, (dict. ante) c. 1 (*CIC-1*, col. 953); although this quote falls in the midst of the counterargument at the beginning of the question, Gratian's intention is not to argue against it but to ask whether, in light of it, the Church is still permitted to defend itself with the use of armed force.

30. In question 8 Gratian cites the Council of Toledo's formulation of the clergy prohibition. "*His a quibus Domini sacramenta tractanda sunt, iudicium sanguinis agitare non licet.*" C. 23, q. 8, c. 30 (*CIC-1*, col. 964).

31. C. 23, q. 5, (rubric) c. 21 (*CIC-1*, col. 937).

32. C. 23, q. 8, (dict. post) c. 18 (*CIC-1*, col. 958); trans. Chodorow, *Christian Political Theory*, 240.

33. C. 23, q. 8, (dict. post) c. 28 (*CIC-1*, col. 963).

34. It is actually a quote from St. Leo the Great. Third Lateran Council (1179), ch. 27 (*DEC-I*, 224). This statement appears again in *Decretal. Gregor. IX*, lib. V, tit. VII, *De Haereticis*, cap. VIII (*CIC-2*, cols. 779–780).

35. From *Chronicon universale anonymi Laudunensis* (twelfth century), in Wakefield and Evans, *Heresies of the High Middle Ages* (*HHM*), 202–3. In 1205 a group of Italian Waldenses broke from the Poor of Lyons and took the name "Poor Lombards"; members of the Poor of Lyons and the Poor Lombards were eventually reconciled with the Church, the former taking the name "Poor Catholics" and the latter the "Reconciled Poor."

36. For an introduction to the rise of the Waldensian heresy in the twelfth century, see Malcolm Lambert, *Medieval Heresy: Popular Movements from the Gregorian Reform to the Reformation*, 2d ed. (Oxford: Blackwell, 1992), 62–87.

37. We learn about this event from an Englishman, Walter Map (a chronicler and servant of Henry II), who claims to have been present at Lateran III; Walter Map, *De nugis curialium*, trans. Montague R. James, in *HHM*, 202–3.

38. *HHM*, 203; on the accuracy of the details of this account, see *HHM*, 708, n. 2.

39. This comes from an account by Stephen of Bourbon, a thirteenth-century French Dominican and Church inquisitor; *Stephani de Borbone tractatus de diversis materiis praedicabilis* iv.vii.342 (*HHM*, 210).

40. Waldes' 1180 oath is translated in *HHM*, 206–8.

41. The oath of December 1208 is preserved in a letter of Innocent III dated the 18th of July, "to the archbishop and suffragans of the Church of Tarragona," alerting them to the reconciliation of Durand and his followers (for the letter see *Innocenti III romani pontificis Regestorum sive epistolarum libri XV, XI.196*, translated in *HHM*, 222–26; it appears in Migne, *PL*, vol. 215, cols. 1510a–1513d, although it is dated 15 January 1209); two copies of Innocent's 1208 letter were made, one sent to Durand himself and the other to certain laymen supervised by the Poor Catholics (*Regesta XI.197, 198*; in Migne, *PL*, vol. 215, col. 1514; see also *HHM*, 716, n. 15).

42. Letter of Innocent III, "to Durand of Huesca and his brethren," 5 July 1209; *Regesta XV, XII.69;* translated in *HHM*, 226–28, quote from 227.

43. Translation with minor revisions from *HHM*, 228.

44. For details surrounding the revising of the 1208 profession, see *HHM*, 716, n. 10.

45. "*De potestate saeculari asserimus quod sine peccato mortali potest judicium sanguinis exercere, dummodo ad inferendam vindictam, non odio, sed judicio, non incaute sed consulte procedat*" (*PL*, vol. 215, col. 1512a), my translation; the entire revised 1210 profession is translated in Denziger, *The Sources of Catholic Dogma*, trans. Roy J. Deferrari (London: B. Herder Book Co., 1957), nos. 420–27, esp. no. 425, English translation from Denziger, *Enchiridion Symbolorum*, 30th edition. Innocent mentions the right of public authority to condemn evildoers again in a letter to Catholic bishops dated 14 June 1210, announcing the conversion of a prominent Waldensian, Bernard the First, and pre-

scribing a similar oath for the reconciliation of members of the sect (*PL*, vol. 216, cols. 289b–293a, esp. 291d).

46. See Susanna K. Treesh, "The Waldensian Recourse to Violence," *Church History* 55 (1986): 294–306. Treesh argues that nonviolence was more a quality of the leaders than a characteristic of the actions of the followers who, she says, at least in the later Middle Ages, "resorted to violence on enough occasions and in enough different locations to justify dropping the idea that they were a nonviolent group" (294).

47. *HHM*, 234; for the question of its authorship see *HHM*, 230.

48. Rainier Sacconi, Inquisitor's records of interrogations of 1254, "Concerning the heresy of the Leonists, or the Poor Men of Lyons," in Edward Peters, *Heresy and Authority in Medieval Europe: Documents in Translation* (London: Scholar Press, 1980), 142, see also 106, 125 ff.

49. *Passau Anonymous*, "Tractate Concerning the Waldensians," in Peters, *Heresy*, 163; see also 141.

50. Peter of Vaux-de-Cernay, *Hystoria albigensis* (ca. 1213), quoted in *HHM*, 240–41.

51. Lambert, *Medieval Heresy*, 75.

52. Sacconi, "Records of 1254," in Peters, *Heresy*, 125.

53. Lambert, *Medieval Heresy*, 75.

54. Ibid.

55. *PL*, vol. 125, col. 850b.

56. Finnis, *Aquinas*, 212.

57. *ST*, II-II, q. 108, a. 4c; see also II-II, q. 99, a. 4c.

58. For example, "As a medicine used for the restoration of health is a kind of disagreeable potion . . . so a penalty used for the restoration of virtue is a kind of medicine," *Commentary on Aristotle's* Nicomachean Ethics, bk. 2, lecture 3, n. 4, par. 270; "punishment may be considered as a medicine, not only healing the past sin, but also preserving from future sin," *ST*, II-II, q. 108, a. 4c; "punishment . . . is necessary so that the mind may adhere more firmly to the good," *SCG*, III, c. 158, n. 6; "When the stain is removed, the wound of sin is healed as regards the will. But punishment is still requisite in order that the other powers of the soul be healed, since they were disordered by the sin committed," *ST*, I-II, q. 87, a. 6, ad 3; "punishments are a sort of medicine . . . for the criminal himself, insofar as they preserve him from guilt or promote virtue," *In Lib. III Sent.*, d. 19, q. 1, a. 3, sol. 2.

59. *In Lib. II Sent.*, d. 42, q. 1, a. 2, sol.; see also *In Lib. III. Sent.*, d. 19, q. 1, a. 3, sol. 2. See also *SCG*, III, c. 144, where Aquinas refers to *human* punishments as medicinal (no. 9) and to *divine* punishment as "for the imposing of order on creatures" (no. 10), but then is to willing to concede—if only for the sake of argument—"that *all* punishments are applied for the correction of behavior" (no. 11); see also c. 158, where Aquinas combines the notions of punishments as medicine for the one punished and punishments for purposes of order by saying punishments can be for the cleansing of the disorder *in the one punished* (no. 5). With these variations in Aquinas' use of the term in mind, John

Finnis describes Aquinas' notion of punishment as "medicinal" in this way: "In any state of affairs [including the order of justice] capable of being improved by it, punishment's justifying point is to make an improvement" (Finnis, *Aquinas*, 212).

60. This is repeated several times: see *SCG*, III, c. 140, n. 7; *In Lib. IV Sent.*, d. 46, q. 1, a. 2, sol. 3, ad 2; *ST*, I-II, q. 87, a. 8, ad 2; *ST*, II-II, q. 33, a. 6c.

61. It also includes restraining criminals in order to prevent future disturbance to the order of justice; *ST*, II-II, q. 108, a. 1c.

62. "*ordinatur ad privationem ordinis,*" *ST*, I-II, q. 87, a. 3, ad 4.

63. "*sed poena recompensat defectum in statu universi, vel etiam reipublicae, propter ordinem justitiae qui in poena apparet,*" *In Lib. II Sent.*, d. 42, q. 1, a. 2, sol.; "*ordinem justitiae justus judex in suis subditis ponere intendit,*" *In Lib. II Sent.*, d. 37, q. 3, a. 1, ad 2.

64. *ST*, II-II, q. 108, a. 4c; *ST*, I-II, q. 87, a. 6c; "*quantum voluntati suae obedivit praeter legem dei, tantum etiam in contrarium recompenset, ut sic justitiae servetur aequalitas,*" *In Lib. II Sent.*, d. 42, q. 1, a. 2, ad 5.

65. See *SCG*, III, c. 142, nos. 1–2.

66. *SCG*, III, c. 140, n. 5.

67. *ST*, II-II, q. 108, a. 4c.

68. *ST*, III, q. 86, a. 4c; I-II, q. 87, a. 6c.

69. *ST*, I-II, q. 87, a. 1, ad 3.

70. Ibid., ad 2.

71. *ST*, I-II, q. 46, a. 6, ad 2; "the nature of punishment is that it is contrary to the will," *On Evil*, q. 1, a. 4c, trans. Jean Oesterle (Notre Dame, Ind.: University of Notre Dame Press, 1995); see also *SCG*, III, c. 140, n. 5, c. 141, nos. 1, 4, 6; *In Lib. II Sent.*, d. 42, q. 1, a. 2, sol.; *ST*, I, q. 48, a. 5c; *ST*, I-II, q. 87, a. 6c.

72. *ST*, I-II, q. 87, a. 6c.

73. *ST*, II-II, q. 108, a. 4c.

74. "*culpae quantitas non mensuratur ex nocumento quod quis facit, sed ex voluntate qua facit contra caritatem,*" *In Lib. IV Sent.*, d. 18, q. 2, a. 1, sol. 3, ad 1; "*sic quantitas poenae radicaliter respondet quantitati culpae,*" *In Lib. IV Sent.*, d. 20, q. 1, a. 2, sol. 1.

75. *SCG*, III, c. 145, n. 1.

76. *SCG*, III, c. 142, n. 1; see also n. 5. Yet because punishment is intended to check sin, Aquinas admits that if the infliction of punishment promises the commission of "more numerous and more grievous sins," then it may and in fact ought to be forgone; *ST*, II-II, q. 43, a. 7, ad 1.

77. "Consequently, it is evident that there is no punishment for man, even in the sense of being contrary to will, without a prior fault," *SCG*, III, c. 141, n. 7; in addition to saying that only offenders are *rightly* punished, this passage says that only offenders are punished *at all*, since the infliction of any amount of temporal evil is no punishment to one whose will is rightly ordered.

78. *ST*, II-II, q. 64, articles 3, 5, 6.

79. Ibid., a. 3c.

80. "*Omnis autem pars ordinatur ad totum ut imperfectum ad perfectum. Et ideo omnis pars naturaliter est propter totum. Et propter hoc videmus quod si saluti totius corporis humani expediat praecisio alicuius membri, puta cum est putridum et corruptivum aliorum, laudabiliter et salubriter abscinditur. Quaelibet autem persona singularis comparatur ad totam communitatem sicut pars ad totum. Et ideo si aliquis homo sit periculosus communitati et corruptivus ipsius propter aliquod peccatum, laudabiliter et salubriter occiditur, ut bonum commune conservetur.*" Ibid., a. 2c, my translation; cf. *SCG*, III, c. 146, nos. 4–5.

81. *Politics*, bk. 1, ch. 2, 1253a19–29.

82. Cf. *SCG*, III, c. 146, n. 4: "the common good is better than the particular good of one person."

83. *Nicomachean Ethics*, bk.1, ch. 2, 1094b7–10. Aristotle's notion that the city's good is more "godlike" is rooted in his understanding that the divine nature exists in isolated, self-sufficient wholeness; that which is most self-sufficient is most like the divine nature. See *Metaphysics*, bk. XII, ch. 9, 1074b15–34; cf. *SCG*, III, c. 69, n. 16.

84. Aquinas' argument also reflects the reasoning of Clement of Alexandria (ca. AD 150–215) whose defense of the death penalty in the *Stromateis* likens killing malefactors to amputating a part for the sake of the whole; see bk. 1, ch. 27.

85. *SCG*, III, c. 17, n. 6; c. 125, n. 10.

86. "*homo peccando ab ordine rationis recedit: et ideo decidit a dignitate humana, prout scilicet homo est naturaliter liber et propter seipsum existens, et incidit quodammodo in servitutem bestiarum, ut scilicet de ipso ordinetur secundum quod est utile aliis. . . . Et ideo quamvis hominem in sua dignitate manentem occidere sit secundum se malum, tamen hominem peccatorem occidere potest esse bonum, sicut occidere bestiam: peior enim est malus homo bestia,*" *ST*, II-II, q. 64, a. 2, ad 3, emphasis added.

87. *ST*, II-II, q. 99, a. 4c and ad 1.

88. *ST*, II-II, q. 64, a. 4c.

89. *ST*, II-II, q. 64, a. 4, obj. 2.

90. *ST*, II-II, q. 64, a. 4, ad 2.

91. Ioannes Duns Scotus, *Quaestiones In Lib IV Sententiarum (In Lib. IV Sent.)*, Opera Omnia, vol. 9, d. 15, q. 3 (Hildesheim: Georg Olms Verlagsbuchhandlung, 1968, reprint from 1639 edition).

92. Scotus, *In Lib. IV Sent.*, d. 15, q. 3, *commentarius (com.)*, no. 33 (p. 221).

93. "*Sed quis est iustus occidens?*" Ibid.

94. Ibid., *dict. post scholium*, no. 7 (p. 220); see also *com.*, no. 33 (p. 221).

95. Ibid., *dict. post scholium*, no. 8 (p. 220).

Notes to Chapter 6

1. Brief accounts include M. B. Crowe, "Theology and Capital Punishment," 44–50; Marc Ancel, "The Problem of the Death Penalty," in *Capital Punishment*, ed.

Thorsten Sellen (New York: Harper and Row, 1967), 4–9; Louis P. Masur, *Rites of Execution: Capital Punishment and the Transformation of American Culture, 1776–1865* (New York: Oxford University Press, 1989), 51–52. Longer treatments include Megivern, *The Death Penalty*, ch. 6, 209–52; Brian P. Block and John Hostettler, *Hanging in the Balance: A History of the Abolition of Capital Punishment in Britain* (Winchester: Waterside Press, 1997); Harry Potter, *Hanging in Judgement: Religion and the Death Penalty in England from the Bloody Code to Abolition* (London: SCM Press, 1993).

2. Joseph Fichter, biographer of Francisco Suárez, writes: "Perhaps in no other university in the world is there to be found so brilliant a succession of professors as that which filled the principal chair of theology at Salamanca during the sixteenth century." *Man of Spain, Francis Suarez* (New York, 1940), 79–80, quoted in Francisco de Vitoria, O.P., *Relection on Homicide* & *Commentary on* Summa theologiae *IIa-IIae Q. 64*, trans. John P. Doyle (Milwaukee: Marquette University Press, 1997), Introduction, 43, n. 49.

3. Thomas de Vio was born at Gaeta (hence Cajetanus), Italy, in 1469. He joined the Dominicans before the age of sixteen against the will of his parents. He was created a cardinal in 1517 by Pope Leo X (r. 1513–1521) and later became one of the chief advisors to Pope Clement VII (1523–1534). He was one of nineteen cardinals who, with the pope, ruled definitively on the validity of the marriage between Henry VIII and Catherine of Aragon. He died at Rome in 1534. *The Catholic Encyclopaedia*, 1911 ed., s.v. "Cajetan."

4. Cajetan's commentaries were incorporated into the Leonine edition of Aquinas' *Summa Theologiae*, the first volume of which appeared in 1882.

5. Cajetan, Commentary on q. 64, a. 2, p. 69, from Cajetan, *Commentaries of Thomas Cajetan*, in Aquinas, *Opera Omnia*, vol. 9, Leonine ed. (1897).

6. Ibid.

7. *ST*, II-II, q. 25, a. 6, ad 2.

8. Cajetan, Commentary on q. 64, a. 2, p. 69; see *ST*, II-II, q. 64, a. 2c.

9. Commentary on q. 64, a. 2, p. 69.

10. Ibid.

11. Commentary on q. 108, a. 3, p. 413. Compare with the words of Aquinas: "And therefore the death penalty is inflicted only for those sins that result in the grave harm of others." *ST*, II-II, q. 108, a. 3, ad 2.

12. "*conjunctio dominii temporalis cum spirituali*," Commentary on q. 64, a. 4, p. 71.

13. Commentary on q. 64, a. 4, p. 71; see *ST*, II-II, q. 64, a. 4, ad 2; while Aquinas' article concerns clerics (*clericis*) in general, Cajetan, interested in the particular case of the prelate-lord, relates the doubt only to bishops (*episcopus/praelatus*).

14. Commentary on q. 64, a. 4, p. 71.

15. Vitoria was sent by the Dominicans to Paris in 1509 to study arts and theology. The Dominican College of St. Jacques, where he studied, was one of two colleges attached to the Sorbonne undergoing a revival after the fifteenth-century nominalist decline. Around 1507 a practice was inaugurated there which was already being used by Cajetan in Italy, namely, publicly lecturing on the *Summa Theologiae* of Aquinas. Having

been introduced to this method as a student, Vitoria, after being elected in 1525 to the principal chair of theology at the University of Salamanca, introduced the method, replacing the teachings of Lombard with those of Aquinas as the basis for his lectures. Vitoria was so well regarded that Emperor Charles V asked him in 1545 to be a member of the Spanish delegation to the Council of Trent, but Vitoria was too ill to accept. According to John P. Doyle, most of the influential moralists of the seventeenth century, including Protestants such as Hugo Grotius (1583–1645), looked to Vitoria as a foremost authority; see Doyle's introduction to Francisco de Vitoria, O.P., *Relection* [literally a 're-lecture', i.e., a re-presenting of material already treated in course lectures] *on Homicide* (hereafter *Relection*) & *Commentary on* Summa theologiae *IIa-IIae Q. 64* (hereafter *Commentary*), 11–14.

16. Vitoria, *Commentary*, q. 64, a. 2, par. 10, pp. 152–53; see also *Relection*, par. 18, pp. 82–85.

17. *Commentary*, q. 64, a. 2, par. 10, pp. 152–53; cf. *Relection*, pars. 19–20, pp. 84–85. In a fascinating passage in *On the Law of War*, Vitoria argues from the premise that public authority lawfully punishes with death persons who are dangerous to the community, to the conclusion that wars of retribution are lawful.

> Indeed, it seems he [i.e., the prince] has this right by natural law [i.e., *to avenge the injury done by the enemy, and to teach the enemy a lesson by punishing them for the damage they have done*]: the world could not exist unless some men had the power and authority to deter the wicked by force from doing harm to the good and the innocent. Yet those things which are necessary for the governance and conservation of the world belong to natural law. What other argument than this can we use to prove that the commonwealth has the authority in natural law to punish those of its own members who are intent on harming it with execution or other penalties? If the commonwealth has these powers against its own members, there can be no doubt that the whole world has the same powers against any harmful and evil man. And these powers can only exist if exercised through the princes of commonwealths. Therefore it is certain that princes have the power to punish enemies who have done harm to the commonwealth; and even after the war has been duly and justly carried to its conclusion, these enemies remain as hateful to the prince as they would be to a proper judge.

Francisco de Vitoria, *On the Law of War*, in *Vitoria: Political Writings*, ed. Anthony Pagden et al., Cambridge Texts in the History of Political Thought (Cambridge: Cambridge University Press, 1991), 305–6.

18. Vitoria, *Commentary*, q. 64, a. 2, par. 10, pp. 152–53.

19. *Commentary*, q. 64, a. 2, par. 10, pp. 154–44.

20. *Commentary*, q. 64, a. 2, par. 1, pp. 138–39; in the *Relection* Vitoria writes: God "made the members of the body solely for the good of the whole, and not for them-

selves," par. 10, pp. 76–77; later he writes, "For whatever a man is, he belongs to the republic in a way similar to that in which a part of himself belongs to his whole reality" (*totius*), par. 22, pp. 84–85; cf. par. 18, pp. 82–85.

21. Lessius began studies in classics and philosophy at Louvain in 1568 and entered the Society of Jesus in 1573. He spent two years as the pupil of Suárez in Rome and the better part of his teaching career as professor of theology at Louvain. His correspondences include such eminent names as Bellarmine, Vasquez, Molina, Frances de Sales, and Pope Urban VIII; *The Catholic Encyclopaedia*, ed. 1911, s.v. "Lessius, Leonard."

22. Leonardo Lessius, *De Iustitia et Iure Caeterisque Virtutibus* (Commentary on *Summa Theologiae*, II-II, qq. 47–171) (Paris, 1606).

23. *De Iustitia et Iure*, lib. 2, cap. 9, dub. 2, par. 2, p. 78.

24. *De Iustitia et Iure*, lib. 2, cap. 9, dub. 3, par. 5, p. 78.

25. *De Iustitia et Iure*, lib. 2, cap. 9, dub. 2, par. 5, p. 78.

26. Lessius uses several terms interchangeably: "*ob totius conseruationem*" (dub. 2, par. 2), "*ob totius incolumitatem*" (dub. 2, par. 4), "*seruato ordine Iuris*" (dub. 2, par. 5), "*ob bonum Reipub.*" (dub. 3, par. 5); "*non licet interficere peccatores, nisi ob bonum Reipub. sicut non licet amputare membrum, nisi ob salutem corporis*" (dub. 3, par. 5). Lessius' wider philosophy of punishment stays close to the ideas of Aquinas. As a father punishes his children or a teacher his disciples, so the law punishes criminals. In this it aims at coercing them from their wickedness. Lessius says this serves as a "kind of defense." But punishment is also retributive. In this sense it is *for* an injury. Punishment is "repaid for an injury," it is "a returning of evil for evil"; a criminal "is punished because of the injury he introduced." Such punishment "corresponds and in a way is owed to the evil-doer just as praise is owed to one who does good." What precisely is the evildoer's injury? A criminal injures the community by "indulging his desire, taking for himself, and taking from others more than is just." The wrongness therefore consists in immoderate willing. Punishment consists in the infliction of something contrary to the offender's will (*contra voluntatem*), returning what is due him on account of his wrong-doing (*debita pro iniuria*), the "due-ness" consisting in a certain "congruity and appropriateness" proportionate to the immoderacy of the offender's wayward willing. The good which in this way is realized is the restoration of order. When the offender suffers something contrary to his will his unjust acquisition is taken away, wrongdoing is repaired, honor is restored, and the good order recovered. Human punishment in this way images divine punishment. Lessius writes, "God, by punishing those who have fallen from the most beautiful order of Justice and divine law and who have disturbed the most orderly arrangement [of things] with [acts which are] disgraceful, restores the order of Justice by inflicting proportionate punishment. In this way, nothing in the world may remain deformed, disordered, or confused, but all things may be excellently arranged in their proper place and position." See *De Iustitia et Iure*, lib. 2, cap. 47, dub. 4, pars. 21–22, pp. 608–9.

27. Cajetan, Commentary on q. 64, a. 2, p. 69.

28. Ibid.

29. Ibid.

30. Vitoria, *Commentary*, q. 64, a. 2, par. 4, pp. 140–41; Vitoria follows the same line of reasoning in the *Relection*, par. 11, pp. 80–81.

31. *Commentary*, q. 64, a. 2, par. 5, pp. 142–43; see also *Relection*, par. 12, pp. 82–83.

32. *Commentary*, q. 64, a. 2, par. 5, pp. 142–43; cf. *Relection*, par. 13, pp. 82–83.

33. *Commentary*, q. 64, a. 2, par. 5, pp. 142–43.

34. In a section dealing with homicide as one of four "sins that cry from heaven," the catechism of Canisius poses the question, "How does Scripture teach that voluntary homicide is to be vindicated?" It answers with passages from the Old Testament (Gen. 4:10, Gen. 9:6 , and Psalm 54:24 [55:23]), which, without mentioning capital punishment directly, could be interpreted as teaching its legitimacy; see Megivern, *The Death Penalty*, 165.

35. Its preparation was entrusted to a committee of four distinguished theologians (three of whom were bishops) under the oversight of three cardinals. St. Charles Borromeo, then Archbishop of Milan, was appointed to preside.

36. The catechism itemizes five exceptions: the killing of animals, execution of criminals, killing in a just war, killing by accident, and killing in self-defense.

37. Pope Pius V, *Catechism of the Council of Trent for Parish Priests*, part III, cap. VI, par. 4, trans. McHugh and Callan, 421 (minor corrections from the Latin included).

38. The Dutch theologian and jurist Hugo Grotius (1583–1645) says something similar half a century later in his work *On the Law of War and Peace* (1625): "Now it is in the love of innocent men that both capital punishment and just wars have their origin." Bk. 1, ch. 2, sec. 6, par. 10, in J. B. Schneewind, *Moral Philosophy from Montaigne to Kant: An Anthology*, vol. 1 (Cambridge: Cambridge University Press, 1990), 101.

39. His catechism, originally in Italian, appeared in two forms, *Dottrina Cristiana Breve* (1597), written for scholars, and *Dichiarazione più Copiosa della Dottrina Cristiana* (1598), written for teachers. My references are from an English translation (1602–5) of the latter: "An Ample Declaration of the Christian Doctrine," trans. Richard Hadock, facsimile in *English Recusant Literature 1558–1640*, ed. D. M. Rogers (London: Scholar Press, 1977).

40. In *Dottrina Cristiana Breve* the opposite is the case, i.e., the teacher asks the questions and the scholar replies.

41. "An Ample Declaration of the Christian Doctrine," 153.

42. Ibid., 153–54, spelling modernized.

43. *De Controversiis* (Disputations on the Controversies of the Christian Faith) was written while Bellarmine (1542–1621) occupied the eminent "Chair of Controversies" in the Roman College (beginning in 1576). It is a systematic refutation of Protestant doctrine and a virtually comprehensive defense of Catholic teaching. According to the

Oxford Dictionary of Saints, the work was so learned in Scripture, the writings of the Fathers, and Protestant doctrine "that it was wrongly believed to be the work of a team of scholars." S.v. "Bellarmine, Robert."

44. See *De Laicis sive Saecularibus (De Laicis)*, trans. Kathleen E. Murphy (1928).

45. *De Laicis*, 54–57.

46. *De Laicis*, 54–55.

47. *De Laicis*, 56.

48. *De Laicis*, 56.

49. *De Laicis*, 55.

50. *Catholic Encyclopaedia*, 1911 ed., s.v. "Heresy." The fact that England *today* retains the death penalty for treason (at least on the books) helps to put a passage like this in perspective.

51. Leo X (r. 1513–1521), Bull *Exsurge Domine* (*Denz.* 773); the proposition was the 33rd of 41 propositions of Luther's that the Bull condemned. The pope's censure of the propositions reads: "All and each of the above mentioned articles or errors, so to speak, as set before you, we condemn, disapprove, and entirely reject as respectively heretical, or scandalous, or false, or offensive to pious ears, or seductive of simple minds, and in opposition to Catholic truth." *Denz.* 781.

52. Suárez was born at Granada in 1548. He entered the Society of Jesus at Salamanca in 1564 and began studies in philosophy and theology. After completing his studies he taught at various places, including Salamanca and Rome. He enjoyed such repute during his lifetime that Pope Gregory XIII attended his first lecture in Rome and Pope Paul V appointed him to refute the doctrines of King James of England. Suárez died at Lisbon in 1617. *The Catholic Encyclopaedia*, 1911 ed., s.v. "Suárez, Francisco."

53. Section heading: *"Utrum possit Ecclesia haereticos mortis supplicio juste punire"*; Francisco Suárez, S.J., *Opera Omnia* (1856), tom. 12, tract. I, disp. 23, sec. 1, p. 577.

54. Ibid., disp. 23, sec. 1, par. 3, p. 578.

55. Ibid., disp. 23, sec. 1, par. 8, p. 579.

56. Ibid., disp. 23, sec. 1, par. 8, p. 579.

57. Ibid., disp. 23, sec. 1, par. 9, p. 580.

58. Ibid., disp. 23, sec. 1, par. 5, p. 578.

59. Ibid.

60. *"potestas ad puniendos malefactores est necessaria in omni republica bene instituta, ad illius conservationem, et bonum regimen,"* ibid., disp. 20, sec. 3, par. 12, p. 513; in this section Suárez does not refer to capital punishment specifically but to punishment in general. Later, however, he says that everything said about power in general in disp. 20, sec. 3 can be applied with proportion to the death penalty: *"Altera pars de potestate generatim probata est supra, disputatione vigesima, sectione tertia, et omnia ibi dicta cum proportione ad hanc poenam mortis appplicari possunt."* Ibid., disp. 23, sec. 1, par. 6, p. 579.

61. Ibid., disp. 20, sec. 3, par. 12, p. 513.

62. "*Distinguimus enim . . . punitionem haeretici a coactione ejus, ut resipiscat.*" Ibid., disp. 20, sec. 3, par. 9, p. 512.

63. Ibid., disp. 20, sec. 3, par. 9, p. 512.

64. Ibid., disp. 23, sec. 1, par. 6, p. 579.

65. Ibid., disp. 23, sec. 1, par. 7, p. 579.

66. "*in magistratu ecclesiastico, et praesertim in Pontifice esse principaliter*"; Suárez immediately adds, "*et eminenti quodam modo.*" Ibid.

67. Ibid.

68. Ibid.

69. Ibid.

70. Ibid.

71. Ibid.

72. Juan De Lugo was born in Madrid in 1583 of Spanish nobility. He studied law at Salamanca and after entering the Society of Jesus in 1603 continued studies in philosophy and theology. In 1611, at the age of twenty-eight, he was made professor of philosophy at Medina del Campo. Pope Urban VIII, impressed by his learning and judgment, consulted De Lugo frequently and finally, in 1643, made him a cardinal. De Lugo's *De Justitia et Jure* was published in Lyons in 1642. He died at Rome in 1660. *The Catholic Encyclopaedia*, 1911 ed., s.v. "Lugo, John de."

73. Juan Cardinal De Lugo, *De Justitia et Jure*, in *Disputationes Scholasticae et Morales*, vol. 6 (Paris, 1893).

74. *De Justitia et Jure*, disp. 10, sec. 2, par. 61, p. 71.

75. *De Justitia et Jure*, disp. 10, sec. 2, par. 64, p. 72.

76. *De Justitia et Jure*, disp. 10, sec. 2, par. 66, p. 72.

77. *De Justitia et Jure*, disp. 10, sec. 2, par. 71, p. 74, marginal gloss.

78. Comprising nineteen volumes, the *Cursus Theologiae* (full name, *Summa S. Thomae Hodiernis Academiarum Moribus Accommodata*) was accepted in eighteenth- and nineteenth-century Europe as one of the leading commentaries on Aquinas.

79. "*occisionem indebitam*"; he later calls it "unfair/unjust killing" (*iniqua occisio*). Charles-René Billuart, *Cursus Theologiae*, vol. 12 (Paris, 1829), diss. 10, art. 1, p. 53.

80. "*Prohibetur occisio hominis . . . auctoritate privata . . . ubi* [i.e., in Gen. 9:6] *aperte docemur homicidam posse auctoritate publica morti addici jure vindictae. Cursus Theologiae*, vol. 12, diss. 10, art. 1, p. 53.

81. Ibid., pp. 52, 54.

82. Ibid., p. 50.

83. Ibid., p. 51.

84. Ibid.

85. Ibid., p. 53; see *ST*, II-II, q. 64, a. 2, ad 3.

86. *Cursus Theologiae*, vol. 12, diss. 10, art. 1, pp. 53–54.

87. Founder of the Redemptorist Congregation and Doctor of the Church, Alphonsus de Liguori (1696–1787) published his first work of theology at the age of forty-nine.

His *Theologia Moralis*, praised for its moderation in steering a course between laxism and rigorism, was first published (in full) in 1755 and underwent nine editions in his lifetime.

88. The other is killing in self-defense. See the treatment in Alphonsus Marie de Liguori, *Theologia Moralis*, tom. 1, lib. 3, tract. 4, cap. 1, dub. 3, pars. 380–381 (Rome: Ex Typographia Vaticana, 1905), pp. 631–33; cf. *ST*, II-II, q. 64, a. 7c.

89. *"Peccant tamen, qui non ex zelo justitiae, sed odio aut privatae vindictae causa faciunt."* De Liguori, *Theologia Moralis*, tom. 1, lib. 3, tract. 4, cap. 1, dub. 2, par. 376, p. 629.

90. Unless "the crime is notorious, there is danger of sedition, or if it would disgrace the king to proceed juridically." Ibid., dub. 2, par. 377, p. 629.

91. *"judex tenetur sub gravi concedere reo tempus sufficiens ad confessionem, . . . [et] tempus pro sumptione Communionis (nisi tamen grave damnum timeatur),"* ibid., dub. 2, par. 379, p. 630.

92. *"Clericis, etiam laicalem potestatem habentibus, illicitum esse, reos poena mortis damnare. In hoc tamen potest Papa dispensare,"* ibid., dub. 2, par. 378, pp. 629–30.

93. *"idque non injuste [occidere proscriptos] cum ad reipublicae defensionem sit necessarium,"* ibid., dub. 2, par. 376, p. 629.

94. *"nisi auctoritate publica, et juris ordine servato,"* ibid., dub. 2, par. 376, p. 629.

95. Aertnys, C.SS.R., and Damen, C.SS.R., *Theologia Moralis*, tom. I, lib. III, tract. V, cap. II, no. 569, pp. 538–40; Victor Cathrein, S.J., *Philosophia Moralis in Usum Scholarum*, 5th ed. (Freiburg: Herder, 1905), pars. II, lib. II, cap. III, thesis XCIX, nos. 638–41, pp. 467–72; Davis, S.J., *Moral and Pastoral Theology*, vol. 2, ch. 4, sect. 6, pp. 151–52; Genicot, S.J., *Institutiones Theologiae Moralis*, vol. I, tract. VI, sect. V, cap. II, no. 366, p. 296; Joanne Petro Gury, S.J., *Compendium Theologiae Moralis* (Regensburg: Typis et Sumptibus Georgii Josephi Manz., 1868), Part I, *Tractatus De Praeceptis Decalogi*, 5th Praec., cap. 2, art. 1, nos. 392–93, pp. 176–77; Haine, *Theologiae Moralis*, tom. I, pars II, cap. III, no. 1, q. 130, p. 453; McHugh, O.P., and Callan, O.P., *Moral Theology: A Complete Course*, vol. 2, nos. 1820–22, pp. 100–102; Benedict Merkelbach, O.P., *Summa Theologiae Moralis* (Paris: Desclée, 1932), tom. II, nos. 354–56, pp. 353–56; H. Noldin, S.J., and A. Schmitt, S.J., *Summa Theologiae Moralis*, vol. 2 (Oeniponte: Typis et Sumptibus Feliciani Rauch, 1957), no. 330, pp. 301–3; Dominic M. Prümmer, O.P., *Vademecum Theologiae Moralis* (Freiburg: Herder, 1921), tract. XI, q. III, cap. III, art. 3, no. 277, p. 156 (hereafter cited as Prümmer-I); idem, *Manuale Theologiae Moralis* (Freiburg: Herder, 1923), tom. II, tract. XI, q. III, § 2, no. 118, pp. 108–10 (hereafter cited as Prümmer-II); and Prümmer, *Handbook of Moral Theology*, 126–27 (hereafter cited as Prümmer-III); Aloysius Sabetti, S.J., and Timothy Barrett, S.J., *Compendium Theologiae Moralis* (Cincinnati: Frederick Pustet Co., 1939), tract. VI, nos. 265–66, pp. 271–72; Scavini, *Theologia Moralis Universa*, tom. III, tract. VII, disp. II, cap. I, art. I, no. 75, q. 7, pp. 73–75; Edward Tanquerey, *Synopsis Theologiae Moralis et Pastoralis*, 8th ed., tom. II (Rome: Desclée, 1927), no. 1086, pp. 721–22; Arthur Vermeersch, S.J., *Theologiae Moralis*, 3rd ed., tom. II (Rome: Pontificia Universitas Gregoriana, 1937), lib. II, tract. V, sect. III, tit. III, cap. II, no. 563, p. 550;

Zalba, S.J., *Theologiae Moralis Compendium*, vol. 1, no. 1587, pp. 866–67. For simplicity, hereafter the moral manuals and similar sources discussed in this section are referenced by author name only, omitting title.

96. Benedict Ojetti, S.J., *Synopsis Rerum Moralium et Iuris Pontificii*, 3rd ed. (Rome: Polygraphica Editrice, 1911), vol. 2, s.v. "Homicidium," col. 2090.

97. Marianus de Luca, *Institutiones Juris Ecclesiastici Publici* (Rome: J. Pustet, Libraria Pontificia, 1901), excerpts in G. G. Coulton, "Roman Catholic Truth: An Open Discussion," *Medieval Studies* 17 (1924): 61–66, and "The Death Penalty for Heresy: From 1184 to 1921 A.D.," *Medieval Studies* 18 (1924): 29.

98. Alexius Marie Lépicier, *De Stabilitate et Progressu Dogmatis*, 2d ed. (Rome: Desclée, 1910), 194–99, excerpts in Coulton, "The Death Penalty for Heresy: From 1184 to 1921 A.D.," 62–69.

99. Haine (Leo XIII), de Luca (Leo XIII), Lépicier (Pius X); the letters are admittedly general and do not imply complete agreement with all that is contained in the works.

100. Ernest Bowen-Rowlands claims in 1924 that "the *general opinion of theologians* on the problem [of the death penalty] is that the supreme right of death belongs to Almighty God, but that right is for certain purposes, e.g., the protection of society, vested in the State." Ernest Bowen-Rowlands, *Judgement of Death* (London: W. Collins Sons and Co., 1924), 129, emphasis added.

101. Tanquerey's short treatment does not mention the need for proper authority, but nor does it state the contrary.

102. E.g., "It is legitimate to kill malefactors who are harmful to the common good," Aertnys-Damen, 538; "The death penalty is necessary to preserve the common good," Prümmer-II, 108. McHugh and Callan admit that capital punishment, though in principle lawful, is not always necessary; they doubt, however, "[w]hether such ideal conditions exist" to warrant "a general suspension of the capital punishment," 101. Genicot's doubts are even stronger: "*Aliqui, sed, ut videtur, perperam, opinantur hanc necessitatem occidendi malefactores ad communitatis tranquillitatem in regionibus excultis iam evanuisse,*" 296.

103. McHugh-Callan, 100.

104. Noldin-Schmitt, 301.

105. Genicot, 296.

106. Gury, 176.

107. Cathrein, 467.

108. Sabetti-Barrett, 271.

109. Davis might be considered an exception; he writes, "God has given to the State the right over life and death, as He has given to every man the right of self-defence against unjust aggression. . . . If, therefore, capital punishment is necessary for peace and the security of life and property, and if no less punishment avails, it is conceded to the State by God"; yet two sentences later he states, "the *crime punished by death* must be

legally *deserving* of the supreme penalty" (emphases added), something the *Catechism* does not say.

While McHugh and Callan say, "experience . . . has shown that, generally speaking, the lives of law-abiding persons and the general peace are not *sufficiently protected* unless the supreme penalty be appointed for certain crimes" (101), the meaning refers more to deterrence and retribution than collective self-defense. The reason a community "fixes a penalty" has more to do with trying to deter (future) crime or redress (past) crime than it does defending against a person whose present aggression (just or unjust) threatens the safety of the community.

110. Haine, 453.

111. Noldin-Schmitt, 301; Cathrein writes, ". . . *dependet ex* necessitate *huius comminationis ad bonum commune*," 468.

112. See chapter 1 in this volume, notes 23–29.

113. E.g., "It [i.e., the right over life and death] is explicitly declared in Scripture to have existed in the Jewish State; it was recognized in the Roman polity by S. Paul (Rom. 13,4)," Davis, 151; see also McHugh-Callan, 100–101; Noldin-Schmitt, 301; Prümmer-II, 109; Aertnys-Damen, 539; Genicot, 296; Scavini, 73; Merkelbach, 354; Zalba, 867.

114. E.g., Noldin-Schmitt, 301; Scavini, 73–74. According to McHugh-Callan (p. 101), "The Church has always taught the lawfulness of capital punishment and rejected contrary errors, as in the case of the Waldensians condemned by Innocent III"; "[T]he experience of all the centuries and of all countries has shown that, generally speaking, the lives of law-abiding persons and the general peace are not sufficiently protected unless the supreme penalty be appointed for certain crimes." See also Genicot, 296; Gury, 176; Merkelbach, 353–54; Sabetti-Barrett, 271; Zalba, 866–67.

115. Noldin-Schmitt, 302; McHugh-Callan, 101; Merkelbach, 354.

116. Lépicier, *De Stabilitate*, in Coulton, "The Death Penalty for Heresy," 62; Father Lépicier (1863–1936) was appointed by Leo XIII in 1892 at the age of twenty-nine to the chair of dogmatic theology at the *Propaganda Fide* (The Papal College of the Propaganda) at Rome, where he had previously earned doctorates in philosophy and theology. He filled positions in five Roman Congregations, was a member of various commissions, apostolic visitor to Scotland, India, and elsewhere, became prefect of the Congregation of Religious in 1920 and was made a cardinal in 1927 by Pius XI. The preface of the work cited here includes a letter of thanks by Pius X; Pius' letter quoted in full in Coulton, 69.

117. Lépicier, *De Stabilitate*, in Coulton, "The Death Penalty for Heresy," 63; in an appendix to *De Stabilitate* (Rome 1910), Fr. Lépicier writes: "In all those things which I have put into my book—whether concerning faith or tradition . . . or of heresy and the penalties thereunto annexed . . . I have said nothing new, but have only expounded things commonly handed down by all theologians, and especially by that prince of theologians, St. Thomas." See Coulton, 68.

118. Zalba, 866; also, "*retributive justice* requires in certain situations that a crime worthy of death be paid for by the killing of the criminal," Zalba, 867.

119. Prümmer-I, 156.

120. Noldin-Schmitt (1928 ed.), 319.

121. Davis, 151.

122. Aertnys-Damen, 539; "the crime must be . . . of such a character that the public welfare requires the supreme punishment . . . on account of the enormity of the act (*e.g.*, murder)," McHugh-Callan, 101–2.

123. Noldin-Schmitt, 301.

124. Cathrein, 468.

125. Haine, Merkelbach, Prümmer, and McHugh-Callan; two are dedicated to the thought of Saint Alphonsus de Liguori: Aertnys-Damen, Scavini. Note the prominence of Aquinas' "putrid limb" analogy in the works of McHugh-Callan, 100; Noldin-Schmitt, 302; Merkelbach, 354–55; Prümmer-II, 109; Aertnys-Damen, 539; Scavini, 74; Cathrein, 468.

126. E.g., "*Auctoritas publica eaque sola ius habet occidendi malefactores,*" Noldin-Schmitt, 301; "*occidere fas,*" Scavini, 73; "the right over life and death," Davis, 151; "Let us conclude then that the Church really does possess the right of the sword," Lépicier (see Coulton, "The Death Penalty for Heresy," 64); see also Prümmer-I, 156; Davis, 151; de Luca (in Coulton, 30); Merkelbach, 353–54; Aertnys-Damen, 538; Cathrein, 467. Recall that Jacques Leclerq flatly rejects the idea that the state has a "right" to kill criminals; see Leclerq, *Les Droits et devoirs individuels,* 89.

127. "*Auctoritati publicae licet occidere directe malefactores propter crimen proportionate grave,*" Zalba, 866; see also Vermeersch, 550; Merkelbach, 353.

128. *The Catholic Encyclopaedia,* 1911 ed., s.v. "Punishment, Capital."

129. Edouard Thamiry, in *Dictionnaire de Théologie Catholique,* ed. A. Vacant and E. Mangenot, vol. 10 (1929), s.v. "Mort (Peine de)," col. 2502.

130. Ibid., cols. 2503–4.

131. Ibid., col. 2504.

132. Review of P. L. Albini (professor of legal philosophy at Royal University of Turin), *Della pena di Morte: Lezioni accademiche* [academic lectures] (Vigevano, 1852), in *Civiltà Cattolica,* series 2, vol. 3 (1853): 434; Review of Pietro Ellero, *Della pena Capitale* (Venice: Tipografia del Commercio, [no date given]), in *Civiltà Cattolica,* series 4, vol. 7 (1860): 590–91.

133. Review of Ellero, 590–92.

134. Ibid., 590.

135. Review of Albini, 435, 440; Review of Ellero, 590–92, 598.

136. Review of Albini, 435: retribution is construed as "expiation" (*espiazione*): "only expiation is essential to every punishment, and inseparable from it." See also 440.

137. Review of Albini, 441; Review of Ellero, 594–95.

138. Review of Albini, 440; Review of Ellero, 595: "a French proverb says 'of one hundred hanged, not one perished' . . . there are many stories of delinquents converted on the point of being killed, and dying with particular edification."

139. Review of Albini, 441; Review of Ellero, 591.

140. Antonio Messineo, S.J., "Il Diritto alla Vita," *Civiltà Cattolica* 2 (1960): 457.

141. Pope Leo XIII (r. 1878–1903), *Pastoralis Officii* (to the bishops of Germany and Austria), 12 September 1891, *AAS* 24 (1891/92): 204b, in *Denz.* 1939; dueling, Leo says, is "*wrongful* slaughter," "*iniqua caede*"; *Denz.* 1940, emphases added.

142. Pope Pius XI (r. 1922–1939), "On Christian Marriage" (*Casti Connubii*), ch. 4, Vatican translation (Boston: Daughters of St. Paul, 1930), 32.

143. Ibid., 35.

144. Ibid.; Aquinas quote from *ST*, II-II, q. 108, a. 4, ad 2; Pius employs the part to whole analogy in his next paragraph to describe the lawful limits of self-mutilation.

145. Pius XII, "Address to the Italian Association of Catholic Jurists," 368.

146. Ibid., 369.

147. Ibid., 371.

148. Pius XII, "Address to Italian Jurists" (26 May 1957), *AAS* 49 (1957): 408; printed in John F. McDonald, *Capital Punishment* (London: Catholic Truth Society, 1964), 15. In the spirit of Ambrose and Augustine, Pius in 1953 appealed for clemency to President Harry Truman on behalf of Julius and Ethel Rosenberg, sentenced to death for espionage.

149. Pius XII, "Lis qui interfuerunt Conventui primo internationali de Histopathologia Systematis nervorum," *AAS* 44 (1952): 787; English, *Catholic Mind* 51 (1953): 311.

150. McDonald, *Capital Punishment*, 1, 16.

151. Beccaria's *Dei delitti e della pene*, translated into French in 1766, passed through six editions in eighteen months and received widespread support from leading critics of penal policy of the day, including David Hume (1711–1776) and Claude-Adrien Helvétius (1715–1771); one edition was published with a commentary by the formidable literary satirist Voltaire (1694–1778) and one annotated by the French encyclopedist philosopher Denis Diderot (1713–1784). Among the national legislations influenced by the work, Catherine of Russia issued a series of instructions in 1767 which, she said, "reflect the spirit and doctrine of Beccaria," and Tuscany in 1786, under Leopold II, abolished capital punishment in the penal code, which was drafted by a commission over which Beccaria presided. A year later, Austria, under Joseph II, abolished capital punishment in its penal code, and France, in the Assembly of 1791, abolished torture and reduced the number of capital crimes from 115 to 32.

152. On 3 February 1766 the Holy Office put Beccaria's work on the Roman Index of prohibited books, but not so much for its views about capital punishment as for the contractarian philosophy which undergirds them. To say the new ideas had little influence on Catholic theologians and clerics is not to say there was no influence on a political and popular level. Not only was the death penalty abolished in Catholic Tuscany and Austria

in the eighteenth century (see preceding note), but Portugal stopped executions in 1848 and abolished it completely in 1867.

153. Switzerland abolished the death penalty in 1874; England in 1800 punished over two hundred offenses with death, but by 1863 only three remained, of which only one had effective application, namely, murder; Ecuador began legally restricting executions in 1852 and abolished them in 1897; Brazil after its independence in 1822 decreased the number of capital offenses from 40 to 3, and abolished it in 1889. All today are "abolitionist" for at least ordinary crimes, although not all remained consistently abolitionist from their date of first abolition; see United Nations, Department of Economic and Social Affairs, *Capital Punishment* (New York, 1968), 30–35.

154. An article published by a French abolitionist named Hello in 1867 in the journal *Revue critique de législation et de jurisprudence* and bearing the lengthy title "List presenting in a chronological order, for several European countries, the names of persons or associations who have played a great part in the movement for the abolition of the death penalty, in the works of science, in the debates of the legislative assemblies and in the acts of the governments," concludes its list of 104 persons with the complaint: "It is rather sad that the reform on the abolition of the death penalty has not yet found one single representative among catholic priests." Quoted in Thamiry, *Dictionnaire de Théologie Catholique*, s.v. "Mort (Peine de)," vol. 10, col. 2501; and Jacques Leclercq says in 1937: "the objections against the ancient penal right came exclusively from the best rationalists of the eighteenth century. Whatever the reasons, it is clear that the problem has not attracted the attention of Catholic theologians." Leclercq, *Les Droits et devoirs individuels*, 95.

155. It is true that the Anabaptists, Socinians and Quakers (Society of Friends) were abolitionist long before the mid-eighteenth century, but because of their exclusivity and countercultural patterns of life, they had little noticeable effect on the wider debate. The prominent German theologian Friedrich Schleiermacher (1786–1834) also rejected capital punishment, but his voice in Germany was muffled by the influential retentionist arguments of Kant (1724–1804) and Hegel (1770–1831).

156. Richard Evans, *Rituals of Retribution: Capital Punishment in Germany 1600–1987* (New York: Oxford University Press, 1996), 901.

157. Avery Cardinal Dulles, S.J., "The Death Penalty: A Right to Life Issue," Laurence J. McGinley Lecture, Fordham University, 17 October 2000, p. 9.

158. See Beccaria, "On Crimes and Punishments," ch. 16.

159. See, for example, Voltaire, "Commentaire sur le livre *Des Delits et des Peines*," in *Oeuvres complètes* de Voltaire: *Mèlanges IV* (Paris: Garnier Frères, 1879; reprint, Nendeln/Liechtenstein: Kraus, 1967), 554.

160. Evans, *Rituals of Retribution*, 901–2. See Dulles, *The Death Penalty*, 9.

161. I rely on a summary of the argument by Rev. Franciscus Skoda, "Doctrina Moralis Catholica de Poena Mortis a C. Beccaria Usque ad Nostros Dies (A. 1956)," Ph.D. diss., Pontifical Lateran University, Pesaro, 1959, p. 18; Skoda cites C. Malanima, *Commento filologico critico sopra i delitti e le pene secondo il gius divino* (Livorno, 1786).

162. *Dictionnaire de théologie* (1867), ed. Bergier, quoted by Thamiry; see Thamiry's discussion of Le Noir's essay in *Dictionnaire de théologie* (1929), s.v. "Mort (Peine de)," vol. 10, cols. 2501–2. Thamiry's reaction is revealing: "the position he [i.e., Le Noir] wants to defend, probably under the influence of the running ideas of his time, cannot be held too seriously . . . and all the more cannot face the reality to which the catholic doctrine refers."

163. Mons. Giuseppe Coco Zanghy (1829–1878), *Il cattolicismo e la pena di morte* (Catania: 1874). Zanghy taught a wide range of subjects in the diocesan seminary in Catania and was chosen to accompany, as a theological advisor, the Cardinal of Catania, G. B. Dusmer, to Vatican I. His position on the death penalty was attacked in the Jesuit journal *Civiltà Cattolica* at the time. A summary of Zanghy's ideas is given by Skoda, *Doctrina Moralis*, 19–20; cf. Megivern, *The Death Penalty*, 242–43 and 542–43, who similarly relies on Skoda's work.

164. See Megivern, *The Death Penalty*, 319–20.

165. Charles Duff, *A Handbook on Hanging* (London: Journeyman Press, 1981), 150.

166. National Conference (of Catholic Bishops) News Service (Domestic), Chicago, 16 April 1959.

167. See Megivern, *The Death Penalty*, 323.

168. Donald Campion, S.J., *America* 102 (5 December 1959): 321, quoted in Megivern, *The Death Penalty*, 322.

169. The Church's classical conception is best formulated by Aquinas; justice, he says, related to the verb "to adjust," denotes a kind of equality of one thing in reference to another (*ST*, II-II, q. 57, a. 1c); the notion of equality, therefore, denotes essentially *relation to another* (*ST*, II-II, q. 58, a. 3); the *rightness* therefore in an act of justice is the adequate expression of equality in relation to another. Speaking from the perspective of an expressing agent *B*, we may say that it is *right* for *B* to express an act of such equality to person *A*, or from *A*'s perspective (the beneficiary of the equality-expressing act), that it is A's *right* to have such an act of equality expressed toward him. To say that person *A* has *right* vis-à-vis person *B* is to say that *A* is equal in some way with *B* and "the right" or "the just" is the expression of that equality. If the equality is natural equality, the correlative right is *natural right*, which can be said to arise by prescription of the natural law; if it is established by agreement or common consent (i.e., by virtue of positive law), then it is *positive right* (*ST*, II-II, q. 57, a. 2c); according to Aquinas, therefore, the proper object of justice is another person's right, or simply "the right" (*ius*). Aquinas develops this definition in his famous account of justice in the *Secunda Secundae:* "justice is the habit by which a person grants to each one his own *ius* by a constant and continuous will" (*ST*, II-II, q. 58, a. 1c) Later he says justice is granting to each one "what belongs to him [*quod suum est*]" (*ST*, II-II, q. 58, a. 1, ad 5). That which belongs to him is "what is due him according to equality of proportion" (*ST*, II-II, q. 58, a. 11c). So when Aquinas says the object of justice is *ius*, he means that justice *secures* what is rightly owed, or again, secures the *right* of another, i.e., secures what is due, what is his own, what he is entitled to

(*ST*, II-II, q. 122, a. 6c). Reciprocally, injustice is a violation of right, a failure to render to another his due; here inequality (*inaequalitatem*) is the object of the act (*ST*, II-II, q. 59, a. 1). It is important to see that Aquinas' word *ius* emphasizes the idea of duty, of responsibility *to*. But it is also important to see that it implicitly contains the idea of the claims of a beneficiary.

170. From the dawn of the Enlightenment through the French Revolution, the notion of right undergoes a fundamental change: from rights as the primary objects of justice to rights simply as primary, detached from claims about justice. Recall Hobbes' (1651) influential notion of natural right as the "Liberty each man hath, to use his own power, as he will himselfe, for the preservation of his own Nature" (*Leviathan*, ch. XIV [64]). Far from being a liberty to secure justice, "right" becomes the liberty to advance self-interest. The denouement of the Hobbesian rights drama is summed up in Hobbes' famous quote: "because the condition of Man [in his natural state] is a condition of Warre of every one against every one; . . . It followeth that in such a condition, every man has a Right to every thing; even to one another's body." Though Hobbes' account was rarely taken up in full, and often harshly criticized, his subjectification of the concept of rights exercised enormous influence. Even when a later theorist like Locke related rights to duties, his account was shaped by the first principle of Hobbes' anthropology, namely, that humans are by nature solitary; hence, Locke locates the essence of natural right not in the just relationship, but in the prerogatives of the autonomous individual.

171. An emerging usage of a subjective language of rights dates back as far as the pontificate of Leo XIII (1878–1903) and Pius IX (1846–1878). For example, in his landmark encyclical *Rerum Novarum* (1891), Pope Leo itemizes among other things a right to private property ("Private ownership, as we have seen, is the natural right of man, and to exercise that right, especially as members of society, is not only lawful, but absolutely necessary") and a right to private associations ("For, to enter into a 'society' of this kind is the natural right of man; and the State has for its office to protect natural rights, not to destroy them"); in fact, the heading to section 1 is "Rights and Duties of Capital and Labor" (*Rerum Novarum*, in *Acta Sanctae Sedis* 23 [1890–91]: 641–73, quotes on 651, no. 22, and 665, no. 51, Vatican translation). Pius IX before him, in his controversial encyclical *Quanta cura*, recognizes a "genuine notion of justice and human right," the "place of legitimate right," and "all rights of parents concerning their children, in the first place the right of seeing to their instruction and education" (see *Quanta cura*, in *Acta Sanctae Sedis* 3 [1867]: 160–67, quotes on 163–64). For a lengthy but helpful guide to early papal statements on human rights, see Mary Elsbernd, "Papal Statements on Rights: A Historical Contextual Study of Encyclical Teaching from Pius VI–Pius XI (1791–1939)," Ph.D. diss., Katholieke Universiteit Leuven, 1985.

172. John XXIII, "On Establishing Universal Peace in Truth, Justice, Charity and Liberty" (*Pacem in Terris*), 11 April 1963, Vatican translation, no. 9, emphasis added. The particular rights itemized in part I of the encyclical closely parallel the catalogue found in the U.N. Declaration, suggesting in this respect a cross-pollination of ideas.

173. This can be gathered from the more detailed European Convention on Human Rights, published within a few years of the U.N. Declaration and taking the latter as its guide and inspiration. It states: "Death may not be inflicted on anyone intentionally, except to execute a capital punishment"; quoted in Messineo, S.J., "Il Diritto alla Vita," 452. In 1982 the Committee of Ministers of the Council of Europe adopted Protocol No. 6 to the European Convention on Human Rights, which provides for the abolition of capital punishment in peacetime; see Hood, *The Death Penalty*, 10.

174. Data is drawn from "Right to Life in Europe: Former European Parliamentarian Addresses Pontifical Academy for Life," Zenit (News Service), Vatican City (23 February 2000), 1.

175. Hood, *The Death Penalty*, 241–43.

176. For example, there was a considerable outcry in the United States in spring 1994 when an American teenager, Michael Peter Fay, after pleading guilty to vandalism, was sentenced by a Singapore court to suffer six strokes of a rattan rod (later reduced to four by the president of Singapore, Ong Teng Cheong, as a gesture of respect for the plea for clemency by President Bill Clinton).

177. Pontifical Commission for Justice and Peace, "The Church and the Death Penalty," *Origins* 6, no. 25 (9 December 1976): 389, 391–92.

178. Ibid., 391; assisted by the Pontifical Commission's document, the U.S. bishops taught in 1980: "We believe that in the conditions of contemporary American society, the legitimate purposes of punishment do not justify the imposition of the death penalty." *Statement on Capital Punishment*, in *Pastoral Letters of the United States Catholic Bishops*, ed. Hugh J. Nolan (Washington, D.C.: National Conference of Catholic Bishops, 1984), vol. 4, p. 430.

179. The bishops published a one-sentence resolution stating: "The U.S. Catholic Conference goes on record in opposition to capital punishment." Resolution passed by the USCC, 18 November 1974, in Nolan, *Pastoral Letters*, vol. 3, p. 464.

180. The first, by the president of the National Conference of Catholic Bishops (NCCB), Archbishop Joseph Bernardin, briefly elaborates the 1974 resolution and then admonishes its readers to reflect prayerfully on what kinds of actions best foster respect for life; Archbishop Joseph L. Bernardin, *Statement on Capital Punishment* (Washington, D.C.: USCC Publications Office, 1977). Second, in one of a series of papers submitted to the Synod of Bishops in Rome, the NCCB states: "Capital punishment is also a matter which requires special attention. All persons of conscience must respect human life in every way in their own personal lives. They are to bring about . . . changes in the attitudes and conditions of society that are detrimental to respect for human life." NCCB, "Human Dignity and the Value of Life," *Origins* 7, no. 18 (20 October 1977): 287.

181. USCC Statement, "A Community Response to Crime," *Origins* 7, no. 38 (9 March 1978): 599.

182. United States Catholic Bishops, *Statement on Capital Punishment* (November 1980), in Nolan, *Pastoral Letters*, vol. 4, pp. 427–34; see also Nolan's introduction, 292–93.

183. Ibid., 430–33.

184. Catholics Against Capital Punishment, *Bibliography of Statements by U.S. Catholic Bishops on the Death Penalty: 1972–1998* (Arlington, Va.: CACP, 1998). The timing no doubt correlates in part with the 1976 U.S. Supreme Court decision *Gregg v. Georgia*, allowing states to resume using the death penalty.

185. Canadian Catholic Bishops, "Declaration of the Administrative Board of the Canadian Catholic Conference," press release, 4 March 1976.

186. Irish Commission for Justice and Peace, "Capital Punishment," *The Furrow* 27 (1976): 697–98; also in *La Documentation Catholique* 78 (1981): 581–84.

187. Social Commission of the French Episcopate, "Éléments de réflexion sur la peine de mort," *La Documentation Catholique* 75 (1978): 108–15.

188. Philippine Bishops, "Restoring the Death Penalty: 'A Backward Step,'" *Catholic International* 3 (1992): 886–88.

189. See Megivern, *The Death Penalty*, 370.

190. Bishops of England and Wales, "Bishops Say 'No' to the Re-introduction of Capital Punishment," Briefing of the Catholic Information Service, 15 July 1983, vol. 13, no. 22.

Notes to Chapter 7

1. *LG*, no. 25.

2. An example where a proposition asserted in a profession of faith has been later set aside is found in the fifteenth-century "Decree for the Armenians" issued both in the form of a bull by Pope Eugene IV, entitled *Exsultate Domino* (22 November 1439), and again by order of the General Council of Florence (1439). In its teaching on the essential rite of the sacrament of Holy Orders it declares: "The sixth sacrament is that of Order. Its matter is that by the handing over of which the Order is conferred: thus the presbyterate is conferred by handing over the chalice with wine and the paten with the bread" (*CF*, no. 1705, see also no. 1305; decree also in *Denz.* 701). The Church both before and subsequently has taught that the sacrament of Holy Orders is conferred, not by the handing over of sacred vessels, but by the laying on of hands by a validly ordained bishop. Neuner and Dupuis have no scruple about concluding that the document in which the statement appears constitutes "neither an infallible definition, nor a document of faith. It is a clear exposition of the sacramental theology commonly held at that time in the Latin Church" (*CF*, introduction to no. 1305).

3. See chap. 6, n. 51. According to Jesuit theologian Francis A. Sullivan, both the late-nineteenth-century theologian Louis Billot in his work *Tractatus de Ecclesia Christi*

(1898) and Edmond Dublanchy in his article on infallibility in the *Dictionnaire de Théologie Catholique* (1927) "recognized dogmatic definitions in the following twelve papal documents," among which is included "*Exsurge Domine* of Leo X condemning the errors of Luther (1520)." Sullivan does not identify which of the articles of Luther singled out in the papal bull fall into this category. Sullivan's own judgment on the matter is "that *Exsurge Domine* does not meet the requirements for a dogmatic definition." See Sullivan, *Creative Fidelity: Weighing and Interpreting Documents of the Magisterium* (Dublin: Gill and Macmillan, 1996), 84–85.

4. I presuppose that the teachings of bishops who became followers of the Waldensian or Cathar heresies, or who split with Rome following German, Swiss, or Bohemian reformers, are not relevant material for an infallible teaching.

5. John C. Ford, S.J., and Germain Grisez, "Contraception and the Infallibility of the Ordinary Magisterium," *Theological Studies* 39, no. 2 (June 1978): 274.

6. Excluding the bishops of Rome, these were Irenaeus of Lyons, Cyprian of Carthage, John Chrysostom of Constantinople, Eusebius of Caesarea, Ambrose of Milan, Augustine of Hippo, Atto of Vercelli, Hincmar of Rheims, Cardinals Cajetan and Bellarmine, and Alphonsus de Liguori. Juan De Lugo, although a cardinal, was not a bishop.

7. Innocent I, Leo the Great, Gregory the Great, Nicholas I, Alexander III, Innocent III, Leo X, Pius V (I take Pius V's promulgation of the Roman Catechism in 1566 as indicating his general assent to the content of its teaching), Leo XIII, Pius XI, and Pius XII.

8. Lateran III (1179), Lateran IV (1215).

9. Elvira (303), Rome (382), Toledo (675).

10. Note that the article relating to the lawfulness of killing heretics was not part of the traditional teaching.

11. Fathers of the Church: Justin Martyr, Irenaeus, Athenagoras, Tertullian, Clement of Alexandria, Hippolytus, Origen, Cyprian, Lactantius, Chrysostom, Eusebius, Gregory Nazianzus, Ambrose, Augustine, Jerome, Leo the Great, and Gregory the Great; Latin Doctors: Ambrose, Augustine, Jerome, Gregory the Great, Aquinas, and Alphonsus de Liguori; Greek Doctors: Chrysostom and Gregory Nazianzus; canon law: the Decretals of Gratian and of Gregory IX.

12. Ford and Grisez, "Contraception and Infallibility," 276.

13. Examples of the former include: "*doctrinam de fide vel moribus definitivo actu proclamat*" (he proclaims in a definitive *act*). We see this usage also in the profession of faith published by the Congregation for the Doctrine of the Faith in 1989 and repeated in 1998 in John Paul II's *motu proprio* letter *Ad Tuendam Fidem* (*TF*): "*veritates definitive propositas*" (truths proposed definitively), *TF*, preface; "*etsi non definitivo actu*" (even if not in a definitive act), *TF*, par. 2.3; "*definitive proponuntur*" (proposed definitively), *TF*, par. 3, cf. *TF*, 4.A.2, 4.B.2. In each instance the term specifies the nature of the *act* of teaching.

14. See *De Civitate Dei*, lib. 1, cap. 21; *De Libero Arbitrio*, lib. 1, cap. 4; *Contra Faustum* (Augustine's reply to the Manichaean heretic, Faustus), book 12, par. 70; *Commentary on the Sermon on the Mount*, ch. 20, pars. 64–65.

15. *Letter LXXXVII* (AD 405), to Emeritus (*FOC*, vol. 18, p. 19).

16. Atto, bishop of Vercelli, teaches a priestly prohibition, but it is in regard to war, not capital punishment.

17. In its treatment of capital punishment, the *Roman Catechism* does not address the question raised by Luther's condemned proposition as to whether it is lawful to kill heretics.

18. Pius XII, "Address to Histopathologists," *AAS* (1952): 787.

19. Systematic works of the sort, however, began as early as the third century; the treatises of Origen, for example, arose from the needs of the catechetical school of Alexandria.

20. See *Decrees of the Council of Trent*, session 5, second decree *"super lectione et praedicatione"* (On instruction and preaching) (*DEC-II*, 667–70).

21. *Dictionary of Moral Theology*, s.v. "Doctrine, Christian" (London: Burns and Oates, 1962), 428–30; *New Catholic Encyclopedia*, vol. 4 (New York: McGraw-Hill, 1967), s.v. "Doctrine," 939–40; Gerald O'Collins, S.J., and Edward G. Farrugia, S.J., *A Concise Dictionary of Theology* (Mahwah, N.J.: Paulist Press, 1991), s.v. "Doctrine," 57, s.v. "Dogma," 57–58.

22. *Dei Verbum* ch. 1, nos. 2, 6.

23. Heb. 1:1–2; *Dei Filius* 2; *Dei Verbum* ch. 1, nos. 2–4.

24. Germain Grisez, "On the Interpretation of Dogmas" (unpublished, 1988), 1; on file with author.

25. Thus faith is (though it is not limited to) the assent to propositions; see Aquinas, *ST*, II-II, q. 1, a. 2c.

26. Decree of the Holy Office, *Lamentabili* (3 July 1907), error 21 (*Denz.* 2021); *LG*, no. 25; *Dei Verbum*, no. 4.

27. Vincent also endeavors to commit the rule to writing as a weapon, so to speak, against his forgetful memory; thus the name *Commonitory* (literally, an aid to memory). Vincent of Lérins, *A Commonitory: For the Antiquity and Universality of the Catholic Faith against the Profane Novelties of All Heresies*, ch. 1, par. 3, ch. 2, par. 4 (*NPNF-II*, vol. 11, 132).

28. *Commonitory*, ch. 2, pars. 5–6.

29. *Commonitory*, ch. 3, par. 8; see also ch. 29, par. 77.

30. *Commonitory*, ch. 3, par. 8; see also ch. 27, par. 70, ch. 29, par. 77.

31. *Commonitory*, ch. 23, par. 54.

32. *Commonitory*, ch. 23, par. 55.

33. *Commonitory*, ch. 23, pars. 57.

34. *Commonitory*, ch. 23, par. 59.

35. Vincent's theorem is admittedly general, too general to provide effective guidance in distinguishing true developments from corruptions; is "believed everywhere" to

be understood as believed in every country, province, city, hamlet, or household? Does "believed always" mean believed and proclaimed in all centuries, years, months, or days? And how are we to verify the claim "believed by everyone"? In order for Vincent's dictum to be effectual, a hard and strict application must be eschewed.

36. John Henry Newman, *An Essay on the Development of Christian Doctrine* (Notre Dame, Ind.: University of Notre Dame Press, 1988), 41, 170.

37. Newman writes: "The point to be ascertained is the unity and identity of the idea with itself through all stages of its development from first to last, and these are seven tokens that it may rightly be accounted one and the same all along. To guarantee its own substantial unity, it must be seen to be one in type, one in its system of principles, one in its unitive power towards externals, one in its logical consecutiveness, one in the witness of its early phases to its later, one in the protection which its later extend to its earlier, and one in its union of vigour with continuance, that is, in its tenacity" (*Essay*, 206).

38. *Essay*, 172; "[Y]oung birds do not grow into fishes, nor does the child degenerate into the brute, wild or domestic, of which he is by inheritance lord" (ibid.). Newman cautions his readers, however, not to be put off by appearances: "An idea . . . does not always bear about it the same external image" (178); on the other hand, corruptions can be masked behind an external similarity to the ideas to which they are related; in religion, he says, a major cause of corruption is an obstinate conservatism which refuses to acknowledge true representations when they arise.

39. *Principles*, according to Newman, are to doctrines what mathematical axioms and postulates are to definitions (*Essay*, 179–80). If principles are destroyed, development corrupts (185). Arius and Nestorius, for example, denied the *principle of the allegorical rule of Scriptural interpretation* and ended by misunderstanding the natures and person of Christ; the Gnostics and Eunomians rejected the *principle of faith*, professing to substitute knowledge in its place; the Reformers, by separating themselves from the Church of Rome, *eo ipso* denied the *sacramental principle* which maintains that God's self-gift has been communicated in a material and visible form (354).

40. An idea like Christianity needs to be tested to see whether over time it assimilated truths from neighboring philosophies or whether in the end it was assimilated by them, whether there was an incorporation of like and a rejection of unlike ideas, or an encroachment of alien ones and hence a loss of identity. "Had [Christianity] the power," Newman asks, "while keeping its own identity, of absorbing its antagonists, as Aaron's rod . . . devoured the rods of the sorcerers of Egypt?" (*Essay*, 186, 355).

41. "An idea under one or other of its aspects grows in the mind . . . it leads to other aspects, and these again to others"; and gradually a body of thought develops which in *retrospect* invites analysis to discern whether there exists a logical dependence of one thought on another (*Essay*, 189–90).

42. "[H]ere and there definite specimens of advanced teaching should very early occur, which in the historical course are not found till a late day. The fact, then, of such

early or recurring intimations of tendencies which afterwards are fully realized, is a sort of evidence that those later and more systematic fulfilments are only in accordance with the original idea" (*Essay*, 196).

43. *Essay*, 200. The body of "a grown man is not merely that of a magnified boy; he differs from what he was in his make and proportions; still manhood is the perfection of boyhood; adding something of its own, yet keeping what it finds" (419–20).

44. The former, called an "active" corruption, ends in rapid death, the latter, a "sleeping" corruption, ends in gradual decay and then death (*Essay*, 437–38).

45. Vatican I, *Dei Filius*, ch. 4 (*DEC-II*, 809); the note references Vincent of Lérins, *Commonitorium*, 28.

46. "*Nullum sane inventum inducitur, nec quidquam additur novi ad earum summam veritatem, quae in deposito revelationis, Ecclesiae tradito, saltem implicite continentur.*" Emphasis added, Pius XI, *Mortalium Animos*, *AAS* (1928): 14.

47. Pius XII, *Humani Generis* (1950) (*Denz.* 2314).

48. Vatican Council II, "Dogmatic Constitution on Divine Revelation" (*Dei Verbum*), no. 8 (*DEC-II*, 974).

49. Vatican II's Pastoral Constitution, *Gaudium et Spes* (no. 62), says: "there is a difference between the deposit or truths of faith and the manner in which—with their sense and judgement [*sensu eademque sententia*] being preserved—they are expressed" (*DEC-II*, 1112).

50. John Paul II writes in *Veritatis Splendor*, no. 28, that doctrinal development in the Church's moral teaching is "analogous to that which has taken place in the realm of the truths of faith."

51. See John Paul II, *Ad Tuendam Fidem* (July 1998), no. 3; *Code of Canon Law*, canon 750, § 2, and canon 1371 (revisions 1998).

52. I am aware that some theologians conclude that it is not within the competency of the magisterium to propose moral teaching infallibly. See, e.g., Francis A. Sullivan, S.J., *Creative Fidelity: Weighing and Interpreting Documents of the Magisterium* (Dublin: Gill and Macmillan, 1996), 83, and "The Authority of the Magisterium on Questions of Natural Moral Law," in *Readings in Moral Theology*, no. 6, ed. Charles E. Curran and Richard A. McCormick, S.J. (Mahwah, N.J.: Paulist Press, 1988), 53–57. But given that the competency of the magisterium to faithfully interpret and authoritatively proclaim—including infallibly proclaim—matters pertaining to the natural moral law has been explicitly asserted and reasserted over the past five hundred years, it is reasonable to presume the magisterium's competency in this regard and place the burden of proof on those who would deny it. See John Paul II, *Ad Tuendam Fidem* (July 1998), no. 3; *Code of Canon Law*, canon 750, § 2, and canon 1371 (revisions 1998); John Paul II, *Veritatis Splendor* (August 1993), nos. 27, 28; Congregation for the Doctrine of the Faith (CDF), *Instruction on the Ecclesial Vocation of the Theologian* (May 1990), nos. 15–17; CDF, *New Formula for the Profession of Faith* (*Professio fidei et Iusiurandum fidelitatis*) (January 1989) (*CF*, no. 41); CDF, "In Defense of the Catholic Doctrine of the Church," *Mysterium Ecclesiae* (June 1973),

242 ■ Notes to pages 156–157

no. 3; Paul VI, *Humanae Vitae* (July 1968), no. 4; Vatican II, "Dogmatic Constitution on the Church," *Lumen Gentium* (November 1964), no. 25; Pius XI, "On Christian Marriage," *Casti Connubii*, ch. 5, section title "Authority of the Church," Vatican translation, St. Paul edition, pp. 65–66; Decree of the Holy Office, *Lamentabili* (July 1907), proposition 5 (*Denz.* 2005); Pius IX, *Syllabus* (1867), sec. 5, proposition 23 (*Denz.* 1723); Leo X, *Exsurge Domine*, proposition 27 (June 1520) (*Denz.* 767); for a helpful discussion of the moral teachings of the Council of Trent, see John Finnis, "'Faith and Morals': A Note," *The Month* (February 1988): 563–67.

53. This object of infallibility was first taught (albeit vaguely) at Vatican II; *LG*, no. 25, reads: "This infallibility, however, with which the divine redeemer willed his church to be endowed in defining doctrine concerning faith or morals, extends just as far as the deposit of divine revelation that is to be guarded as sacred and faithfully expounded" (*DEC-II*, 869); the first schema of Vatican II on the Church, chapter 7, throws light on this passage; it states that the magisterium is competent to define not only truths which are explicitly or implicitly revealed, but also truths which are connected with revealed truths and necessary for guarding and rightly interpreting them; see *Acta synodalia sacrosancti Concilii Oecumenici Vaticani II* 1/4 (Typis Polyglottis Vaticanis, 1971), 48–51. In 1973 the CDF taught the same only with greater clarity in its declaration *Mysterium Ecclesiae;* sec. 3 reads: "the infallibility of the Church's Magisterium extends not only to the deposit of faith but also to those matters without which that deposit cannot be rightly preserved and expounded" (trans. N.C. News Service); it was reasserted by John Paul II in *Ad Tuendam Fidem* (July 1998), no. 3, and officially incorporated into the *Code of Canon Law* (canon 750, § 2) at that time. Perhaps its clearest formulation is by Joseph Cardinal Ratzinger in his *Commentary on Profession of Faith's Concluding Paragraph* (June 1998); in par. 6 he writes: "The object taught by this formula [i.e., the formula stating: "I also firmly accept and hold each and everything definitively proposed by the church regarding faith and morals."] includes *all those teachings belonging to the dogmatic or moral area which are necessary for faithfully keeping and expounding the deposit of faith.* . . . Such doctrines *can be defined solemnly by the Roman pontiff when he speaks 'ex cathedra' or by the college of bishops gathered in council, or they can be taught infallibly by the ordinary and universal magisterium of the church as a 'sententia definitive tenenda.'"* Vatican translation, *Origins* 28, no. 8 (July 1998): 117.

54. CDF, *Instruction on the Ecclesial Vocation of the Theologian*, no. 16, emphasis added; see also CDF, *Mysterium Ecclesiae*, no. 3.

55. While its wrongful affirmation as true is made more intelligible by understanding the false complex assertion in relation to its presupposed true judgments, the false assertion is no less false.

56. "One must therefore take into account the proper character of every exercise of the Magisterium, considering the extent to which its authority is engaged." CDF, *Ecclesial Vocation of the Theologian*, no. 17.

57. See Vatican II, *LG*, no. 25; Pius XII's statement on the teaching authority of encyclical letters, *Humani Generis*, 1950 (*Denz.* 2313); and the instruction of the CDF, *Ecclesial Vocation of the Theologian*, nos. 23, 24, 33.

58. CDF, *Ecclesial Vocation of the Theologian*, no. 24.

59. A rough analogy with the doctrine of religious liberty might be drawn. Formerly the following proposition was rejected: all men and women are entitled to freely pursue the religious beliefs of their preference. The proposition, as stated, implied among other things the judgment that actions corresponding to those beliefs were socially destructive and hence illegitimate. Over time and with changes in social and political conditions, new states of affairs arose in which it was appropriate to filter out the latter judgment and formulate anew the assertion; the Church's reformulated teaching holds that although the destructive acts formerly specified are still illegitimate, each person, within the limits of respect for public order and public morality, has the right to follow his or her particular belief; maintaining some continuity with the past, however, Vatican II's "Decree on Religious Liberty" (*Dignitatis Humanae*) teaches: "society has the right to protect itself against the abuses that can occur under the guise of religious liberty. . . . Nevertheless, that principle of full freedom is to be preserved in society according to which people are given the maximum of liberty, and only restrained *when and in so far as is necessary*"; no. 7, emphasis added (*DEC-II*, 1005–6).

60. Concetti, *Pena di morte*, 7.

Notes to Chapter 8

1. *ST*, II-II, q. 64, a. 6; I-II, q. 88, a. 6, ad 3, q. 100, a. 8, ad 3; *In Lib. I Sent.*, d. 47, a. 4, ad 2; *In Lib. III Sent.*, d. 23, q. 3, a. 1, sol. 3c.

2. See *EV*, nos. 57, 62, 65.

3. See chapter 6 for evidence in defense of this assertion.

4. *ST*, II-II, q. 64, a. 3c, ad 3, a. 5, ad 3, a. 7, ad 1.

5. *ST*, II-II, q. 64, a. 5, ad 1, emphasis added.

6. Ibid., a. 5c.

7. *ST*, I-II, q. 94, a. 2c.

8. "*in apprehensione omnium cadunt*," ibid.

9. Aquinas, *Commentary on Aristotle's* Nicomachean Ethics, bk. 6, lecture 3, par 1148.

10. Aquinas is clear that in order to attain knowledge of first principles, "we need sensory experience and memory." *In Lib. II Sent.*, d. 24, q. 2, a. 3c.

11. "*bonum est primum quod cadit in apprehensione practicae rationis*," *ST*, I-II, q. 94, a. 2c.

12. "*Hoc est ergo primum praeceptum legis, quod bonum est faciendum et prosequendum, et malum vitandum.*" Ibid., a. 2c, ad 1, 2.

244 ■ Notes to pages 167–169

13. Ibid., a. 2c.

14. Aquinas teaches elsewhere that among ends, some ends are ultimate in that beyond these ends the agent seeks nothing further, for instance, a doctor intends health with which he is satisfied. If this were not the case then actions would tend to infinity, which is impossible. (See *SCG*, III, c. 2, n. 3.)

15. Aquinas writes that "the proximate mover of the will is the good as apprehended, which is its object, and it is moved by it, just as sight is by color. So, no created substance can move the will except by means of a good which is understood. Now, this is done by showing it that something is a good thing to do: this is the act of *persuading.*" *SCG*, III, c. 88, n. 2.

16. *ST*, I-II, q. 94, a. 2c.

17. By the middle of the thirteenth century the works of Dionysius the pseudo-Areopagite (ca. 500), so called because he was mistakenly thought to be the Athenian convert of St. Paul referred to in Acts 17:34, were an important source for Western theologians. The cosmology of Dionysius' *Celestial Hierarchy* exercised significant influence on the cosmology of the medieval Schools, particularly on Aquinas' mentor Albert the Great (ca. 1206–1280).

18. *SCG*, III, c. 3, n. 7.

19. *ST*, II-II, q. 64, a. 6c.

20. *ST*, I-II, q. 94, a. 2c.

21. Ibid.

22. *ST*, I-II, q. 1, a. 3c, ad 3; II-II, q. 150, a. 2c; II-II, q. 37, a. 1c; cf. I-II, q. 73, a. 8c.

23. Among the moral precepts formulated by Grisez and Finnis in their development of Aquinas is one that singles out *every* action which intends as an end or means the destruction of any basic human good; see Finnis, *Natural Law and Natural Rights*, 118–25; *Moral Absolutes*, 54–55; *Fundamentals of Ethics*, 124–27; Grisez, *Christian Moral Principles*, 215–22; Germain Grisez and Russell Shaw, *Beyond the New Morality*, 3rd ed. (Notre Dame, Ind.: University of Notre Dame Press, 1988), 131; John Finnis, Joseph Boyle, Jr., and Germain Grisez, *Nuclear Deterrence, Morality and Realism* (Oxford: Clarendon Press, 1987), 286–87. In *Aquinas*, Finnis elaborates Aquinas' construal of the norm as excluding all intentional killing by private persons, and excluding without exception the intentional killing of the innocent; see 140–41.

24. Unfortunately, Aquinas never gives an account of just how we get from the allegedly self-evident first principles of the natural law to the concrete moral conclusions which he claims follow from them. He states that moral norms are "referred to [first principles] as conclusions to general principles"; "[the Natural Law's] secondary principles . . . are certain detailed proximate conclusions drawn from the first principles"; "certain matters of detail . . . are conclusions, as it were, of those general principles"; and again, "there belong to the natural law, first, certain most general precepts, that are known to all; and secondly, certain secondary and more detailed precepts, which are, as

it were, conclusions following closely from first principles" (*ST*, I-II, q. 100, a. 3, ad 1, q. 94, a. 4c, 5c, a. 6c). But when he addresses the question of the scope of the natural law's concrete specifications, he turns to the Decalogue (see *ST*, I-II, q. 100, a. 3c); even precepts apparently superadded to the Decalogue are reducible to the Decalogue (see ibid., a. 11c). The absence in Aquinas of an account specifying the nature of the transition from judgments regarding first principles to judgments about right action in any given instance is admittedly a weakness.

25. See Aristotle, *Politics*, bk. 1, ch. 2, 1253a18–29.

26. *ST*, II-II, q. 64, a. 2c; comments on the Aristotelian background to the model presented in this passage may be found in chapter 5; see also *SCG*, III, c. 146, nos. 4–5.

27. Aquinas, *Commentary on Aristotle's* Nicomachean Ethics, bk. 1, lecture 1, par. 5, pp. 2–3.

28. Germain Grisez makes this point in "Toward a Consistent Natural-Law Ethics of Killing," *The American Journal of Jurisprudence* 15 (1970): 67–68.

29. *ST*, II-II, q. 64, a. 5c.

30. "[I]nterdependence (between nations) . . . is leading to an increasingly universal common good, the sum total of the conditions of social life enabling groups and individuals to realize their perfection more fully and readily," *Gaudium et Spes*, no. 26 (*DEC-II*, 1084); "And the common good comprises the sum of the conditions of social life which enable individuals, families and associations to reach their own perfection more completely and more readily." Ibid., no. 74 (*DEC-II*, 1121).

31. Augustine, *De Doctrina Christiana*, bk. 1, no. 7; Latin and English edition, trans. R. P. H. Green (Oxford: Oxford University Press, 1995).

32. Augustine actually itemizes three categories: things to be enjoyed (God), things to be used (everything else), and things which enjoy and use (intelligent agents alone).

33. *De Doctrina Christiana*, bk. 1, nos. 59–65, 76.

34. The *usus/fruitio* discussion was well known in the Schools via the Master of the Schools, Peter Lombard, upon whom book I of *De Doctrina Christiana* exercised major influence.

35. *SCG*, III, c. 112, nos. 1–2.

36. *SCG*, III, c. 111.

37. *SCG*, III, c. 112.

38. *SCG*, III, c. 113.

39. *SCG*, III, c. 112, n. 5.

40. Ibid.

41. Ibid.

42. *SCG*, III, c. 113.

43. *ST*, II-II, q. 64, a. 2, ad 3, emphasis added.

44. *"quia dignitas significat bonitatem alicujus propter seipsum"*; *In Lib III Sent.*, d. 35, q. 1, a. 4, sol. 1c.

45. "Therefore, corporeity [i.e., bodiliness], as the substantial form in man, cannot be other than the rational soul, which requires in its own matter the possession of three dimensions, for the soul is the act of a body." *SCG*, IV, c. 81, n. 7.

46. *ST*, I, q. 29, a. 3, ad 2; Aquinas says: "because to subsist in a rational nature is of great dignity, therefore every individual of a rational nature is called a *person*."

47. John Paul II says essentially this when he writes, "*Not even a murderer loses his personal dignity*" (*EV*, no. 9), emphasis in text.

48. *ST*, I, q. 93, a. 4c.

49. "We may speak of God's image in two ways: first, we may consider in it that in which the image chiefly consists, that is, the intellectual nature." Ibid., a. 3c.

50. "Secondly, we may consider the image of God in man as regards its accidental qualities, so far as to observe in man a certain imitation of God, consisting in the fact that man proceeds from man, as God from God; and also in the fact that the whole human soul is in the whole body, and again, . . ." Ibid.

51. "But these do not of themselves belong to the nature of the Divine image in man, unless we presuppose the first likeness, which is in the intellectual nature." Ibid.

52. *ST*, II-II, q. 64, a. 6c.

53. "Sinners do not cease to be human, since sin does not do away with nature; therefore sinners ought to be loved out of charity." *ST*, II-II, q. 25, a. 6, *sed contra*; see also 6c.

54. *ST*, II-II, q. 64, a. 5c.

55. *ST*, II-II, q. 25, a. 6, ad 2, emphasis added.

56. See *ST*, II-II, q. 25, a. 6c, ad 2; q. 64, a. 2.

57. "*irreparabile nocumentum*" or "*horribilem deformitatem*," *ST*, II-II, q. 66, a. 6, ad 2.

58. *ST*, II-II, q. 25, a. 6, ad 2.

59. "He to whom authority is delegated, and who is but the sword in the hand of him who uses it, is not himself responsible for the death he deals." *De Civitate Dei*, bk. I, ch. 21 (*NPNF-I*, vol. 2, p. 15).

60. "*ille aliquid facit cuius auctoritate fit,*" *ST*, II-II, q. 64, a. 3, ad 1; see also *SCG*, III, c. 76, n. 6.

61. *SCG*, III, c. 146, nos. 2–3.

62. *SCG*, III, c. 146, n. 2.

63. *ST*, II-II, q. 64, a. 6, ad 1.

64. He does appeal to the authority of God to ground the prerogative of public authority to determine who should and should not be punished; *ST*, I-II, q. 100, a. 8, ad 3.

65. *ST*, II-II, q. 64, a. 6, ad 3.

66. *ST*, II-II, q. 64, a. 3, ad 1.

67. *ST*, II-II, q. 64, a. 6, ad 1.

68. *ST*, I-II, q. 100, a. 8, ad 3.

69. *ST*, I-II, q. 100, a. 1c.

70. *ST*, I-II, q. 94, a. 2c.

71. *ST*, I-II, q. 100, a. 1c.

72. Since the natural law is none other than the law of reason, Aquinas concludes that all moral precepts, including those of the Old Law, of necessity belong to the natural law.

73. *ST*, I-II, q. 95, a. 2c.

74. *ST*, II-II, q. 64, a. 6, ad 3.

75. *ST*, I-II, q. 100, a. 8, ad 3.

76. Penal mutilation as an intentional *harming* of the basic good of life would therefore also be wrong. For Aquinas' argument in defense of its licitness, see *ST*, II-II, q. 65, a. 1.

77. I presuppose here that certain Enlightenment theories which appeal to various "forfeiture of rights" arguments to justify the death penalty, as in Hobbes, Locke, and Rousseau, also fail to meet the charge because their notions of rights are unsound. By grounding human rights claims in a fundamentally egoistic anthropology within the context of a struggle to flee from a fictional state of nature into an artificial social construct, they neglect altogether the origin of moral claims and hence of human rights, namely, basic human goods.

78. Germain Grisez, Joseph Boyle, Jr., and John Finnis, "Practical Principles, Moral Truth, and Ultimate Ends," *The American Journal of Jurisprudence* 32 (1987): 103.

79. When we reason practically, we arrive at certain desirable purposes (e.g., "It would be good to exercise today"), which, when traced to their most remote motive (e.g., "Why do you desire to exercise?" "To be in better shape." "Why do you want to be in shape?"), lead to certain ends beyond which no more basic ends attract us (e.g., "Because when I am in shape I have more energy, feel better and think more clearly." "Why do you want this?" "Because bodily health is good.").

80. Some have argued against this view on the grounds that a sound theory of natural law and its corresponding normative precepts must in some way derive from a prior account of human nature. This, however, is to confuse the epistemological order with the ontological order in relation to the arising of moral norms. For an account of the two orders in relation to morality, see Finnis, *Fundamentals of Ethics*, 21–22; for criticisms of the Grisez/Finnis position see Russell Hittinger, *A Critique of the New Natural Law Theory* (Notre Dame, Ind.: University of Notre Dame Press, 1987), 39–41, 73–78, passim; Ralph McInerny, "The Principles of Natural Law," in *Readings in Moral Theology*, no. 7, ed. Charles E. Curran and Richard A. McCormick, S.J. (Mahway, N.J.: Paulist Press, 1991), 139–56. For a critique of Hittinger see Germain Grisez, "A Critique of Russell Hittinger's Book, *A Critique of the New Natural Law Theory*," in *The New Scholasticism* 62, no. 4 (Autumn 1988): 438–65, esp. 441–43; for a critique of McInerny see John Finnis and Germain Grisez, "The Basic Principles of Natural Law: A Reply to Ralph McInerny," in *Readings in Moral Theology*, no. 7, pp. 157–70.

81. Hittinger, *A Critique,* 29–30, 77.

82. Since goodness in general lies in the fulfillment or perfection of being; *ST,* I, q. 5, a. 5.

83. See Grisez, *Christian Moral Principles,* 121.

84. *ST,* I-II, q. 94, a. 2c.

85. Grisez, Boyle, and Finnis, "Practical Principles, Moral Truth, and Ultimate Ends," 107–8; see also Finnis, *Natural Law and Natural Rights,* 86–90.

86. Ibid., 128.

87. Grisez, *Christian Moral Principles,* 185–86.

88. Ibid., 215.

89. Finnis, *Aquinas,* 128.

90. For more on the retributive purpose of punishment, see chapter 2.

91. *ST,* I, q. 48, a. 6c.

92. *Commentary on Aristotle's* Nicomachean Ethics, bk. 1, lecture 1, pars. 1–2.

93. For a detailed consideration of the morality of "conditional intent," see Finnis, Boyle. and Grisez, *Nuclear Deterrence, Morality and Realism,* 81–86.

94. Aquinas calls this *determinatio* and says that while it is governed by the natural law, its derivation is not as a conclusion from premises but rather a derivation via certain generalities, just as an architect, who is limited by the general form of a house, is left to his own to determine the particular shape, and so on, of *this* house; *ST,* I-II, q. 95, a. 2c; see also *SCG,* III, c. 97, n. 12.

95. *ST,* II-II, q. 64, a. 7.

96. *ST,* II-II, q. 64, a. 7c.

97. The insight developed by (but not originating with) Aquinas regarding the morally relevant distinction between intention and side effects—sometimes referred to as double-effect reasoning, or the principle (doctrine) of double effect—is not without its opponents; and even among defenders, views differ widely on its proper scope. Essays on both sides of the debate are conveniently compiled in *The Doctrine of Double Effect: Philosophers Debate a Controversial Moral Principle,* ed. P. A. Woodward (Notre Dame, Ind.: University of Notre Dame Press, 2001).

98. *ST,* I-II, q. 12, a. 1, ad 3, q. 6, a. 2c, q. 15, a. 3c, q. 9, a. 1c.

99. *ST,* I-II, q. 6, a. 2, ad 1.

100. *ST,* I, q. 19, a. 1c.

101. Joseph M. Boyle helpfully elaborates this point in "Toward Understanding the Principle of Double Effect," in *The Doctrine of Double Effect,* ed. Woodward, 7–20, esp. 9.

102. *"si non sit proportionatus fini." ST,* II-II, q. 64, a. 7c.

103. Aquinas uses the terms *"debita sollicitudo"* and *"debita diligentia"* synonymously; *ST,* II-II, q. 64, a. 8c.

104. Finnis, *Aquinas,* 142.

105. This is Jacques Leclercq's conclusion. He writes: "The condemnation of the death penalty always goes hand in hand with condemnation of war." *Les Droits et devoirs individuels*, 91.

106. Grisez's treatment of war goes well beyond what I have sketched out here; see Grisez, *Living a Christian Life*, 897–911, esp. 898–900, 904–6.

107. Finnis, Grisez, and Boyle, in *Nuclear Deterrence, Morality and Realism*, 309–19, argue that a norm excluding all intentional killing leaves many kinds of effective military operations morally available.

108. Far more people are treated inhumanely than are punished by death. Nor do supporters of capital punishment seem much concerned about prison reform! Indeed, the two fit nicely together—criminals have lost their human dignity, so kill a few and treat millions like animals.

Bibliography

Achtemeier, Paul. *Romans.* Atlanta: John Knox Press, 1985.

Aertnys, I., C.SS.R., and C. Damen, C.SS.R. *Theologia Moralis.* Rome: Marietti, 1956.

Alexander III, Pope. "To Archbishop of Canterbury." In *Decretal. Gregor. IX*, lib. III, tit. L, cap. V. In *Corpus Iuris Canonici*, vol. 2. Lipsiae: Ex Officina Bernhardi Tauchnitz, 1881.

Alt, Albrecht. "The Origins of Israelite Law." In *Essays on Old Testament History and Religion.* Oxford: Basil Blackwell, 1966.

Ambrose. *Epistola L (XXV)*, to Studius. In *Corpus Scriptorum Ecclesiasticorum Latinorum*, vol. 82. Translation from *Irenaeus to Grotius: A Sourcebook in Christian Political Thought*, ed. Oliver O'Donovan and Joan Lockwood O'Donovan. Grand Rapids: Eerdmans, 1999.

———. *On Cain and Abel.* In *Fathers of the Church*, vol. 42. Translated by John Savage. Washington, D.C.: The Catholic University of America Press, 1961. 359–437.

Amnesty International. *Abolition of the Death Penalty Worldwide: Developments in 2002.* Available at http://web.amnesty.org/library/Index/ENGACT500022003.

———. *Africa: A New Future Without the Death Penalty.* AI Index: AFR (1 April 1997). Available at http://www.amnesty.org/.

———. *Constitutional Prohibitions of the Death Penalty.* Available at http://web.amnesty.org/library/Index/ENGACT500051999.

———. *The Death Penalty: List of Abolitionist and Retentionist Countries.* Report, 1 January 2003. Available at http://web.amnesty.org/library/Index/ENGACT 50003-2003.

Ancel, Marc. "The Problem of the Death Penalty." In *Capital Punishment.* Edited by Thorsten Sellin. New York: Harper and Row, 1967.

Andrews, William. *Bygone Punishments.* London: William Andrews and Co., 1899.

Aquinas, Thomas. *Commentary on Aristotle's* Nicomachean Ethics. Translated by C. I. Litzinger, O.P. Notre Dame, Ind.: Dumb Ox Books, 1993.

———. *On Evil*. Translated by Jean Oesterle. Notre Dame, Ind.: University of Notre Dame Press, 1995.

———. *Scriptum super Libros Sententiarum Petri Lombardi*, Books I–IV (Paris, 1873).

———. *Summa Contra Gentiles*. Translated by Vernon J. Bourke. Notre Dame, Ind.: University of Notre Dame Press, 1975.

———. *Summa Theologiae*. Leonine Edition. Rome: Marietti, 1950.

Aristotle. *Metaphysics*. Translated by W. D. Ross. In *The Complete Works of Aristotle*, vol. 2. Edited by Jonathan Barnes. Princeton: Princeton University Press, 1984. 1552–1728.

———. *Politics*. Translated by B. Jowett. In *The Complete Works of Aristotle*, vol. 2. Edited by Jonathan Barnes. Princeton: Princeton University Press, 1984. 1986–2129.

———. *Nicomachean Ethics*. Translated by W. D. Ross. In *The Complete Works of Aristotle*, vol. 2. Edited by Jonathan Barnes. Princeton: Princeton University Press, 1984. 1729–1867.

Athenagoras. *A Plea for the Christians*. In *Ante-Nicene Fathers*, vol. 2. Edited by Alexander Roberts and James Donaldson. Peabody, Mass.: Hendrickson Publishers, 1994. 129–48.

Atto of Vercelli. *De Pressuris Ecclesiasticis*. In *Patrologia Cursus Completus, Series Latina*, vol. 134. Edited by J. P. Migne, 1853. Cols. 51D–96A.

Augustine. *Commentary on the Lord's Sermon on the Mount*. In *Fathers of the Church*, vol. 11. Translated by Denis Kavanagh. Washington, D.C.: The Catholic University of America Press, 1951. 19–199.

———. *De Civitate Dei*. In *Fathers of the Church*, vol. 8. Translated by D. Zema and G. G. Walsh. Washington, D.C.: The Catholic University of America Press, 1962.

———. *De Doctrina Christiana*. Translated by R. P. H. Green. Oxford: Oxford University Press, 1995.

———. *De Ordine* (ca. 387). Excerpt in "Theology and Capital Punishment," by M. B. Crowe. *Irish Theological Quarterly* 31, no. 1 (January 1964): 36.

———. *Letter X** (AD 422), to Alypius. In *Fathers of the Church*, vol. 81. Translated by Robert Eno. Washington, D.C.: The Catholic University of America Press, 1989. 75–80.

———. *Letter XLVII* (AD 398), to Publicola. In *Fathers of the Church*, vol. 12. Translated by Wilfrid Parsons. Washington, D.C.: The Catholic University of America Press, 1951. 225–31.

———. *Letter LXXXVI* (AD 405), to Caecilianus. In *Fathers of the Church*, vol. 18. Translated by Wilfrid Parsons. New York: Fathers of the Church, 1953. 11–12.

———. *Letter LXXXVII* (ca. AD 405), to Emeritus. In *Fathers of the Church*, vol. 18. Translated by Wilfrid Parsons. New York: Fathers of the Church, 1953. 12–22.

———. *Letter XC* (AD 408), Nectarius to Augustine. In *Fathers of the Church*, vol. 18. Translated by Wilfrid Parsons. New York: Fathers of the Church, 1953. 41–42.

———. *Letter C* (ca. AD 409), to Donatus. In *Fathers of the Church*, vol. 18. Translated by Wilfrid Parsons. New York: Fathers of the Church, 1953. 141–43.

———. *Letter CIV* (AD 409), to Nectarius. In *Fathers of the Church*, vol. 18. Translated by Wilfrid Parsons. New York: Fathers of the Church, 1953. 180–95.

———. *Letter CXXXIII* (AD 412), to Marcellinus. In *Fathers of the Church*, vol. 20. Translated by Wilfrid Parsons. New York: Fathers of the Church, 1953. 6–8.

———. *Letter CXXXIV* (AD 412), to Apringius. In *Fathers of the Church*, vol. 20. Translated by Wilfrid Parsons. New York: Fathers of the Church, 1953. 9–12.

———. *Letter CLXXXV* (AD 417), to Boniface. In *Fathers of the Church*, vol. 30. Translated by Wilfrid Parsons. New York: Fathers of the Church, 1955. 141–90.

———. *Letter CXXXIX* (AD 412), to Marcellinus. In *Fathers of the Church*, vol. 20. Translated by Wilfrid Parsons. New York: Fathers of the Church, 1953. 53–57.

———. *Letter CLIII* (AD 414), to Macedonius. In *Fathers of the Church*, vol. 20. Translated by Wilfrid Parsons. New York: Fathers of the Church, 1953. 281–303.

———. *On Free Choice of the Will*. In *Fathers of the Church*, vol. 59. Translated by Robert P. Russell. Washington, D.C.: The Catholic University of America Press, 1968. 72–241.

———. *Reply to Faustus the Manichaean* (AD 400). In *Nicene and Post-Nicene Fathers*, 1st series, vol. 4. Edited by Philip Schaff. Peabody, Mass.: Hendrickson Publishers, 1994. 155–345.

———. *Tractate 33 on the Gospel of John*. In *Nicene and Post-Nicene Fathers*, 1st series, vol. 7. Edited by Philip Schaff. Peabody, Mass.: Hendrickson Publishers, 1994. 197–200.

Bailey, William C., and Ruth D. Peterson. "Murder, Capital Punishment, and Deterrence: A Review of the Literature." In *The Death Penalty in America: Current Controversies*. Edited by Hugo A. Bedau. Oxford: Oxford University Press, 1997. 135–61.

Barr, James. *Capital Punishment from the Christian Standpoint*. London: National Council for the Abolition of the Death Penalty, 1938.

Basil. *Letter CXII*, to Andronicus. In *Fathers of the Church*, vol. 13. Translated by Agnes C. Way. Washington D.C.: The Catholic University of America Press, 1951. 236–39.

———. *Letter CCLXXXVI*. In *Nicene and Post-Nicene Fathers*, 2d series, vol. 8. Edited by Philip Schaff and Henry Wace. Peabody, Mass.: Hendrickson Publishers, 1994. 313.

———. *Letter CCLXXXIX*. In *Nicene and Post-Nicene Fathers*, 2d series, vol. 8. Edited by Philip Schaff and Henry Wace. Peabody, Mass.: Hendrickson Publishers, 1994. 314.

Beccaria, Cesare. "On Crimes and Punishments." In *On Crimes and Punishments and Other Writings*. Edited by Richard Bellamy. Cambridge Texts in the History of Political Thought. Cambridge: Cambridge University Press, 1995.

Bedau, Hugo A. "The Controversy over Deterrence and Incapacitation." In *The Death Penalty in America: Current Controversies*. Edited by Hugo A. Bedau. Oxford: Oxford University Press, 1997. 127–34.

———. *Death Is Different: Studies in the Morality, Law, and Politics of Capital Punishment*. Boston, Mass.: Northeastern University Press, 1987.

———. "Deterrence." In *The Case Against the Death Penalty*. New York: American Civil Liberties Union, 1992. Available at http://www.dnai.com/~mwood/deathpen.html.

———. "A Reply to van den Haag." In *The Death Penalty in America: Current Controversies*. Edited by Hugo A. Bedau. Oxford: Oxford University Press, 1997. 461–63.

———, ed. *The Death Penalty in America: Current Controversies*. Oxford: Oxford University Press, 1997.

Bellarmine, Robert Cardinal. "An Ample Declaration of the Christian Doctrine." Translated by Richard Hadock. Facsimile in *English Recusant Literature 1558–1640*. Edited by D. M. Rogers. London: Scholar Press, 1977.

———. *De Laicis sive Saecularibus*. Translated by Kathleen E. Murphy. Westport, Conn.: Hyperion Press, 1928.

Benedict XV, Pope. *Codex Iuris Canonici*. Rome: Typis Polyglottis Vaticanis, 1917.

Bentham, Jeremy. *An Introduction to the Principles of Morals and Legislation*. Edited by J. H. Burns and H. L. A. Hart. London: Methuen and Co., 1982.

Bernardin, Joseph L. "Remaining a Vigorous Voice for Life in Society." *Origins* 26, no. 15 (September 1996): 237–42.

———. *Statement on Capital Punishment*. Washington, D.C.: United States Catholic Conference Publications Office, 1977.

Best, E. "The Letter of Paul to the Romans." *The Cambridge Bible Commentary*. Cambridge: Cambridge University Press, 1967.

Billuart, Charles-René. *Summa S. Thomae Hodiernis Academiarum Moribus Accommodata (Cursus Theologiae)*. Paris, 1829.

Bishops of England and Wales. "Bishops Say 'No' to the Re-introduction of Capital Punishment." Briefing of the Catholic Information Service, 15 July 1983, vol. 13, no. 22.

Blidstein, Gerald J. "Capital Punishment—The Classic Jewish Discussion." *Judaism* 14 (1965): 159–71.

Block, Brian P., and John Hostettler. *Hanging in the Balance: A History of the Abolition of Capital Punishment in Britain*. Winchester: Waterside Press, 1997.

Bornkamm, Günther. "The Letter to the Romans as Paul's Last Will and Testament." In *The Romans Debate*, rev. ed. Edited by Karl P. Donfried. Peabody, Mass.: Hendrickson Publishers, 1991.

Bowen-Rowlands, Ernest. *Judgement of Death*. London: W. Collins Sons and Co., 1924.

Bradley, Gerard V. "No Intentional Killing Whatsoever: The Case of Capital Punishment." In *Natural Law and Moral Inquiry: Ethics, Metaphysics, and Politics in the*

Work of Germain Grisez, ed. Robert P. George. Washington, D.C.: Georgetown University Press, 1998. 155–73.

Bruce, F. F. "The Romans Debate—Continued." In *The Romans Debate*, rev. ed. Edited by Karl P. Donfried. Peabody, Mass.: Hendrickson Publishers, 1991.

Burgh, Richard W. "Do the Guilty Deserve Punishment?" *Journal of Philosophy* 79 (1982): 193–210.

Byrne, Brendan, S.J. *Romans*. Edited by Daniel J. Harrington, S.J. Series *Sacra Pagina*. Collegeville, Minn.: Liturgical Press, 1996. 361–433.

Cajetan, Thomas Cardinal. *Commentaries of Thomas Cajetan*. In Aquinas, *Opera Omnia*, Leonine edition (1897).

Calvert, Roy. *Countries Which Have Abolished the Death Penalty: What Their Experience Has Been*. London: National Council for the Abolition of the Death Penalty, 1936.

Camus, Albert. "Reflections on the Guillotine." In *Resistance, Rebellion and Death*. Translated by Justin O'Brien. London: Hamish Hamilton, 1964. 127–65.

Canadian Catholic Bishops. "Declaration of the Administrative Board of the Canadian Catholic Conference" (on capital punishment), 1976.

Casini, Carlo. "Right to Life in Europe: Former European Parliamentarian Addresses Pontifical Academy for Life." Zenit (News Service), Vatican City, 23 February 2000.

Catholics Against Capital Punishment. *Bibliography of Statements by U.S. Catholic Bishops on the Death Penalty: 1972–1998*. Arlington, Va: CACP, 1998.

Cathrein, Victor, S.J. *Philosophia Moralis in Usum Scholarum*. 5th ed. Freiburg: Herder, 1905.

Chodorow, Stanley. *Christian Political Theory and Church Politics in the Mid-Twelfth Century: The Ecclesiology of the Gratian's Decretum*. Berkeley: University of California Press, 1972.

Chronicon universale anonymi Laudunensis (twelfth century). In *Heresies of the High Middle Ages: Selected Sources Translated and Annotated*, edited and translated by Walter L. Wakefield and Austin P. Evans. New York: Columbia University Press, 1969. 200–202.

Chrysostom, John. *Gospel According to St. Matthew, Homily 146*. In *Nicene and Post-Nicene Fathers*, 1st series, vol. 10. Edited by Philip Schaff and Henry Wace. Peabody, Mass.: Hendrickson Publishers, 1994.

———. *Homilies on the Statues*. In *Nicene and Post-Nicene Fathers*, 1st series, vol. 9. Edited by Philip Schaff. Peabody, Mass.: Hendrickson Publishers, 1994. 331–489.

Ciccone, Lino. *Non Uccidere: Questioni di Morale della Vita Fisica*. Milano: Edizioni Ares, 1984.

Clement of Alexandria. *Paidagogos*. In *Fathers of the Church*, vol. 23. Translated by Simon P. Wood. New York: Fathers of the Church, 1954.

———. *Stromateis: Books One to Three*. In *Fathers of the Church*, vol. 85. Translated by John Ferguson. Washington, D.C.: The Catholic University of America Press, 1991.

————. *Stromateis: Book Four*. In *Ante-Nicene Fathers*, vol. 2. Edited by Alexander Roberts and James Donaldson. Peabody, Mass.: Hendrickson Publishers, 1994.

Compagnoni, Francesco, O.P. "Capital Punishment and Torture in the Tradition of the Roman Catholic Church." *Concilium* 120 (1978).

Concetti, Gino. "Inviolabilità della vita umana." *L'Osservatore Romano* (8 September 1978), 2 ff.

————. *Pena di morte*. Casale Monferrato: Edizioni Piemme, 1993.

————. "Può ancora ritenersi legittima la pena di morte?" *L'Osservatore Romano* (23 January 1977), 1 ff.

Congregation for the Doctrine of the Faith. *In Defense of the Catholic Doctrine of the Church (Mysterium Ecclesiae)* (11 May 1973). Boston: St. Paul Books and Media.

————. *Instruction on the Ecclesial Vocation of the Theologian* (24 May 1990). Boston: St. Paul Books and Media.

Conrad, Edgar W. "Ban." *The Oxford Companion to the Bible*. Edited by Bruce Metzger and Michael D. Coogan. Oxford: Oxford University Press, 1993. 73.

Conrad, John P. "The Retributivist's Case against Capital Punishment." In *The Death Penalty: A Debate*. Edited by Ernest van den Haag. New York: Plenum Press, 1983. 17–28.

Coulton, George Gordon. "The Death Penalty for Heresy: From 1184 to 1921 AD." *Medieval Studies* 18 (1924).

Coulton, George Gordon, and L. J. Walker, S.J. "Roman Catholic Truth: An Open Discussion." *Medieval Studies* 17 (1924).

Council of Florence. "Decree for the Armenians (1439)." In *Enchiridion Symbolorum, definitionum et declarationum de rebus fidei et morum*, 30th ed., no. 701. Edited by Henry Denzinger. Translated by Roy J. Deferrari. In *Sources of Catholic Dogma*. London: B. Herder Book Co., 1957. Also in *The Christian Faith*, 6th ed., no. 1705. Edited by Josef Neuner, S.J., and Jacques Dupuis, S.J. New York: Alba House, 1996.

Council of Rome. "Epistola X, seu Canones Synodi Romanorum ad Gallos Episcopos." In *Patrologia Cursus Completus, Series Latina*, vol. 13. Edited by J. P. Migne, 1845. Cols. 1181A–1196A.

Council of Toledo (4th). In *Decretum Magistri Gratiani*, Causa XXIII, q. VIII, c. XXIX. In *Corpus Iuris Canonici*, vol. 1. Lipsiae: Ex Officina Bernhardi Tauchnitz, 1879.

Council of Toledo (11th). In *Decretum Magistri Gratiani*, Causa XXIII, q. VIII, c. XXX. In *Corpus Iuris Canonici*, vol. 1. Lipsiae: Ex Officina Bernhardi Tauchnitz, 1879.

Cranfield, C. E. B. *A Critical and Exegetical Commentary on The Epistle to the Romans*. Vol. 2. Edinburgh: T&T Clark, 1979.

Crowe, M. B. "Theology and Capital Punishment." *The Irish Theological Quarterly* 31, nos. 1–2 (January 1964): 24–61, 99–131.

Cyprian. *Ad Demetrianum*. In *Fathers of the Church*, vol. 36. Translated by Roy J. Deferrari. New York: Fathers of the Church, 1958. 167–91.

———. *Ad Donatum*. In *Fathers of the Church*, vol. 36. Translated by Roy J. Deferrari. New York: Fathers of the Church, 1958. 7–21.

———. *De Idolorum Vanitate*. In *Fathers of the Church*, vol. 36. Translated by Roy J. Deferrari. New York: Fathers of the Church, 1958. 349–60.

———. *Epistle 60*, To Cornelius. In *Fathers of the Church*, vol. 51. Translated by Rose B. Donna. Washington, D.C.: The Catholic University of America Press, 1964. 193–96.

———. *Testimonies Against the Jews*. In *The Treatises of Cyprian*. In *Ante-Nicene Fathers*, vol. 5. Edited by Alexander Roberts and James Donaldson. Peabody, Mass.: Hendrickson Publishers, 1994. 507–557.

Dailey, Thomas G. "The Church's Position on the Death Penalty in Canada and the United States." *Concilium* 120 (1978): 121–25.

Davis, Henry, S.J. *Moral and Pastoral Theology*, 5th ed. London: Sheed and Ward, 1946.

De Lubac, Henri. "The Problem of the Development of Dogma." In *Theology in History*. San Francisco: Ignatius Press, 1996. 248–80.

De Luca, Marianus. *Institutiones Juris Ecclesiastici Publici*. Rome: J. Pustet, Libraria Pontificia, 1901. Excerpted in "Roman Catholic Truth: An Open Discussion," by George Gordon Coulton and L. J. Walker, S.J., *Medieval Studies* 17 (1924): 61–66; and in "The Death Penalty for Heresy: From 1184 to 1921 A.D.," by George Gordon Coulton, *Medieval Studies* 18 (1924): 29.

De Lugo, Juan Cardinal. *De Justitia et Jure*. In *Disputationes Scholasticae et Morales*. Paris, 1893.

De Vaux, R., O.P. *Ancient Israel: Its Life and Institutions*. London: Darton, Longman and Todd, 1961.

De Vitoria, Francisco, O.P. *On the Law of War*. In *Vitoria: Political Writings*. Edited by Anthony Pagden et al. Cambridge Texts in the History of Political Thought. Cambridge: Cambridge University Press, 1991.

———. *Relection on Homicide* & *Commentary on Summa theologiae IIa-IIae Q. 64*. Translated by John P. Doyle. Milwaukee: Marquette University Press, 1997.

Decree of the Holy Office. "The Errors of Modernists, on the Church, Revelation, Christ, the Sacraments" (*Lamentabili*) (3 July 1907). *Acta Apostolicae Sedis* 40.

Denzinger, Henry. *Enchiridion Symbolorum, definitionum et declarationum de rebus fidei et morum*. 30th ed. Translated by Roy J. Deferrari. In *Sources of Catholic Dogma*. London: B. Herder Book Co., 1954.

Didascalia et Constitutiones Apostolorum. Edited by F. X. Funk. Vol. 1. Paderborn, 1905.

Drinan, Robert F. "Catholics and the Death Penalty." *America* 18 (June 1994): 13–15.

Duff, Charles. *A Handbook on Hanging*. London: Journeyman Press, 1981.

Dulles, Cardinal Avery, S.J. "The Death Penalty: A Right to Life Issue." Laurence J. McGinley Lecture, Fordham University, 17 October 2000.

Elsbernd, Mary. "Papal Statements on Rights: A Historical Contextual Study of Encyclical Teaching from Pius VI–Pius XI (1791–1939)." Ph.D. diss. Katholieke Universiteit Leuven, 1985.

Erez, Edna. "Thou Shalt Not Execute: Hebrew Law Perspective on Capital Punishment." *Criminology* 19, no. 1 (May 1981): 25–43.

Eusebius. *Church History.* In *Nicene and Post-Nicene Fathers,* 2d series, vol. 1. Edited by Philip Schaff and Henry Wace. Peabody, Mass.: Hendrickson Publishers, 1994. 81–403.

———. *The Life of Constantine the Great.* In *Nicene and Post-Nicene Fathers,* 2d series, vol. 1. Edited by Philip Schaff and Henry Wace. Peabody, Mass.: Hendrickson Publishers, 1994. 481–559.

Evans, Richard. *Rituals of Retribution: Capital Punishment in Germany 1600–1987.* New York: Oxford University Press, 1996.

Finnis, John M. *Aquinas: Moral, Political, and Legal Theory.* Founders of Modern Political and Social Thought. Oxford: Oxford University Press, 1998.

———. "Comment." In *Issues in Contemporary Legal Philosophy.* Edited by Ruth Gavison. Oxford: Clarendon Press, 1987. 62–75.

———. " 'Faith and Morals': A Note." *The Month* (February 1988): 563–67.

———. *Fundamentals of Ethics.* Washington, D.C.: Georgetown University Press, 1983.

———. "Meaning and Ambiguity in Punishment (and Penology)." *Osgoode Hall Law Journal* 10, no. 1 (August 1972): 264–68.

———. *Moral Absolutes: Tradition, Revision, and Truth.* Washington, D.C.: The Catholic University of America Press, 1991.

———. *Natural Law and Natural Rights.* Oxford: Clarendon Press, 1980.

———. "Old and New in Hart's Philosophy of Punishment." *The Oxford Review,* 6S (Trinity 1968), 73–80.

———. "The Restoration of Retribution." *Analysis* 32 (1971–72): 131–35.

Finnis, John M., Joseph Boyle, Jr., and Germain Grisez. *Nuclear Deterrence, Morality and Realism.* Oxford: Oxford University Press, 1987.

Finnis, John, and Germain Grisez. "The Basic Principles of Natural Law: A Reply to Ralph McInerny." In *Readings in Moral Theology,* no. 7. Edited by Charles E. Curran and Richard A. McCormick, S.J. Mahway, N.J.: Paulist Press, 1991. 157–70.

First Vatican Council (1869–70). "Dogmatic Constitution on the Catholic Faith" (*Dei Filius*). In *Decrees of the Ecumenical Councils,* vol. 2. Edited by Norman P. Tanner, S.J., and G. Alberigo. London: Sheed and Ward, 1990.

Fitzmyer, Joseph A., S.J. *Romans.* Series Anchor Bible. New York: Doubleday, 1993.

Ford, John C., S.J., and Germain Grisez. "Contraception and the Infallibility of the Ordinary Magisterium." *Theological Studies* 39, no. 2 (June 1978): 258–312.

Genicot, Edward, S.J. *Institutiones Theologiae Moralis.* Brussels: Alb. Dewit, 1927.

Gratian. *Concordantia discordantium canonum (Decretum Magistri Gratiani).* In *Corpus Iuris Canonici,* vol. 1. Lipsiae: Ex Officina Bernhardi Tauchnitz, 1879.

Greenberg, J. "Crimes and Punishments." *Interpreter's Dictionary of the Bible,* vol. 1. New York: Abingdon Press, 1962.

Gregory the Great. *Epistle XLVII*, to Sabinianus. In *Nicene and Post-Nicene Fathers*, 2d series, vol. 12. Edited by Philip Schaff and Henry Wace. Peabody, Mass.: Hendrickson Publishers, 1994. 161.

Gregory of Nazianzus. *Epistola LXXVIII*. In *Patrologia Cursus Completus, Series Graeca*, vol. 37. Edited by J. P. Migne, 1862. Cols. 147A–C.

———. *Oratio XVII*. In *Patrologia Cursus Completus, Series Graeca*, vol. 35. Edited by J. P. Migne, 1857. Cols. 963B–982A.

Grisez, Germain. *Christian Moral Principles*. Vol. 1 of *The Way of the Lord Jesus*. Chicago: Franciscan Herald Press, 1983.

———. "A Critique of Russell Hittinger's Book, *A Critique of the New Natural Law Theory*." *The New Scholasticism* 62, no. 4 (Autumn 1988): 438–65.

———. *Living a Christian Life*. Vol. 2 of *The Way of the Lord Jesus*. Quincy, Ill.: Franciscan Press, 1993.

———. "On the Interpretation of Dogmas." Unpublished, 1988.

———. "Toward a Consistent Natural-Law Ethics of Killing." *The American Journal of Jurisprudence* 15 (1970): 64–96.

Grisez, Germain, and Joseph M. Boyle, Jr. *Life and Death with Liberty and Justice: A Contribution to the Euthanasia Debate*. Notre Dame, Ind.: University of Notre Dame Press, 1979.

Grisez, Germain, Joseph Boyle, Jr., and John Finnis. "Practical Principles, Moral Truth, and Ultimate Ends." *The American Journal of Jurisprudence* 32 (1987): 99–151.

Grisez, Germain, and Russell Shaw. *Beyond the New Morality*. 3rd ed. Notre Dame, Ind.: University of Notre Dame Press, 1988.

Grotius, Hugo. "On the Law of War and Peace." In *Moral Philosophy from Montaigne to Kant: An Anthology*, vol. 1. Edited by J. B. Schneewind. Cambridge: Cambridge University Press, 1990.

Gury, Joanne Petro, S.J. *Compendium Theologiae Moralis*. Regensburg: Typis et Sumptibus Georgii Josephi Manz, 1868.

Haine, A. J. J. F. *Theologiae Moralis*. 5th ed. Rome: Desclée, 1900.

Hansen, Mark. "Danger vs. Due Process." *American Bar Association Journal* (August 1997): 43.

Harland, P. J. *The Value of Human Life: A Study of the Story of the Flood (Gen. 6–9)*. Leiden, New York, Köln: E. J. Brill, 1996.

Hart, H. L. A. *Law, Liberty and Morality*. Oxford: Oxford University Press. 1963.

———. "Prolegomenon to the Principles of Punishment." In *Philosophy of Punishment*. Edited by Robert M. Baird and S. E. Rosenbaum. New York: Prometheus Books, 1988. 15–21.

———. *Punishment and Responsibility: Essays in the Philosophy of Law*. Oxford: Clarendon Press, 1995.

Hegel, Georg Wilhelm Friedrich. *Hegel's Philosophy of Right*. Translated by T. M. Knox. Oxford: Oxford University Press, 1967.

Hincmar of Reims. *De Regis Persona et Regio Ministerio*. In *Patrologia Cursus Completus, Series Latina*, vol. 125. Edited by J. P. Migne, 1852. Cols. 833B–856D.

Higgins, Michael. "Is Capital Punishment for Killers Only?" *American Bar Association Journal* (August 1997): 30–31.

Hippolytus. *The Apostolic Tradition of St. Hippolytus of Rome*. Edited by Gregory Dix. Reissued by Henry Chadwick. London: S.P.C.K., 1968.

Hittinger, Russell. *A Critique of the New Natural Law Theory*. Notre Dame, Ind.: University of Notre Dame Press, 1987.

Hobbes, Thomas. *Leviathan*. Edited by Richard Tuck. Cambridge Texts in the History of Political Thought. Cambridge: Cambridge University Press, 1991.

Honecker, Martin. "Capital Punishment in German Protestant Theology." *Concilium* 120 (1978): 54–63.

Honeyman, Jennifer C., and James Ogloff. "Capital Punishment: Arguments for Life and Death." *Canadian Journal of Behavioral Sciences* 28 (1 January 1996). Available at http://www.cpa.ca/cjbsnew/1996/ful_ogloff.html.

Hood, Roger. *The Death Penalty: A World-wide Perspective*. Oxford: Clarendon Press, 1996.

Hornum, Finn. "Two Debates: France, 1791; England, 1956." In *Capital Punishment*. Edited by Thorsten Sellin. New York: Harper and Row, 1967.

Hughes, Philip. *A History of the Church*. Vol. 2. New York: Sheed and Ward, 1949.

Imbert, Jean. *La Peine de mort: Histoire-actualité*. Paris: Armand Colin, 1967.

Innocent I, Pope. *Epistle VI*, to Exsuperium. In *Patrologia Cursus Completus, Series Latina*, vol. 20. Edited by J. P. Migne, 1845. Cols. 495A–502A.

Innocent III, Pope. "Letter of 14 June 1210." In *Patrologia Cursus Completus, Series Latina*, vol. 216. Edited by J. P. Migne, 1855. Cols. 289A–293A.

———. "Letter to Durand of Huesca and his brethren (5 July 1209)." In *Heresies of the High Middle Ages*. Edited by Walter L. Wakefield and Austin P. Evans. New York: Columbia University Press, 1969. 226–28.

———. "Profession of Faith Prescribed for Durand of Osca and His Waldensian Companions." In *Enchiridion Symbolorum, definitionum et declarationum de rebus fidei et morum*, 30th ed., nos. 420–27. Edited by Henry Denzinger. Translated by Roy J. Deferrari. In *Sources of Catholic Dogma*. London: B. Herder Book Co., 1957.

———. "To the archbishop and suffragans of the Church of Tarragona (18 December 1208)." In *Heresies of the High Middle Ages*. Edited by Walter L. Wakefield and Austin P. Evans. New York: Columbia University Press, 1969. 222–26.

Irenaeus of Lyons. *Against Heresies*. In *Ante-Nicene Fathers*, vol. 1. Edited by Alexander Roberts and James Donaldson. Peabody, Mass.: Hendrickson Publishers, 1994. 315–567.

Irish Commission for Justice and Peace (Irish Bishops). "Capital Punishment." *The Furrow* 27 (1976): 697–98, and *La Documentation Catholique* 78 (1981): 581–84.

Jerome. *Commentariorum in Jeremiam*. In *Patrologia Cursus Completus, Series Latina*, vol. 24. Edited by J. P. Migne, 1845. Cols. 679–900.

John XXIII, Pope. *On Establishing Universal Peace in Truth, Justice, Charity and Liberty (Pacem in Terris)* (11 April 1963). Vatican translation. London: Catholic Truth Society, 1963.

John Paul II, Pope. *Ad Tuendam Fidem* (18 May 1998). *Origins* 28, no. 8 (16 July 1998): 115, 117–18.

———. *Catechismus Catholicae Ecclesiae. Editio typica Latina*. Rome: Liberia Editrice Vaticana, 1997.

———. "Homily at the Saint Louis Trans World Dome" (27 January 1999). *Origins* 28, no. 34 (11 February 1999).

———. "Illuminating Present World Problems with Bethlehem's Light" (*Urbi et Orbi* address, 25 December 1998). *Origins* 28, no. 29 (7 January 1999): 505–6.

———. *On the Value and Inviolability of Human Life (Evangelium Vitae)* (25 March 1995). Vatican translation. New York: Random House, 1995.

———. *Regarding Certain Fundamental Questions of the Church's Moral Teaching (Veritatis Splendor)* (6 August 1993). Vatican translation. Boston: St. Paul Books and Media.

———. "Vatican List of Catechism Changes." *Origins* 27, no. 15 (25 September 1997): 257–62.

John of Salisbury. *Policraticus: Of the Frivolities of Courtiers and the Footprints of Philosophers*. Translated by Cary J. Nederman. Cambridge Texts in the History of Political Thought. Cambridge: Cambridge University Press, 1990.

Johnston, L. "Old Testament Morality." *Catholic Biblical Quarterly* 20 (1958): 19–25.

Justin Martyr. *The First Apology*. In *Fathers of the Church*, vol. 6. Translated by Thomas Falls. New York: Christian Heritage, 1948. 33–111.

Kant, Immanuel. *Groundwork of the Metaphysics of Morals*. Translated by H. J. Paton. New York: Harper and Row, 1964.

———. *The Metaphysics of Morals*. Translated by Mary Gregor. Cambridge: Cambridge University Press, 1991.

———. *Political Writings*. Edited by Hans Reiss. Cambridge Texts in the History of Political Thought. Cambridge: Cambridge University Press, 1970.

Käsemann, Ernst. *Commentary on Romans*. Grand Rapids: Eerdmans, 1980.

———. "Principles of Interpretation of Romans 13." In *New Testament Questions of Today*. Philadelphia: Fortress Press, 1969.

Kaufman, Irving R. "Sentencing: The Judge's Problem." *The Atlantic Monthly* (January 1960). Available at http://www.theatlantic.com/unbound/flashbks/death/kaufman.htm.

Kennedy, A. R. S. "Ban." *Dictionary of the Bible*. Edited by J. Hastings (1909; reprint, New York: Charles Scribner and Son, 1963).

Kenny, Anthony. *Freewill and Responsibility.* London: Routledge and Kegan Paul, 1978.

Koestler, Arthur. *Reflections on Hanging.* New York: MacMillan, 1957.

Lactantius. *De Ira.* In *Corpus Scriptorum Ecclesiasticorum Latinorum*, vol. 27. Translated in *Ante-Nicene Fathers*, vol. 7. Edited by Alexander Roberts and James Donaldson. Peabody, Mass.: Hendrickson Publishers, 1994. 259–80.

———. *Divinae Institutiones.* In *Corpus Scriptorum Ecclesiasticorum Latinorum*, vol. 19. Translated in *Ante-Nicene Fathers*, vol. 7. Edited by Alexander Roberts and James Donaldson. Peabody, Mass.: Hendrickson Publishers, 1994. 9–223.

———. *Epitome Divinarum Institutionum.* In *Corpus Scriptorum Ecclesiasticorum Latinorum*, vol. 19. Translated in *Ante-Nicene Fathers*, vol. 7. Edited by Alexander Roberts and James Donaldson. Peabody, Mass.: Hendrickson Publishers, 1994. 224–55.

Lambert, Malcolm. *Medieval Heresy: Popular Movements from the Gregorian Reform to the Reformation.* 2d ed. Oxford: Blackwell, 1992.

Langan, John, S.J. "Capital Punishment." *Theological Studies* 54, no. 1 (March 1993): 111–24.

Lateran Council IV (1215). "Constitution 18." In *Decrees of the Ecumenical Councils*, vol. 1. Edited by Norman P. Tanner, S.J., and G. Alberigo. London: Sheed and Ward, 1990.

Latourelle, René, S.J. *Theology of Revelation.* New York: Alba House, 1966.

Leclercq, Jacques. *Les Droits et devoirs individuels.* Vol. 4 of *Leçons de droit naturel.* Louvain: Société D'Études Morales, 1946.

Leo the Great. *Epistola XV.* In *Patrologia Cursus Completus, Series Latina*, vol. 54. Edited by J. P. Migne, 1865. Cols. 677B–692B.

Leo X, Pope. *Bull Exsurge Domine* (1520) (Errors of Luther Condemned). In *Enchiridion Symbolorum, definitionum et declarationum de rebus fidei et morum*, 30th ed., no. 773. Edited by Henry Denzinger. Translated by Roy J. Deferrari. In *Sources of Catholic Dogma.* London: B. Herder Book Co., 1957.

Leo XIII, Pope. *Pastoralis Officii* (to the bishops of Germany and Austria) (12 September 1891). *Acta Sanctae Sedis* 24 (1891/92): 204b.

Lépicier, Alexius Marie. *De Stabilitate et Progressu Dogmatis.* 2d ed. Rome: Desclée, 1910. Excerpted in "The Death Penalty for Heresy: From 1184 to 1921 A.D.," by George Gordon Coulton, *Medieval Studies* 18 (1924): 62–69.

Lessius, Leonard. *De Iustitia et Iure Caeterisque Virtutibus* (Commentary on *Summa Theologiae*, II-II, qq. 47–171). Paris, 1606.

Lewis, C. S. "The Humanitarian Theory of Punishment." In *God in the Dock.* Edited by Walter Hooper. Grand Rapids: Eerdmans Publishing Co., 1970. 287–300.

Liguori, Alphonsus Marie de. *Theologia Moralis.* Rome: Ex Typographia Vaticana, 1905.

Linsenmann, F. X. *Lehrbuch der Moraltheologie.* Freiburg im Breisgau: Herder, 1878.

Locke, John. *Second Treatise on Government.* Edited by Richard Cox. Arlington Heights, Ill.: Harlan Davidson, 1982.

Long, Steven A. "*Evangelium Vitae*, St. Thomas Aquinas, and the Death Penalty." *The Thomist* 63, no. 4 (October 1999): 511–52.

Manson, T. W. "St. Paul's Letter to the Romans—and Others." In *The Romans Debate*, rev. ed. Edited by Karl P. Donfried. Peabody, Mass.: Hendrickson Publishers, 1991.

Map, Walter. *De nugis curialium*. Translated by Montague R. James. In *Heresies of the High Middle Ages*. Edited by Walter L. Wakefield and Austin P. Evans. New York: Columbia University Press, 1969. 202–3.

Martino, Renato. "The United Nations and the Death Penalty." *Origins* 28, no. 39 (8 March 1999): 682–85.

Masur, Louis P. *Rites of Execution: Capital Punishment and the Transformation of American Culture, 1776–1865*. New York: Oxford University Press, 1989.

McDonald, John F. *Capital Punishment*. London: Catholic Truth Society, 1964.

McHugh, John A., O.P., and Charles J. Callan, O.P. *Moral Theology: A Complete Course*. Vol. 2. New York: Joseph F. Wagner, 1930.

McInerny, Ralph. "The Principles of Natural Law." In *Readings in Moral Theology*, no. 7. Edited by Charles E. Curran and Richard A. McCormick, S.J. Mahway, N.J.: Paulist Press, 1991. 139–56.

McLynn, Niel B. *Ambrose of Milan: Church and Court in a Christian Capital*. Berkeley: University of California Press, 1994.

Megivern, James J. *The Death Penalty: An Historical and Theological Survey*. New York: Paulist Press, 1997.

Merkelbach, Benedict, O.P. *Summa Theologiae Moralis*. Paris: Desclée, 1932.

Messineo, Antonio, S.J. "Il Diritto alla Vita." *Civiltà Cattolica* 2 (1960): 449–62.

Mill, John Stuart. "Speech (before Parliament) in Favor of Capital Punishment (21 April 1868)." Available at http://ethics.acusd.edu/Mill.html.

Minucius Felix. *Octavius*. In *Fathers of the Church*, vol. 10. Translated by R. Arbesmann. Washington, D.C.: The Catholic University of America Press, 1950. 321–402.

Montagu, Basil, ed. *The Opinions of Different Authors upon the Punishment of Death*. 3 vols. London: Longman, Hurst, Rees, Orme and Brown, Paternoster Row, 1809. Reprint, New York: Hein and Co., 1984.

Mooney, Michael. "The Morality of State-Punishment." Ph.D. diss. Maynooth College, 1942.

———. "The Morality of State-Punishment." *The Irish Ecclesiastical Record* (August 1942): 127–43.

———. "The Morality of State-Punishment: Medicinal and Deterrent Theories." *The Irish Ecclesiastical Record* (February 1943): 104–15.

———. "The Morality of State-Punishment: The True Notion of Punishment." *The Irish Ecclesiastical Record* (1943): 167–78.

Morris, Herbert. "Persons and Punishment." In *Philosophy of Punishment*. Edited by Robert M. Baird and Stuart E. Rosenbaum. New York: Prometheus Books, 1988. 67–82.

Murphy, Jeffrie G. "Marxism and Retribution." In *Retribution, Justice, and Therapy: Essays in the Philosophy of Law*. Edited by Jeffrie Murphy. Dordrecht: D. Reidel, 1979.

———. "Three Mistakes About Retribution." *Analysis* 31 (1970–71): 166–69.

Nathanson, Stephen. "Does It Matter if the Death Penalty Is Arbitrarily Administered?" In *Philosophy of Punishment.* Edited by Robert M. Baird and S. E. Rosenbaum. New York: Prometheus Books, 1988. 95–108.

National Conference of Catholic Bishops (USA). "Human Dignity and the Value of Life." *Origins* 7, no. 18 (20 October 1977): 287.

———. "Statement on Capital Punishment." In *Pastoral Letters of the United States Catholic Bishops.* Edited by Hugh J. Nolan. Vol. 4, 427–34. Washington, D.C.: National Conference of Catholic Bishops, United States Catholic Conference, 1984.

Neuhaus, Richard J. "The Public Square" (quoting Joseph Cardinal Ratzinger). *First Things*, no. 56 (October 1995): 83.

Newman, John Henry. *An Essay on the Development of Christian Doctrine.* Notre Dame, Ind.: University of Notre Dame Press, 1989.

Nicholas I, Pope. *Epistle 97*, Letter to the Bulgars. In "Capital Punishment and Torture in the Tradition of the Roman Catholic Church," by Francesco Compagnoni, O.P. *Concilium* 120 (1978): 47–48.

———. "Letter to Archbishop Albino." In *Decretum Magistri Gratiani*, Causa XXXIII, q. II, c. VI. In *Corpus Iuris Canonici*, vol. 1. Lipsiae: Ex Officina Bernhardi Tauchnitz, 1879.

Noldin, H., S.J., and A. Schmitt, S.J. *Summa Theologiae Moralis.* Vol. 2. Oeniponte: Typis et Sumptibus Feliciani Rauch, 1957.

Noonan, John T., Jr. *Contraception: A History of Its Treatment by the Catholic Theologians and Canonists.* Enlarged ed. Cambridge: Harvard University Press, 1986.

O'Collins, Gerald, S.J., and Edward G. Farrugia, S.J. "Doctrine" and "Dogma." *A Concise Dictionary of Theology.* Mahwah, N.J. : Paulist Press, 1991.

O'Donovan, Oliver. "Peine." *Dictionnaire critique de théologie.* Edited by Jean-Yves Lacoste. Paris: Presses Universitaires de France, 1998. 877–80.

———. Review of *The Death Penalty: For and Against*, by Lous P. Pojman and Jeffrey Reiman. In *Studies in Christian Ethics* 13, no. 1 (1999): 141–43.

———. "Todesstrafe." *Theologische Realenzyklopädie.* Edited by Gerhard Müller. Berlin: Verlag Walter de Gruyter, forthcoming.

Ojetti, Benedict, S.J. *Synopsis Rerum Moralium et Iuris Pontificii.* 3rd ed. Rome: Polygraphica Editrice, 1911.

Origen. *Comment. In Epist. ad Rom. Lib. VI.* In *Patrologia Cursus Completus, Series Graeca*, vol. 14. Edited by J. P. Migne, 1857. Cols. 1055B–1102D.

———. *Comment. In Epist. ad Rom. Lib. IX.* In *Patrologia Cursus Completus, Series Graeca*, vol. 14. Edited by J. P. Migne, 1857. Cols. 1201C–1250B.

———. *Comment. In Matthaeum Tomus X.* In *Patrologia Cursus Completus, Series Graeca*, vol. 13. Edited by J. P. Migne, 1857. Cols. 835A–904A.

———. *Contra Celsum.* Translated by Henry Chadwick. Cambridge: Cambridge University Press, 1953.

————. *In Jeremiam Homilia XII*. In *Patrologia Cursus Completus, Series Graeca*, vol. 13. Edited by J. P. Migne, 1857. Cols. 378A–398D.

————. *In Leviticum Homilia XI*. In *Patrologia Cursus Completus, Series Graeca*, vol. 12. Edited by J. P. Migne, 1857. Cols. 529A–535A.

————. *In Leviticum Homilia XIV*. In *Patrologia Cursus Completus, Series Graeca*, vol. 12. Edited by J. P. Migne, 1857. Cols. 552B–558C.

————. *In Matthaeum* (Series *Veteris Interpretationis Commentariorum Origenis in Matthaeum*), par. 83. In *Patrologia Cursus Completus, Series Graeca*, vol. 13. Edited by J. P. Migne, 1857. Cols. 1732C–1733A.

Passau Anonymous. "Tractate Concerning the Waldensians." In *Heresy and Authority in Medieval Europe: Documents in Translation*. Edited by Edward Peters. London: Scholar Press, 1980. 163.

Paul VI, Pope. *On the Regulation of Birth* (*Humanae Vitae*) (25 July 1968). Boston: St. Paul Books and Media.

Pelikan, Jaroslav. *The Spirit of Eastern Christendom (600–1700)*. Vol. 2 of *The Christian Tradition: A History of the Development of Doctrine*. Chicago: University of Chicago Press, 1974.

Peter of Vaux-de-Cernay. *Hystoria albigensis*. In *Heresies of the High Middle Ages*. Edited by Walter L. Wakefield and Austin P. Evans. New York: Columbia University Press, 1969. 240–41.

Peters, Edward, ed. and trans. *Heresy and Authority in Medieval Europe: Documents in Translation*. London: Scholar Press, 1980.

————. *Inquisition*. Berkeley: University of California Press, 1988.

Philippine Bishops. "Restoring the Death Penalty: 'A Backward Step.'" *Catholic International* 3 (1992): 886–88.

Phillips, Anthony. "Deuteronomy." In *The Cambridge Bible Commentary*. Edited by P. R. Ackroyd, A. R. Cleaney, and J. I. Packer. Cambridge: Cambridge University Press, 1973.

Pius V, Pope. *Catechism of the Council of Trent for Parish Priests*. Translated by John A. McHugh, O.P., and Charles J. Callan, O.P. New York: Joseph F. Wagner, 1923.

Pius XI, Pope. *Mortalium animos*. *Acta Apostolicae Sedis* 20 (1928).

————. "On Christian Marriage" (*Casti Connubii*) (1930). Vatican translation. Boston: Daughters of St. Paul.

Pius XII, Pope. "Address to the Italian Association of Catholic Jurists" (5 December 1954). *Acta Apostolicae Sedis* 47 (1955). English translation, *Catholic Mind* 53 (1955): 364–73.

————. "Address to Italian Jurists" (26 May 1957). *Acta Apostolicae Sedis* 49 (1957).

————. "Christmas Message" (24 December 1944). *Acta Apostolicae Sedis* 37 (1945).

————. "Christmas Message" (24 December 1948). *Acta Apostolicae Sedis* 41 (1949).

————. "Concerning Some False Opinions Which Threaten to Undermine the Foundations of Catholic Doctrine" (*Humani Generis*). *Acta Apostolicae Sedis* 42 (1950). In

Enchiridion Symbolorum, definitionum et declarationum de rebus fidei et morum, 30th ed., nos. 2305–2330. Edited by Henry Denzinger. Translated by Roy J. Deferrari. In *Sources of Catholic Dogma.* London: B. Herder Book Co., 1957.

———. "Lis qui interfuerunt Conventui primo internationali de Histopathologia Systematis nervorum" (13 September 1952). *Acta Apostolicae Sedis* 44 (1952). English translation, "Address to the First International Congress on the Histopathology of the Nervous System." *Catholic Mind* 51 (1953): 305–13.

———. *The Mind of Pius XII.* Edited by Robert C. Pollock. London: Fireside Press, 1955.

———. "Nous croyons que très" (3 October 1953). *Acta Apostolicae Sedis* 45 (1953). English translation, "Address to the Sixth International Congress of Penal Law." *Catholic Mind* 52 (1954): 107–18.

Plato. *Gorgias.* Translated by W. D. Woodhead. In *The Collected Dialogues of Plato.* Edited by E. Hamilton and H. Cairns. Princeton: Princeton University Press, 1989. 229–307.

———. *Laws.* Translated by A. E. Taylor. In *The Collected Dialogues of Plato.* Edited by E. Hamilton and H. Cairns. Princeton: Princeton University Press, 1989. 1225–1513.

———. *Protagoras.* Translated by W. K. C. Guthrie. In *The Collected Dialogues of Plato.* Edited by E. Hamilton and H. Cairns. Princeton: Princeton University Press, 1989. 308–52.

Playfair, Giles. "Is the Death Penalty Necessary?" *The Atlantic Monthly* (September 1957). Available at http://www.theatlantic.com/unbound/flashbks/death/playnecc.htm.

Pontifical Commission for Justice and Peace. "The Church & the Death Penalty." *Origins* 6, no. 25 (9 December 1976): 389, 391–92.

Potter, Harry. *Hanging in Judgement: Religion and the Death Penalty in England from the Bloody Code to Abolition.* London: SCM Press, 1993.

Pro Ecclesia (pseud.). *Capital Punishment Not Opposed to the Doctrine of the Christian Religion: Considered in Two Letters by a Priest of the Catholic Church.* London: William Pickering, 1850.

———. *The Conduct of the Populace at Executions Not a Conclusive Proof of the Inefficiency of Capital Punishment: Considered in Two Letters by a Priest of the Catholic Church.* London: William Pickering, 1850.

Prümmer, Dominic M., O.P. *Handbook of Moral Theology.* Cork: Mercier Press, 1956.

———. *Manuale Theologiae Moralis.* Freiburg: Herder and Co., 1923.

———. *Vademecum Theologiae Moralis.* Freiburg: Herder and Co., 1921.

Ratzinger, Joseph Cardinal. "Commentary on Profession of Faith's Concluding Paragraph" (June 1998). Vatican translation. *Origins* 28, no. 8 (July 1998): 116–19.

———. Miscellaneous Comments on *Evangelium Vitae,* no. 56. *Origins* 27, no. 6 (June 1997): 84, gloss.

Rawls, John. *A Theory of Justice.* Oxford: Oxford University Press, 1972.

———. "Two Concepts of Rules." *The Philosophical Review* 64 (1955): 3–13.

Regan, Augustine, C.SS.R. "Image of God." *Studia Moralia* 4 (1966): 115–39.

————. "Moral Argument on Self-Killing." *Studia Moralia* 18 (1980): 299–332.

————. "The Worth of Human Life." *Studia Moralia* 6 (1968): 207–77.

Reiman, Jeffrey. "Justice, Civilization and the Death Penalty: Answering van den Haag." *Philosophy and Public Affairs* 14 (Spring 1985): 119–34.

Review of *Della pena capitale*, by Pietro Ellero. Tipografia del Commercio, Venice. *Civiltà Cattolica*, series 4, vol. 7 (1860): 589–98.

Review of *Della pena di morte: Lezioni accademiche* (academic lectures), by P. L. Albini. Vigevano, 1852. *Civiltà Cattolica*, series 2, vol. 3 (1853): 432–42.

Rhode Island Religious Leaders. "Statement on Capital Punishment." *Origins* 5, no. 40 (25 March 1976): 629–32.

Rousseau, Jean-Jacques. *The Social Contract*. Translated by Maurice Cranston. London: Penguin Books, 1968.

Sabetti, Aloysius, S.J., and Timothy Barrett, S.J. *Compendium Theologiae Moralis*. Cincinnati: Frederick Pustet Co., 1939.

Sacconi, Rainier. "Inquisitor's records of interrogations of 1254: Concerning the heresy of the Leonists, or the Poor Men of Lyons." In *Heresy and Authority in Medieval Europe: Documents in Translation*. Edited by Edward Peters. London: Scholar Press, 1980. 142.

Scavini, Petro. *Theologia Moralis Universa*. Paris: Jacob Lecoffre, 1863.

Scharbert, Josef. "Blood." In *Encyclopedia of Biblical Theology*, vol. 1. Edited by J. Bauer. London: Sheed and Ward, 1970.

Schillebeeckx, Edward, O.P. *Revelation and Theology*. Vol. 2. New York: Sheed and Ward, 1968.

Schmid, Josef. "Blood of Christ." In *Encyclopedia of Biblical Theology*, vol. 1. Edited by J. Bauer. London: Sheed and Ward, 1970.

Schönborn, Christoph Cardinal. "Brief Note on the Revision of the Passages in the Catechism of the Catholic Church Having to Do with the Death Penalty." *Catholic Dossier* 4, no. 5 (September–October 1998): 9–11.

Schöpf, Bernard. *Das Tötungsrecht bei den frühchristlichen Schriftstellern*. Regensburg: Friedrich Pustet, 1958.

Scotus, Ioannes Duns. *Quaestiones in Lib IV Sententiarum*. In *Opera Omnia*, vol. 9. Reprint from 1683 edition, Hildesheim: Georg Olms Verlagsbuchhandlung, 1968.

Second Vatican Council. "Declaration on Religious Freedom." (*Dignitatis Humanae*) (7 December 1965). In *Decrees of the Ecumenical Councils*, vol. 2. Edited by Norman P. Tanner, S.J., and G. Alberigo. London: Sheed and Ward, 1990.

————. "Dogmatic Constitution on the Church" (*Lumen Gentium*) (21 November 1964). In *Decrees of the Ecumenical Councils*, vol. 2. Edited by Norman P. Tanner, S.J., and G. Alberigo. London: Sheed and Ward, 1990.

————. "Dogmatic Constitution on Divine Revelation" (*Dei Verbum*) (18 November 1965). In *Decrees of the Ecumenical Councils*, vol. 2. Edited by Norman P. Tanner, S.J., and G. Alberigo. London: Sheed and Ward, 1990.

————. "Pastoral Constitution on the Church in the Modern World" (*Gaudium et Spes*) (7 December 1965). In *Decrees of the Ecumenical Councils*, vol. 2. Edited by Norman P. Tanner, S.J., and G. Alberigo. London: Sheed and Ward, 1990.

Seneca. *De Ira*. In *Moral Essays*, vol. 1. Translated by John Basore. Loeb Classical Library. Cambridge: Harvard University Press, 1928. 106–355.

Shaw, George Bernard. "Capital Punishment." *The Atlantic Monthly* (June 1948). Available at http://www.theatlantic.com/unbound/flashbks/death/dpenshaw.htm.

Skoda, Francis. "Doctrina Moralis Catholica de Poena Mortis A C. Beccaria Usque ad Nostros Dies (A. 1956)." Ph.D. diss. Pontifical Lateran University, 1959.

Soane, Brendan. *Capital Punishment: What Does the Church Teach?* London: Catholic Truth Society, 1986.

Social Commission of the French Episcopate. "Éléments de refléxion sur la peine de mort." *La Documentation Catholique* 75 (1978): 108–15.

Stephen of Bourbon. *Tractatus de diversis materiis praedicabilis*. In *Heresies of the High Middle Ages*. Edited by Walter L. Wakefield and Austin P. Evans. New York: Columbia University Press, 1969. 208–10.

Suárez, Francisco, S.J. *Opera Omnia* (1856).

Sullivan, Francis A., S.J. "The Authority of the Magisterium on Questions of Natural Moral Law." In *Readings in Moral Theology*, no. 6. Edited by Charles E. Curran and Richard A. McCormick, S.J. Mahwah, N.J.: Paulist Press, 1988. 53–57.

————. *Creative Fidelity: Weighing and Interpreting Documents of the Magisterium*. Dublin: Gill and Macmillan, 1996.

Tanquerey, Edward. *Synopsis Theologiae Moralis et Pastoralis*. 8th ed. Rome: Desclée, 1927.

Ten, C. L. *Crime, Guilt, and Punishment*. Oxford: Clarendon Press, 1987.

Tertullian. *Apology*. In *Fathers of the Church*, vol. 10. Translated by Emily J. Daly, C.S.J. Washington, D.C.: The Catholic University of America Press, 1950. 7–126.

————. *De Anima*. In *Fathers of the Church*, vol. 10. Translated by Edwin A. Quain, S.J. Washington, D.C.: The Catholic University of America Press, 1950. 179–309.

————. *De Corona*. In *Fathers of the Church*, vol. 40. Translated by Edwin A. Quain, S.J. New York: Fathers of the Church, 1959. 231–67.

————. *De Idolatria*. In *Ante-Nicene Fathers*, vol. 3. Edited by Alexander Roberts and James Donaldson. Peabody, Mass.: Hendrickson Publishers, 1994. 61–76.

————. *De Spectaculis*. In *Fathers of the Church*, vol. 40. Translated by Rudolph Arbesmann, O.S.A. New York: Fathers of the Church, 1959. 47–107.

————. *Scorpiace*. In *Ante-Nicene Fathers*, vol. 3. Edited by Alexander Roberts and James Donaldson. Peabody, Mass.: Hendrickson Publishers, 1994. 633–48.

————. *Treatise on the Resurrection*. Edited by Ernest Evans. London: S.P.C.K., 1960.

Thamiry, Edouard. "Mort (Peine de)." In *Dictionnaire de Théologie Catholique*, ed. A. Vacant and E. Mangenot, vol. 10 (1929). Paris VI: Letouzey et Ané, 1923–1950.

Theodore the Studite. *Epistola CLV*, to Theophilus of Ephesus. In *Patrologia Cursus Completus, Series Graeca*, vol. 99. Edited by J. P. Migne, 1860. Cols. 1482C–1486D.

Theophilus of Antioch. "To Autolycus." In *Ante-Nicene Fathers*, vol. 2. Edited by Alexander Roberts and James Donaldson. Peabody, Mass.: Hendrickson Publishers, 1994. 89–121.

Thoma, Clemens. "The Death Penalty and Torture in the Jewish Tradition." *Concilium* 120 (1978): 64–74.

Tidmarsh, Mannes, O.P., J. D. Halloran, and K. J. Connolly. *Capital Punishment: A Case for Abolition*. London: Sheed and Ward, 1963.

Treesh, Susanna K. "The Waldensian Recourse to Violence." *Church History* 55 (1986): 294–306.

Ude, Johannes. *Du sollst nicht töten!* Dornbirn: Hugo Mayer, 1948.

United Nations. *Universal Declaration of Human Rights*. General Assembly Resolution 217 (10 December 1948).

United Nations, Department of Economic and Social Affairs. *Capital Punishment*. New York, 1962.

———. *Capital Punishment*. New York, 1968.

United Nations, Social Defense Research Institute. *The Death Penalty: A Bibliographical Research*. New York, 1988.

United States Catholic Conference. "The Challenge of Peace: God's Promise and Our Response" (3 May 1983). *Origins* 13, no. 1 (19 May 1983): 8–9.

———. "A Community Response to Crime." *Origins* 7, no. 38 (9 March 1978): 593–604.

———. "Resolution against Capital Punishment" (18 November 1974). In *Pastoral Letters of the United States Catholic Bishops*. Edited by Hugh J. Nolan. Vol. 3, 464. Washington, D.C.: National Conference of Catholic Bishops, United States Catholic Conference, 1984.

United States Supreme Court. *Furman v. Georgia* (1972), Justice Stewart concurring. In *The Death Penalty in America: Current Controversies*. Edited by Hugo A. Bedau. Oxford: Oxford University Press, 1997. 189–95.

———. *Gregg v. Georgia* 428 U.S. 153 (1976), plurality opinion of Justice Potter Stewart. In *The Death Penalty in America: Current Controversies*. Edited by Hugo A. Bedau. Oxford: Oxford University Press, 1997. 196–205.

———. *Woodson v. North Carolina* 428 US 280 (1976), plurality opinion of Justice Potter Stewart. In *The Death Penalty in America: Current Controversies*. Edited by Hugo A. Bedau. Oxford: Oxford University Press, 1997. 206–9.

Van den Haag, Ernest. *The Death Penalty: A Debate*. New York: Plenum Press, 1983.

———. "The Death Penalty Once More." *University of California-Davis Law Review* 18, no. 4 (Summer 1985): 957–72. Reprint in *The Death Penalty in America: Current Controversies*. Edited by Hugo A. Bedau. Oxford: Oxford University Press, 1997. 445–56.

———. *Punishing Criminals: Concerning a Very Old and Painful Question*. New York: Basic Books, 1975.

———. "Refuting Reiman and Nathanson." In *Philosophy of Punishment*. Edited by Robert M. Baird and S. E. Rosenbaum. New York: Prometheus Books, 1988. 141–51.

————. "The Retributivist's Case against Capital Punishment" (van den Haag Replies). In *The Death Penalty: A Debate*. Edited by Ernest van den Haag. New York: Plenum Press, 1983. 28–53.

————. "The Ultimate Punishment: A Defense." *Harvard Law Review* 99 (May 1986): 1665–66.

Vermeersch, Arthur, S.J. *Theologiae Moralis*. 3rd ed. Rome: Pontificia Universitas Gregoriana, 1937.

Vincent of Lérins. *A Commonitory: For the Antiquity and Universality of the Catholic Faith Against the Profane Novelties of All Heresies*. In *Nicene and Post-Nicene Fathers*, 2d series, vol. 11. Edited by Philip Schaff and Henry Wace. Peabody, Mass.: Hendrickson Publishers, 1994. 131–56.

Wakefield, Walter L. *Heresy, Crusade and Inquisition in Southern France 1100–1250*. Berkeley: University of California Press, 1974.

Wakefield, Walter L., and Austin P. Evans, eds. *Heresies of the High Middle Ages: Selected Sources Translated and Annotated*. New York: Columbia University Press, 1969.

Wasserstrom, Richard. "Punishment v. Rehabilitation." In *Philosophy of Punishment*. Edited by Robert M. Baird and S. E. Rosenbaum. New York: Prometheus Books, 1988. 57–66.

Weinfeld, Moshe. "Book of Deuteronomy." *The Anchor Bible Dictionary*, vol. 2. New York, London: Doubleday, 1992. 168–82.

Weisengoff, John P. "Inerrancy of the Old Testament in Religious Matters." *The Catholic Biblical Quarterly* 17 (1955): 128–37.

Woodward, P. A., ed. *The Doctrine of Double Effect: Philosophers Debate a Controversial Moral Principle*. Notre Dame, Ind.: University of Notre Dame Press, 2001.

Wootton, Barbara. "Diminished Responsibility: A Layman's View." *Law Quarterly Review* 76 (1960): 224.

Wright, G. Ernest. "Romans 7:1–4." *The Interpreter's Bible*, vol. 2. New York: Abingdon Press, 1953.

Zalba, Marcellinus, S.J. *Theologiae Moralis Compendium*. Vol. 1. Madrid: Biblioteca De Autores Cristianos, 1958.

Zimring, Franklin E., and Gordon J. Hawkins. *Deterrence: The Legal Threat in Crime Control*. Chicago: University of Chicago Press, 1973.

INDEX OF AUTHORS

INDEX OF SUBJECTS